T0073763

MONKEY TO MAN

Monkey to Man

The Evolution of the March of Progress Image

GOWAN DAWSON

Yale

UNIVERSITY PRESS

NEW HAVEN AND LONDON

Published with assistance from the foundation established in memory
of Philip Hamilton McMillan of the Class of 1894, Yale College.

Yale University Press books may be purchased in quantity for educational, business,
or promotional use. For information, please e-mail sales.press@yale.edu (U.S. office)
or sales@yaleup.co.uk (U.K. office).

Set in Electra type by Integrated Publishing Solutions.
Printed in the United States of America.

Library of Congress Control Number: 2023938168
ISBN 978-0-300-27062-4 (hardcover : alk. paper)

A catalogue record for this book is available from the British Library.

This paper meets the requirements of ANSI/NISO Z39.48-1992
(Permanence of Paper).

10 9 8 7 6 5 4 3 2 1

For Thomas, Sam, and Alex Dawson

CONTENTS

CONTENTS

ACKNOWLEDGMENTS

Much of this book was written during the enforced social isolation of the Covid-19 pandemic. It is nevertheless the result of interactions, both in person and virtually, with many people and institutions, and I would like to record my thanks for the support and generosity shown to me during the time I was working on the book. I am particularly grateful to the Leverhulme Trust for the award of a Research Fellowship (RF-2020–085). A previous Leverhulme Fellowship (RF-2012–338) similarly facilitated the writing of my last book, so my gratitude and respect for the Trust's commitment to independent research is deeply felt. I also received funding from various sources at the University of Leicester, which enabled crucial research trips, provided a period of research leave, and helped with the cost of images and permissions as well as a subvention; again, I am very grateful.

I am greatly obliged to several friends and colleagues whose guidance helped shape the book. With enormous kindness, Janet Browne, George Levine, and Bernie Lightman all read the manuscript in its entirety (in fact, in a slightly longer version), and their enthusiasm and acumen are very much appreciated. I am also grateful to Jim Secord for reading and commenting on the initial chapters and to my colleague David Ekserdjian for lending his art historical expertise to later ones. Lisa David kindly read the chapters concerning her father, Rudolph Zallinger, and provided some unique insights into his working practices. As ever, Sally Shuttleworth has been a fount of wise counsel and encouragement. Additionally, the book has benefited from the suggestions and assistance of Rabah Aissaoui, Alison Bashford,

James Braund, James Chapman, Rosi Crane, Richard Fallon, Ian Hesketh, Erika Lorraine Milam, Keith Moore, Catherine Morley, Alison Pearn, Ruth Richardson, Anne Secord, Myrna Perez Sheldon, Victoria Stewart, Jon Topham, Matthew Wale, Paul White, and Claire Wood. It was at the urging of Toru Sasaki, while we strolled through one of Kyoto's Zen gardens in spring 2016, that I focused on what should be my next book project. The answer came soon after.

It has been a pleasure to work with Yale University Press, especially my editor, Jean Thomson Black, who has been encouraging and supportive since we first began discussing the book in summer 2019. Elizabeth Sylvia has also been very helpful in answering my queries, while Mary Pasti was an excellent copyeditor. Three anonymous readers for the press provided extremely generous and thoughtful feedback, which, I am sure, has improved the final book. I would like to take this opportunity to thank them for their time and effort.

This book could not have been written, at least not in its current form, without the assistance and kindness of numerous librarians, archivists, and museum professionals. Research trips to New Haven, New York, and Washington, DC, in April 2018 and October 2019, were particularly invaluable, and I am indebted to all those who helped make them so productive. At the Yale Peabody Museum of Natural History, I would like to thank Daniel Brinkman, Armand Morgan, Barbara Narendra, and Nathan Utrup (for photography). At the American Museum of Natural History, my thanks go to Susan Bell, Carl Mehling, Gregory Raml, and Mai Reitmeyer. And at the Smithsonian National Museum of Natural History, I am very grateful to Jennifer Clark, Brittany M. Hance (for photography), Rick Potts, and Kristen Quarles. Thomas Bach was also very generous in providing digital scans of items in the Archiv des Ernst-Haeckel-Haus when it was not possible to visit the archive during the pandemic.

I am grateful to those libraries, archives, and individuals who have allowed me to quote unpublished material that is either in their possession or for which they are the rights holder: the Thomas Henry Huxley Papers and T. H. Huxley Correspondence with Henrietta Heathorn are quoted by permission of Archives Imperial College London; Museum Letter Book Series 2 is quoted by permission of the Royal College of Surgeons, London; ANSP.

Correspondence 1812–1920 is quoted by permission of Archives of the Academy of Natural Sciences of Drexel University; correspondence in the Archiv des Ernst-Haeckel-Haus is quoted by permission of Friedrich-Schiller-Universität, Jena; the Richard Swann Lull Papers are quoted by permission of the Yale Peabody Museum of Natural History; correspondence from the Vertebrate Paleontology Archives is quoted by permission of the Division of Paleontology, American Museum of Natural History; the William King Gregory Papers and Central Administration Archives are quoted by permission of Special Collections, American Museum of Natural History; correspondence in the Elwyn LaVerne Simons Archives is quoted by permission of the Simons family and the Yale Peabody Museum of Natural History; Maitland Edey's "Some Notes on the Early Days of Time-Life Books" is quoted by permission of Beatrice Phear. Permissions for illustrations are given in the captions.

An earlier version of portions of chapter 1 appeared as "'A Monkey into a Man': Thomas Henry Huxley, Benjamin Waterhouse Hawkins, and the Making of an Evolutionary Icon," in *Imagining the Darwinian Revolution: Historical Narratives of Evolution from the Nineteenth Century to the Present*, edited by Ian Hesketh (Pittsburgh: University of Pittsburgh Press, 2022), 80–100. Permission to reprint is gratefully acknowledged.

Finally, I thank my family for their love, support, and patience. The book is dedicated, with love and joy, to my nephews Thomas, Sam, and Alex Dawson, who are just beginning their own marches of progress.

MONKEY TO MAN

Uplift from the Ape

A black-and-white photograph shows a sequence of primate skeletons that, moving from gibbon to gorilla, become successively taller and more erect before finally reaching the upright human form (fig. I.1). It is immediately recognizable as an image of evolution. This, presumably, is why National Public Radio, a liberal organization with a reputation as one of America's most trusted news sources, used it in reporting on a statistical decline of Republican voters who believe in evolution. On NPR's website the photograph was captioned "a series of skeletons showing the evolution of humans."[1] The only problem is that what it depicts is not, in any conceivable way, the evolution of humans.

Primates do not evolve one into another, nor are humans descended from still-living simian species such as gorillas or chimpanzees. Indeed, in a rare moment of agreement, evolutionary biologists took the side of Republican Darwin-deniers to protest against the misuse of the image. They produced an annotated version of the same picture with a new caption: "I don't believe in evolution either . . . if this is your idea of evolution, NPR."[2] Although the skeletal sequence in the photograph seems to show evolution as a linear and implicitly progressive process that concludes, inevitably, with humans, modern biologists instead employ complex branching phylogenies in which evolutionary change is random, variational, and entirely nonprogressive. Yet it is this image, in numerous different iterations, that retains its power as the twenty-first century's iconic visual representation of evolution.

The photograph reproduced on NPR's website was of an exhibit installed

1

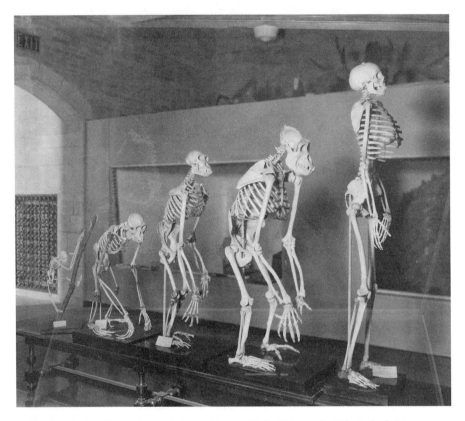

Fig. I.1. Display of five primate skeletons from the Hall of Man at the Yale Peabody Museum of Natural History. The exhibit, installed in 1925, was a response to the famous Scopes monkey trial in the same year and, at the time, was celebrated for its innovative approach to representing human evolution. This photograph of the display has subsequently been used mistakenly in media reports about evolution, arousing anger among evolutionary biologists. Photograph, ca. 1925. (YPM YPMAR.000538, Yale Peabody Museum of Natural History. Courtesy of the Yale Peabody Museum.)

at Yale University's Peabody Museum of Natural History in 1925. The exhibit was the culmination of a sequence of displays charting the progress of organic evolution. Its series of skeletal simians seemingly striding toward humanity itself replicated, in three dimensions, a wood engraving produced in the mid-nineteenth century: the frontispiece to Thomas Henry Huxley's *Evidence as to Man's Place in Nature* (1863). In the book Huxley argued, for the first time, that humans shared their ancestry with apes. The carefully

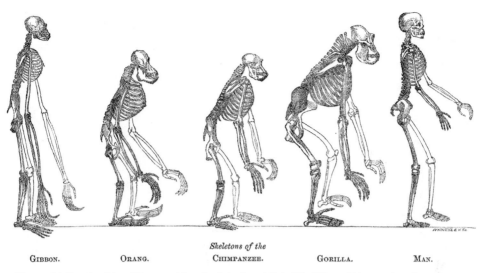

Skeletons of the

GIBBON.　　　ORANG.　　　CHIMPANZEE.　　　GORILLA.　　　MAN.

Photographically reduced from Diagrams of the natural size (except that of the Gibbon, which was twice as large as nature),
drawn by Mr. Waterhouse Hawkins from specimens in the Museum of the Royal College of Surgeons.

Fig. I.2. Wood engraving of drawings by Benjamin Waterhouse Hawkins of five primate skeletons from the Royal College of Surgeons' Hunterian Museum. The skeletons were initially drawn life-sized before being reduced by the brand-new process of photographic reduction, which enabled the original proportions of the different skeletons, with the exception of the gibbon, to be retained. Frontispiece to Thomas Henry Huxley, *Evidence as to Man's Place in Nature* (London: Williams and Norgate, 1863). (University of Leicester Library, SCM.12908.)

configured skeletons in its frontispiece revealed their anatomical similarities (fig. I.2). Like NPR a century and a half later, Victorian critics assumed that the image showed the progressive transmutation of "a Monkey into a Man" and berated it as a "grim and grotesque procession."[3] Despite these animadversions, the opening illustration was soon more famous than the rest of Huxley's book. As historians have noted, the "attention-grabbing frontispiece" would quickly "become one of evolutionary theory's most popular icons," with the "clever . . . skeletal icon, caricatured to this day as an ad-man's dream."[4] It was this visual potency, deriving from the image's distinctive upward curve, that induced the Peabody to convert it into a museum exhibit, and NPR to use a 1920s photograph to illustrate its online news report.

The arrangement of Huxley's skeletons also provided the template for

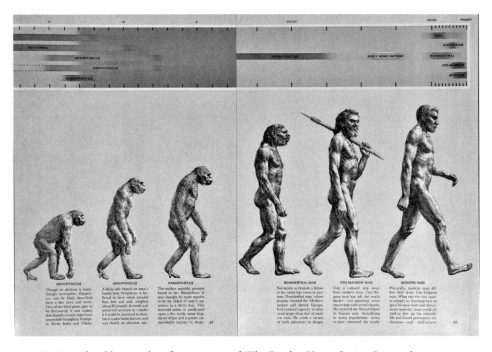

Fig. I.3. The abbreviated six-figure version of "The Road to Homo Sapiens"—now better known as the march of progress—in *Early Man*. The fold-out pages, containing the remaining nine figures, are not opened (see plates 5 and 6). In F. Clark Howell and the Editors of Time-Life Books, *Early Man* (New York: Time-Life Books, 1965), 42 and 45. (Author's collection. By permission of Zallinger Family LLC.)

another portrayal of humanity's evolutionary ancestry, one that has become even more famous and influential. This is "The Road to Homo Sapiens," printed over five fold-out pages in the best-selling book *Early Man* (1965), although the image is now better known as the "march of progress" (fig. I.3). Even though the epithet was initially applied to this illustration by the biologist Stephen Jay Gould, it was first used by D. H. Lawrence in relation to earlier evolutionary scenarios involving a "gradual . . . uplift from the ape." In a book review from 1926 the novelist wrote scornfully about what he called the "march of human progress."[5] Gould used the same appellation, only slightly less pejoratively, for a chronological series of fifteen figures that, beginning with proto-apes and moving through successively more advanced simian and hominid species, gradually ascend to the height and posture of a decidedly modern man. Like the skeletons in Huxley's frontispiece, the

4

figures in "The Road to Homo Sapiens" all take elongated steps forward, affording a powerful sense of momentum to the image. The corresponding strides again permit anatomical comparisons between different species, although the primates in this longer sequence are drawn with skin, hair, and external features intact, often on the basis of reconstructions inferred from only limited fossil evidence. The vitality with which the figures are endowed, even those representing species that have been extinct for millions of years, makes the image less forbidding than Huxley's skeletons, and it has surpassed Huxley's austere wood engraving as one of the most familiar and incessantly replicated pictures in the modern world.

The image has become so ubiquitous that it has even defined, albeit mistakenly, what evolution actually means. The "march of progress," Gould has contended, "is *the* canonical representation of evolution—the one picture immediately grasped and viscerally understood by all." Indeed, its "straitjacket of linear advance goes beyond iconography to the definition of evolution: the word itself becomes a synonym for *progress*."[6] Progress, at least in Western conceptions of it, habitually involves a hierarchical structure, often envisioned as a chain or a ladder, that entails evaluative judgments of superiority and inferiority.[7] A march, moreover, has military connotations, implying a predetermined route with a fixed endpoint, and the progress portrayed in the image is inexorably toward the teleological triumph of humanity. The "familiar iconographies of evolution," as Gould has lamented, have been integral to "reinforcing a comfortable view of human inevitability and superiority."[8] Such arrogant exceptionalism is not only scientifically untenable but, more significantly, continues to have deleterious consequences. Perhaps more than any written texts, this visual image has had a decisive impact on how evolution is understood and, ultimately, an impact on how humans conceive their relation to the natural world. Even the innumerable parodies of the march of progress that are one of the most persistent memes in contemporary culture, especially on the internet, have only made its imagery of ascent still more pervasive.

Remarkably, although the original pictures are instantly recognizable and hugely consequential, hardly anything is known about them. All the things that historians conventionally study in visual images, including their commissioning, creation, and circulation, have hitherto never been examined

in relation either to the frontispiece to *Man's Place in Nature* or to *Early Man's* fold-out diagram of "The Road to Homo Sapiens." This is all the more surprising since both are regarded, even by their detractors, as indubitably iconic or even as the "ultimate icon of evolution," as one critic has labeled the pictorial motif they share.[9] Other images that have achieved the status of icons, from Renaissance paintings to postwar advertising logos, have received the intensive attention appropriate to an aesthetic category that recalls the worship of devotional artifacts. Iconicity is now defined, more prosaically, as reaching "wholly exceptional levels of widespread recognizability," in which condition, as the art historian Martin Kemp proposes, an image has "transgressed the parameters of its initial making, function, context, and meaning."[10] With the icon of evolution, however, the very circumstances whose transgression is a prerequisite for becoming iconic still remain almost completely unknown.

The task of uncovering these circumstances is undertaken here by tracing the interconnected histories of images and museum exhibits depicting the ascent from apes to humans from the 1860s to the 1970s. Early twentieth-century representations of evolution that bridge the gap between Huxley's skeletal frontispiece and the reconstructed figures in "The Road to Homo Sapiens" constitute "connecting links," a term adopted in the 1920s by Richard Swann Lull, who, as director of Yale's Peabody Museum, installed the exhibit of ascending primate skeletons that would be so egregiously misunderstood on NPR's website. Drawing on his own paleontological research, Lull was adamant that the "main evolutionary lines are indicated by tangible evidence, not alone by inference," and he employed the concept of "connecting links" as a contrast to the more famous idea of "missing links."[11] Here, similarly, the focus is on tangible connections. We follow the direct line of evolution to the march of progress via a series of connecting links, replicating the phylogenetic pattern of the images being examined.

Using this narrative structure does not imply any endorsement of such a linear, transformational understanding of evolution, but nor is the concern here merely to expose the errors of illustrations and exhibits that seem to uphold this view. As the response to the misapprehension on NPR's website shows, such debunking criticisms are already legion and themselves have an

important history. Instead, the approach taken to the controversial iconographic tradition of ascending unilinear progress is self-consciously neutral, or symmetrical.[12] The focus is on how the tradition originated and then recurred at different times and in varying contexts, often in conjunction with shifting scientific attitudes toward how humans evolved as well as with new artistic approaches and technologies.

The images were products of both differing national contexts and nascent processes of transnational circulation, and their history moves from Victorian Britain to Germany at the turn of the twentieth century, and then to the United States in two periods encompassing the 1920–30s and the 1960–70s.[13] There are also brief interludes in India in the 1910s, Tasmania in the 1920s, and East Africa in the 1960s. In each place and period, particular attention is paid to the issue of artistic production. This emphasis on how the images were made, and by whom, deliberately foregrounds the contribution of "Invisible Technicians," whether artists, engravers, printers, art directors, or publishers' marketing teams, whose generally overlooked involvement was nevertheless integral to the creation of these evolutionary icons.[14] Scientific images, no matter how celebrated and recognizable they become, are rarely attributed to individual artists in the same way as more conventional artworks are. To counteract this tendency, unpublished correspondence, interviews, preparatory artwork, and alternative versions of the images give a voice to artists involved in collaborations with scientific practitioners who, almost without exception, had more prestigious and powerful roles in the process. This disparity was, inevitably, still more pronounced when the artists were women. Despite this imbalance in authority, the collaborations were not without disagreements, sometimes bitterly acrimonious and enduring, which had significant implications for the images that were being created.

By focusing on the previously unheralded contributions of artists and others involved in the practicalities of artistic production, *Monkey to Man* offers an entirely new understanding of some of the most recognizable and consequential images in the modern world. They are far more remarkable, contentious, and paradoxical than ever before realized. One thing this perspective helps us see is that modern criticisms of the march of progress motif

misconceive its history and artistry just as grievously as the image itself misrepresents the process of evolution.

Gould's Bane

As disparaging epithets like "grotesque procession" suggest, images that seemingly depict humanity's evolution from apes have long been subject to fierce censure. This was particularly the case for those created in Germany in the early twentieth century under the aegis of Ernst Haeckel, which, like his notorious comparative diagrams of embryos, were charged with deliberate falsification and forgery.[15] Yet the most sustained and pervasive condemnation of such progressive imagery began only in the mid-1970s. This campaign of criticism, which continues to the present day, does not simply reflect eventual enlightenment and the realization of problems that were always inherent, a case of modern truth vanquishing historical error. Rather, it is directly related to certain shifts in the theoretical understanding of how evolution operates that occurred at the same time and which are not themselves without contestation.

It was Gould who, in 1976, first highlighted what he called a "fundamental, but little appreciated, issue in evolutionary theory—the conflict between 'ladders' and 'bushes' as metaphors for evolutionary change." He clarified that "by 'ladders' I refer to the popular picture of evolution as a continuous sequence of ancestors and descendants . . . a single progressive sequence linking some apish ancestor with modern man by gradual and continuous transformation."[16] This rather caricatured description was set in opposition to more sophisticated arboreal representations of polyphyletic branching, in language that, as Gould must have recognized, explicitly evoked the longstanding conflict thesis in which, more usually, science was pitted against religion. While Gould himself rejected such a simplistic "religion vs. science" binary, maintaining that "no such opposition exists," he was nevertheless willing to reinstate its bellicose rhetoric in criticizing the imagery of progress.[17] The opening salvo in his conflict against this "false picture . . . that most of us hold" was occasioned by recent fossil discoveries in Africa that had challenged earlier paleoanthropological orthodoxies about humanity's nearest ancestors.[18] This, however, was not the field in which Gould

was himself principally involved. Instead, it was his own work on much older invertebrate fossils, and the theoretical insights he drew from them, that was the real impetus behind an antagonism that became so persistent it has been termed "Gould's Bane."[19]

The theory of punctuated equilibrium, which Gould first announced with Niles Eldredge in 1972, introduced a conception of evolutionary change that was inherently antithetical to linear representations of the gradual transformation, propelled by natural selection, of one species into another.[20] Its alternative model of long periods of stasis with sudden bursts of rapid change, and emphasis on species splitting into distinct lineages rather than undergoing modifications over successive generations, suggested that, as Gould urged, "nature really works in precisely the opposite way" from the "conventional iconography" of evolution. In fact, by extracting the rest of the profuse phylogenetic bush and privileging just "one surviving twig," such "progressive and triumphant" images could "only apply to unsuccessful lineages on the very brink of extinction," something that Gould dubbed "life's little joke."[21] The actual operation of the natural world was, for Gould, more appropriately represented by abstract cladograms, which charted branching patterns of speciation by linking organisms according to their possession of certain ancestral characters (see fig. E.2).[22] Such a graphic arrangement, which was first applied to human ancestry in the mid-1970s by Eldredge and Ian Tattersall, offered no information about each organism's putative rate of development from an inferred common ancestor, thus explicitly precluding the possibility that the indicated evolutionary relationships constituted a progressive succession.[23]

Punctuated equilibrium remained controversial for many of Gould's scientific peers, not least because it appeared to call into question aspects of Charles Darwin's own gradualist account of evolution.[24] In 1987 he jovially acknowledged that its apparent negation of the "lock step of the ladder" seemed imperative "at least as read by yours truly, who must confess his bias as coauthor of the theory."[25] Two years later, Gould's most detailed and influential critique of the "false iconography of a march of progress" formed a prologue to *Wonderful Life* (1989), his best-selling account of the Canadian Burgess Shale and its rich profusion of Cambrian fossils. The punctuated pattern of evolution revealed by these fossils, in which a "rush of diversifica-

tion" was followed by a period in which "life settles down" and only a few forms persist, required, as Gould insisted, a "revised iconography reflecting the lessons of the Burgess Shale." Even though these lessons were principally imparted by an arthropod named *Opabinia* that Gould affectionately called an "oddball invertebrate," his book began with the conventional flawed iconography of human evolution, several examples of which were reproduced. This "Prologue in Pictures," as Gould titled it, could be read separately from the rest of *Wonderful Life*, and this has enabled its criticisms of such progressive images to be disaggregated from the particular theoretical perspectives with which they were so intricately entwined.[26]

At the same time, Gould's pellucid prose and ability to address audiences beyond paleontological specialists meant that his particular bête noire could appear to be both a pressing scientific problem and something on which scientists invariably agreed. Gould's antipathy toward the march of progress has certainly been taken up, since his death in 2002, by a new generation of advocates, especially in the field of science communication, who feel an "instinctive . . . kind of rage" against the image and angrily remonstrate about misunderstandings like that in NPR's online news report.[27] For modern paleoanthropologists themselves, the issue is less clear-cut. On the one hand, Gould's insistence that the "genealogy of human evolution took the form of a bush with many branches, rather than a ladder," has been celebrated by Tattersall as a "seminal contribution."[28]

Another equally eminent authority, by contrast, is just as adamant that that the "metaphor of a hominid bush has been forcibly imposed on hominid paleobiology," precipitating a deleterious "diversity mania" that obscures the actual pattern of the fossil record.[29] Tim D. White has been directly involved in some of the most momentous paleoanthropological discoveries of the past forty years, and his resistance to Gould's "misused, and often abused . . . descriptive metaphor" seems to have alerted him to a related misuse of its linear counterpart. In 2013 he protested that the "unilineal depiction of human evolution popularized by the familiar iconography of an evolutionary 'march to modern man' has been proven wrong for more than 60 years. However, the cartoon continues to provide a popular straw man for scientists, writers and editors alike."[30] Significantly, the same "straw man" that, in

White's view, proved so advantageous to Gould and his followers, could also be attacked by those with entirely different interests.

Grist for Creationist Mills

In 1981 Gould acknowledged that punctuated equilibrium's disavowal of Darwinian gradualism "provides grist for creationist mills" by exposing the absence of an unequivocal scientific consensus.[31] After all, theoretical debate could be misconstrued as an admission that evolution itself remained unproven, a point of view increasingly encouraged by the resurgent religious fundamentalists of the early 1980s. Two decades later, it was Gould's attacks on the march of progress that similarly afforded grist for the mills of a new and more subtle manifestation of creationism whose proponents strategically targeted what they perceived to be cracks in the edifice of evolutionary science.

Jonathan Wells's *Icons of Evolution* (2000) began with a lengthy epigraph taken from the prologue to *Wonderful Life* in which Gould warned that "many of our pictures are incarnations of concepts masquerading as neutral descriptions of nature." The same caution, with its apparent intimation of deliberate concealment and deceit, was repeated in the book's text. Here it accompanied a "typical illustration," clearly based on "The Road to Homo Sapiens," showing what Wells described as a "knuckle-walking ape evolving through a series of intermediate forms into an upright human being." This illustration also appeared on the book's front cover as the "ultimate icon of evolution," adding urgency to Wells's allegation that it "goes far beyond the evidence." The ascending image was in fact, Wells insisted, merely "old fashioned materialistic philosophy disguised as modern empirical science." This duplicity had been inherent in the image's original incarnation, the frontispiece to *Man's Place in Nature*, which Wells labeled "Huxley's version of the ultimate icon." The format of this skeletal "series showing progression toward the human form," Wells contended, "preceded any fossil evidence of ancestor-descendant relationships, and it made do with whatever happened to be at hand—in this case, similarities to living apes."[32] Both of the images that served as iconic representations of evolution were fraudulent masquer-

ades, dependent on the manipulation of the evidence available when they were made, and, crucially, Wells seemed to have had Gould's scientific imprimatur in making this grave accusation.

A review of *Icons of Evolution* in *Nature* charged the book itself with "masquerading as a scientific critique," a pretense that could be maintained only because it "studiously avoids mentioning religion."[33] In Wells's book, language evoking the sacred was reserved for the icons, which, in the case of the definitive image of ascending apes, "enshrined . . . the Darwinian view of human origins."[34] This eschewal of anything pertaining to religion was a deliberate strategy that was branded, in *Nature*'s review, "stealth creationism."[35] Its exponents, who endorsed the concept of intelligent design, preferred their own designation: the "wedge." The aim of the strategy was to undermine evolution by cleaving open small fissures in its theoretical foundations.[36] This was to be achieved by ostensibly empirical means, and Wells, who had himself studied biology, readily appropriated Gould's complaints against the conventional iconography of evolutionary progress to drive in his own wedge.[37] Such images, Wells implied, were part of the evidence on which modern evolutionism still depended, and the exposure of their apparent spuriousness helped lay bare a scientific conspiracy that prohibited more truthful theistic explanations of organic life. Although Wells's approach has been described as the "making—for politico-religious purposes—of an enormous mountain from a scattering of molehills," it proved highly effective, and *Icons of Evolution* has been pivotal in ongoing debates over evolution and public education in North America.[38]

Wells's particular wedge has subsequently been struck deeper into the same cracks by less stealthy creationists. Most notably, Jerry Bergman in *Evolution's Blunders, Frauds and Forgeries* (2017) has contended that the "most famous icon of evolution . . . was known to be fake when it was first published," and was "drawn from largely manufactured or distorted evidence." Bergman refers specifically to the fold-out diagram of "The Road to Homo Sapiens," and he suggests that, since its publication in 1965, the image's "outrageous . . . raw propaganda" has "influenced millions of people to accept the Darwinian worldview of human evolution." Although Bergman makes no efforts to conceal his own religious commitments as a Young-Earth Creationist, he, too, like Wells, utilizes Gould's scientific criticisms against

"what he calls the *march of progress*" to validate his own accusations of fraud.[39] But there is a further indictment against the image that, as Bergman recognizes, has the potential to be still more damaging.

One of the tactics of the original wedge strategy was to tarnish modern evolutionism by emphasizing its complicity in historical racism.[40] In previous publications, Bergman has alleged that nineteenth-century Darwinism led directly to Nazism, and he avers of the fraudulent "ape-to-human evolutionary progression" that the "drawings originally were very racist and still have clear racist implications," with the figures apparently "having lighter skin . . . as they evolved into modern humans."[41] Bergman evidently does not realize it, but Gould had himself asserted, in 1995, that the "progressivist equation of evolution with linear advance" was "undeniably racist," and throughout his career he had warned that all conceptions of progress necessarily entailed evaluative judgments about the superiority of certain groups, whether races, genders, or cultures, on a fixed scale of worth.[42] More recently, other supporters of evolution similarly intent on "eradicating the 'March of Progress' image" have been just as adamant that it is "racist" and was actually "originally intended to be racist when it was first created."[43] As with the reaction to the photograph of primate skeletons on NPR's website, the motif of the ascent from apes to humans has a habit of reconciling evolutionists with their ostensible foes. These odd bedfellows even unite in making the most grievous allegations against its imagery.

Replaying Life's Tape

The combined, and often indistinguishable, criticisms of evolutionists and creationists have, in recent years, rendered the march of progress as infamous as it was once merely famous. What is equally absent from both scientific and theistic critiques, however, is any sense of the actual history of the images that are traduced with such vehemence and such apparent certainty. On the contentious issue of race, for instance, even a cursory understanding of the circumstances of their artistic production discloses a much more complex and ambivalent situation than has been assumed, and exposes claims about the images being "undeniably" or "deliberately" racist as demonstrably false. In fact, the series of primate skeletons in the frontispiece to Hux-

ley's *Man's Place in Nature* was embraced—and reengraved—by abolition-ists during the American Civil War as a timely rebuke to the "human pride of race."[44] Similar depictions of ascending skeletons in the 1920s and 1930s were fashioned, in part, as ripostes to anti-immigration legislation, eugenic ideals of racial selection, and even fascism. Likewise, "The Road to Homo Sapiens" in the mid-1960s embodied certain strains of postwar antiracism and was used, into the following decade, to illustrate arguments against the then-current supposition that different racial groups had evolved separately. This is not, of course, to deny that the ascent from ape to human motif has often been used in ways that are egregiously racist. Nor is it to overlook that even the avowed antiracism of earlier periods is generally, at best, deeply complacent from a present-day perspective. The various uses that have been made of the images do nevertheless confirm the vital necessity of under-standing their complicated and interconnected histories before making cat-egorical assumptions about them.

If anything, creationists like Bergman have been slightly more attentive to these histories than their scientific brethren have.[45] This is all the more surprising since Gould himself was acutely aware of the value of what he called the "explanatory world of history," and he frequently complained of its omission from scientific explanations of various phenomena.[46] One of his principal objections to the march of progress was that its ascending figures were "constrained to rise in the same general direction" with "each step . . . predictable and repeatable," making the logic of the image "essentially ahis-torical."[47] Gould's own conception of evolution was instead predicated on the "invocation of contingency," which rendered evolutionary lineages en-tirely unpredictable. In fact, he posited that "replaying life's tape" would yield different results, in terms of which species survived and which became extinct, each time.[48] Notably, Gould suggested that the same hypothetical exercise could be applied to the "large-scale course of events" that have shaped recent social and political history. He proposed that "contingent events have made our world and our lives" and that they would likely be very different if "we could rerun history."[49]

Evolution, Gould acknowledged, was a "subject that could, in theory, be rendered visually in a hundred different ways."[50] It is therefore, by his own reasoning, only a unique set of contingent circumstances, a "particular run

of history's 'tape'" rather than an "inevitable unrolling of events," that resulted in the march of progress becoming its iconic visual representation.[51] While Gould himself was strangely reluctant to extend this logic to the actual image, it is nonetheless possible to recover the different junctures where particular chance occurrences, which on the surface appear entirely incidental, determined its distinctive linear, progressive configuration. These contingent events, moreover, rarely involved scientific issues and instead often related to the more quotidian aspects of artistic production. So it was the fortuitous advent of a brand-new photomechanical technology, which was itself utilized only because of the deficiencies of an inexperienced engraver, that enabled the creation of a continuous sequence of precisely calibrated—and thus gradually ascending—primate skeletons for the frontispiece to Man's Place in Nature. Similarly, a scribbled request for a minor revision, from a corporate art director concerned only with aesthetic considerations, was responsible for the successive forward strides taken by the figures in "The Road to Homo Sapiens." Although the structure of this book replicates the phylogenetic pattern of the images that are examined, there are also moments of contingency where the historical tape might have run very differently.

If, as Gould proposed, the progressive imagery that was created in these contingent circumstances has defined, erroneously, the very meaning of evolution, it might seem strange that so little attention has been paid to how the imagery came into being. This has been the case even beyond the scientists and the creationists who are equally affronted by its putative fabrications. The march of progress has been subjected to elaborate rhetorical analysis, and its implicit ideological commitments, particularly in relation to race and gender, have been intensively scrutinized, but only the scantest consideration has been given to the actual contexts in which the image was produced.[52] This is, in part, because the materials necessary to understand those contexts remain largely unpublished and are dispersed in archival collections across the world, some of which have only recently become available. This is the case, for example, with the papers of the paleoanthropologist Elwyn LaVerne Simons, whose integral involvement in the creation of "The Road to Homo Sapiens," which was not publicly acknowledged, can now be examined for the first time. Simons's covert contribution to the image has

important implications for many of the assumptions that have been made about it, including with regard to race.

There have, of course, been several previous historical accounts of the visual representation of evolution. Most have tended to provide broad synthetic surveys—often spanning from Aristotle to the present day—that, inevitably, lack nuance or detail.[53] Others, by contrast, have focused only on a specific period or historical figure, particularly Darwin.[54] This approach has yielded important insights into certain manifestations of what has been called the "visual cliché" of the "ape-to-man series," but only by tracking the image across a prolonged period of time, through various incarnations and transformations, does it become possible to strip away the overfamiliarity and restore the original impact that the pictures once had.[55] The tight focus on this specific pictorial motif ensures that a lengthy timeframe, spanning more than a century, does not preclude the kind of finely textured account of artistic production that has never previously been extended to this iconic imagery.

This unusual combination, of a relatively long timeframe with detailed historical analysis, entails certain problems, especially with terminology, which, on the vexed issue of human evolution, altered significantly between the 1860s and 1970s—and continues to change. Some of the technical language used in the book therefore shifts between chapters, with, for instance, the term "hominid" being employed only after it became accepted, in the mid-twentieth century, as the preferred designation for the taxonomic group comprising modern and extinct humans along with their immediate ancestors. The term is used here in that historical sense rather than with its current meaning of all living and extinct anthropoid apes; "hominin" now assumes the more restricted sense.[56] Refraining from anachronistic or present-day terminology is the general rule here, with only a few exceptions—for example, where certain instances of historical language, such as the pervasive use of "man" to refer to humanity as a whole, are now jarringly inappropriate. Although some insensitive and offensive terms are retained, that is only within quotations where the precise language used is necessary to understand the historical dynamics of a particular context or situation. Equally, terms such as "European" and "African" are used in their historical senses—as effectively synonyms for White and Black—when explaining images based on

presumptions, and prejudices, current at the time they were made. These pictures can be offensive and even upsetting, but they are essential for understanding the specific historical circumstances from which the march of progress imagery emerged and in which it was often implicated.

Huxley's Diagram

A further problem for any attempt to chart with precision the entire history of a pictorial motif is the question of where to begin. Some of the synthetic surveys of evolutionary imagery mentioned above propose that the ascent from apes to humans is merely another repetition of the ancient conception of the *scala naturae*, or the "metaphorical imagery that will not die," as J. David Archibald has hyperbolically described it.[57] There are indeed important resonances of the great chain of being—a conception of the natural world as a graded scale—in both nineteenth- and twentieth-century representations of evolutionary progress, as is implied by Gould's categorization of them as "ladders." But the habitual imagery of a hierarchical stairway was only rarely invoked explicitly, and the frontispiece to *Man's Place in Nature*, inflected with Huxley's characteristically mordant humor, knowingly deviated from the conventions of the *scala naturae*.

Rather than reiterating the great chain of being, the anthropologist Edward Burnett Tylor proposed, in 1910, that "Huxley's diagram of simian and human skeletons" was "evidently suggested by the Linnean picture" in which appeared "set in a row . . . a recognizable orang-utan . . . a chimpanzee, absurdly humanized . . . a hairy woman . . . [and] another woman, more completely coated with hair."[58] This illustration of the taxonomic group Anthropomorpha, from Carl Linnaeus's *Amoenitates Academicae* (1749–90), was itself reproduced in *Man's Place in Nature*, although the facetious tone in which Huxley discussed its "fictitious" figures hardly supports Tylor's claim, for which there is no other evidence beyond the rather superficial compositional similarities (fig. I.4).[59] Instead, the book's frontispiece inaugurated an approach to depicting the relationship between humans and apes that was both distinctively new and, from an artistic perspective, only viable from the mid-nineteenth century onward.

While the author of *Man's Place in Nature* was intimately involved with

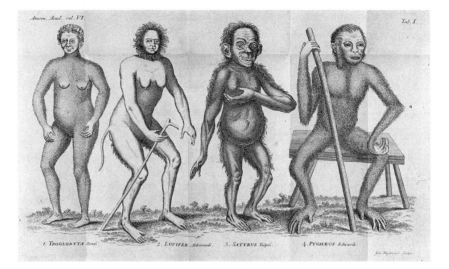

Fig. I.4. Engraving by Johann Nussbiegel, first published in 1763, showing members of the taxon Anthropomorpha, in which Carl Linnaeus grouped humans, apes, and sloths. The figures shown are, from right to left, an orangutan (4), chimpanzee (3), and two species of early humans, both evidently female (2–1). In Carl Linnaeus, *Amoenitates Academicae*, 10 vols. (Stockholm: Laurentii Salvi, 1749–90), 6:plate I. (Wellcome Collection CC BY 4.0.)

both the frontispiece's design and its production, Tylor's identification of it as simply "Huxley's diagram" is a misnomer. Such convenient possessive nouns are difficult to avoid, and this book is itself not exempt from them. They nevertheless betray certain assumptions about the control and owner-ship of images that, in reality, were very much the outcome of an intensive process of collaboration.[60] In the case of scientific illustrations, the collabo-rations usually involved scientific practitioners and artists, although a num-ber of other contributors often participated as well.[61] The evolution of the march of progress involved a series of creative and sometimes combative collaborations between science and art.

But literature was also involved in the process; it was, after all, D. H. Lawrence who coined the epithet the "march of human progress." The as-cending images that Gould later branded with the same label were inspired by literature, and they themselves influenced literary and cultural represen-tations. In fact, this reciprocity becomes evident even within different gen-erations of the same family. The composition of *Man's Place in Nature*'s

frontispiece owed much to Huxley's fondness for the writing of Thomas Car-
lyle, especially the quasi-fictional *Sartor Resartus* (1833–34), while his grand-
son, Aldous, used the literary technique of ekphrasis to portray an elaborate
and distorted drawing of evolutionary progress in his novel *Point Counter
Point* (1928). Aldous described the image, with knowing familial irony, as
a "grotesque procession of monsters" that "marched . . . across the paper,"
invoking the very same pejorative label applied to his grandfather's frontis-
piece sixty years before.[62] Still more remarkably, Aldous Huxley wrote the
novel in which this appellation appeared with Lawrence, a close friend,
literally in the same room, angrily condemning the evolutionary march of
progress. Such curious conjunctions, crossing boundaries between science,
art, and literature, occurred frequently in the creation of this iconic image.
While the unilinear motif examined in *Monkey to Man* proceeds in a straight
line, its history is anything but straightforward.

Grotesque Procession, 1862–1893

Lions in the Path

Thomas Henry Huxley gave his inaugural lecture as Hunterian Profes-
sor at the Royal College of Surgeons on February 17, 1863, just three
days before the publication of *Evidence as to Man's Place in Nature*. Rather
than outlining the controversial affinities between humans and apes de-
tailed in his book, Huxley's lecture was on a reconstructed fossil skeleton
of the *Glyptodon*, an extinct giant armadillo. He began by expressing his
"warmest thanks" for the "exertions of the skilful artist by whose care these
broken fragments have been put together." It was the "skill and persever-
ance" of Benjamin Waterhouse Hawkins, Huxley informed his audience,
that had "brought the specimen to the condition in which you now see it."[1]
Hawkins had been tasked with restoring the *Glyptodon*'s disjointed remains
in the summer of 1862. During the "execution of this laborious undertak-
ing," as Huxley noted in November of the same year, "Mr. Hawkins has had,
from time to time, all the anatomical aid . . . that I could afford him."[2] At
precisely the same time, Hawkins was also working with Huxley, again at the
Royal College of Surgeons, on anatomical illustrations that would appear in
Man's Place in Nature. These included a frontispiece showing a sequence
of primate skeletons becoming successively taller and more erect before fi-
nally reaching the upright human form (see fig. I.2). This illustration would
soon become the most celebrated and contentious component of Huxley's
book. Huxley's praise for Hawkins might suggest that he approved of the
distinctive pictorial contribution the "skilful artist" made to his forthcom-
ing book and that, in the summer of 1862, they enjoyed a productive work-

ing relationship. Historians have certainly assumed that the two men were friends.[3] In private, however, Huxley's appraisal of Hawkins's artistic abilities and aptitudes was very different, and their relationship was closer to mutual animosity.

When Hawkins was requested by the Royal College of Surgeons to reconstruct the *Glyptodon*, Huxley was commissioned to publish a description of the specimen with accompanying illustrations. Having himself created the "artificial parts uniting the pieces of real bone," Hawkins knew the restored skeleton more intimately even than Huxley.[4] Also an accomplished natural history artist of more than three decades' experience with a particular expertise in lithography, he was the obvious choice to produce the lithographic plates that would supplement Huxley's written text. But Huxley, notwithstanding his subsequent public approbation, was unconvinced. In a private letter from August 1862, he demurred—"If Hawkins does the plates I must have a serious talk to him about sticking to the work and about the execution thereof"—then reflected, "and if he does not he will feel himself hugely aggrieved."[5] Despite this risk, Huxley opted to endure Hawkins's inevitable indignation. The plates that accompanied his memoir on the *Glyptodon* in the Royal Society's *Philosophical Transactions* were drawn not by Hawkins but by James Erxleben. Ironically, it quickly became apparent that Hawkins's replacement was himself unsuited to the task. Erxleben's tardy execution of the plates delayed the memoir's publication, leaving Huxley fuming that the "artist is keeping me waiting & I have stirred him up over & over again."[6] Huxley must have had very good reasons to rebuff Hawkins, who completed the *Glyptodon*'s skeletal reconstruction promptly "in accordance with the instructions received," in favor of the exasperatingly unpunctual Erxleben.[7]

Huxley's skeptical comments regarding Hawkins were addressed to William Henry Flower, conservator of the Royal College of Surgeons' Hunterian Museum. It was amid the Hunterian's profusion of anatomical specimens that Hawkins had already been working on another collaboration with Huxley, *An Elementary Atlas of Comparative Osteology* (1864), which included twelve lithographic plates. Huxley's misgivings must have derived from his immediate experience of the artist's working practices in the preceding few months. Reviewers of the *Elementary Atlas* certainly found fault with the

aesthetic qualities of Hawkins's lithographs. The wood-engraved illustrations that Hawkins helped create for *Man's Place in Nature* were better received. Indeed, Charles Darwin, having acquired an advance copy of what he called the "Monkey Book," declared, before having read any of the text, that the "pictures are splendid."[8] The most conspicuous of these pictures, the frontispiece of ascending primate skeletons, has become an iconic image of evolution and one of the most celebrated scientific illustrations ever produced. Yet Huxley's animadversions against Hawkins's artistic capabilities seem to have been closely related to this particular image.

Huxley concluded the discussion of Hawkins's shortcomings in his letter to Flower by avowing that he "wish[ed] somebody else had to do the Van Amburgh business."[9] This was a droll allusion, typical of Huxley's mordant tone in correspondence with friends, to the celebrated American lion tamer and menagerie keeper Isaac Van Amburgh. In the mid-nineteenth century, Van Amburgh had brought his spectacular cavalcades of trained animals to Britain, presenting, as was reported in 1842, a "triumphal . . . procession" in which "his performers, brute and human, appear in his train."[10] While this bestial "Grand Procession" was led by lions, the other "terrible and powerful creatures" over whom "Mr. Van Amburgh . . . could hold absolute supremacy" included a "Baboon nearly resembl[ing] in size and form the Chimpanzee."[11] The "Van Amburgh business" therefore seems likely to have been the drawings of simian skeletons, to be placed in a sequential series in the train of a human, that Hawkins was just then preparing.

The frontispiece to *Man's Place in Nature* was depicted by critics as a "grim and grotesque procession" and, less portentously, as a "train" of "poor relations . . . going in procession . . . with their best legs foremost."[12] Huxley, in his ironic aside to Flower, may have had this aspect of the image's pictorial arrangement in mind even before the initial drawings of each skeleton, which were made separately, had been completed. If Huxley did refer to the drawings for the frontispiece as the "Van Amburgh business," his attitude toward what would become such an important and iconic image seems strikingly facetious and dismissive. More significantly, the comment also indicates that he wished that an artist other than Hawkins had been commissioned for the job.

Van Amburgh's tamed and submissive specimens were not the only leo-

nine analogies that Huxley invoked in relation to Hawkins. Drawing on an intensive reading of the Italian poet Dante, Huxley compared his fraught relationship with the artist to being trapped by a recalcitrant lion in the dark outskirts of hell. As this hyperbolic allusion suggests, the problems with artistic "execution" were not all that made Huxley regret Hawkins's involvement in the frontispiece or the other images that Hawkins contributed to *Man's Place in Nature*. Hawkins, as Huxley must have been acutely aware, was vehemently opposed to what he called the "grotesque *theory of development*."[13] In fact, since the beginning of the 1860s Hawkins had used drawings of primate skeletons made at the Hunterian Museum to repudiate, in lectures and his own publications, the very same theories of human evolution that Huxley would advance in *Man's Place in Nature*. The artist's disagreement might explain his distaste for "sticking to the work," in contrast to his subsequent steadfastness when reconstructing the *Glyptodon* skeleton, whose evolutionary affinities were not within the remit of the descriptive memoir that the Royal College of Surgeons requested from Huxley.

Before this apathetic petulance became apparent, Huxley had likely employed Hawkins due to the convenience of his prior knowledge of the Hunterian's collections, to which he had had privileged access for the past decade. In addition, his experience of drawing simians, stretching back to the 1830s, far surpassed that of any other artist in Victorian Britain. Hawkins's own motives for working with Huxley were more pragmatic. The early 1860s was a period of pressing financial need for the artist who, since his dismissal from a full-time post at the Crystal Palace in 1855, had had to rely on irregular freelance commissions while supporting two separate families following a bigamous second marriage. He could hardly have refused Huxley's overtures, regardless of his own scientific views.

Huxley tended to take a loftily dismissive attitude toward the artists who illustrated his work, whom, as he told Flower, he often found unwarrantably "conceited."[14] He presumably disregarded Hawkins's fervent opposition to evolution as irrelevant. Hawkins, after all, was merely a paid subordinate implementing Huxley's directives; in the conventional arrangement, scientific illustrators were little more than technical assistants.[15] The divergent views of the two men, as well as the festering tensions between them, nevertheless had hugely important implications for the frontispiece to *Man's Place*

in Nature and consequences for both the iconography and the understanding of evolution that persist to the present day.

On the Heels of Humanity

Hawkins was perhaps the first British artist to draw an anthropoid ape from life. In 1835 he published a lithographic print, advertised as "Drawn on Stone from Nature," of a chimpanzee dressed in a patterned frock sitting meditatively on a wooden crate (fig. 1.1). This was, as the *New Sporting Magazine* proclaimed, a "portrait of the great man-monkey lately arrived at the Zoological Gardens, Regent's Park, and now 'the last new lion' there."[16] The celebrity chimpanzee was the very first ape received by the Zoological Society of London since its foundation in 1826, and the *Spectator* reported that it "holds . . . numerously-attended levees in his little reception-room," where he "sat for his portrait to Mr. WATERHOUSE HAWKINS." The more established artist George Johann Scharf subsequently also "made a sketch of the little fellow," but this, as the *Spectator* adjudged, was "slighter than that by HAWKINS." More troublingly, it also rendered the animal "ludicrously human . . . the artist has given him such a pensive air that he might almost pass for an Esquimaux looking sentimental."[17] From the very first arrival of anthropoid apes in Britain, they were often perceived in explicitly racialized terms.

While Hawkins's rival print avoided such absurd anthropomorphism, the "very striking likeness of his monkeyship, in full costume," still showed, as the *Spectator* noted, the "gravity and shrewdness of the little man-monkey."[18] The creature was portrayed with the same sentimental compassion and emphasis on intelligence and sensitivity that had characterized many eighteenth-century depictions of apes.[19] The *Spectator* concluded its appraisal of Hawkins's drawing with a related reflection: "The Chimpanzee certainly treads more closely on the heels of humanity than any other of the oran-outan species. If not strictly speaking a biped, he is *less* than a quadruped: indeed his foot is half a hand."[20] Hawkins's lithograph depicts the chimpanzee's opposable big toe spread out in an equivalent position to the thumb of the creature's hand, which, in a pose that is naturalistic while nonetheless facilitating comparison, is held out directly above its foot. Although Hawkins did not receive his first commission as a natural history artist until the beginning

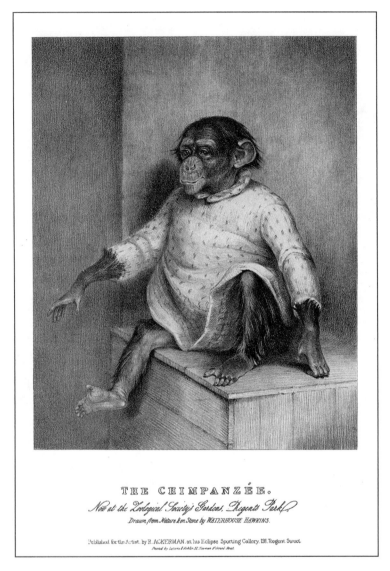

THE CHIMPANZÉE.

Now at the Zoological Society's Gardens, Regents Park.

Drawn from Nature & on Stone by WATERHOUSE HAWKINS.

Published for the Artist. by R. ACKERMAN. at his Eclipse Sporting Gallery. 191. Regent Street.

Printed by Lefevre & Kohler St. Twyman St. Grand Street.

Fig. 1.1. Lithographic print by Benjamin Waterhouse Hawkins showing a chimpanzee, named Tommy, who in 1835 was the first ape received by the Zoological Society of London. This image was probably the first one of an anthropoid ape that a British artist had drawn from life; previous depictions had relied on imaginatively revivifying dead specimens. Waterhouse Hawkins, "The Chimpanzée. Now at the Zoological Society's Gardens, Regents Park." Lithograph, 1835. (Author's collection.)

of the 1830s, he was already, by the middle of the decade, the leading specialist in portraying the new and intriguing anthropoid apes that were just then arriving in Britain.[21] His early drawings, as the *Spectator* noted in a foreshadowing of the frontispiece to *Man's Place in Nature*, revealed them as treading on the heels of humanity.

Long before his involvement with Huxley's book, Hawkins had already created a frontispiece featuring four simians for Adam White's *A Popular History of Mammalia* (1850). This chromolithograph shows a composite scene in which a chimpanzee climbs on a tree above three monkeys, with the agile ape clasping the tree using its opposable toe much the way it uses its thumb (plate 1). While the *Spectator* had discerned an incipient bipedalism in the chimpanzee's quadrumanal pose in Hawkins's earlier lithograph, White's *Popular History* instead invoked the "illustrations, executed by B. Waterhouse Hawkins," as part of an argument that in chimpanzees the "full expansion of the foot, which is necessary in walking, is unnatural in them, and . . . their natural position is on 'all fours.'" The chimpanzee's lumbering quadrupedal posture, White mockingly observed, "cannot flatter the vanity of those who believe it to be closely allied to the human species." As will be seen again, Hawkins's drawings of primates could be used to uphold diametrically opposed opinions of the relation between apes and humans. If Hawkins's sentimental depiction of the lithe and sprightly chimpanzee in the frontispiece to White's *Popular History* does not actually conform with the book's textual denunciation of the creature's ungainliness and allegedly "very filthy . . . habits," then his artistic renderings of apes in three dimensions were soon utilized in a much more authoritative attempt to differentiate humans from other primates.[22]

Natural History Upholstery

At the meeting of the British Association for the Advancement of Science in Liverpool in 1854, Richard Owen gave a lecture, "On the Anthropoid Apes," that provoked so much interest that it had to be switched from the meeting's zoology section to its general assembly. Owen was the preeminent comparative anatomist in Europe, and he "pointed out the relative proximity of the orangs and chimpanzees to the human species; and indicated the leading

distinctions that separate the most anthropoid of these apes from man." In conclusion, Owen pronounced imperiously: "Man is the sole species of his genus—the sole representative of his order."[23] Although none of the official accounts of Owen's lecture mentioned his use of visual aids, the *Morning Post* noted that "on the table were two specimens of the chimpanzee and ourang-outang, prepared by Mr. Waterhouse Hawkins for the Earl of Derby, who had kindly lent them for the occasion to Professor Owen."[24] These specimens were presumably taxidermized cadavers created for the natural history museum at Knowsley Hall, where Hawkins had worked for the Earl of Derby in the 1840s. Among his many artistic capabilities, Hawkins had experience as a "beast stuffer," as he self-deprecatingly termed those engaged in such "natural history upholstery," and his knowledge of taxidermical procedures afforded new and innovative elements to his drawings of apes and humans.[25] With Hawkins's stuffed simians before him at the British Association, Owen, as the *Morning Post* reported, "entered upon a comparison of their structures with that of man . . . showing the difference in the construction of the various limbs."[26] Knowsley Hall was conveniently near to Liverpool, and Hawkins may have been unaware of the loan by his erstwhile aristocratic patron, but the artist was already working with Owen, at least nominally, back in London.

In 1852 Hawkins had been commissioned to create a series of life-sized models of extinct animals to adorn the gardens of the reconstructed Crystal Palace, which, following the spectacular success of the previous year's Great Exhibition, had been acquired by a commercial syndicate and removed from Hyde Park to the southern outskirts of London. The Crystal Palace Company also employed Owen as a scientific advisor on the project, although he rarely met with Hawkins and, haughtily apathetic about the popular pedagogic models, conducted their collaboration almost exclusively through correspondence.[27] Hawkins did gain one major benefit from his otherwise problematic partnership with Owen. Lamenting that mid-Victorian London was "without a collection of animal skeletons accessible to the mere artistic student," the artist reflected that, in his own case, "when . . . I commenced the restoration of the extinct or fossil animals at the Crystal Palace . . . I was favoured, through Professor Owen, with unrestricted access to . . . the magnificent Museum of the Royal College of Surgeons." This "invaluable priv-

ilege" was a crucial turning point in Hawkins's artistic career.[28] It gave him exclusive access to the collection of primate specimens that, begun by John Hunter in the eighteenth century and now rapidly expanding under Owen's stewardship, would be pivotal in the momentous disputes over the relationship between apes and humans in the coming decade.

Owen, despite his chariness about Hawkins's brick-and-mortar models at the Crystal Palace, must have been impressed with the artist's preparation of the stuffed chimpanzee and orangutan skins that he lectured with at the British Association in 1854. Two years later Owen stood down as Hunterian Professor at the Royal College of Surgeons to become superintendent of the British Museum's natural history collections. In 1858 the British Museum received a "cask of spirits" from Gabon containing what Owen immediately recognized as the "first and only entire specimen of the Gorilla which had reached England."[29] Although Owen himself had acquired a complete skeleton of the gorilla for the Hunterian Museum back in 1851, this new specimen retained the creature's skin and hair, albeit with "decomposition ha[ving] made some advance" during the long sea voyage.[30]

The very existence of this enigmatic primate had not been established until the late 1840s, and a decade later Owen was still cautious in distinguishing the "animal which it seems now agreed to call 'Gorilla'" from other species of anthropoid ape.[31] After "removing the animal from the preserving liquor," Owen needed specialist assistance with the British Museum's important new acquisition, and he seems to have called upon someone with the requisite technical and artistic skills to restore the decrepit cadaver.[32] Hawkins, who had "gratefully retained" his privileged access to the Hunterian after Owen's departure, complained of the innumerable specimens "inaccessibly buried in the crypt of the British Museum," but he was still willing to help with this intriguing new ape.[33] He later said of the first gorillas to arrive in Europe: "The British Museum obtained one which he (Mr. Hawkins) had the preparation of, as it had come home in rather a damaged state." The rare specimen's defective condition, Hawkins joked, had been caused by the sailors who transported it: they extracted the rum in which it was preserved "by means of straws," and almost drank the cask dry.[34]

There is no other record of Hawkins's alleged involvement with the first complete gorilla specimen to reach Britain, and Abraham Dee Bartlett, a

taxidermist with whom Hawkins worked at the Crystal Palace, subsequently claimed that Owen had "placed it in my possession to preserve and mount for the National Museum."[35] Nor did Owen acknowledge Hawkins in any of his published descriptions of this "most singular phenomenon in natural history"; instead, he deployed both photographs and, more gallingly, the "graphic skill" of the rival natural history artists George Henry Ford and Joseph Wolf for the illustrative plates.[36] It was nevertheless Hawkins who, at the beginning of the 1860s, was the artist best acquainted with the new simian species as a fashionable obsession with gorillas engulfed Victorian Britain.

The Great Question of the Day

When, in November 1862, the *Times* reported that a ship had docked in Liverpool carrying the "only live specimen of the gorilla . . . ever brought to this country," Hawkins was the first to arrive on the scene.[37] He came "expressly . . . on the faith of the public announcements" only to find that the "so-called Gorilla is simply a Chimpanzee."[38] Even though Hawkins's eagerness was misplaced on this occasion, he was successful in harnessing the "popularity of the gorilla." Indeed, following the decline of public interest in his models of extinct animals at the Crystal Palace, Hawkins now gained much of his income from what he called the "'great question of the day' . . . that had so entirely engrossed the attention of everybody": the gorilla's relation to humans.[39] By the time of his wasted trip to Liverpool, Hawkins was not only working with Huxley at the Hunterian Museum on illustrations of gorilla anatomy but also giving commercial lecture tours across Britain on the subject of the sensational simian.

In these illustrated talks, which he had been giving continually since the summer of 1861, the provincial lecture halls were adorned with Hawkins's own "large coloured diagrams" and "full-size cartoon[s] of the Gorilla." The lecturer also extemporaneously "drew on the diagram board . . . spirited sketches" of its anatomy.[40] As well as displaying his own illustrations, Hawkins, with his unsurpassed experience with gorilla specimens, used his lectures to disparage other artists' depictions of the ape, which had still never been drawn from life (at least outside of Africa). He recounted, for instance,

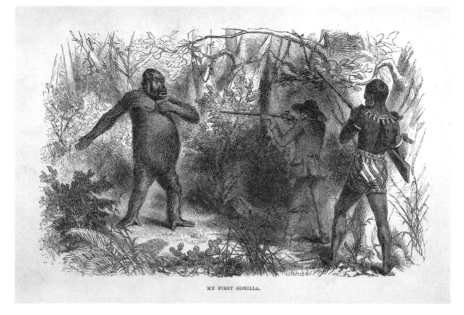

MY FIRST GORILLA.

Fig. 1.2. Engraving by Elias Whitney entitled "My First Gorilla." It purports to show the moment when the French-American explorer Paul Du Chaillu first shot a gorilla, who is depicted standing upright, while traveling in West Africa. In Paul B. Du Chaillu, *Explorations and Adventures in Equatorial Africa* (London: John Murray, 1861), plate facing 71. (© The British Library Board 010095.g.1.)

how he had berated the explorer Paul Du Chaillu "on the subject of one of the illustrations in his book, where the gorilla is standing erect," proposing instead that "perhaps the animal might have sat down" (fig. 1.2).[41] When Du Chaillu defended the aesthetic qualities of the image, Hawkins retorted: "Well, the diagram may be a very good one, but the question is—is it correct[?]"[42] Du Chaillu had actually seen living gorillas, although the authenticity of the wood engravings depicting the creature in his *Explorations and Adventures in Equatorial Africa* (1861), made by the American artist Elias Whitney, had already been contested. The *Morning Advertiser*, in reviewing Du Chaillu's controversial book, advised readers to "tear out all these wonderful pictures, and throw them away, and take our ideas of the animal from the reality in the British Museum."[43] Hawkins, however, was no less censorious of these putatively authentic exhibits, notwithstanding his own involvement with the British Museum's taxidermized gorilla.

33

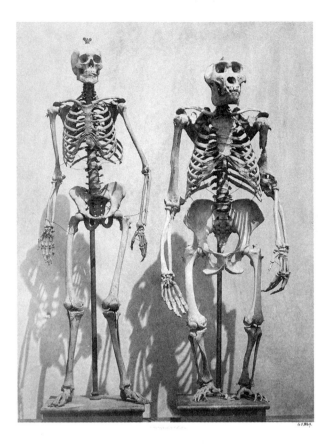

Fig. 1.3. Display of a gorilla and a human skeleton mounted upright by using poles to which their skulls appear to be screwed, and positioned alongside each other. The exhibit, created in the mid-1850s, was part of the natural history collections at the British Museum. Roger Fenton, "Skeleton of a Human and a Gorilla." Salted paper print, ca. 1858. (© Victoria and Albert Museum, London.)

He began another lecture by showing "photographs of the skeletons of man and the gorilla in the British Museum . . . point[ing] out that they unfairly represented the comparison between the two, because the latter was forced into an erect position that it could never assume in life."[44] These were two photographs taken by Roger Fenton in the late 1850s which, in frontal and lateral views, placed a standing human skeleton alongside the bones of a gorilla that the British Museum had "obtained from Paris . . . and mounted

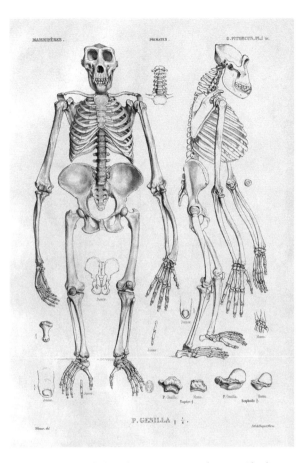

Fig. 1.4. Lithograph, based on an engraving by Jean-Charles Werner, showing gorilla skeletons mounted upright in the so-called French manner developed in the 1840s at the Muséum d'histoire naturelle in Paris. In H. M. Ducrotay de Blainville, *Ostéographie*, 4 vols. (Paris: Arthus Bertrand, 1839–64), 1(Atlas): plate [2] ("P. Gesilla"). (Bibliothèque nationale de France.)

in the best French manner" (fig. 1.3).[45] The Gallic method of mounting was developed in Paris at the Muséum d'histoire naturelle, where, as shown in a lithographic plate from Henri de Blainville's *Ostéographie* (1839–55), gorilla skeletons had been articulated in an upright position since the late 1840s (fig. 1.4). Fenton was interested in the artistic possibilities of the new medium of photography, and his photographs of the British Museum's two upright skeletons register the ethereal shadows that they cast, giving the bones

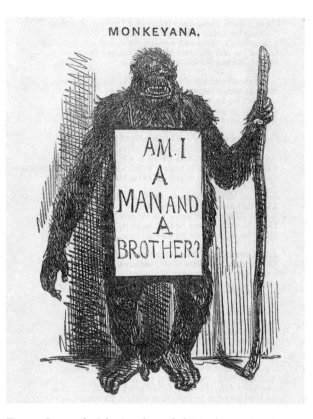

Fig. 1.5. Cartoon by John Leech entitled "Monkeyana." In it, a gorilla, who maintains its upright position with the help of a wooden staff, wears a placard asking the same question that had originally been used as a slogan by campaigners for the abolition of slavery. In *Punch* 40 (1861): 206. (Wellcome Collection. CC BY 4.0.)

an eerie sense of movement and even vitality. Hawkins, however, disliked new methods of photomechanical reproduction, opining in the 1840s that there was "no daguerreotype but the hand and pencil," and he remained oblivious to the aesthetic effects created by the innovative lighting of Fenton's photographs.[46] As with his response to Du Chaillu, Hawkins was adamant that an artist's principal duty was accuracy and fairness.

The only illustration of the gorilla by another artist for which Hawkins had any regard was the wood-engraved cartoon "Monkeyana" by John Leech (fig. 1.5). Appearing in the satirical journal *Punch* in May 1861, it "put so

pithily," as Hawkins enthused, the imperative "enquiry made by the gorilla himself: 'Am I not a man and a brother?'"[47] In Leech's cartoon this antislavery slogan, originally coined by Quaker abolitionists, is emblazoned across a placard worn by a gorilla eager to prove its kinship with humans, although, as Hawkins would have noted approvingly, the creature requires a long wooden staff to maintain its upright posture. Hawkins later introduced still more explicit connotations of race and slavery in his own drawings of apes. To him, "*Punch*'s sarcastic question" had, with the exception of Leech's sardonically ambivalent lampoon, been answered erroneously in other artists' inexpert and specious depictions of the gorilla.[48]

Pictures in Lieu of Words

Hawkins's condescending disdain was not confined to his fellow artists. In his lectures, he brusquely expressed himself "at a loss to understand how any naturalist or anatomist could ever suppose" that the gorilla could stand upright.[49] Hawkins felt that his combination of artistic ability and scientific knowledge afforded him special insights; he maintained that "in every department of science . . . the study of form and facility in drawing are indispensable," and lamented that "it rarely happens that naturalists can draw."[50] This conviction informed his *Comparative View of the Human and Animal Frame* (1860), an illustrated textbook ostensibly "addressing the art student." Hawkins, however, drew on his privileged access to the "most instructive osteological specimens" in the Hunterian Museum to refute, through visual analysis of anatomical structures, the intimate "relationship of Gorilla to Man, which our chief anatomists have lately so emphatically claimed for him."[51] Pragmatically, the jobbing artist refrained from identifying the particular "chief anatomists" he had in mind. Notably, although Huxley had yet to publish anything on the gorilla when Hawkins's book came out in February 1860, he had, since 1858, been urging audiences at his own lectures to "admit that there is very little greater interval . . . between the *Gorilla* & the *Man* than exists between the *Gorilla* & the *Cynocephalus* [baboon]."[52]

The initial tinted lithographic plate in Hawkins's *Comparative View* was titled "Man, the Gorilla, and the Bear" and shows skeletons of the three at different scales but placed in postures that "approximate each other . . . with-

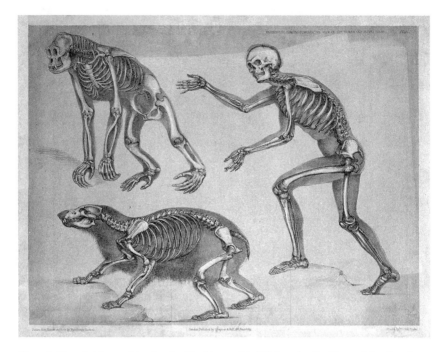

Fig. 1.6. Tinted lithographic plate by Hawkins entitled "Man, the Gorilla, and the Bear." The three skeletons, shown within the shaded silhouettes of their skins, are drawn at different scales but placed in equivalent postures, although the human, who bends from an upright position, seems to present the gorilla to the viewer like the impresario of an exotic menagerie. In B. Waterhouse Hawkins, *A Comparative View of the Human and Animal Frame* (London: Chapman and Hall, 1860), plate 1. (Wel/BOT/Alamy Stock Photo.)

out deviating from natural action" (fig. 1.6).[53] The skeletons are depicted within the shaded silhouettes of their skins, and the new and "distinctive 'X-Ray' style" of the drawings presumably drew on Hawkins's involvement in taxidermy, especially since it eliminated the musculature and unsightly viscera from each of the three bodies.[54] The innovative pictorial method enabled Hawkins to demonstrate that the gorilla's physique, both bones and skin, facilitated only a quadrupedal mode of locomotion. By contrast, the human, whose feet more closely resemble those of the bear, can bend forward from a standing position. Indeed, like an impresario of an exotic menagerie, the human seems to present the gorilla to the viewer. Employing such "pictures in lieu of words," Hawkins was confident that his artistic skills in conjunction with his long experience of ape anatomy would reveal im-

portant details previously unnoticed by "unthinking" and "prejudiced observer[s]," among whom, Hawkins made clear, he included eminent scientific specialists.[55]

Hawkins acknowledged that he had "obtained all the materials" for his lithograph from the "Hunterian collection."[56] The crouching simian in the plate was therefore based on the same gorilla skeleton that he would soon be commissioned to draw for Huxley and that appeared in the frontispiece to *Man's Place in Nature*, though in a less elaborate style and with an entirely different posture. Hawkins must have begun working with Huxley in the spring of 1862, for the *Bookseller* announced at the end of April that Williams and Norgate would soon be publishing both *Man's Place in Nature* and *An Elementary Atlas of Comparative Osteology*. The latter would consist of "12 plates in folio, drawn on Stone by B. Waterhouse Hawkins, Esq. The Figures selected and arranged by Professor T. H. Huxley."[57] The twelve lithographic plates contained several images of skeletal gorilla hands, feet, and pelvises, some of which were subsequently engraved on wood and reused in *Man's Place in Nature*. Even though the *Bookseller*'s advance notice turned out to be premature, with the *Elementary Atlas* not being published for another two years, Huxley and Hawkins must have at least begun preliminary discussions of the illustrations before the announcement was made. At precisely this time, however, Hawkins was growing increasingly bold in his resistance to the opinions of even the most renowned scientific experts.

In a lecture in February 1862, Hawkins reflected, with evident exasperation, that some anatomists believed that the human frame retained remnants of earlier apelike attributes. Indeed, as he recounted, "The other day Sir C. Lyell himself had told him (Mr. Hawkins) that he [i.e. man] still had the power of grasping with the great toe, but he [i.e. Hawkins] contended that this did not make the great toe any nearer approximation to the hinder thumb of the gorilla."[58] Charles Lyell spoke with Hawkins while completing his *Geological Evidences of the Antiquity of Man* (1863), for which the eminent geologist relied on Huxley's guidance on anatomical matters. Lyell, equivocating over human evolution, had initially considered that "the 'great toe,'" as he told Huxley in June 1861, afforded a convenient "gap between man . . . & the gorilla."[59] But by the time of his contretemps with Hawkins in the following February, Lyell had been persuaded that, as Huxley stated,

with some "barefooted people" such as "Chinese boatmen" the "great toe ... retains a great deal of mobility."[60] This indicated that the human foot differed only in degree from what Hawkins insisted were the hands of the gorilla.

If the human hallux could be used like an opposable thumb, then the rear hands of the quadrumana, as Georges Cuvier had classified supposedly four-handed apes, might themselves be recategorized as feet. In *The Antiquity of Man*, Lyell approvingly quoted Huxley's pronouncement, in the still-to-be-published *Man's Place in Nature*, that the "hind-limb of the Gorilla ... with [its] very moveable great toe ... is a foot which differs from that of Man in no fundamental character."[61] This completely contradicted Hawkins's tetchy insistence, during his conversation with Lyell, that there was no approximation between the "hinder thumb" of the gorilla and humanity's great toe, although the artist evidently remained confident that he knew better than both Lyell and Huxley.

When reading the proof sheets of *Man's Place in Nature*, Lyell had told Huxley that the "citations I shall make ... will help my book much, & I trust send some of my readers" to Huxley's own forthcoming volume. Lyell also inquired: "Are there to be woodcuts of bones of hands & feet of man & ape? I hope so worked into the text."[62] Such images were just then being prepared, although, ironically, it was Lyell's irritable adversary who was making original drawings that negated the very views he had himself so vociferously asserted (fig. 1.7).

Obliquely Upwards and Forwards

Hawkins's haughty curtness in his remarks to Lyell, who was among the most revered men of science in Britain at this time, reflected the significance of the issue they were discussing for the artist's conception of how gorillas and other apes looked and moved. While Lyell rejoiced that Huxley's recategorization of the gorilla's rear hands as feet would "for ever dispel a very prevalent delusion" concerning the "so-called quadrumana," Hawkins regularly employed the contested classification.[63] In 1861, for instance, he had given "GRAPHIC LECTURES on NATURAL HISTORY" on the topic of the "Order Quadrumana, or four handed animals, from the Lemur to the Gorilla, con-

92

resemblances between the foot of Man and the foot of the Gorilla are far more striking and important than the differences.

I have dwelt upon this point at length, because it is one regarding which much delusion prevails; but I might have passed it over without detriment to my argument, which only requires me to show that, be the differences between the hand and foot of Man and those of the Gorilla what they may—the differences between those of the Gorilla, and those of the lower Apes are much greater.

It is not necessary to descend lower in the scale than the Orang for conclusive evidence on this head.

The thumb of the Orang differs more from that of the Gorilla than the thumb of the Gorilla differs from that of Man, not only by its shortness, but by the absence of any special long flexor muscle. The carpus of the Orang, like

Man Gorilla Orang

FIG. 20.—Foot of Man, Gorilla, and Orang-Utan of the same absolute length, to show the differences in proportion of each. Letters as in Fig. 19. Reduced from original drawings by Mr. Waterhouse Hawkins.

Fig. 1.7. Wood engraving of original drawings made by Hawkins of the left feet of human, gorilla, and orangutan skeletons. The drawings, which emphasize the structural similarities of the three feet, directly contradicted Hawkins's own personal opinions on the matter. In Thomas Henry Huxley, *Evidence as to Man's Place in Nature* (London: Williams and Norgate, 1863), 92. (University of Leicester Library, SCM.12908.)

trasting Gorilla with the human frame."[64] Even when he shifted his nomenclature and acknowledged that the gorilla possessed "hind feet," Hawkins insisted that they "showed such a difference in structure" when "compared with the feet of man . . . that they formed almost his strongest argument."

The particular argument Hawkins was making, supported by the gorilla's feet being exclusively "adapted . . . for climbing," was that the creature, like other simians, "could not stand in an erect position for more than two minutes" and was constitutionally "incapable of walking erect upon its hind legs."[65] It was this physiological assessment that had prompted Hawkins's criticism of the portrayals of upright gorillas by artists such as Whitney and Fenton.

In his lectures, Hawkins reinforced his view of the gorilla's inability to maintain an erect posture by showcasing both skeletal specimens, some borrowed from Du Chaillu, and "his skill in sketching." He provided impromptu "chalk drawings" where "real bones failed to illustrate the point enforced."[66] He also "exhibited . . . a reduced model of the gorilla in a walking position" to demonstrate how the creature was "obliged to place its fore feet or hands upon the ground for the purpose of progression."[67] However, when Hawkins drew the complete skeleton of the gorilla and those skeletons of the chimpanzee, orangutan, and gibbon that appeared in the frontispiece to *Man's Place in Nature*, he depicted them as distinctly upright. This portrayal was in the "French manner" that Hawkins found so objectionable (see figs. 1.3 and 1.4). Yet Fenton's photographic gorilla remains resolutely stationary, notwithstanding the eerie suggestion of vitality evoked by the shadows it casts, while the one in Blainville's plate only tentatively lifts its left foot. The skeletal simians that Hawkins drew for Huxley, by contrast, seem to stride forward—with their left legs protruding and raised from the ground—in a way that the artist himself had denied, in words, pictures, and models, was possible (see fig. I.2).

The appearance of ambulatory motion in the bipedal simian skeletons that Hawkins drew for Huxley, along with the increase in size and verticality of their respective postures going from left to right, makes it seem that they are successively ascending to the height and uprightness of the human skeleton. This particular visual effect, which was quickly perceived as depicting a progressive ascent from apes to human and would prove hugely influential for subsequent visual representations of evolution, was almost certainly not intended by Hawkins, who instead drew each skeleton separately. In fact, Hawkins may not have created the images specifically for the frontis-

piece to *Man's Place in Nature*, for they appear to have first been used by Huxley during a lecture to working men at the Museum of Practical Geology on November 10, 1862.

In this lecture, entitled "The Present Condition of Organic Nature," the first of a series of six, Huxley illustrated his argument that different animals are "made in very much the same sort of fashion" by showing his plebeian audience a drawing of the frontal view of the "skeleton . . . of a kind of lemur." He then instructed them on how to examine the skeleton: "In your mind's eye turn him round, so as to put his backbone in a position inclined obliquely upwards and forwards, just as in the next three diagrams, which represent the skeletons of an Orang, a Chimpanzee, a Gorilla." After considering these side-on views of ascending apes, Huxley's auditors were told to "turn to the end of the series, the diagram representing a man's skeleton." With this "line of diagrams," Huxley explained, "we pass on and on, with gradual steps, until we arrive at last at the highest known forms."[68] The four lateral drawings that Huxley employed in this pedagogical procedure, along with a subsequently added gibbon skeleton that replaced the lemur, are almost certainly the *"Diagrams of the natural size . . . drawn by Mr. Waterhouse Hawkins from specimens in the Museum of the Royal College of Surgeons"* reproduced in exactly the same sequence in the frontispiece to *Man's Place in Nature*.[69] The frontispiece's five skeletons were, inevitably, reproduced at a greatly reduced size, with their original life-sized dimensions having been necessary so that they could be seen in a large lecture theater.

While the original drawings do not survive and their medium is not known, they were very likely "full-size cartoon[s]" similar to those that Hawkins displayed in his own lectures on the gorilla.[70] Cartoons were large outline drawings, made in pencil or ink on strong, heavy paper, that were suited to being hung in a lecture theater. It therefore seems probable that while Hawkins was at the Hunterian Museum working on the lithographs for the *Elementary Atlas of Comparative Osteology*, Huxley asked him to switch mediums and also draw life-sized cartoons of primate skeletons in ascending order for his lecture. It was this separate commission that Huxley sardonically dubbed the "Van Amburgh business" in his letter to Flower.[71] Having had a number of these visual props drawn for him, Huxley initially proposed

to "revise & illustrate" his series of lectures to working men "and make them into a book."[72] But the plan never came to fruition and instead a cheap unillustrated edition, based on the transcript of a shorthand reporter, was rushed out by the enterprising publisher Robert Hardwicke. With the diagrams of primate skeletons no longer required for any other purposes, Huxley could make permanent the distinctive "obliquely upwards and forwards" sequence he had briefly placed them in on the lecture platform at the Museum of Practical Geology.

The first proofs of *Man's Place in Nature* had been printed at the beginning of August 1862, three months before Huxley used the diagrams in his lecture to working men in November. Proofreading progressed slowly, though, with Lyell complaining that the "reader should not have sent out a proof with such obvious mistakes" and urging Huxley to request "revised sheet[s] as the errors of type are very numerous."[73] The printing of Huxley's book, as established by the printer's imprint on the final page, was undertaken by the firm of George Norman, whose shoddy work with the proofs permitted more time for late revisions and additions, which Huxley continued to make throughout the rest of the year. By October, Lyell was even assuring him that in his own experience of working with printers it would "not be too late to make alterations which shall not disturb the paging" until very near to a book's final publication date.[74]

Frontispieces were traditionally printed separately as part of a book's front matter and would not affect the pagination of the typeset body text, enabling them to be appended late in the publication process.[75] It was far from impossible, from the printer's perspective, for Huxley to redeploy the diagrams of primate skeletons drawn by Hawkins after his lecture to working men in mid-November and possibly even after Hardwicke had published his unillustrated edition of the lecture series at the end of 1862. The process used to convert the life-sized cartoons into a much smaller wood engraving certainly implies that speed and expediency were important considerations. More significantly, what this hurried publication schedule suggests is that the frontispiece to *Man's Place in Nature* may have been added to the book merely as a last-minute afterthought, a recycling of awkwardly sized diagrams that were available only because Huxley had imprudently granted Hardwicke the copyright to the lectures they originally illustrated.

A Continuous Line of Development

Whatever the circumstances of the drawings' publication, Hawkins must have been aghast at their placement in an "obliquely upwards and forwards" sequence. After all, putting the discrete drawings in such a sequence seemed to exemplify a "doctrine that," as he angrily avowed in 1861, "I never taught, promulgated, or believed in—viz. the 'development theory,' or Lamarckian transmutation of species."[76] Hawkins was equally hostile to the more recent "Darwinian theory of . . . transmutation," although he does not seem to have read *On the Origin of Species* (1859) very closely and told one lecture audience that "in Mr. Darwin's very clever book . . . was a description of the gorilla, with an account of its . . . resemblance to man."[77] Of course, Darwin famously eschewed discussing human origins in his book and, like Huxley in *Man's Place in Nature*, never suggested any direct evolutionary ancestry between humans and living simians. Hawkins, with characteristic imprecision, nevertheless traduced the "speculative notions of the most eminent physiologists" who "endeavoured to establish a continuous line of development." He mockingly challenged these "transcendental Anatomists to develop (if they can) a Monkey into a Man."[78]

The frontispiece to *Man's Place in Nature* soon became an icon of precisely such linear models of progressive transmutation, with contemporary critics expostulating: "Look . . . at Huxley's book . . . with its grotesque skeleton procession, a book written to establish the resemblance of man to the monkey, and our descent from that animal because of such resemblance."[79] Across the Atlantic, these evolutionary implications even provoked outbursts of comical but nonetheless disconcerting rhetorical violence. As one incensed commentator warned: "It makes my blood run cold to imagine this infernal Huxley pertly holding up the frontispiece of his book . . . and saying 'Here, my friends, are drawings of skeletons of gibbon, orang, chimpanzee, gorilla; select your ancestors; you pays your money and has your choice' . . . if the fellow should do this thing to me, I would blow out of his skull everything in it which allied him with the ape." Hawkins, who subsequently worked in America, would himself later invoke the language of dueling with pistols to describe his own antagonism toward Huxley. The incendiary idea that "monkey . . . rises anatomically into man" allegedly expounded in

the frontispiece's design, could not have been more jarringly discordant with the profound and long-standing convictions of the artist who created the original drawings of ascending primate skeletons.[80]

Hawkins was sometimes mistaken for an "expositor of the theory of progressive development," as the *Morning Post* erroneously declared him, and his models of extinct animals at the Crystal Palace, which were positioned in a chronological sequence, were similarly misconceived as presenting an evolutionary tableau.[81] This might explain why the remarkable disparity between Hawkins's own anti-evolutionary views and the anatomical illustrations he drew for Huxley has so rarely been noticed, either by his contemporaries or historians. The cause of the confusion is that Hawkins believed, as he explained in a response to the *Morning Post*, that there was "evidence of distinct acts of creative power, but without necessarily implying the separate creation of all that are now considered as species."[82] Hawkins, who was influenced by Richard Owen's Platonic conception of the vertebral archetype, instead proposed that there existed a "constant unity of plan" in the vertebrate skeleton that was "susceptible of adaptation to various conditions of existence."[83] These "slight modifications" of the original vertebrate ideal, which helped "fit" organisms to "changing circumstances," enabled the creation of new, though providentially planned, species.[84]

While Hawkins was later adamant that "such modifications are radically distinct from the evolution theories of Darwin and Huxley," Huxley himself had lectured to working men in November 1862 on the "unity of plan, or conformity of construction, among animals."[85] The structural similarities found in the composition of widely divergent animals were amenable to both naturalistic and theistic explanations, and Huxley, without invoking any evolutionary rationale, reduced the diversity of the "whole of the animal world . . . to modifications of one primordial unit."[86] This was the very same lecture, given at the Museum of Practical Geology, in which Huxley first used the life-sized diagrams of the orangutan, chimpanzee, gorilla, and human that Hawkins had created for him. Their presentation in a successive series, with a comparable upright posture and raised left leg, was an effective means of disclosing the numerous homologies in their respective skeletal forms. Indeed, Hawkins may have drawn these primate skeletons

under the impression that they would be employed merely to provide "evidence of . . . a unity of plan among all the animals" as described in Huxley's uncontentious introductory lecture.[87]

Hawkins would quickly have been disabused of this hope, especially as Huxley's series of lectures began to extoll "Mr. Darwin's views" and provocatively extend them to include the "improvement of man from some simpler and lower stock."[88] The artist had nevertheless ensured that he still retained some control over the images that were now, seemingly, the property of Huxley and his publishers, Williams and Norgate, and that were redeployed in *Man's Place in Nature*. As with the lithe chimpanzee in his earlier simian frontispiece for White's *Popular History of Mammalia* (see plate 1), Hawkins's drawing of the gorilla actually contradicted crucial aspects of Huxley's textual description of the same creature.

The Most Waddling Gait Imaginable

In his lectures, Hawkins insisted that the "tarsus or ankle" of humans was "entirely different" from that of gorillas. The structure of these bones in the ape, he contended, rendered it "absolutely necessary for the animal if he walked at all, to walk on the side of his foot, or in other words in the . . . most waddling gait imaginable."[89] Hawkins additionally "showed, by sketching the outlines of the frame of a gorilla," that the creature was "unable to put its feet down flat" and "could only support itself on the outside of the foot," meaning that its legs appeared "bandy."[90] In *Man's Place in Nature*, Huxley flatly contradicted this interpretation, asserting, with cool authority, that the gorilla's "tarsal bones, in all important circumstances . . . resemble those of man." While acknowledging that the "foot is set more obliquely upon the leg than in man," Huxley did not mention the position of the gorilla's feet in walking and instead maintained that the "resemblances between the foot of Man and the foot of the Gorilla are far more striking and important than the differences."[91] In the book's frontispiece, however, the gorilla, though standing upright, otherwise embodies Hawkins's conception of the creature's gait rather than that presented by Huxley later in the same volume (fig. 1.8).

The gorilla's skeletal right foot, unlike that of the human or the other

GORILLA.

Fig. 1.8. Detail of figure I.2 showing the skeleton of the gorilla in the frontispiece to Huxley's *Man's Place in Nature*. It reveals that the gorilla's gait is notably awkward, something that surreptitiously expressed Hawkins's anti-evolutionary views.

three simians, does not rest flat on the ground, represented in the engraving by a simple straight line. It is instead arched, giving the impression that the creature is walking, uneasily, on the sides of its feet. The gorilla's left leg, meanwhile, is raised considerably higher than those of the other four skeletons, making it appear further apart from the right knee and thus likely to produce a bandy-legged gait that, when examined closely, is distinctively waddling. The gorilla skeleton in the Hunterian Museum that Hawkins

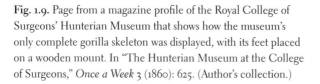

[DEC. 1, 1860.] THE HUNTERIAN MUSEUM. 625

Butchell, who has most certainly not been preserved for her beauty. We are apt to think that in this age we have arrived at the very perfection of advertising, direct and indirect; yet here is a specimen of the ability of the last century, which will bear comparison with our best efforts. Think of a charlatan utilising his defunct partner in this direction! Van Butchell, who would seem to have been a kind of St. John Long of his day, appears to have had his wife embalmed—on the same principle that Barnum stuffed his mermaid—to draw the public purse; and like that worthy he advertised his wares judiciously in the public press. On the breast of the lady, for instance, we find a card inscribed with the following notice from the "St. James's Chronicle" of October 21st, 1773:—

"Van Butchell (not willing to be unfortunately circumstanced, and wishing to convince some good minds they have been misinformed) acquaints the curious no stranger can see his embalmed wife unless (by a friend personally) introduced to himself any day between nine and one, Sundays excepted."

What could induce persons to pay a visit to Mr. Van Butchell in order to see such a shocking spectacle we cannot conceive. In this collection the body is by no means out of place, flanked on either hand by an Egyptian mummy, and by the preserved remains of a woman who died in the Lock Hospital, whilst a dried specimen of the genus homo, sitting crouched up on his haunches, looks on apparently amazed at the change of scene he experiences from the Guaco at Caxamanca, in Peru. There is food for conjecture in another

that in all probability the poor little fellow was employed in some way in the interment, and must have been forgotten by the workmen when the vault was finally closed.

Next to the cases containing the human skeletons is a golgotha, or place of skulls. These domes of bone tell of the wide diversity of power that ranges through the human race. Here we have the full scale, from the head of the Caucasian type (a line from the forehead of which to the lower jaw is almost perpendicular) to that of the Carib (in which the line slants outwards towards the jaw with a most animal-like slant). If the visitor will take the trouble to examine the skull

Peruvian mummy.

skeleton of a young lad close at hand. All his history is comprised in the fact that he was found erect in a vault, with the remnants of his clothes on, under St. Botolph's, Aldgate, old church, in the year 1742. The last time the vault had been opened was during the Great Plague in 1665, so

Skeleton of gorilla or highest order of ape.

of the gorilla, a gigantic chimpanzee, in the adjoining room, he will see that between the skull of the most debased tribe of mankind, and that of the highest ape, the difference is immense. The gorilla's skull seems all taken up with the facial

Fig. 1.9. Page from a magazine profile of the Royal College of Surgeons' Hunterian Museum that shows how the museum's only complete gorilla skeleton was displayed, with its feet placed on a wooden mount. In "The Hunterian Museum at the College of Surgeons," *Once a Week* 3 (1860): 625. (Author's collection.)

drew for the image was not articulated in this particular pose. As in the illustrations to a profile of the museum in *Once a Week* in 1860, it had both its feet placed on a wooden mount (fig. 1.9). The ungainly positioning of the gorilla's skeletal feet and legs in the life-sized drawing must therefore have been Hawkins's own. Even while the composite wood engraving that this separate image was subsequently incorporated into seemed to present the

apes striding purposefully toward humanity's evolutionary apex, Hawkins, in his depiction of the gorilla's awkward gait, managed to surreptitiously secrete some of his own defiantly anti-evolutionary interpretations into the frontispiece.

Many of the lectures in which Hawkins disparaged the gorilla's waddling gait were given at the Crystal Palace, where, by the early 1860s, the emphasis had switched from pedagogic attractions such as Hawkins's models of extinct animals to more remunerative popular entertainments. These included performances by the celebrated French tightrope walker Charles Blondin, whose spectacular stunts while balancing on ropes stretched across the towering glass structure often overlapped with Hawkins's lectures. When, in June 1861, Hawkins concluded another discourse in which his illustrations afforded "unmistakable evidence that the erect position was unnatural" to the gorilla, he could not resist contrasting the creature's egregious clumsiness with the imminent feats of acrobatic dexterity. As the *Critic* reported: "Before dismissing his numerous audience, the lecturer explained to them that the performances of Blondin, then about to commence, were really triumphs of human skill, and feats which the gorilla, notwithstanding its high position in the animal scale, would be utterly unable to accomplish."[92] If Blondin himself negated the potency of Hawkins's contrast by regularly performing "dressed up in a monkey uniform," then the design of *Man's Place in Nature*'s frontispiece inadvertently confirmed the distinction made by Hawkins in the impromptu coda to his lecture.[93]

While Hawkins had no involvement in creating the engraved straight line on which the feet of the primate skeletons in the frontispiece stand (see fig. I.2), it has been suggested that it creates a visual effect in which the "skeletons seem to parade across a tight rope."[94] This particular impression accentuates the ungainliness of the gorilla skeleton, which appears to totter on the verge of falling from the taut tightrope. The depiction in the frontispiece once again—albeit this time unintentionally—exemplifies Hawkins's contemptuous attitude toward the creature he declared "incapable of tightrope performance," not Huxley's more positive view.[95]

Hawkins did not, at this stage, directly name Huxley in any of his lectures on the gorilla. But the contrast between their respective positions on the simian would have been obvious to those who attended them. When, in

March 1863, the *Chatham News* warned its readers that the "latest expounder of the 'development' system is Professor Huxley, who has published 'Evidence as to Man's Place in Nature,' to show what noble ancestors we had," it was at least able to reassure them that "Mr. W. Hawkins, when he lectured at Chatham . . . did not . . . arrive at the conclusion that man had ever been a gorilla."[96] What the newspaper did not appear to recognize was that vestiges of the sketches made by Hawkins during his lectures, in Chatham and elsewhere, remained perceptible in the illustrations of Huxley's perturbing new tome. The lecturer's antagonism toward Huxley's views had endowed the procession of primate skeletons that formed the book's frontispiece with a sting in its tail.

The Under-World of Life

Not only provincial newspapers failed to discern Hawkins's subtle subversion of the emblematic image that begins *Man's Place in Nature*. The overall impact of its upward motion, progressing from left to right through a sequence of ascending skeletons, seems to have distracted the attention of its viewers away from the gorilla skeleton's peculiar positioning. And if it was not noticed by the book's initial readers in the 1860s, then the fading from memory of Hawkins's once fashionable lectures, which were recorded only in newspaper reports, made it virtually impossible for subsequent generations to recognize the anomalous gait that Hawkins had sketched in numerous lecture halls to demonstrate the gorilla's divergence from humanity. The circumstances of the frontispiece's production, hitherto as little known as Hawkins's forgotten lectures, nevertheless make it clear that his and Huxley's conflicting scientific agendas, as well as their festering personal tensions, had a profound impact upon the image.

In the summer of 1862, Huxley confided to Flower his misgivings regarding Hawkins "sticking to the work and about the execution thereof." He also prefaced his "wish" that "somebody else had to do the Van Amburgh business" by observing despondently: "I perceive lions in the path on all sides."[97] This was an allusion to the lion obstructing the straight road to salvation in the first canto of the *Inferno*, a poem that Huxley had read intensively while aboard HMS *Rattlesnake* in the 1840s.[98] The invocation of Dante's

fourteenth-century epic adds further bathetic humor to the subsequent allusion to the celebrity lion tamer Van Amburgh. More significantly, it also implies that Huxley considered working with Hawkins as akin to being ensnared in the "dark depths of a wild and tangled forest," as he later described the scene of the same section of the *Inferno*.[99] Indeed, although Huxley could, as he did with the lithographic plates of the *Glyptodon* skeleton, decline to commission further illustrations from Hawkins, he seems to have had no option but to continue with the recalcitrant artist for work that had already been contracted. The *Inferno* was evidently on Huxley's mind when he was composing the text of *Man's Place in Nature*, in which he pointedly alluded to the distaste many would feel at humanity's close "relations to the underworld of life."[100] The book's frontispiece representing this chastening connection was the result of a working relationship that, for Huxley, resembled being trapped in the dark wood where Dante begins his journey through the underworld.

The *Bookseller* had announced Huxley's collaboration with Hawkins on the *Elementary Atlas of Comparative Osteology* back in April 1862. When the book was finally published in October 1864, Huxley circumspectly outlined their respective remits: "Mr. Waterhouse Hawkins is responsible for the accuracy and for the artistic execution of the drawings; while my share of the work consists of the selection, the arrangement, and the nomenclature of the parts of the objects figured." The *Elementary Atlas*'s twelve lithographic plates placed the skulls, hands, feet, and pelvises of humans and various apes, as well as other mammals, birds, and fish, alongside each other, although there was no mention of any potential evolutionary relationship (fig. 1.10). Instead, Huxley assured readers that the textbook was "intended simply to aid students in comprehending the general arrangement of the bony framework of the Vertebrata, and some its most important modifications."[101] This seemed merely to entail the conception of a unity of plan that, with different inflections, both Huxley and Hawkins could agree on. It was, after all, to illustrate the same idea that Hawkins had created the drawings of primate skeletons for Huxley's lecture to working men in November 1862.

Like the diagrams that appeared in the frontispiece to *Man's Place in Nature*, parts of two of the lithographic plates in the *Elementary Atlas* — showing

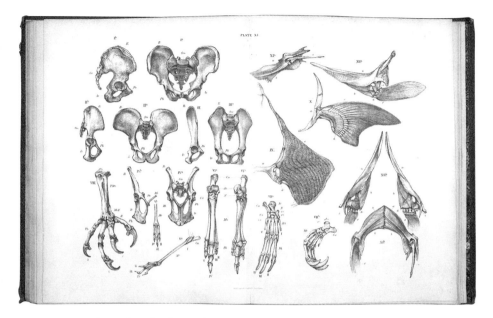

Fig. 1.10. Lithographic plate by Hawkins showing the pelvis and sacrum, hind foot, and pectoral arch in a number of primates, marsupials, birds, and fish. The human, gorilla, and gibbon pelvises, figures Ia, IIa, and IIIa, were reproduced as wood engravings in *Man's Place in Nature* (see fig. 1.11). In T. H. Huxley and B. Waterhouse Hawkins, *An Elementary Atlas of Comparative Osteology* (London: Williams and Norgate, 1864), plate XI. (© The British Library Board 1831.a.17.)

front and side views of the pelvises of humans, gorillas, and gibbons and the feet of humans, gorillas, and orangutans—were similarly reused in Huxley's book (fig. 1.11; see fig. 1.7). Here they appeared as wood engravings, with the attribution "reduced from drawings, made from nature . . . by Mr. Water-house Hawkins". In fact, the delay in the publication of the *Elementary Atlas* meant that these two illustrations were printed in *Man's Place in Nature* in this reduced and altered format—Hawkins's drawings actually appeared in reverse—more than a year before they appeared in the original folio lithographic plates. For Hawkins, it must have been extremely perturbing that images created to uphold an understanding of vertebrate morphology that seemingly differed little from his own were being recycled, even before their originally intended use, in a book that explained the "structural unity of man with the rest of the animal world" in explicitly evolutionary terms.[102]

75

no doubt whatsoever as to the marked difference between Man and the Gorilla; but there is as little, that equally marked differences, of the very same order, obtain between the Gorilla and the lower apes.

Man.

Gorilla.

Gibbon.

FIG. 16.—Front and side views of the bony pelvis of Man, the Gorilla and Gibbon: reduced from drawings made from nature, of the same absolute length, by Mr. Waterhouse Hawkins.

Fig. 1.11. Wood engraving of original drawings made by Hawkins of human, gorilla, and gibbon pelvises. They were made as part of a lithographic plate for Huxley and Hawkins's *Elementary Atlas of Comparative Osteology* (see fig. 1.10), but were published in this reduced and reversed format more than a year before that book appeared. In Thomas Henry Huxley, *Evidence as to Man's Place in Nature* (London: Williams and Norgate, 1863), 75. (University of Leicester Library, SCM.12908.)

An Accumulation of Arrears

Hawkins, for all his bold defiance of Lyell over the intricacies of gorilla feet and for all his bombastic denunciations of evolution in his lectures, did permit his drawings to be repurposed in a discussion of evolution and even to be printed with clear attributions to himself. Just as commercial science

writers had to regularly tailor their opinions to the demands of the literary marketplace, adopting different outlooks depending on which publications they were writing for, scientific illustrators reliant on irregular commissions had to be amenable to the requirements of their different patrons.[103] The disparity between Hawkins's own views, which he expressed regularly and often abrasively in public, and those articulated in *Man's Place in Nature*, a book by an intellectual opponent but with his illustrations, is nonetheless remarkable. And unlike many freelance journalists in this period, Hawkins did not have the convention of anonymity to conceal the contradiction between the arguments and drawings in his lectures and the images he contributed to Huxley's book. There must have been compelling reasons for Hawkins to lend his name, which appears three times in *Man's Place in Nature*, to Huxley's hugely controversial affirmation of humanity's apelike ancestry.

After being abruptly dismissed from his full-time post as director of the Fossil Department for the Crystal Palace Company in 1855, Hawkins was rarely in a position where he could demur over whom he worked for. The beginning of the following decade was a period of particular pecuniary need. An "accumulation of arrears," as he explained to a creditor in 1860, had resulted from a "serious loss which I sustained."[104] This seems to have been the collapse in the value of his shares in a railway company, but Hawkins was especially vulnerable to such financial vicissitudes because, for nearly three decades, he had been maintaining two separate households. Having bigamously married for a second time in 1836, Hawkins had two families to support, including five unmarried daughters. These potentially scandalous personal circumstances, which Hawkins managed to conceal from those he worked with and even from his second wife, Louisa, left him needing to maximize his income from whatever commissions came his way.[105]

Until recently Huxley had himself depended on freelance journalism to support his family, and he brazenly acknowledged: "I never do it except for filthy lucre."[106] But it was not merely money that Hawkins received from his uneasy collaboration with Huxley. When, in March 1868, Hawkins traveled to America seeking new opportunities for his artistic talents—leaving Louisa, from whom he seems to have become estranged—he called on the influential science writer Edward Livingston Youmans "with a card from Huxley."

Youmans had helped facilitate the American edition of *Man's Place in Nature*, although he had "never heard of B. W. H." before the arrival of the book's artist on his doorstep in New York with the message that "Huxley sent him to me, and told him to put himself in my hands." While Youmans soon found himself "up to my eyes in this Hawkins business," his assistance in getting Hawkins "set a-going" in America, where he spent the next six years, shows that Huxley's imprimatur was not something that Hawkins could afford to spurn, regardless of their profound scientific disagreements.[107]

Actualities and Realities in Art

Huxley's testimonial must have been based on Hawkins's reconstruction of the *Glyptodon* skeleton, which he had lauded at the Royal College of Surgeons. Otherwise his recommendation of the artist to Youmans would have been disingenuous. As his barbed comments to Flower regarding Hawkins's artistic "execution" make clear, Huxley was far from impressed with the lithographs that were being made for the *Elementary Atlas of Comparative Osteology*. These aesthetic reservations might even explain the protracted publication of the book, which, though advertised in February 1863 as being "(*In the press*)," would take a further twenty months to appear.[108]

Nor was disapprobation of the lithographs confined to the book's co-author. The *Westminster Review* observed of the *Elementary Atlas* when it was finally published: "We must confess that we are rather disappointed with the execution of the plates, which is by no means worthy of the plan so carefully elaborated by Professor Huxley . . . certainly the effect of roughness exhibited by many of Mr. Hawkins's figures might easily have been avoided."[109] The *Popular Science Review* likewise commended Huxley's contribution to the "useful volume" before remarking: "We only have one ill word to say, and that relates to the manner in which the artist has performed his part of the work. We do not think Mr. Hawkins has done justice to his subject . . . there is an absence of good definition, which we are sorry to observe."[110] Despite the roughness and lack of definition, precisely these same "lithographed figures of bones" had already been used, albeit converted into wood engravings, to illustrate crucial anatomical arguments in *Man's Place in Nature*.[111] And the primate skeletons that formed the book's frontispiece were

themselves based on drawings made at the very same time by Hawkins's allegedly defective hand.

Such caustic reviews must have mortified the thin-skinned Hawkins. After all, he had mastered the technique of lithography as far back as 1829, when the process of printing from flat limestone slabs drawn on with waxy crayons, creating marks that chemically attracted ink, was still relatively new.[112] Throughout his career, Hawkins remained interested in new developments in lithography, and he had quickly embraced the opportunity to add bright colors created by the invention of chromolithography (see plate 1). Even the plates for the *Elementary Atlas*, notwithstanding their critical mauling in the press, were produced by the specialist lithographic printer Frederick Dangerfield on a recently patented cylinder press.[113]

By the early 1860s, though, Hawkins, who had already found fault with the daguerreotype process, was becoming increasingly hostile to the new photomechanical methods that were enabling artists to create ever more detailed and precise images. In April 1863 he complained that the "development of the photographic art had stimulated a taste . . . for the re-production of actualities and realities in art." This punctilious objectivity, in which it was "necessary to reproduce every fold in the drapery," actually "encumbered the artist in the expression of his thoughts." Hawkins instead avowed that he would always prefer the "old system of sketching, which was an indication of the mental operation of the artist."[114] This older, more impressionistic approach might explain the "absence of good definition" that reviewers bemoaned in the *Elementary Atlas*'s lithographic plates.

Hawkins delivered his self-consciously "out of date" lament just two months after the publication of *Man's Place in Nature*.[115] During the book's production Huxley had evidently grown frustrated with the artist's resistance to employing optical technologies. Remarking to Flower how few artists "know anything about the camera lucida," Huxley reflected, with palpable exasperation, that he had even "had to discourse on the virtues of it to Hawkins."[116] If Hawkins could not be persuaded to employ a camera lucida, an early nineteenth-century device using mirrors to create a virtual image of an object whose outlines could be traced, then he would have had no truck with the brand-new reproductive methods on which the particular visual effect of the frontispiece to *Man's Place in Nature* depended. Clearly, Huxley

required another artist. Hawkins, however, could not be dismissed so easily, and Huxley's concern that the artist would "feel himself hugely aggrieved" was fully vindicated. For several decades to come, Hawkins considered himself to be engaged in nothing less than an intellectual duel with Huxley. His weapons of choice were new, alternative versions of the iconic sequence of primate skeletons, this time showing their differences rather than their similarities.

Throwing Down the Gauntlet

At the end of August 1862 Huxley informed Flower that the person he had hired to complete the illustrations for *Man's Place in Nature* was a "willing fellow enough and less conceited than any artist I have had to do with."[1] He must certainly have been a refreshing change from his recalcitrant and haughty predecessor, Hawkins. The new artist's eager acquiescence was hardly surprising, for the commission seems to have been his very first paid employment. Having recently completed a seven-year apprenticeship, "W. H. WESLEY (Jun.)" advertised his services as "Draughtsman, and Engraver on Wood," in the classified columns of the *Bookseller* for August 30, 1862.[2] By the time the advertisement appeared, however, he had already begun working for Huxley at the Royal College of Surgeons. William Henry Wesley had turned twenty-one just a week earlier, and the tasks that the young engraver undertook at the college's Hunterian Museum went beyond those taught during his apprenticeship. They also required more than the two particular skills he touted in the *Bookseller*.

In the mid-Victorian wood-engraving trade, the role of a draftsman was to transfer, by pencil, original images created by an artist onto blocks of hardwood ready for the engraver to cut away, with a steel graver, the parts of the woodblock that would not be printed.[3] Wesley evidently felt confident that he had acquired the two skills required for the latter stages in the process, even if they were usually performed by different people in wood-engraving workshops.[4] Huxley later remarked exultingly of another engraver in his employ, "I have discovered an artist who can draw with reasonable

accuracy on wood & who does the cutting himself which is an essential find." Huxley himself "made the [original] drawings for the . . . woodcuts," but the engraver in question, William Ballingall, was late in performing his parts of the work and, like the unpunctual lithographer James Erxleben, left Huxley "altogether in despair about the cuts."[5] The duplication of responsibilities that Huxley had considered so advantageous was clearly not without problems.

Yet, remarkably, Huxley seems to have asked Wesley to go beyond the already difficult combination of tasks assigned later to Ballingall. The young engraver was also tasked with drawing the artifacts at the Hunterian Museum directly onto the surface of the woodblock, without, as was usual, the assistance of an artist's original drawing. If a drawing was made on sufficiently thin paper, it could be placed, face down, on the woodblock and traced onto the surface, albeit destroying the original image in the process. Drawing from an object straight onto the wood was a much more difficult skill, especially as it had to be done in reverse (so that the image appeared the right way around on the printed page). The task was particularly challenging for a twenty-one-year-old neophyte on his very first commission.

The technique of "drawing from Nature & on wood" had been employed in the celebrated wood engravings for Henry Gray's *Anatomy* (1858), but it was the book's artist, Henry Vandyke Carter, rather than its unknown engraver who had drawn the images on the woodblocks.[6] Although an obituary of Wesley later noted that he spent "spare time" during his apprenticeship "cultivat[ing] his drawing by making studies at the British Museum," this was hardly equivalent to the intensive training that most specialist artists would have undertaken.[7] Wesley drafted the lithographic images that Hawkins had drawn for the *Elementary Atlas of Comparative Osteology* and that were repurposed as wood engravings for *Man's Place in Nature*, even if his inexperience meant that they were rendered in reverse (see figs. 1.10 and 1.11). Wesley's rapid elevation to the more demanding role of making original drawings on the woodblocks for some of the other images in the book, thus removing the need for a separate artist, was almost certainly a direct result of Huxley's determination not to give Hawkins any more work than was necessary.

Unsurprisingly, the novice engraver had neither the skills nor the experi-

ence to create original drawings of the required precision, especially for the sections of *Man's Place in Nature* that dealt with minute cerebral distinctions between apes and humans. As Flower observed to Huxley on August 25, 1862: "Your artist came last week and I victimized a human brain for him . . . He did not succeed in making a very brilliant sketch of it, I fear, but you can touch it up a little before the cut is made."[8] Huxley was unconcerned about his own artistic abilities extending to refining Wesley's rough sketch on the woodblock ahead of its being engraved.[9] Moreover, his phlegmatic response to Flower, whom he thanked—"I am very much obliged to you for taking so much trouble with my artist. I knew he would not know much about drawing from the object"—suggests that he accepted the inevitable limitations of Wesley's inexperience.[10]

The solution was to deploy the very optical technologies that Hawkins, in his intransigent adherence to freehand sketching, had refused to countenance. Flower informed Huxley how he had helped the new artist: "For the other drawings I lent him a camera lucida (with the use of which he was previously unacquainted) and which he found of great assistance."[11] Following this fortuitous introduction to the instrument, Wesley was soon convinced, as he reflected in 1866, that the "use of the camera lucida . . . is indispensable, both for the great saving of labour and for the accuracy of outline obtained by its employment." While he also insisted that the "work of the artist will never be altogether dispensed with, nor be superseded by any merely mechanical process," Wesley, in marked contrast to Hawkins, relied on precisely such technological assistance to compensate for his lack of experience and artistic training.[12]

Even with these mechanical aids at his disposal, the publisher Edmund Sydney Williams did not seem entirely convinced of Wesley's capabilities when combining the roles of artist and draftsman. In December 1864 Williams suggested unenthusiastically to Huxley: "If you can refer Wesley to books or to the objects themselves I have no doubt he would be able to make the drawings on wood well enough."[13] This was almost two years after Wesley had completed his first commission for Huxley, and his abilities, especially in the difficult skill of drawing in reverse, would likely have been even less accomplished when he was making drawings on the woodblocks used for *Man's Place in Nature*. In fact, Wesley's deficiencies as a draftsman, even

when he was not required to make original drawings, seem to have had hugely significant implications for the most notable of the wood engravings that he contributed to Huxley's book.

Huxley's public praise for the "skill, painstaking, and thorough faithfulness" of the "young artist, Mr. W. H. Wesley" no more reflected the private concerns he had about him than had his earlier approbation of Hawkins.[14] It was nevertheless the twenty-one-year-old novice who was tasked with engraving the emblematic frontispiece to *Man's Place in Nature*. Wesley's contribution to the composition of this image was as important as that of Hawkins, whose five separate life-sized diagrams of primate skeletons had to be reduced by more than twenty times to fit the dimensions of Huxley's book. Crucially, Wesley's inexperience in such a challenging undertaking seems to have induced Huxley to adopt another optical technology. This was photographic reduction. The brand-new photomechanical innovation was integral to the iconographic potency of the frontispiece's continuous sequence of precisely proportioned skeletons. Notably, though, Wesley, soon after completing his commission for Huxley, chose to design, engrave, and publish an evangelical wall hanging with passages from Scripture. It seems unlikely that he endorsed the controversial understanding of human origins advanced in the images he was making for *Man's Place in Nature* any more than Hawkins did.

Hawkins's antagonism toward those images, and his seeming resentment at his own part in their creation, intensified in the years after the publication of *Man's Place in Nature*. His festering personal tensions with Huxley by no means ended when they ceased working together. In fact, Hawkins considered himself to be engaged in an intellectual duel with Huxley, which he fought out, on both sides of the Atlantic, in increasingly explicit and rancorous lectures and publications. It was in alternative versions of the succession of ape and human skeletons, which both echoed and contested the now famous frontispiece, that Hawkins threw down the gauntlet to Huxley.

The Limits of a Page

The diagrams of ascending primate skeletons that Hawkins drew for Huxley's lecture to working men at the Museum of Practical Geology in No-

vember 1862 were *"of the natural size."*[15] The height of the "skeleton of a male Gorilla, measur[ed] 5 feet 6 inches, in as erect a position as it can naturally be brought," and a fully upright human skeleton generally reached even higher.[16] This made it difficult to redeploy Hawkins's life-sized pictures in the way Huxley had clearly determined upon for the frontispiece to *Man's Place in Nature*. Even the additional diagram of the smaller gibbon skeleton that was subsequently created by Hawkins was drawn *"twice as large as nature,"* presumably to enable its use in another of Huxley's lectures, meaning that it would have been more than four feet high.[17] The sheer scale of these discrete drawings, designed to be visible to an audience in a crowded lecture theater, presented a particular challenge to Wesley in his role of draftsman. After all, he had to transfer the drawings, together as a new composite image and in reverse, onto a woodblock that, when engraved, could be printed onto a demy octavo page (approximately nine by six inches) also including four lines of typeset text (see fig. I.2).

The hard endgrain of boxwood necessary for wood engravings rarely yielded blocks more than four by six inches in size, so each of Hawkins's drawings would need to be more than twenty times smaller than their original dimensions. The traditional method of achieving such reductions was to place a frame with "threads . . . stretched lengthwise and crosswise" onto the original image and trace, in light pencil markings, an equivalent grid onto the woodblock. The draftsman had then only to ensure that "whatever parts lie within any opening in the frame are copied within the corresponding opening on the wood" to create a reduced "copy in exact proportion."[18] It was almost certainly this method that Wesley would have learned during his recently completed apprenticeship.

The typeset caption to the frontispiece to *Man's Place in Nature* proclaims that the successive skeletons were *"Photographically reduced from Diagrams of the natural size."*[19] This seems to have been one of the very first occasions when an image in a commercial publication was created using photographic reduction. Indeed, the technique was so innovative that in January 1863, only weeks before Huxley's book was published, the *Saturday Review* was excitedly acclaiming the "extraordinary capacity of this new art in reducing facsimiles—without injury to their accuracy—to any scale that may be required by the limits of a page."[20] The technique had been de-

veloped by Alexander De Courcy Scott at the Ordnance Survey Office in Southampton, where it enabled the adjustment of maps to different scales in an efficient and cost-effective manner. By placing a "sensitive plate" and the image to be copied "as parallel as possible" and "draw[ing] the camera stand backwards and forwards" on "brass runners," it was possible, Scott explained, to produce a "correct reduced image . . . to a given scale." While the method had thus far been employed only on official maps, it could, as Scott proposed in 1862, be extended to commercial purposes such as the "copying of engravings or manuscripts." Although there is no other evidence beyond the frontispiece's caption, it seems likely that Hawkins's life-sized diagrams were photographed and, in the process recently adumbrated by Scott, reduced to the required dimensions. Wesley would then have transferred this new smaller photographic reproduction—which, in Scott's system, was rendered as a "positive chromo-carbon print" on a "sheet of thin paper"—onto a woodblock before engraving it.[21] Scott's new process was predicated on speed and expediency, so it would have been particularly attractive given the likelihood that the frontispiece was added toward the end of *Man's Place in Nature*'s publication schedule.

In the early 1860s the wood-engraving trade was just beginning to undergo the wholesale mechanization of its processes that would soon make draftsmen obsolete, replaced by the photographic transfer of images onto sensitized woodblocks.[22] When photographic reduction was initially deployed in commercial publications, it still required the skills of a draftsman to transfer the reduced image onto wood, by pencil and in reverse, as seems to have been the case with the frontispiece to Huxley's book. The new technique was nevertheless denounced for diminishing the craftsmanship that had enabled mid-nineteenth-century wood engraving to become a widely respected art form.[23]

The influential master-engraver William James Linton declared that even the "poorest draughtsman is capable of correctly reducing a drawing to any required size, without the aid of photography."[24] Like Hawkins, with his distaste for photomechanical methods, Linton feared that photographic reduction induced a slavish fastidiousness that prevented draftsmen from exercising their individual judgment as to which aspects of an image needed to be brought out most clearly. In the mid-1860s Hawkins himself similarly

expressed his conviction as to the "advantages which the wood-engraver still possessed . . . over the various processes which had been introduced, trenching . . . upon that branch of art."[25] Wesley had been trained in precisely the older craft methods favored by Linton and Hawkins, but having been lent a camera lucida by Flower to compensate for the shortcomings in his original drawings, it was now considered necessary to supplement his skills in the more basic elements of draftsmanship. For Wesley to complete the tasks he had been assigned, the manual dexterity required by the traditional grid method of reduction had to be supplanted with the very newest photomechanical proxy for the artist's hand, even if, as Linton insisted, it compromised the integrity of the final wood engraving.

Embodying a Principle of Progress

If the pioneering technique of photographic reduction was initially adopted for *Man's Place in Nature* because of concerns about Wesley's proficiency as a draftsman, it must have quickly become apparent that the process was particularly suited to the requirements of the emblematic image that Huxley wanted for his frontispiece. Whereas human and gorilla skeletons looked quite different when compared directly, when they were placed in a series, alongside a chimpanzee, orangutan, and gibbon, the differences were actually no less conspicuous than those disclosed by a comparison of the gorilla with the other anthropoid apes. In *Man's Place in Nature*, Huxley assured his readers that if man's purportedly "perfect structure be compared with . . . the animals which lie immediately below him," then it would be seen that "he resembles them as they resemble one another—he differs from them as they differ from one another." But in order for the five successive primate skeletons in the frontispiece to be comparable, thus revealing the "differences and resemblances" of their respective osseous structures, then they had to be depicted at the same scale.[26] Accurate calibration was important to Huxley, and six years after the publication of *Man's Place in Nature*, in 1869, he stipulated that ethnological photographs of people from across the British Empire should be taken at the same scale so that the "relative proportions of the different figures could thus be apprehended almost at a glance."[27] While living colonial subjects had to be positioned and kept in place using

cumbersome measuring rods, photographic reduction meant that the comparative dimensions of the more pliable primate skeletons could be seen with the same immediacy.

The only time that Huxley referred to the frontispiece in the text of *Man's Place in Nature* was during an intricate anatomical comparison when he proposed that the gibbon was "as much longer in the legs than the Man, as the Man is longer in the legs than the Gorilla . . . (see the Frontispiece)." But it was complicated for readers to make such an assessment because, incongruously, the gibbon actually appeared at twice the scale of the other skeletons. This perhaps indicates that with the still experimental process of photographic reduction all five of Hawkins's lecture diagrams had to be photographed and reduced together, to a uniform scale of approximately 1:27, rather than individually. The discrepancy that was caused by Hawkins originally drawing the gibbon *"twice as large as nature"* was nevertheless fully acknowledged in the frontispiece's caption. A quarter of the caption was taken up with a parenthetical notice beginning "(*except that of the Gibbon* . . .)," demonstrating that, for Huxley, it was imperative that viewers of the image took the issues of size and scale into account.[28] Wesley himself urged, in 1866, that when "delineating natural objects upon a plane surface . . . for scientific purposes," the "drawings should always be made to some fixed scale" so "their measurements are easily comparable with one another."[29] Such a meticulous fixed scale, especially when the drawings had to be reduced from colossal lecture diagrams to tiny engraved figures each measuring less than three inches in height, was best ensured by the photomechanical precision of a sliding camera on brass runners rather than by a draftsman's hand and eye guided by a frame with threads. This was the case even with the constraints of photographic reduction's inflexibility—itself a result of the new technique's mechanized uniformity—when dealing with the gibbon's original twofold magnification.

Once a consistent scale had been attained, Wesley averred, it was "absolutely necessary, if drawings . . . are to be comparable with one another, that some fixed . . . base line be adopted, which shall regulate their position." In the frontispiece to *Man's Place in Nature* Wesley instituted precisely such a "fixed horizontal line" on which each of the skeletons stands on its right foot in a comparable pose, albeit somewhat awkwardly in the case of the

gorilla.[30] This standardizing baseline that situated the five skeletons together on the same visual plane was absent from Hawkins's originally discrete diagrams, and Wesley asserted his artistic proprietorship by placing his signature, "w. h. wesley Sc.," directly below the far end of the line under the human skeleton's raised left foot.[31]

Wesley made his pronouncements about the need for fixed scales and baselines at the Anthropological Society, where it was affirmed that these views "had the approval of Professor Huxley."[32] Together Wesley and Huxley seem to have found in the technique of photographic reduction a means of achieving the precise pictorial effects, especially the delineation of proportional similarities, that Huxley desired for the opening illustration of his analysis of the comparative anatomy of apes and humans. The hand-drawn illustrations of earlier comparative anatomy publications had generally paid little attention to issues of accurate and consistent scale, as with the plates in Hawkins's own *Comparative View of the Human and Animal Frame* (see fig. 1.6). Indeed, in such images the dimensions of widely divergent creatures were often purposely standardized, thereby accentuating their homological structures and minimizing the appearance of differences.[33] The newly invented method of photographic reduction facilitated a much more precise calibration of variations in size, which, in turn, enabled a refinement in comparing analogous forms.

Another member of the Anthropological Society also recognized the benefits of photographic reduction for creating illustrations that permitted comparisons to be made between a "series of specimens of the same type." In 1868 Augustus Henry Lane Fox (who later took the surname Pitt Rivers) produced a lithographic chart showing flint weapons made by "primeval man" in which all the "figures . . . are traced from the implements themselves, and reduced by photography" at the "*scale 1/8*" (fig. 2.1). This meant that each of the individual drawings of weapons could "be regarded as fac similes," which was, Lane Fox observed, "a point of great importance when our subject has to deal with the minute gradations of difference observable between them." But photographic reduction, in enabling a diverse array of flint implements to be depicted alongside each other at exactly the same scale, did not merely facilitate the comparison of such small distinctions. It also, as Lane Fox contended, revealed that these differences were "clearly embody-

Fig. 2.1. Lithographic chart made for Augustus Henry Lane Fox entitled "Transition from the Drift to the Celt Type." It shows the development of primeval flint weapons, which are depicted at the same scale using the process of photographic reduction. In A. H. Lane Fox, "Primitive Warfare," *Journal of the Royal United Service Institution* 12 (1868): plate XVII. (© The British Library Board 10007.dd.10.)

ing a principle of progress." In fact, "casting the eye from left to right" along each "row on the sheet" allowed the viewer to trace "numerous intermediate gradations of form" that disclosed a striking "continuity of development."[34] In museum displays, Lane Fox sought to arrange his famous collection of ethnological artifacts "in a sequence with a view to show . . . the successive ideas by which the minds of men in a primitive condition of culture have progressed . . . from the simple to the complex" in accordance with modern conceptions of "evolution and development."[35] The still relatively new process of photographic reduction afforded him the opportunity to also create similar progressive evolutionary sequences in two-dimensional illustrations.

While it is much less certain that Huxley intended the same explicitly evolutionary implications as Lane Fox did, the succession of ascending primate skeletons in the frontispiece to *Man's Place in Nature* has certainly been interpreted by many viewers, both in the nineteenth century and subsequently, as depicting a progressive advancement. As with Lane Fox's chart

of incrementally more sophisticated flint weapons, the mechanized process of photographic reduction was integral to transforming Hawkins's separate diagrams into a continuous sequence that, progressing from left to right at a fixed scale, which renders the primate skeletons successively taller, seemed to show humanity's evolutionary development. Even if Huxley turned to photographic reduction only out of sheer practical necessity once the defects in Wesley's draftsmanship became apparent, the particular iconographic potency of the frontispiece to *Man's Place in Nature* was actually made possible by this brand-new technological innovation.

Within the Pale of Orthodoxy

Although Huxley and Wesley evidently agreed on compositional issues such as the need for a fixed scale, there was not necessarily any intellectual affinity between them. In fact, Wesley, like Hawkins before him, was soon also working for Richard Owen, Huxley's principal opponent in the dispute over the relation between apes and humans, even if he had to deferentially implore the eminent anatomist to "let me know (which you have not as yet done)" about the details of the illustrations he wanted.[36] As well as undertaking paid work for such supercilious men of science, Wesley, shortly after completing the illustrations for *Man's Place in Nature*, was able to design and execute a wood engraving of his own. Just as Hawkins created stridently anti-evolutionary drawings for his own lectures and publications, Wesly now chose to create an original engraving that contrasted jarringly with the anatomical images he had been commissioned to produce.

In May 1864 the *Bookseller* reported that "Mr. W. H. Wesley, a clever young artist . . . has just issued an elegantly illuminated emblem to be hung up in a bed-room or nursery." This decorative wall hanging, sold as a scroll, was published by the artist's father, William Wesley, and, unusually for an inexpensive commercial wood engraving, was printed—using multiple woodblocks—in color. What was still more notable, however, was that, as the *Bookseller* observed, it "contains a number of striking passages from Scripture on the duties of husbands and wives, fathers and children, masters and servants."[37] Only a year earlier Wesley had engraved the emblematic frontispiece to a book that provoked the evangelical *Morning Advertiser*

to angrily protest that teaching "we are sprung from the ape" threatened to "steal away our confidence in . . . Christian Scriptures."[38] He was now embellishing scriptural injunctions to obedience and piety with floral decorations in an engraving, entitled "The Way of the Happy Life," that was intended to adorn the homes of devout evangelicals (fig. 2.2).

As with the frontispiece to *Man's Place in Nature*, "The Way of the Happy Life" was clearly attributed to Wesley, who carved his signature, "DESIGNED AND ENGRAVED BY W.H.WESLEY," in the bottom left corner.[39] Despite this, his close involvement with the two incongruous images, in a period of little more than a year, does not appear to have been noticed. Instead, the evangelical press was unequivocal in its praise for "The Way of the Happy Life," with the *Primitive Methodist Magazine* pronouncing it a "very tasty little article" that "will look well on the walls of our rooms, and may be of service in suggesting valuable thoughts and reflections in our families."[40] The devout decoration was attractively priced at just a shilling, but it seems unlikely that Wesley intended merely to exploit the lucrative market for cheap publications created by the evangelical emphasis upon the printed word.

There are no other indications of Wesley's own religious beliefs, either in his writings on astronomy after becoming assistant secretary to the Royal Astronomical Society in 1875 or in any subsequent artistic works. However, his decision, seemingly at his own behest, to undertake all aspects of the production and, with his father, the publication of "The Way of the Happy Life" implies at least some personal investment in the scriptural doctrines it espoused. Several nineteenth-century evangelicals were able to accommodate certain aspects of evolution with their revealed theology, and Wesley's putative beliefs were certainly no impediment to what an obituary described as his "long and intimate friendship" with the evolutionary philosopher Herbert Spencer.[41] The remarkable disparity between the images of ape anatomy Wesley engraved for Huxley and the pious wall hanging he chose to create soon after nevertheless suggests that, like Hawkins before him, he would not have endorsed the controversial understanding of human evolution epitomized in the illustrations he made for *Man's Place in Nature*.

Among the passages from Scripture that Wesley included in "The Way of the Happy Life" was the directive "Remember the Sabbath day, to keep it holy."[42] As an engraver, Wesley worked closely with printers to ensure the

Fig. 2.2. This wood-engraved wall hanging, which combines passages from Scripture with floral decorations, was created by William Henry Wesley soon after he completed the anatomical engravings he was commissioned to make for Huxley's *Man's Place in Nature*. W. H. Wesley, "The Way of the Happy Life" (London: W. Wesley, [1864]). (© The British Library Board 1897.c.19.(25.).)

quality and precision of images on the page, with Spencer, an employer as well as a friend, observing gratefully how "Mr. W. H. Wesley . . . superintended the printing" of engravings he commissioned.[43] In similarly overseeing the printing of the illustrations for *Man's Place in Nature*, Wesley would have been able to adhere to his own injunction, from Exodus 20:8, to maintain the sanctity of the Sabbath. The printing of Huxley's book was undertaken by the firm of George Norman, one of whose staff, himself a member of the evangelical Moravian Church, recalled that while most "printing-office[s] . . . worked seven days a week" to "meet the demands of authors and publishers," "with all our pressure, Mr. Norman never would permit any work on Sunday."[44] Ironically, the printing of *Man's Place in Nature* was put on hold by the need to observe a custom that, according to Huxley, was inherited from archaic and incomprehensible Jewish prohibitions, a heritage that any "Protestant . . . within the pale of orthodoxy" ought to consider "shockingly heretical."[45]

With the exception of Huxley himself, everyone else involved in the production of the book's frontispiece—from Hawkins, making the original drawings, to Wesley, engraving them onto wood, and, finally, Norman and his staff, printing the composite image from the woodblock and letterpress—would have been vehemently opposed to the evolutionary implications of its procession of primate skeletons.

To Preach the Truth

Like Wesley and the printers of *Man's Place in Nature*, Hawkins did not work on Sundays. As he told a correspondent in the 1870s, he would adjourn his incessant lecture tours to "spend my Sabbath" with pious friends who "took me to Church, and invited me to tea in the evening." The natural history lectures that he commenced again on Mondays were, he avowed, themselves attempts "to preach the *Truth*," and Hawkins's High Church Anglican faith, which had supplanted the Catholicism of his childhood, was an important component in his rejection of evolutionary accounts of human origins.[46] As with his decidedly unchristian marital arrangements, however, Hawkins refused to observe scriptural injunctions to turn the other cheek. Both his enmity toward Huxley and his dislike of the frontispiece

he had helped to create became increasingly virulent and outspoken in the years following the publication of *Man's Place in Nature.*

Until now, Hawkins had refrained from directly naming Huxley in any of the lectures and publications in which he expressed his antipathy toward evolution. This changed in October 1867 when, in another of his numerous lectures on anthropoid apes, he lamented that it was "extraordinary that this group of animals had got sadly out of their natural place in the minds of many people." Hawkins then informed his audience of a particularly egregious instance of this misapprehension: "Professor Huxley argued that the monkey was more like man than the whole of the monkies [*sic*] were like each other."[47] This imprecise paraphrase of an argument encapsulated in drawings that the lecturer himself had made was delivered when Hawkins was considering emigrating to America, which may have liberated him to be less discreet about his erstwhile employer.

Four months later Hawkins resolved to travel to the New World, and, on February 12, 1868, he invited his "kindly resolute friends" to a farewell gathering at the Crystal Palace, where they would visit what he called "my *Birds* !!! *Huxley.*"[48] Only five days earlier, Huxley had taken what he acknowledged was a "most unlikely direction" in pronouncing, at the Royal Institution, that the "hind quarters of the *Dinosauria* wonderfully approached those of birds in their general structure."[49] This seemingly implausible rejection of the prevailing assumptions of vertebrate paleontology would, Hawkins joked to his friends, transform the models of bulky quadrupedal dinosaurs he had constructed at the Crystal Palace into incongruous birds.[50] As Hawkins departed for America with a card from Huxley recommending him to Edward Livingston Youmans, he could not resist a parting gibe at his benefactor.

Hawkins came to Youmans with a plan to "reconstruct the American monsters in the Central Park" and, with Huxley's friend vouching for him, was soon commissioned to create in New York a series of life-sized models of extinct creatures similar to those at the Crystal Palace.[51] In modeling the pelvic bones of dinosaurs recently discovered in America, Hawkins rescinded the scorn he had expressed in the invitation to his farewell party. Now he was determined to "ascertain their true position according to . . . Prof. Huxley's views." But while he now conceded that the creatures might indeed

have been bipedal, Hawkins was adamant that he "utterly failed" in his attempts to position their pelvises in the avian posture Huxley proposed. Instead, he suggested that the "bipedal carriage of the body" was more akin to that of a "marsupial" like a kangaroo.[52] Hawkins's ambitious plan for Central Park became mired in local politics, and in May 1871 vandals took sledgehammers to his marsupalian models.[53] Hawkins nevertheless found other ways to maintain his antagonism toward Huxley and, with the Atlantic now between them, became bolder and more explicit in contesting his views.

As he had in Britain, Hawkins made much of his income in America from giving commercial lectures about the still fashionable gorilla. A short series of these, as Youmans calculated, could yield a "thousand dollars profit," although it would require Youmans to be "completely engrossed day and night" in arranging them to secure Hawkins a favorable reception.[54] This he did at Huxley's behest, who may have been more than happy to have the recalcitrant artist established on another continent. Whatever Huxley's motives, Hawkins's gratitude for his support did not last long, and in January 1871 he began a lecture in New York by announcing that "he was not in favor of the theories advanced by Professor Huxley . . . as to what is called simious man, and the close alliance of the human race to the ape species of the brute creation." Hawkins demonstrated why "he was hardly prepared . . . to embrace [the] gorilla . . . as a man and a brother" with "copious crayon illustrations" showing how the creature's anatomical structure differed fundamentally from that of humans.[55]

Soon after this lecture, Hawkins's illustrations became still more pointed in their repudiation of humanity's simian ancestry. This was a direct reaction to Darwin's *Descent of Man*, an American edition of which was published, with Youmans's assistance, in February 1871. On several occasions in the book, Darwin acknowledged that his own claims about the "points of structure in which man agrees with the other Primates" were indebted to "our great anatomist and philosopher, Prof. Huxley."[56] Having recently criticized Huxley's position in his lecture in New York, Hawkins now responded artistically to *The Descent of Man* by satirizing and subverting the successive sequence in which his own drawings had been placed in the frontispiece to *Man's Place in Nature*.

A Combination of Disproportions

In a drawing that Hawkins designated, with characteristic imprecision, a "Physiographical Illustration of Darwin's Descent of Man," the artist depicted ten primate species in an irregular but approximately circular sequence.[57] The series follows the curve of the decorative border before concluding, in the center of the image, with a human and a bear linking arms in a boisterous dance (fig. 2.3). In the initial version of the image, which Hawkins signed in pencil with the date 1871, the creatures are shown with

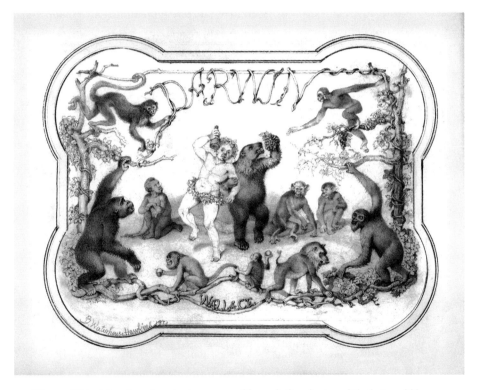

Fig. 2.3. This elaborate watercolor image, possibly made for a lantern slide that could be used in lectures, both echoes and subverts the frontispiece to Huxley's *Man's Place in Nature*, in the creation of which Hawkins had been intimately involved. Benjamin Waterhouse Hawkins, "Physiographical Illustration of Darwin's Descent of Man." Watercolor and ink, 1871. (Academy of Natural Sciences Library & Archives, Benjamin Waterhouse Hawkins Album, Collection 803:11c.)

their external fur and flesh intact and in poses suggesting a lively vitality. The simians climb on two saplings and on a grapevine whose twisting tendrils spell out the names "DARWIN" and, in much smaller letters, "WALLACE."[58] Hawkins was seemingly unaware that Alfred Russel Wallace's views, particularly on the role of spiritual agencies in the development of intelligence, had recently diverged markedly from Darwin's own conception of human evolution. Darwin had noted this with piqued "surprise" in *The Descent of Man*, indicating that Hawkins had not read the book any more closely than he had read *On the Origin of Species*.[59] In any case, an accompanying "Key" to the "Physiographical Illustration," which presented the same image but with the creatures' skeletons exposed in an austere tableau that also stripped the trees and grapevine of their foliage and revealed their roots, suggested that Hawkins's barbed imagery was not really aimed at Wallace or even Darwin (fig. 2.4).

In a handwritten explanation of the paired pictures, Hawkins observed that they showed how the "Darwinian Theory explains the 'Descent of Man' as from the lowest form of Baboon to the highest Ape." He clarified that the two drawings portrayed the "type forms of Baboons, Monkeys and Apes," who were positioned upon a "base line"—fashioned from the gnarled tendrils of the grapevine—and depicted "in succession" according to their proximity to humans. The parallels with the by-now-famous frontispiece to *Man's Place in Nature* were palpable and, presumably, deliberate, although Hawkins also made clear how the arrangement of his "Physiographical Illustration" differed from that of his own drawings in Huxley's book.[60]

While the gorilla is still positioned closest in the line of succession to humanity in Hawkins's drawing, he questioned this placement in his handwritten explanation: "In the . . . lower angle is the celebrated Gorilla for which naturalists have claimed the nearest place to man in consequence of his size tho' the excessive length of the arms, shortness of legs & projection of the jaws form a combination of disproportions much farther removed from any resemblance to the human contour than the figure of the Chimpanzee."[61] Hawkins's comments implicitly elevate the status of the chimpanzee, although his long-standing aversion to the "celebrated Gorilla," with its ungainly "disproportions," was seemingly growing stronger. As well as echoing while simultaneously disputing the sequence in which his own discrete draw-

Fig. 2.4. This counterpart to figure 2.3 strips the primates and bear of their skin and fur and denudes the plants of their leaves, thus reinforcing the resemblance to the frontispiece to *Man's Place in Nature*. Benjamin Waterhouse Hawkins, "Key to Ancestral Names in the Physiographical Illustration of Darwin's Descent of Man." Watercolor and ink, 1871. (Academy of Natural Sciences Library & Archives, Benjamin Waterhouse Hawkins Album, Collection 803:11b.)

ings had been positioned by Huxley and the engraver Wesley, Hawkins also made a hugely significant addition to the successive series.

In his notes to the "Physiographical Illustration," Hawkins explained: "On the platform nearest to the Gorilla the African Negro is placed next to the highest form of Man."[62] This diminutive African man wears the chains of enslavement and is portrayed crouching and staring upward at a White man. The kneeling figure retains the familiar supplicant posture of much early nineteenth-century abolitionist art, in which passive and deferential slaves entreat an answer to the question "Am I not a man and a brother?" (fig. 2.5).[63] Hawkins's figure departs from this iconographic tradition in only

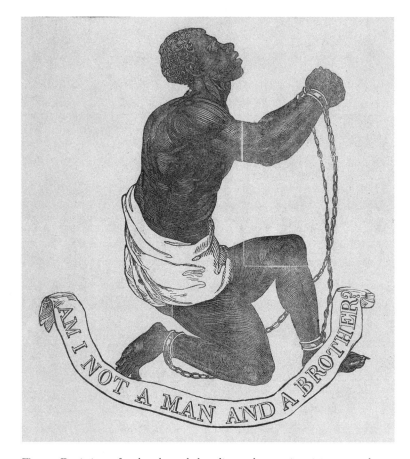

Fig. 2.5. Depictions of enslaved people kneeling and entreating an answer to the question "Am I not a man and a brother?" had first been produced by Quaker abolitionists in eighteenth-century Britain, and the iconographic tradition continued into the following century, particularly in America. In J. G. Whittier, "Our Countrymen in Chains!" (New York: Anti-Slavery Office, 1837). (Library of Congress, Broadside Collection, portfolio 118, no. 32a c-Rare Bk Coll.)

one detail. The kneeling man is looking over his shoulder, seemingly away from the chains of his past servitude and toward a more elevated future. This posture would have been especially meaningful in America in the wake of the Civil War and the recently passed Reconstruction Amendments, which granted formerly enslaved people rights of citizenship. Notably, though, Hawkins had, on several occasions, satirically invoked the same

imperative question asked by slaves in abolitionist art in his refutations of the gorilla's supposed kinship with humanity; he did so in the lecture he gave in New York in January 1871. Hawkins was seemingly more willing to answer in the affirmative regarding the status of enslaved people: yes, they were human beings and kin. However, the racialized addendum that he made, in the "Physiographical Illustration," to the equivalent sequence in Huxley's frontispiece—which represented all humans with a single skeleton— still afforded an expedient buffer between White people and their alleged simian ancestry.

The demeanor of the crouching African man may be more bemused than imploring, since the "highest form of Man" to whom he looks up is not himself entirely upright. Adorned with bacchanalian vine leaves, the central figure seems to reel unsteadily while brandishing a wine flask. This "state of inebriation," Hawkins pointed out, was meant to "indicate that the only possible relationship between Man and the Brute arises from the subjuga-tion of Man's reason by intoxication."[64] Like the human at the head of the progressive series in *Man's Place in Nature*'s frontispiece, Hawkins's "high-est form" has one leg raised from the ground, but it now facilitates a drunken stagger rather than a purposeful stride. As he had a decade earlier in his *Comparative View of the Human and Animal Frame* (see fig. 1.6), Hawkins included a bear, which seems to prop up its shambling dancing partner, to demonstrate that, in his view, the ursine skeletal structure was much closer to that of humans than the simian was.

Using the same technique he had developed in his *Comparative View*, the "Key" to Hawkins's "Physiographical Illustration" once more displayed the various skeletons within the shaded silhouettes of their skins. This time, though, the distinctive effect, deriving from Hawkins's experience of taxi-dermy, was created with watercolor, not lithography. This choice of medium suggests that the drawing, also made using pencil and ink, was not intended for publication and instead may have been used to create a lantern slide for Hawkins's lectures.[65] His American audiences would have had projected before them an impertinent alternative to the series of ape and human skeletons in *Man's Place in Nature*, one that parodied and subverted the familiar imagery in order to show the creatures' differences rather than their similarities.

Declining to Pick Up My Glove

When Hawkins returned to Britain in July 1874, he maintained the vociferous antagonism toward Huxley that had been unleashed across the Atlantic. Within a month, he confronted his adversary at the annual meeting of the British Association for the Advancement of Science in Belfast. There Hawkins gave a paper in which he reiterated his contention that the pelvic bones of bipedal dinosaurs resembled those of marsupials more than they did those of birds, as Huxley had proposed. Huxley, however, haughtily declined to attend Hawkins's session and, as *Nature* reported, "only appeared at the conclusion of the discussion in time to hear" the following paper.[66] When "*Prof Huxley* entered," Hawkins recounted in a letter to an American friend, "I added to my temerity by offering to recapitulate my statements & argument but the learned Professor declined any challenge on the plea that the business of the section was so largely in arrears of time." While this calculated froideur recalls Huxley's metaphorical description of their relationship, back in the early 1860s, as akin to Dante's vision of hell, Hawkins used another analogy to express his sense of their personal tensions. As he remarked to his friend, "I considered this declining to pick up my glove as very encouraging to my theory concerning the true place of the bones in question."[67] For Hawkins, he and Huxley were engaged in nothing less than an intellectual duel, a contest in which Hawkins felt he held the more honorable and advantageous position.

Hawkins soon extended the conflict beyond the specific question of the dinosaurian pelvis, loftily criticizing Huxley's presentation at Belfast, a lecture in which Huxley argued that humans were conscious automata. This, claimed Hawkins, was "like everything else he did and said, grandly logical in its way, speaking without reference to the inferences drawn."[68] Huxley's controversial lecture and the even more incendiary presidential address of John Tyndall were "regarded as a throwing down the gauntlet" to orthodoxy, as Herbert Spencer exultingly told Youmans.[69] A gauntlet was the glove ceremoniously dropped to initiate a duel, and Hawkins, having himself already adopted the same metaphor, evidently considered that he was able to accept the challenge and gain satisfaction from Huxley on any of the scientific issues that arose at the British Association's Belfast meeting. It was, however,

the way his drawings had been used in the frontispiece to *Man's Place in Nature* that, more than anything else, prompted Hawkins to continue throwing down his own gauntlet to Huxley.

Notwithstanding the codes of gentlemanly honor he invoked in describing this metaphorical duel, Hawkins soon found himself embroiled in what he termed a "climax of domestic troubles." This was seemingly when his second wife, Louisa, learned that their marriage had been unlawful. The exposed bigamist returned to America with "most injudicious impetuosity" in 1875.[70] Hawkins was followed a year later by Huxley, who, at Youmans's invitation, lectured on the "direct evidence of evolution" in New York in September 1876. Huxley warned Youmans that he was unable to "bring diagrams" across the Atlantic, and before lecturing on the ancestry of the horse, on which he was shown compelling new evidence in America, he had to ask the Yale paleontologist Othniel Charles Marsh to create an illustration for him.[71] The diagram that Marsh supplied, which Huxley soon published in his *American Addresses* (1877), depicted equine evolution as a "direct line of succession" through a "backward order in time," showing in particular the sequential reduction in the number of toes in horse species as they ascended higher in the developmental scale (fig. 2.6).[72]

This, of course, was precisely the kind of linear model of progressive evolution that the frontispiece to *Man's Place in Nature* had been widely perceived as endorsing, and Huxley's language in the text of that book certainly implied the existence of an ascending "scale" in which anthropoid apes "lie immediately below" humanity.[73] The new illustration of equine ascent helped augment such a view of the earlier image, with Huxley himself now explicitly charting the "ancestral evolution of the higher Mammalia" along what he called a "main line of evolution."[74] This would be particularly perturbing for Hawkins, since he had earlier traduced such a "continuous line of development."[75] Indeed, he responded furiously to Huxley's New York lecture in one of his own lectures in the same city. Scorning the supposed evidence for evolution, Hawkins avowed that he "had no sympathy with the fuss now making by the advocate of that theory on the score of variations in the number of toes possessed by animals in the past and present." Regardless of the successive and seemingly progressive changes to their feet, Hawkins insisted that "it was not to be supposed that the horse of the

FIG. 9.

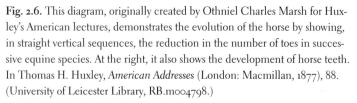

Fig. 2.6. This diagram, originally created by Othniel Charles Marsh for Huxley's American lectures, demonstrates the evolution of the horse by showing, in straight vertical sequences, the reduction in the number of toes in successive equine species. At the right, it also shows the development of horse teeth. In Thomas H. Huxley, *American Addresses* (London: Macmillan, 1877), 88. (University of Leicester Library, RB.m004798.)

present differs otherwise from his ancestor."[76] Though this time refraining from directly naming Huxley, Hawkins explicitly rebutted the argument Huxley made on the basis of an illustration showing an ascending series of evolutionary advancements.

After returning to Britain for a final time in 1878, Hawkins became still more explicit and, for the first time, specifically criticized the book in whose production he had been so intimately involved. He began a lecture in 1881 by declaring, "In 1863 there was published . . . an important book." His "object was to reply to or to make a species of commentaries upon that clever book in its way—'Man's place in nature.'" He explained that the "book went to show that . . . man's place was in connection with the apes: that they were the originals and he the descendant." Hawkins, however, assured his auditors that "he did not subscribe to that," insisting that while there "might be a resemblance" between humans and apes, the "difference was so great that the theory would not hold." It is unclear whether Hawkins acknowledged his own contribution to a book that he hyperbolically blamed for inaugurating the "fall" that had resulted in the "degeneration of the human race," but, as he informed his audience, he now "wished to contrast" his own views with that ruinous "theory propagated since 1863."[77]

To do this, he "drew the skeletons of a man and a gorilla, and contrasted at length the differences in the structures of each." While the human, as Hawkins's drawing demonstrated, could "walk upright . . . in a graceful, erect position," the gorilla's foot was "arched" and "rested on the side," rendering it, as Hawkins proclaimed with spiteful relish, a "positively crippled animal in the act of walking." Ironically, Hawkins's impromptu sketch revealing the gorilla's incapacity for "walking gracefully" was, presumably, not that different from his previous drawing of the same creature in the frontispiece to *Man's Place in Nature*, which had anomalously arched feet and a clumsy gait (see fig. 1.8). In a lecture that was specifically aimed at rebutting Huxley's book, Hawkins reclaimed and reinterpreted his own image of the gorilla, using it to show, in direct contrast to its purpose in the frontispiece, that there was "nothing so degrading or depressing as the idea that the human race had originated from the most odious, most useless, and most atrocious animal."[78]

Stages of Incompetence and Ugliness

That Hawkins's previous distaste for simians had, by his old age, become a veritable loathing was even more apparent in his final publication, *Comparative Anatomy Applied to the Purposes of the Artist* (1883). Here he lambasted the "three anthropomorphous apes, the chimpanzee, gorilla and orang-utan," as "hideous in appearance, malicious in action, fitful in nature, dangerous to man and beast." Hawkins had begun his artistic career with sensitive and sentimental portrayals of the apes that the Zoological Society began to receive in the mid-1830s, who were depicted wearing winsome frocks and reflecting pensively (see fig. 1.1). By the close of his career half a century later, he was insisting that the same creatures "always carry the external evidence of a deformity." He even implied that because they were "without the power to contribute in any manner or degree towards . . . the animal or vegetable life of the world," their deserved fate was extinction. Indeed, they had "no heritable place in nature, but like Macbeth's witches, they 'are on the earth but not of it.'" What had prompted this extraordinary transformation in his attitude was, unsurprisingly, the "theory of development" and its pernicious proposition that the "lord of creation" had "gradually developed through stages of incompetence and ugliness" from simian ancestors. More particularly, though, it was Hawkins's mortification at his own involvement with the image that, over the past two decades, had become emblematic of this "absurd paradox" that seems to have instigated his peculiar vindictiveness.[79] After all, by the early 1880s the frontispiece to *Man's Place in Nature* was considered a "celebrated drawing" that, according to the anthropologist Edward Burnett Tylor, was still the "readiest means" of demonstrating the intimate proximity of humans and simians.[80]

In *Comparative Anatomy*, Hawkins, now in his mid-seventies, fired the final shot in his long-running duel with Huxley. Urgently imploring that "graphic illustrations must now be brought to the front to identify or contradict degrading theories in support of the fallacy of the Darwinian Paradox," he once more provided his own alternative to the frontispiece. As with his "Physiographical Illustration" a decade earlier, Hawkins made two images, one of "two human beings and four 'manlike apes' . . . presented in their natural clothing" (fig. 2.7) and the other, more closely echoing Huxley's

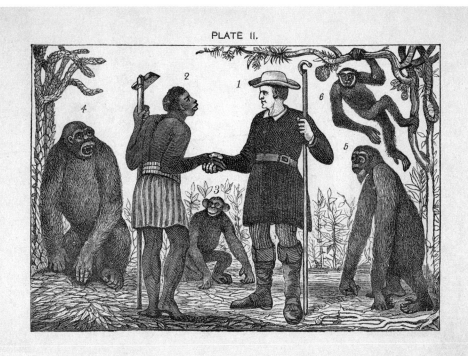

Fig. 2.7. Lithographic plate by Hawkins entitled "Human Figures, European and African, and Four Man-Like Apes." Like figure 2.3, the plate deliberately echoes the arrangement of the frontispiece to *Man's Place in Nature*. This time, however, the figure of the enslaved person has been emancipated from his chains, although the firm handshake of William Wilberforce has unnerving echoes of shackles. In B. Waterhouse Hawkins, *Comparative Anatomy Applied to the Purposes of the Artist* (London: Windsor & Newton, 1883), plate II. (© The British Library Board 7421.b.12.)

frontispiece, showing the "skeletons of the same figures, divested of the muscles and integuments" (fig. 2.8).[81]

Again like the "Physiographical Illustration," in these new illustrations one of the humans is Black, this time standing upright and freed of his chains, while the larger "white man," who had danced drunkenly in the earlier image, is now the distinctly sober and "suggestive figure of the great friend of the negro race—the slave emancipator, Wilberforce." The specific historical figure of the evangelical abolitionist William Wilberforce, Hawkins explained, is "represented as offering the hand of brotherhood to the

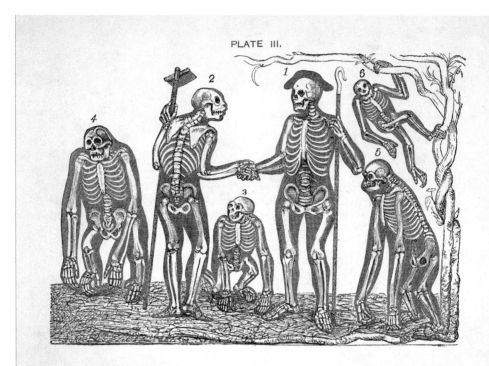

Fig. 2.8. Lithographic plate by Hawkins entitled "Six Skeletons of the Figures as Arranged in Plate II." This skeletal counterpart to figure 2.7, made when Hawkins was in his seventies, was the final shot in his intellectual duel with Huxley over the relation between humans and apes. In B. Waterhouse Hawkins, *Comparative Anatomy Applied to the Purposes of the Artist* (London: Windsor & Newton, 1883), plate III. (© The British Library Board 7421.b.12.)

negro figure, who from long oppression, reciprocates but timidly the friendly action."[82] Eschewing the visual conventions that the "Physiographical Illustration" shared with earlier abolitionist art, this timid Black man is no longer kneeling, and instead Hawkins emphasizes the sinuous musculature of his upright legs. Wilberforce's greater height still positions the other man as his inferior, while the conspicuously firm grasp of the emancipator's handshake—which ostensibly resolves the question as to whether the other was a man and a brother—has unnerving echoes of the shackles that formerly bound enslaved people's wrists.[83] Even with such ambivalences, fraternal feeling might still tentatively unite the different human races. But the feeling is definitely not extended to the "four accompanying apes," a gorilla, a

chimpanzee, an orangutan, and a gibbon, who surround the central scene, which appears to be a plantation whose crops the emancipated slave has been hoeing, apparently of his own volition.[84] Instead, the simians seem to regard this validation of the uniquely human attributes of empathy and righteousness with perplexed curiosity and, possibly, envy.

These earnest lithographic plates lack the artistic vigor and skill of the parodic "Physiographical Illustration," with, for instance, the gorilla's head in the fleshed-out image pointing in the opposite direction from its exposed skull in the skeletal iteration. The placement of the images nevertheless imitates the placement of Hawkins's own drawings in the frontispiece to *Man's Place in Nature* in order to subvert the evolutionary implications for which it had become so celebrated. Exactly the same four apes that appeared in the frontispiece, Hawkins elucidated, are here "placed in juxtaposition with the human figures as the next assumed highest vertebrates," although Hawkins himself had no truck with such "modern speculations" about the "nearest relatives to man," which he still regarded as the "genus Ursus." Rather than including a bear, however, the composition of Hawkins's image fastidiously apes the apes in Huxley's frontispiece, but only to demonstrate that humans are fundamentally distinct from their supposedly simian brethren.[85]

The portrayal of the apes with their "external form complete" in the initial plate provided, as Hawkins proposed, a "more ready comparison of the differences between them and the beauties of the human form." He implied that Huxley had willfully suppressed these distinctions in *Man's Place in Nature* by including just skeletons in the frontispiece. But even when, as in the second of Hawkins's plates, the "skeleton of each figure" seemingly "presents so close a resemblance" to each other, close analysis would once more reveal the apes' "deformity as compared with the symmetrical proportions of the Human figures." Most conspicuously, the gorilla, as Hawkins avowed, could "only use the foot in walking by resting on its outer margin, which throws out the ankle joint in a manner which gives a bandy appearance to the limb and an effect of lameness to the action."[86] Although the gorilla in the plates in *Comparative Anatomy* is squatting, not walking, readers of Hawkins's book who turned from its deliberately imitative illustrations to the original image that the plates recalled would have found the perfect

exemplification of the gorilla's awkwardly waddling gait. The frontispiece to *Man's Place in Nature*, as Hawkins continued to intimate until the very end of his career, was far from the triumphant procession of evolutionary progress that both its admirers and its critics seemed to assume.

Like his loathing of apes, Hawkins's long-standing animosity toward Huxley became more rancorous in his old age. His resentment at having been obliged, seemingly by his pecuniary problems in the 1860s, to contribute the original artwork for the frontispiece intensified as the image became increasingly pervasive and influential as a visual representation of evolution. It is far from certain, however, that portraying humanity's evolutionary development was Huxley's intention for the illustration. Having thus far focused on the respective contributions to the frontispiece of Hawkins and the inexperienced engraver Wesley, it is now time to examine Huxley's own input into the iconic image.

The Dance of Death

Less than a fortnight after the publication of *Man's Place in Nature*, a grand public celebration meant that, as Huxley observed on March 12, 1863, "London has been crazy during the past week." The mayhem was caused by the arrival of Princess Alexandra of Denmark before her marriage to the Prince of Wales, which was marked by a ceremonial procession through the thronged streets of the capital. Even Huxley "went to see the little Princess pass through," reporting to a friend, "A jolly girl she looks . . . with a certain squareness of jaw which augurs well for her holding her own."[1] Notably, the same procession, which received extensive coverage in the press and was commemorated with paintings and poems, put some in mind of Huxley's recently published book. As a reviewer in the *Athenæum* proclaimed, "Most people as they advance in life are apt to disown their poor relations; but our Professor takes an honest pride in parading them all before us in his frontispiece . . . Here is a skeletonized Man lightly tripping forward, followed by a skeletonized Gorilla . . . after whom come Messieurs Chimpanzee, Orang and Gibbon, all in their best bones, and with their best legs foremost . . . the whole train appear as gleesome as if they were going in procession to meet the Princess on her entrance into London, and to claim a not very agreeable kinship with her."[2] Huxley had already acknowledged the frontispiece's resemblance to a procession when he dubbed its creation the "Van Amburgh business." More particularly, its simian skeletons, as the *Athenæum*'s reviewer insisted, evoked a cortège conveying a distasteful message to the procession's regal leader.

Although this rather facetious response to *Man's Place in Nature*'s frontispiece was prompted by the royal festivities, it also echoed a passage in the book's text that alluded to similarly grandiose imperial processions from the ancient past. Reflecting on the "series of gradations" that ineluctably connected the "crown and summit of the animal creation" with lower forms of life, Huxley wrote: "It is as if nature herself had foreseen the arrogance of man, and with Roman severity had provided that his intellect, by its very triumphs, should call into prominence the slaves, admonishing the conqueror that he is but dust."[3] This mournful classical motif, in which a slave sits behind the conquering emperor in Roman triumphal processions whispering admonishments to remember his mortality, was transformed by Huxley into an imperative scientific warning.[4] He positions himself both as the majestic conqueror, a wearer of humanity's "crown," and as the figure whose intellectual abilities, in *Man's Place in Nature*, have given a new significance to the lower primates who now perform the role of multiple whispering slaves. These simians not only murmur the biblical warning, from Ecclesiastes 3:20, of humanity's dusty transience. They also add a new evolutionary admonition: "man . . . originated . . . by the gradual modification of a man-like ape" and is merely a "ramification of the same primitive stock" as themselves.[5] The skeletal apes in the frontispiece, like the reproving Roman slave, whisper in the human's ear—or at least the bony cavity at the corresponding place in his skull—a reminder of his naturalistic origins (see fig. I.2).

This "Roman severity," Huxley made clear, applied equally to royals, including the newly arrived Princess Alexandra, and to those who merely wore humanity's less exclusive crown. He regularly invoked the class distinctions that stratified Victorian society to describe the vaunted but fallacious superiority with which virtually all humans regarded other animals. In 1861 he sardonically traduced the anatomist Richard Owen, who prided himself on his social connections with the upper classes, for "arrogat[ing] to his fellows so high a place in the aristocracy of nature as to deny that mankind can be thought of zoologically at all."[6] Much of *Man's Place in Nature* was an exasperated rebuke to Owen for his haughty and long-standing refusal to acknowledge the anatomical similarities of humans and apes. The procession of primate skeletons with which the book begins, as the *Athenæum*'s reviewer intuited, invites the viewer to scrutinize the common proportions that the

species which claims a "divine right of kingship over nature" shares with less exalted members of its biological order.[7]

This aspect of the frontispiece, which directly reflects Huxley's own egalitarian instincts as well as his mordant sense of humor, suggests strongly that he had a direct input into the placement of Hawkins's originally discrete life-sized drawings when they were engraved as a composite, and much reduced, image by Wesley. Huxley thought carefully about the design and impact of the illustrations in his work, which, he proposed, could "help ignorant people to find what they ought to see."[8] Not only unschooled plebeian readers required such visual guidance on scientific matters, and Lyell counseled Huxley, when he was planning *Man's Place in Nature*, that "some wood-cuts would be most welcome where there is so little knowledge among so many classically educated men."[9] These cultivated readers might require rudimentary images of comparative anatomy, but they could appreciate the sophisticated visual connotations and allusiveness with which such illustrations might also be imbued.

Although the image chosen for the book's frontispiece has been regularly perceived to depict an ascending series of evolutionary advancements, Huxley's own intentions were both more modest and more discomfiting. By exposing so starkly the equivalence of the human skeleton to the osseous structures of anthropoid apes, the frontispiece affords a chastening corrective to humanity's pride in its presumed superiority. As well as evoking the reminders of mortality whispered by the Roman slave, the row of primate skeletons serves as a scientific counterpart to the memento mori, or, given the jauntily raised skeletal legs, even suggests the dance of death. Like that medieval motif, the skeletons jolt humanity from its willful obliviousness about its place in nature. The frontispiece's erudite allusiveness also draws on more contemporary sources. Huxley's interest in revealing the ordinariness concealed by pretense and hypocrisy was directly related to his reading of Thomas Carlyle; he had long revered the "profound ragings" of the "resolute and singleminded" sage who sought to "get rid of cant and shams of all sorts."[10] But the frontispiece also adds a new and strikingly demotic dimension of its own.

As Huxley must have been aware, the particular skeleton that was used to epitomize the pinnacle of humanity had decidedly dubious origins. Like

many of the original artifacts in the Royal College of Surgeons' Hunterian Museum, it had likely been acquired from so-called body snatchers after having been illicitly disinterred, a history that augmented the deliberately debasing and disconcerting purposes of the image at whose apex it appeared. These aspects of the frontispiece were certainly evident to American audiences when *Man's Place in Nature* was reprinted across the Atlantic at the height of the Civil War. They also complicated the connotations of race and slavery that were invoked by Hawkins in his own alternative reworkings of the image. Significantly, the version of the frontispiece seen by American readers was not that created by Huxley's inexperienced engraver, Wesley. The image had been reengraved by a scion of the most prominent family of abolitionist artists in America.

Scientific Saturnians

Prior to alluding to the classical motif of a Roman slave admonishing the triumphant emperor, Huxley had deployed a more modern literary analogy. In pondering the "question . . . is Man so different from . . . Apes[?]," he proclaimed: "Let us endeavour for a moment to disconnect our thinking selves from the mask of humanity; let us imagine ourselves scientific Saturnians, if you will, fairly acquainted with such animals as now inhabit the Earth, and employed in discussing the relations they bear to a new and singular 'erect and featherless biped,' which some enterprising traveller, overcoming the difficulties of space and gravitation, has brought from that distant planet for our inspection, well preserved, may be, in a cask of rum."[11] The source of the conceit of the "scientific Saturnians" is *Micromégas* (1752), a story by Voltaire in which a secretary of Saturn's scientific academy comes to earth and is bemused to find that its tiny but conceited inhabitants consider the universe to have been made uniquely for themselves. Huxley was a keen reader of Voltaire's heretical fiction and later applauded the scientific logic of *Zadig* (1747).[12] In the mid-1860s, however, he balked at what he called the "destructive . . . squadrons of Voltairean Cossacks" that were assailing conventional ethical beliefs.[13] Instead, the "scientific Saturnians" that he asks his readers to imagine themselves as had a much closer relation to the protagonist of a book that Huxley had "devoured," alongside Dante's

Inferno, while aboard HMS *Rattlesnake*, one that had served as a guiding "Enchiridion" to him.[14]

This book was Carlyle's *Sartor Resartus* (1833–34), a quasi-fictional biography of a mystical German philosopher, Diogenes Teufelsdröckh, who enjoins the necessity of "looking through the Shows or Vestures into . . . Things themselves."[15] Such intellectual penetration, and the bracing candor with which Teufelsdröckh delivers his insights, appealed strongly to Huxley throughout his career. Indeed, his scientific ideal, as he later expressed it in an autobiographical fragment, required the "resolute facing of the world as it is when the garment of make-believe by which pious hands have hidden its uglier features is stripped off."[16] In particular, it was in *Man's Place in Nature*, as the botanist William Turner Thiselton-Dyer reflected, that Huxley "carried the veracity of 'Sartor Resartus' a step further."[17] Thiselton-Dyer did not clarify his insightful comment, and the affinities between the two books have not otherwise been recognized, but they are evident throughout *Man's Place in Nature* and have an especially important bearing on its frontispiece.[18]

In *Sartor Resartus* Carlyle expounded Teufelsdröckh's "*Philosophy of Clothes*," which, among other things, reveals how man "masks himself in clothes." Huxley endeavored to discard the "mask of humanity," just as Teufelsdröckh proposed that once divested of this artificial "wearing apparel," humans, of whatever social rank, are exposed as merely "two-legged animals without feathers." A man is just a "Biped that wears Breeches" and might actually be considered "below most animals." Even the purported "sacredness of majesty" is "properly a Vesture and Raiment." The radical insights of Teufelsdröckh's "science of clothes" are made possible by his capacity to "look . . . with a strange impartiality, a strange scientific freedom . . . like a man dropped thither from the moon."[19] What such extraterrestrial disinterestedness discloses is, inevitably, the very same vision of the human species as a "singular 'erect and featherless biped'" that Huxley ascribed to his "scientific Saturnians." Huxley's quotation marks do not indicate a direct quotation from *Sartor Resartus* (although he may have been quoting from memory), and the statement was, in any case, originally attributed to Plato.[20] It is nevertheless clear that in *Man's Place in Nature*, Huxley required his readers to heed Teufelsdröckh's injunction to disregard those who were "pur-

blinded by enchantment" and, when considering humanity's relation to other animals, to "open [their] eyes and look."[21]

This is precisely what the frontispiece invites readers to do, even before they have progressed beyond the book's title page. The viewer is in the position of the "scientific Saturnians" examining a row of familiar anatomical specimens previously obtained from earth alongside a new one, placed at the end, that an "enterprising traveller" has recently returned with. Huxley specifies that the singular new specimen has been brought from the distant planet "for our inspection," which emphasizes, as had Teufelsdröckh, the vital significance of visual perception. The new specimen has been removed from the "cask of rum" in which it was transported across the solar system and, like many of the exotic creatures that European travelers brought back home by similar means, was stripped down to the elements that would be best preserved after such a hazardous journey (compare, for instance, the decrepit gorilla sent to the British Museum preserved in rum that Hawkins claimed to have worked on). The frontispiece's stark white background, standardizing baseline, and unadorned osseous forms, which do not even cast shadows, induce a sense of "judicial calmness." This allows viewers, like the impartial Saturnians, an opportunity to remain "happily free from all . . . personal interest in the results of the inquiry" into the similarities or otherwise between the respective skeletons.[22]

In *Sartor Resartus* Teufelsdröckh occasionally extends his "science of clothes" to include the "Fleshly Clothes, the muscular and osseous Tissues (lying *under* . . . skin)," and reduces even the most revered of men to the "bones . . . under his Clothes."[23] With exactly the same sartorial metaphors, Huxley, in *Man's Place in Nature*, designated the "muscles . . . [and] viscera" as "animal fabric" and proposed that one of the lower primates "puts on a Rodent clothing" when its external features seem to suggest that it belonged to that order.[24] Elsewhere, he referred to the "physical organisation of man" as "his bony frame and all that clothes it."[25] In the same vein as Teufelsdröckh, Huxley insisted that it was imperative to "look beneath the skin" so that the spuriousness of the supposed "structural distinctions between man and the apes . . . may be exposed."[26] After all, when stripped down to the skeleton, most of the differences between humans and simians were revealed to be—quite literally—skin-deep. The ultimate logic of this egalitarian "Sans-

culottic Earthquake," as Carlyle reflected uneasily in his next book, *The French Revolution* (1837), was the anarchical appropriation of "Human Skins . . . for breeches" during the Jacobin Reign of Terror.[27] *Man's Place in Nature* did not endorse such revolutionary leveling, but its distinctively Carlylean sensibility, informed by Teufelsdröckh's radical philosophy of clothes, is very much at odds with the sense of ascending hierarchical progress that the book's frontispiece is usually assumed to represent. And there are other ways in which the image stymies such perceptions.

Hyperion to a Satyr

In 1877 Huxley confidently proclaimed that the ancient "idea . . . that animals form a great scale of being, in which there are a series of gradations from the most complicated form to the lowest and simplest . . . turns out to be substantially correct."[28] Fourteen years earlier, in *Man's Place in Nature*, he had been more circumspect but still regularly referred to the "series of vertebrate animals," or, more specifically, the "simian series." He explained that these inferior creatures "step higher in the scale" and "progress . . . through a complete series of steps to man." Alongside these offhand reversions to language redolent of the *scala naturae*, Huxley elaborated a new means of determining the changes that the "skull undergoes in ascending from the lower animals up to man." This would, he suggested, enhance the methods "devised by Peter Camper, in order to attain what he called the 'facial angle.'"[29] The Dutch anatomist Petrus Camper had, in the 1760s, developed a technique for measuring the diversity of humans' cranial shapes by inscribing a line, on comparative images of a variety of skulls, from the forehead to the front of the jaw. He created charts demonstrating this so-called facial angle in a progressive series of crania that, reflecting Enlightenment notions of the scale of nature, ascended from that of an orangutan through various human races. The cranial sequence, which was frequently reprinted in the early nineteenth century, concluded with the Greek god Apollo, although Camper had to draw the skull of this Hellenic exemplar, which existed only in classical statuary, from imagination (fig. 3.1).

Camper took his conception that Greek statues expressed the ideal form of human development—they had an almost perpendicular facial angle of

Fig. 3.1. Hand-colored engraving by E. Guérin entitled *"Phrénologie: Determination de l'angle facial de Camper."* It shows a sequence of skulls and heads ranging from an orangutan through different human races before culminating with the Greek god Apollo, whose skull was drawn from imagination. Such sequences had originally been produced in the mid-eighteenth century by Petrus Camper to demonstrate his so-called facial angle, which was measured, as in this later version, by inscribing a line from the forehead to the front of the jaw. In *Dictionnaire pittoresque d'histoire naturelle et des phénomènes de la nature*, 9 vols. (Paris: Bureau de Souscription, 1833–40), 7:491. (Antiqua Print Gallery / Alamy Stock Photo.)

100 degrees in contrast to the orangutan's 58 degrees—from Johann Joachim Winckelmann. The German art historian's influential writings on aesthetics also induced Camper to portray the heads and skulls in his charts laterally, like the profile portraits on ancient coins.[30] Subsequent depictions of a series of lower creatures ascending toward the apex of human development, especially those made by the Swiss physiognomist Johann Caspar Lavater, likewise placed a profile of the Greek divinity, usually based on the celebrated marble sculpture of the Apollo Belvedere, at the apotheosis of the progressive sequence.[31]

As Lavater recognized, both Winckelmann and Camper had carefully

distinguished this Apollonian ideal of beauty and facial proportion from the relative deficiencies of the actual European heads that invariably came before it in the ascending scale of perfection, followed by putatively lower races. By the mid-nineteenth century, however, such distinctions between the ideal and the real were increasingly disregarded.[32] Hawkins, like many other commentators, regularly conflated the two. At his numerous lectures on anthropoid apes in the 1860s he often drew his own "profile views of the Adonis and Gorilla" and "displayed before his audience a life-sized model of the formidable Gorilla by the side of the Apollo." While Hawkins used these depictions of classical exemplars of beauty to refute any suggestion that the simian could "rival man's noble proportions," he also displayed them alongside the "skulls severally of a . . . gorilla, and a Hindoo" and "casts of the brain of the gorilla and that of a South Australian."[33] The absence of any equivalent specimens from other races implies that, in Hawkins's lectures, the idealized figures of Adonis and Apollo were intended to represent actual European characteristics.

It was Hawkins who drew the primate skeletons in the frontispiece to *Man's Place in Nature,* departing from the conventional sequence of progressive ascent initiated by Camper by using a single skeleton to represent all humans. Hawkins's depiction of the human skeleton in the frontispiece was nevertheless perceived to represent a pinnacle of perfection every bit as graceful as Camper's Apollonian ideal. As a reviewer of Huxley's book in the *Reflector* observed in June 1863: "Even . . . while we study the frontispiece . . . exhibiting the skeletons of apes from the gibbon up to the gorilla, and one step more to man—from the ridiculous up to the sublime—man still comes forth 'the paragon of animals'; and unless we choose to shut our eyes to all that we see and know, he is still, compared with a gorilla, Hyperion to a satyr."[34] There was a long tradition of depicting apes as satyrs, classical demigods that amalgamated human characteristics with those of a goat and were notorious for their frenzied lust for wine and women.[35] Hyperion, by contrast, was the Titan solar deity who was succeeded by the Olympian Apollo, and the human at the end of the skeletal series in the frontispiece cut a figure that, as the *Reflector*'s reviewer insisted, was as noble and majestic as the most revered Greek god.

The primates in the frontispiece were presented in profile, echoing, like

Camper's array of classical crania, the lateral portraits of gods and emperors on ancient coins. This might augment the perception that the simians perform a function equivalent to that of the Roman slave who admonished the conquering emperor in triumphal processions. But Huxley, in the text of *Man's Place in Nature*, used this trope to puncture the pretensions of those who exalted themselves above ordinary mortals, including apes. Huxley's frontispiece also stripped off the falsifying "Fleshly Clothes" which, as Carlyle's *Sartor Resartus* had shown, upheld a specious sense of superiority. There was, however, a further reason why the *Reflector's* comparison of the human skeleton in the frontispiece to a classical deity was so misplaced, even if it was one that only Huxley and a small coterie of those he worked with at the Hunterian Museum would have known about.

The Resurrection Men

In the summer of 1862, when Huxley was writing and arranging the illustrations for *Man's Place in Nature*, he spent his time at the Royal College of Surgeons in a secluded "recess . . . high up in the roof." This eyrie, as a journalist had earlier commented, had the "look of an auctioneer's room filled with the sold-off stock of a broken down anatomical teacher."[36] Huxley occupied this crowded "workroom at the top of the college . . . mostly in the evenings," which was, as William Henry Flower later recalled, a special "arrangement which my residence in the college buildings enabled me to make for him." Flower, who recounted that "on these evenings it was always my privilege to be with him," had taken up the post of conservator of the Hunterian Museum at the beginning of the year.[37] While he was spending his evenings with Huxley, he was also beginning the task of creating a new catalogue of the museum's burgeoning collections. Despite his best efforts, as Flower acknowledged when the catalogue was finally published more than a decade later, there still remained some specimens "received into the collection in former times, the history of which is doubtful or unknown." These were generally those given the attribution "*Hunterian*," indicating that they came from the original "private collection" of the museum's founder, John Hunter.[38] The human skeleton drawn by Hawkins that appeared in the frontispiece to *Man's Place in Nature* was one of these enigmatic specimens.

Although there is no formal way of confirming it, the human skeleton that Hawkins selected to draw was almost certainly the specimen that Richard Owen, in his own earlier attempt to catalogue the Hunterian, had given the identifying number 5569 to and labeled "The skeleton of a male European."[39] Owen gave no measurements for this skeleton, but Flower, in his subsequent account of the same specimen, noted: "Height . . . 5 feet 7.5 inches."[40] Owen had recorded the Hunterian's only complete gorilla skeleton as "measuring 5 feet 6 inches, in as erect a position as it can naturally be brought," and Hawkins's life-sized lecture diagram of the creature, when photographically reduced for inclusion in the frontispiece, reached 2.46 inches.[41] The slightly taller human that follows it measured 2.59 inches and so, proportionally, must have been reduced from a life-sized diagram in which it originally stood at slightly less than 5 feet 8 inches. Besides two other male European skeletons, the Hunterian did possess an "articulated skeleton of an Englishman," although this one, standing at "5 feet 11.1 inches," was too tall to have been the specimen drawn by Hawkins.[42]

This skeletal Englishman was given the generic attribution *"Purchased,"* indicating that it had been procured since Hunter bequeathed his original specimens to the Royal College of Surgeons. Its actual accession to the Hunterian's collections, however, was far more complicated than the label suggested. Owen, in his own catalogue, explained that the "skeleton . . . as in the case of the male Frenchman, No. 5571, was of a convict."[43] It, like that of the French felon, had presumably been obtained after a public execution, although those who seized the cadaver and then sold it, known as corpse takers, may have had to fight off the prisoner's relatives to remove it from the gallows.[44] Such gruesome origins did not prevent these specimens, when articulated once the flesh had been boiled off, from being adopted as models of normal human anatomical development. Executed criminals died suddenly, generally when still young, and so were likely to be free from the diseases that attended natural deaths. In 1868 Hawkins made "measurements of human femurs at the Museum of the Royal College of Surgeons" for a medical friend and, as an exemplar of the dimensions of an "Average European Man," used the bones of "5571," the precise specimen that Owen had identified as an executed French convict.[45] It is evident that Hawkins had not chosen the same Gallic specimen, which was only "5 feet 6.9 inches" and

had an "unusually low and retreating . . . forehead," when he was commissioned to draw a representative human skeleton for Huxley six years earlier.[46] The likely origin of the particular skeleton that did appear in the frontispiece to *Man's Place in Nature* was, however, no less shocking and disreputable.

Hunter's anatomical collection, which he began displaying to the public in 1787, largely consisted of specimens he had personally dissected. After arriving in London in the late 1740s, he had initially obtained the bodies of hanged criminals from the gallows at Tyburn. But as would have been the case with the English and French skeletons later purchased for the Hunterian's collections, the supply of such cadavers was irregular and competition for their ownership fierce and frequently violent. Hunter instead preferred a more discreet means of procuring bodies, and, as a biographer disclosed in the 1830s, "he became a great favourite with that certainly not too respectable class of persons the resurrection men."[47] Hunter employed these shady characters to plunder the graves of the recently deceased, whose resurrected cadavers would still be fresh enough for dissection. The trade was lucrative, and the supply of bodies, particularly those of the poor, whose graves were most easily accessible, almost limitless.[48] As a new student of Hunter's remarked in 1793, "There is a dead carcase just at this moment rumbling up the stairs and the Resurrection Men swearing most terribly. I am informed this will be the case most mornings."[49] Hunter himself sometimes went out with body-snatching gangs, who worked only in the darkness of night, and he recorded how, in 1758, "we got a stout Man . . . from St George's ground."[50] Such records are fleeting because, inevitably, the illicit trade in stolen corpses, generally taken from the sacred ground of churchyards, had to be kept secret. To make matters worse, Hunter's executor, Everard Home, subsequently stole and then burned the papers in which Hunter described and identified the items in his anatomical collection. It is nevertheless clear that many of the specimens to which Owen and then Flower gave the attribution "*Hunterian*" derived from the nefarious activities of the resurrection men.

In the early 1840s Huxley was taught surgery by Thomas Wharton Jones, who had earlier been implicated in Robert Knox's infamous arrangements with the resurrection men of Edinburgh.[51] Two decades later, he spent his evenings with Flower in the rafters of the Royal College of Surgeons while the new conservator endeavored to elucidate the origins of the Hunterian's

myriad specimens. So Huxley must surely have known that the human skeleton he was using for the frontispiece to *Man's Place in Nature* was either an executed criminal or, more likely, a victim of eighteenth-century body snatchers. A corpse secured in such a way was very far removed from the Apollonian apex of poise and nobility with which the progressive sequences created by Camper and Lavater had culminated and which the *Reflector* tried to find in Huxley's image. Instead, the human at the vanguard of the frontispiece's skeletal series was, at best, one of the nameless and impoverished underclass—perhaps the "stout Man" or the "carcase . . . rumbling up the stairs"—upon whom Hunter and his foulmouthed resurrectionists preyed. Rather than the Enlightenment *scala naturae*, or even more recent models of evolutionary development, the frontispiece, with its rattling procession of animated skeletons led by the human's purloined bones, resembles a more gruesome and melancholy type of pictorial series.

A Grim and Grotesque Procession

Two years after the publication of *Man's Place in Nature*, George Campbell, the Duke of Argyll, observed that the "frontispiece of this work . . . exhibits in a series the skeletons of the Anthropoid Apes and of Man." Campbell, who believed that the recognition of design in nature elevated humans above animals, could discern some structural distinctions between the "Form which leads" and the skeletal simians that followed in its train. He was adamant, though, that these distinctions were "as nothing to the differences which emerge in the living creatures." What particularly incensed Campbell about the frontispiece was its depiction of osseous specimens, a complaint that was also made by Hawkins. More perturbingly, these skeletons, ushered on by the starkly depersonalized "Form" in front, still seemed to retain a strange agency. As Campbell thundered, "It is a grim and grotesque procession."[52] The grotesque, by the mid-nineteenth century, had come to signify a departure from classical decorum and coherence and the unruly fusion of disparate elements.[53] As Campbell recognized, the incongruous vitality exhibited by the frontispiece's dead but nonetheless purposefully striding skeletons encapsulated this notion of the grotesque. Artists had traditionally used cadaverous revenants in allegories of death. Similarly, animated skeletons

had appeared in anatomical illustrations since the sixteenth century, but Huxley had amplified this tradition, begun by Andreas Vesalius, by arranging his primate skeletons into a disconcerting parade.[54]

The portentous language with which Campbell vented his revulsion against the frontispiece was more usually associated with the dance of death. This genre of artistic allegory, in which a skeletal representation of death leads a parade of figures to the grave, had originated in the later Middle Ages, but it was still familiar in the nineteenth century (fig. 3.2).[55] In the historical novel *Old Saint Paul's* (1841), William Harrison Ainsworth, one of the few writers to rival Charles Dickens in the Victorian literary marketplace, described an attempt to "realize the Dance of Death," in which a series of "grotesque figures," accompanied by "animated skeleton[s]," form a "fantastic procession" with a "train of grisly attendants."[56] With the *Athenæum*'s review of *Man's Place in Nature* describing the "skeletonized Man" in the frontispiece as "tripping forward" with his own "train . . . of grim relatives," who themselves cavort with "their best legs foremost," it is clear that when contemporary readers took "another look at the grim procession of skeletons," they saw in it the precise characteristics of the medieval dance of death.[57] Indeed, when Huxley's frontispiece was reprinted in Germany, it was explicitly dubbed a "*Gespensterzuge,*" a ghost train or procession—a counterpart of the dance of death in Germanic Shrovetide carnivals.[58]

This connection with the morbid imagery of the dance of death was augmented in *Man's Place in Nature* by a lurid illustration that soon followed the frontispiece. Entitled "Butcher's Shop of the Anziques, Anno 1598," it showed human flesh displayed at a butcher's slaughterhouse, or shambles, that catered for the allegedly cannibalistic tastes of African tribesmen (fig. 3.3). Like the frontispiece, this gruesome tableau, based on a sixteenth-century intaglio print, was rendered by the inexperienced Wesley in a wood engraving, a medium that had traditionally been associated with cheapness and, in consequence, with shocking and sensational images.[59] The use of wood engravings rather than more expensive lithographs or steel etchings was one of the means by which Huxley and his publishers, Williams and Norgate, kept the price of *Man's Place in Nature* to a relatively modest six shillings (by contrast, Darwin's *On the Origin of Species*, with just a single illustration, cost fifteen shillings). However, the book's conspicuously inexpensive for-

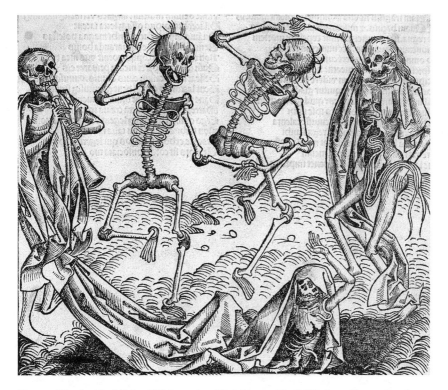

Fig. 3.2. Woodcut by Michael Wolgemut entitled *"Imago Mortis."* It shows the medieval motif of the dance of death, in which animated skeletons lead a train of figures to the grave, thereby revealing their ultimate equality regardless of the social ranks they had in life. In Hartmann Schedel, *Liber chronicarum* (Nuremberg: Anton Koberger, 1493), leaf CCLVII. (Open Access Image from the Davison Art Center, Wesleyan University.)

mat, and particularly the methods used to create its illustrations, had important implications for how more refined readers responded to it.

Even Huxley's close friend Joseph Dalton Hooker, who had earlier found the proofs of the text "amazingly clever" and commended the "magnificence of Huxley's language," considered the finished product a "coarse looking little book. — not fit as somebody said to me, for a gentlemans [*sic*] table."[60] Still worse, Hooker reported that the paleontologist Hugh Falconer, who had a "most delicate & refined sense in such matters," was "disgusted with the wood-cut of the shambles, & would let no young Lady look at it."[61] The "grim and grotesque procession" with which the *Man's Place in Nature* began was no less distasteful to the Duke of Argyll, and the frontispiece's

African Cannibalism in the Sixteenth Century.

In turning over Pigafetta's version of the narrative of Lopez, which I have quoted above, I came upon so curious and unexpected an anticipation, by some two centuries and a half, of one of the most startling parts of M. Du Chaillu's narrative, that I cannot refrain from drawing attention to it in a note, although I must confess that the subject is not strictly relevant to the matter in hand.

In the fifth chapter of the first book of the "Descriptio," "Concerning the northern part of the Kingdom of Congo and its boundaries," is mentioned a people whose king is called 'Maniloango,' and who live under the equator, and as far westward as Cape Lopez. This appears to be the country now inhabited by the Ogobai and Bakalai according to M. Du Chaillu.—"Beyond these dwell another people called 'Anziques,' of incredible ferocity, for they eat one another, sparing neither friends nor relations."

FIG. 12.—Butcher's Shop of the Anziques, Anno 1598.

These people are armed with small bows bound tightly round with snake skins, and strung with a reed or rush. Their arrows, short and slender, but made of hard wood, are shot with great rapidity. They have iron axes, the handles of which are bound round with snake skins, and swords with scabbards of the same material ; for defensive armour they employ elephant hides. They cut their skins when young, so as to produce scars. " Their butchers' shops are filled with

Fig. 3.3. Wood engraving by William Henry Wesley entitled "Butcher's Shop of the Anziques, Anno 1598." It was based on an intaglio print in an edition of Filippo Pigafetta's *Regnum Congo* (1591) and shows a butcher's slaughterhouse that caters for the purportedly cannibalistic tastes of African tribesmen. In Thomas Henry Huxley, *Evidence as to Man's Place in Nature* (London: Williams and Norgate, 1863), 55. (University of Leicester Library, SCM.12908.)

macabre dance of death was clearly as unwelcome as the gory engraving of the cannibal butcher's shop to such genteel readers.

One of the features that made the dance of death so disconcerting was that the figures in its ostensibly hierarchical procession, beginning with popes and emperors and ending with the lowliest mendicants, were made equal by death's revelation of the ultimate fate they all shared. This tradition continued into the nineteenth century, and the elaborate "Dance of Macabre" in Ainsworth's novel "comprehended all ranks of society," from a "monarch . . . arrayed in the habiliments of royalty" to a "blind man, and a beggar."[62] The dance constituted the very same reminder of mortality and the worthlessness of worldly vanity with which Roman slaves had confronted the emperors in triumphal processions. The dance of death enacted in *Man's Place in Nature*'s frontispiece was seen to have similarly leveling implications, with the *Athenæum* lamenting: "If the beholder can but conclude that he is one 'in substance and structure' with those gibbering, grovelling apes behind man, then where is our pride of ancestry, our heraldic pomp, our vaunted nobility of descent? Any man can now mount armorial bearings in the shape of the long arms of the gibbon or the gorilla. These are our true 'kings-at-arms.'"[63] The perception that the frontispiece revealed "our true 'kings-at-arms'" to be merely long-limbed simians was, in part, a consequence of Huxley's deliberate humbling, in the book's text, of the species that conceitedly considered itself the "crown . . . of the animal creation." The "demonstration of a pithecoid pedigree," as he mockingly reflected elsewhere, was akin to discovering that one's "father was a cobbler."[64] But if the ignoble procession of primate skeletons prompted concerns about rank and social class when it was viewed in Britain, the same image had very different connotations when it was reprinted across the Atlantic.

Pride of Race

When the "advance sheets" of *Man's Place in Nature* arrived in New York in March 1863, they immediately provoked fierce competition for the book among American publishers, who, as Edward Livingston Youmans remarked, "wanted it badly." The contest was won by William Henry Appleton, whose publishing house was sufficiently wealthy to withstand the "terrible com-

mercial catastrophes," including new taxes on book sales and the tripling of the cost of paper, caused by the ongoing Civil War.[65] Appleton's affluence derived from the absence of international copyright restrictions, which had enabled the firm to piratically reprint British books for American audiences, although by the 1860s it was increasingly offering financial recompense to British authors, as it did with Huxley.[66]

In the previous decade the firm began using new methods of maintaining its profits from the trade in transatlantic reprints, and in 1855 there were reports that "Appleton, of New York, is now extensively re-printing large line engravings from English and other foreign proofs without re-engraving." While these facsimile engravings, made by the process of anastatic printing, retained an "essential fidelity" to the original images, they were admittedly "inferior in quality."[67] Such shoddiness was evidently not acceptable for the coveted reprint of *Man's Place in Nature*. Notwithstanding the privations of the war, Appleton instead chose the more expensive option of having the book's numerous illustrations reengraved by American artists. Those interspersed within the text were mostly unattributed, although some had an indistinct signature that may be either "FULIER" or "FULLER," possibly indicating that they were made by Sarah E. Fuller, who in the 1860s ran her own wood-engraving workshop in New York.[68] The book's frontispiece, however, was reengraved separately from the other illustrations and had a conspicuous attribution, "JOCELYN," in the same place where Wesley's more discreet signature appeared in British editions (fig. 3.4; see fig. I.2).

The frontispiece was already provoking particular attention in reviews of *Man's Place in Nature* in Britain, and the artist whom Appleton tasked with reengraving the controversial image was considerably more experienced than Wesley. Albert Higley Jocelyn had been a successful commercial wood engraver since the early 1850s, and in his replication of the frontispiece the engraved lines are more clearly defined than in the original, giving the successive skeletons a bolder, more pronounced appearance. Significantly, Jocelyn hailed from a famous artistic family whose paintings and engravings, particularly his uncle Nathaniel Jocelyn's celebrated portrait of Sengbe Pieh (Joseph Cinqué), leader of the 1839 revolt on the Spanish slave ship *La Amistad*, were often used to advance the cause of the abolition of slavery (fig. 3.5).[69] Jocelyn's own skills in wood engraving were honed from illustrat-

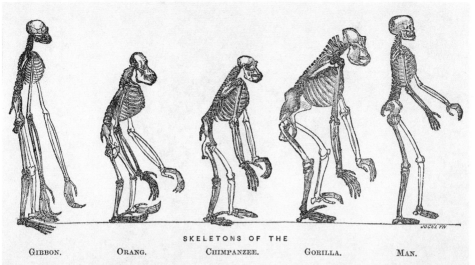

SKELETONS OF THE

GIBBON. ORANG. CHIMPANZEE. GORILLA. MAN.

Photographically reduced from Diagrams of the natural size (except that of the Gibbon, which was twice as large as nature), drawn by Mr. Waterhouse Hawkins from specimens in the Museum of the Royal College of Surgeons.

Fig. 3.4. For the American edition of Huxley's *Man's Place in Nature*, the frontispiece was reengraved by Albert Higley Jocelyn, whose artistic work often reflected his commitment to the cause of the abolition of slavery. Frontispiece to Thomas Henry Huxley, *Evidence as to Man's Place in Nature* (New York: D. Appleton, 1863). (By permission of the Haddon Library, Cambridge.)

ing the publications of the American and Foreign Anti-Slavery Society; an example is his title page for the *Liberty Almanac* in 1852 depicting, among other things, a row of "human skulls emblematical of the crushing and direful influence of slavery" (fig. 3.6). This uncompromising allegory, which provided a "permanent record of American Slavery," carried the very same signature, with the addition of "sc. ny," as the similarly skeletal frontispiece that Appleton commissioned from Jocelyn a decade later.[70] He had previously supplied the publisher with engravings informed by his own antipathy toward slavery, notably those for a sensational biography of the slave trader Théodore Canot, and may have had more than merely monetary reasons for accepting the opportunity to reengrave the frontispiece from Huxley's book.[71]

The particular aspect of the image that might have spurred Jocelyn's interest was immediately intuited in a review of Appleton's reprint in the *New-York Daily Tribune*, which began: "The frontispiece to this volume presents

Engraved by J. Sartain.

Cinque

Fig, 3.5. Mezzotint by John Sartain entitled "Cinqué." It reproduces Nathaniel Jocelyn's oil painting *Portrait of Sengbe Pieh (Joseph Cinqué)*, which, made in 1840, portrayed the leader of the 1839 revolt on the Spanish slave ship *La Amistad*. (National Portrait Gallery, Smithsonian Institution, NPG.69.66. CC0.)

Fig. 3.6. Wood engraving by Albert Higley Jocelyn entitled "No Higher Law." It shows an allegorical representation of the baleful consequences of slavery, depicting a row of the skulls of enslaved people killed by the cruelty of their masters. Jocelyn would later also engrave skulls for the frontispiece to the American edition of *Man's Place in Nature* (fig. 3.4). Title page of *The Liberty Almanac for 1852* (New York: American and Foreign Anti-Slavery Society, 1852). (Library of Congress, AY256.N5 L53 Am Almanac Coll 1852 c.1.)

a specimen of comparative anatomy by no means flattering to the human pride of race."[72] The biblical sin of pride, especially in relation to race, was considered one of the root causes of the Civil War. As the political philosopher Francis Lieber pronounced in an address in April 1863, "Slavery . . . begot pride in the leading men of the South—absurdly even pretending to be of a different and better race."[73] Besides responding to White southerners' assumed superiority over their enslaved workers, Lieber was also addressing claims that the White inhabitants of the South were descended from the Normans, whereas their counterparts in the North were of inferior Anglo-Saxon descent. Although the war had begun in an attempt to prevent the secession of states inhabited by such supercilious southerners, by the time American readers first saw Jocelyn's reengraved frontispiece, the Union's principal objective had become the abolition of slavery itself. Indeed, the *Tribune*'s declaration that the frontispiece had deleterious implications for "pride of race" was made, on July 6, 1863, amid the mounting resentment of many of New York's inhabitants at being conscripted into an army whose main purpose was liberating enslaved people. This anger would break out, less than a week later, in violent draft riots, during which White mobs attacked and killed Black residents.[74] In this tumultuous atmosphere, the frontispiece's use of a single skeleton to represent all humans, with no mention of racial difference, was hugely consequential.

The message of the frontispiece was certainly at odds with the claims of polygenists such as the New York physician John H. Van Evrie, who, in his *Negroes and Negro "Slavery"* (1861), noted the "resemblance between the negro and the ourang-outang." To justify his sympathy with the Confederate cause, Van Evrie asserted that as the "negro is the lowest in the scale of the human creation . . . those things common to men and animals are much more prominent in him" than they are in other races.[75] In the same vein, Hawkins added a kneeling African as an expedient buffer between a White man and his simian ancestors in an illustration, otherwise a deliberate echo of Huxley's frontispiece, that he displayed in his lectures in New York in the early 1870s. Hawkins had also followed the pattern established by Camper and Lavater in the eighteenth century of depicting a progressive ascent of human races toward the sublimity of the Greek god Apollo, images of whom Hawkins used to represent European characteristics. In striking contrast,

the skeletal sequence reengraved by Jocelyn, as the *New-York Daily Tribune* insisted, demonstrated the "strongly marked resemblance in the skeletons of the . . . detestable apes, and of man," without any reference to race whatso-ever.[76] For an avowed abolitionist like Jocelyn, the frontispiece offered a pow-erful and timely affirmation that humanity constituted only one species.

The *Tribune* was itself an important advocate of abolitionism, and its offices were a target, just days after its review of *Man's Place in Nature*, for White mobs during the New York draft riots.[77] Less than a year later, in March 1864, the newspaper reported that it had exclusive "permission from Professor Huxley" to print "his remarks upon a question of such great impor-tance to us in the United States." These were Huxley's tentatively monog-enist assertions that on the "balance of probabilities," he felt "warranted . . . in speaking of the human race rather than the diversity of species." In fact, there was, Huxley proposed, "no race which could in any sense be . . . re-garded as transitional or midway between the lower orders of nature and man."[78] These statements seemed to confirm the *Tribune*'s own understand-ing, shared by Jocelyn, of Huxley's frontispiece as a chastening confirmation that all humans—whether slaves, soldiers, or senators—shared the same mor-phological proximity with anthropoid apes. Such abolitionist implications corresponded with the egalitarianism attributed to the same image back in Britain. But while the frontispiece could, when seen amid the turmoil of the Civil War, be interpreted as tempering any bigoted "pride of race," Huxley's own attitudes on the subject were more complex.

Perhaps the reason Jocelyn reengraved only the frontispiece was that some of *Man's Place in Nature*'s later illustrations, interspersed in the text, helped to validate an argument that, in the "important matter of cranial capacity," "Men differ more widely from one another than they do from the Apes." This proposal helped bolster Huxley's larger claim about the evolutionary continuity between humans and the highest simians, suggesting that what he called the "different races of mankind" varied more among themselves than they did from the gorilla. At the close of the book, Huxley likewise proposed that a recently discovered fossil cranium with strikingly "ape-like characters" was actually that of a human, a conclusion reached on the basis of "several points of similarity" with "certain Australian skulls." This newly named Neanderthal, like its still extant Aboriginal counterparts, helped "fill

up . . . the structural interval which exists between Man and the man-like apes."[79] Such arguments were predicated on an explicitly hierarchical conception of the relation of different races to each other, even if, ultimately, they all belonged to the same species.[80] This view tallied with Huxley's egregious conclusion, after the "fierce trial by battle on the other side of the Atlantic," that the natural "inferiority of the negro to the white man . . . in the hierarchy of civilization" made it likely that "emancipation may convert the slave from a well-fed animal into a pauperized man."[81] Huxley, as he freely acknowledged, never professed any sympathy for enslaved people during the Civil War and supported the Union cause only because he felt slavery was morally degrading for the slaveholders. His disdain for what he called the "aberrations from scientific fact . . . on the anti-slavery side" would hardly have been gratifying to an ardent abolitionist like Jocelyn.[82]

The Picture Contains No Reservations

A year before the publication of *Man's Place in Nature*, Huxley, in February 1862, gave a lecture in which, to demonstrate the loss of the "distinctive characters of man as we pass down to the apes," he "referred to diagrams of the skeletons of the Bush-woman, Gorilla, Chimpanzee, Orang, and Gibbon."[83] It is unknown whether these lecture diagrams represented the skeletons from a lateral perspective or at what scale they were drawn, and there is no record of Hawkins having any involvement in their preparation. All the same, their arrangement, on the lecture platform, in a stratified series has a clear resemblance to the later sequence of lecture diagrams of primate skeletons that formed *Man's Place in Nature*'s frontispiece. There was, however, one conspicuous difference. In placing a picture of the skeleton of a female from the Saan peoples of southern Africa at the front of the series, Huxley intimated, ineluctably, that the proximity to the simians behind her was nearer than would have been the case with an equivalent European skeleton, particularly that of a male.[84] He dismissed the so-called "BUSHMEN" from which the woman came as a "strange people" of "remarkably small stature."[85] Indeed, the diagrams at his lecture in February 1862 were seemingly placed in a regressive order that, "pass[ing] down to the apes," showed a diminution of putatively normal human characteristics.

This sequence contrasted with the distinctively progressive sequence, described by Huxley as moving "upwards and forwards," in which the subsequent series of lecture diagrams from November 1862 were permanently positioned in the frontispiece.[86] There the skeleton representing humans was that of a European man. Stephen Jay Gould has proposed that the "progressivist equation of evolution with linear advance" necessitated the "undeniably racist" assumptions that Huxley was prone to. This "fallacy in his evolutionary reasoning," according to Gould, compelled him to posit a "series of rising steps . . . that arranged all humans in a line of advancing worth." Gould's historical judgment clearly relates to his own broader scientific antipathy to linear representations of evolution. It also implies that what Gould calls "Huxley's racist argument" in the pages of *Man's Place in Nature* was reflected in the book's frontispiece.[87]

Yet the same image could, for both the abolitionist engraver Jocelyn and the *New-York Daily Tribune*, be a vital resource for combating precisely such racist assumptions. As Jocelyn's involvement with just the frontispiece implies, moreover, it is hazardous to conflate the image with the rest of Huxley's book. After all, Hawkins's depiction of the gorilla skeleton's awkward gait flatly contradicted much of Huxley's textual description of the same creature. Frontispieces, which are etymologically related to the human forehead and the front of a building, traditionally serve to epitomize a book's contents.[88] But the series of primate skeletons that readers first encountered when they opened *Man's Place in Nature* diverged from the text of the book in several crucial respects.

This sense that the frontispiece was, in some ways, distinct from the rest of *Man's Place in Nature* became increasingly apparent as the image grew ever more ubiquitous, on both sides of the Atlantic, in later decades of the nineteenth century. By 1893 the *American Catholic Quarterly Review* was exclaiming of Huxley: "His frontispiece exhibited the famous series of apes, all in a row—the gibbon, orang, chimpanzee, gorilla, man. In the book he made the proper reservations, as became a rigidly scientific man; but the picture contains no reservations; and it is now part of the stock in trade of every scientific work and review, of every large dictionary and even of textbooks in the public schools. It cannot complain of not being seen to advantage; for it requires only the 'wet light' of passion and sensuality, which is

sufficiently diffused among mankind, to throw about the picture a proper atmosphere as of an evening mist; the 'dry light' of calm reason is reserved for the reservations."[89]

The insinuation that the frontispiece would be viewed in the "'wet light' of passion and sensuality" was not unprecedented, albeit seemingly confined to Catholics. The biologist St. George Mivart, who had been a protégé of Huxley's before converting to Catholicism, similarly noted, with malicious glee, that in Italy he had seen "'Man's Place in Nature' for sale at most of the railway stations amongst a crowd of *obscenities*," with the "Vendors count[ing] on what we may term a 'tendency to reversion.'"[90] Curiously, the frontispiece was also ascribed its own agency in the *American Catholic Quarterly Review*'s rather peevish suggestion that "it cannot complain of not being seen to advantage." This "famous series of apes, all in a row," had clearly taken on a life of its own.

By the final years of the nineteenth century, the frontispiece had, as the *American Catholic Quarterly Review* intimated, become the "stock in trade" of a huge variety of scientific and pedagogic publications, in which it was generally reproduced in isolation from the rest of *Man's Place in Nature*. Immediately after its original publication in Huxley's book, it was already being interpreted in radically different ways, especially in relation to issues of race. When it was subsequently appropriated, reworked, and recontextualized in a wide range of other publications, the connotations of the frontispiece became even more variable. In particular, the image that Huxley himself seems to have intended, at least in part, as a demotic and darkly sardonic dance of death became increasingly implicated with progressive and linear conceptions of evolution that now, in retrospect, seem its ineluctable meaning. But this view was far from inevitable and came about only when the "famous series of apes" was repurposed for new scientific agendas.

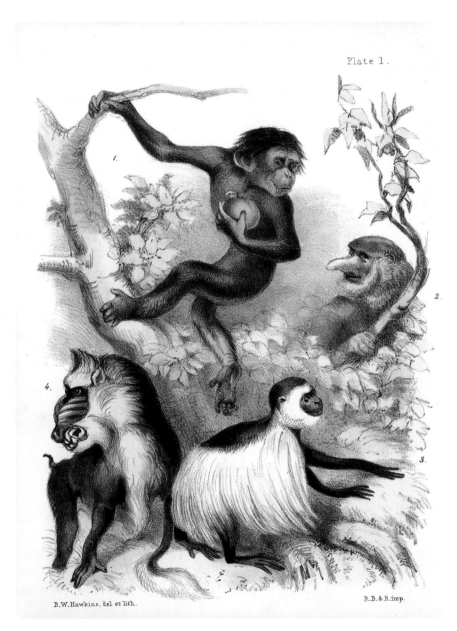

Plate 1. Chromolithograph by Benjamin Waterhouse Hawkins showing a chimpanzee (1) and three monkeys, a proboscis (2), a colobus (3), and a mandrill (4). In Adam White, *A Popular History of Mammalia* (London: Reeve and Benham, 1850), plate 1. (Author's collection.)

Plate 2. Oil painting by Caspar David Friedrich showing an oak tree in snow, which, in a departure from compositional conventions that placed trees at the periphery, appears at the center of the image. Caspar David Friedrich, *Eiche im Schnee Alte*. Oil on canvas, 1827–28. (Wallraf-Richartz-Museum and Foundation Corboud, Cologne. Photo © Rheinisches Bildarchiv Cologne, rba_c005014.)

Plate 3. Chromolithograph by Joseph Wolf entitled "The Chimpanzee (*Troglodytes niger*)." The image was copied without attribution in Giltsch's "Catarrhine Quartet" (fig. 4.3). In Joseph Wolf, *Zoological Sketches*, 2 vols. (London: Henry Graves, 1861–67), 1:plate I. (Image from the Biodiversity Heritage Library. Contributed by Harvard University. https://www.biodiversitylibrary.org.)

THE

To be completed in about 30 Fortnightly Parts.

SCIENCE of LIFE

JULIAN HUXLEY H.G.WELLS G.P.WELLS

1 1/3

ARISTOTLE

The Range and Nature of Life

Plate 4. Chromolithograph by William Spencer Bagdatopolous entitled "The Range and Nature of Life." The slight misalignment in the printing of the wrapper on which the image appears, evident in the top left corner, was made in the original production process, indicating that the serialized installments of *The Science of Life* were cheap, mass-produced publications. Wrapper of *The Science of Life*, part 1 (London: Amalgamated Press, 1929). (The Bodleian Libraries, University of Oxford, QH309 WEL 1929. Orphan Works License OWLS000316–1; https://www.orphanworkslicensing.service.gov.uk/view-register).

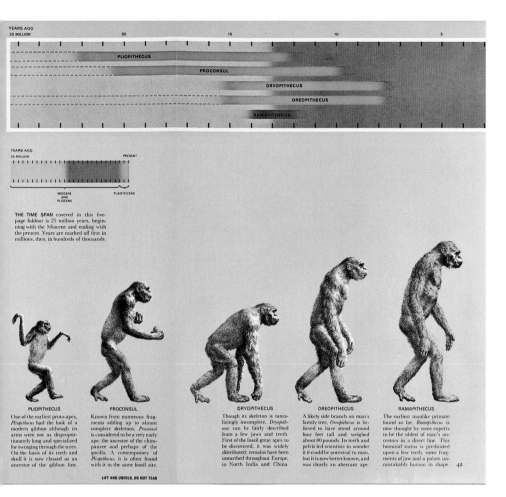

Plates 5 and 6. Fold-out illustration by Rudolf Zallinger entitled "The Road to Homo Sapiens." The five fold-out pages on which Zallinger's chronological sequence of simian and hominid figures was printed in *Early Man* could not be viewed simultaneously by the book's readers. Plate 5 (here) shows the initial two pages, with the five earliest figures, and plate 6 (overleaf) shows the final three pages, with the remaining ten figures. In F. Clark Howell and the Editors of Time-Life Books, *Early Man* (New York: Time-Life Books, 1965), 41–42 and 43–45. (Author's collection. By permission of Zallinger Family LLC.)

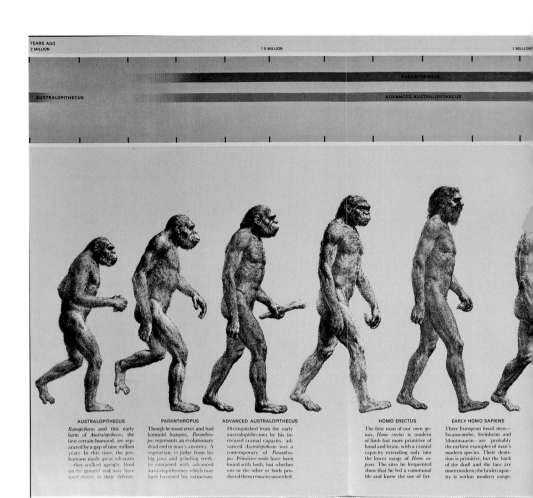

PARANTHROPUS

AUSTRALOPITHECUS

ADVANCED AUSTRALOPITHECUS

AUSTRALOPITHECUS

Ramapithecus and this early form of *Australopithecus*, the first certain hominid, are separated by a gap of nine million years. In this time, the prehumans made great advances —they walked upright, lived on the ground and may have used stones in their defense.

PARANTHROPUS

Though he stood erect and had hominid features, *Paranthropus* represents an evolutionary dead end in man's ancestry. A vegetarian, to judge from his big jaws and grinding teeth, he competed with advanced australopithecines, which may have hastened his extinction.

ADVANCED AUSTRALOPITHECUS

Distinguished from the early australopithecines by his increased cranial capacity, advanced *Australopithecus* was a contemporary of *Paranthropus*. Primitive tools have been found with both, but whether one or the other or both produced them remains unsettled.

HOMO ERECTUS

The first man of our own genus, *Homo erectus* is modern of limb but more primitive of hand and brain, with a cranial capacity extending only into the lower range of *Homo sapiens*. The sites he frequented show that he led a communal life and knew the use of fire.

EARLY HOMO SAPIENS

Three European fossil men— Swanscombe, Steinheim and Montmaurin—are probably the earliest examples of man's modern species. Their dentition is primitive, but the back of the skull and the face are more modern; the brain capacity is within modern range.

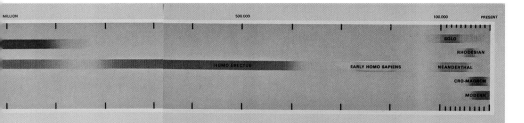

SOLO

RHODESIAN

HOMO ERECTUS EARLY HOMO SAPIENS NEANDERTHAL

CRO-MAGNON

MODERN

SOLO MAN

An extinct race of *Homo sapiens* in Java, Solo man is recognized so far only from two shin bones and some fragmentary skulls. These indicate that his limbs were modern in appearance; his skull, however, was massive and thick, with heavy brows and sloping forehead.

RHODESIAN MAN

Another extinct race of *Homo sapiens* that dwelled in Africa, these men were more modern than *Homo erectus* but more primitive than the first Bushmanlike peoples. Fossil remains have been found with cutting and scraping tools of stone as well as some of bone.

NEANDERTHAL MAN

Not nearly as brutish a fellow as his name has come to connote, Neanderthal man, whose peoples rimmed the Mediterranean and dotted Europe, had a cranial capacity in some cases larger than that of modern man. He made a variety of tools advanced in design.

CRO-MAGNON MAN

Only a cultural step away from modern man, Cro-Magnon man has left the world his art—cave paintings, stone engravings and carved figures. He replaced the Neanderthals in Europe and, diversifying in many populations, seems to have colonized the world.

MODERN MAN

Physically, modern man differs little from Cro-Magnon man. What sets the two apart is culture; by learning how to grow his own food and domesticate animals, man could afford to give up his nomadic life and found permanent settlements—and civilizations.

45

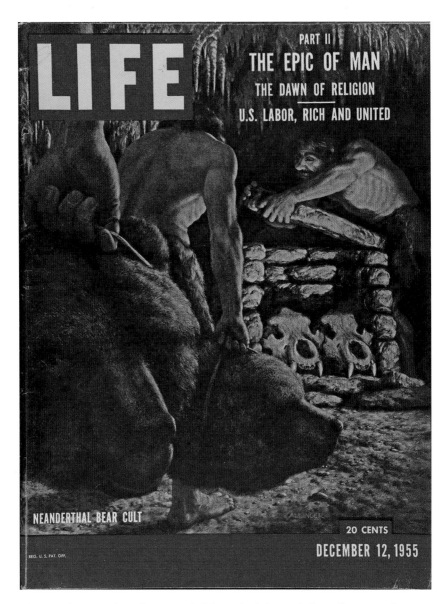

PART II
THE EPIC OF MAN
THE DAWN OF RELIGION
U.S. LABOR, RICH AND UNITED

NEANDERTHAL BEAR CULT

REG. U. S. PAT. OFF.

20 CENTS

DECEMBER 12, 1955

Plate 7. Oil painting by Zallinger entitled "Neanderthal Bear Cult." Zallinger uses fore-shortening and chiaroscuro lighting to place the viewer in the middle of the action, in line with *Life* magazine's distinctive style of photojournalism. Cover of *Life*, 39, no. 24 (1955). (Author's collection. By permission of Zallinger Family LLC; © 1955 Meredith Operations Corporation. All rights reserved. Reprinted from LIFE and published with permission of Meredith Operations Corporation. Reproduction in any manner in any language in whole or in part without written permission is prohibited. LIFE and the LIFE logo are registered trademarks of Meredith Operations Corporation. Used under license.)

Connecting Links, 1874–1935

Frauds and Forgeries

In November 1874 the German naturalist Ernst Haeckel asked Huxley to review his latest book, *Anthropogenie*, in the British press. Huxley, as Haeckel acknowledged in his letter, was "reluctant to write reviews" and had told his correspondent that his earlier book *Generelle Morphologie der Organismen* (1866) was "not exactly a novel to be taken up and read in the intervals of business."[1] Huxley's penchant for reading works of imaginative literature has already been seen, and early reviews of Haeckel's new tome, whose title applied a specialist term for fetal development to human evolution more generally, suggested that its "extremely difficult subject" was "not at all fitted for popular treatment."[2] Huxley nevertheless soon completed the desired notice of *Anthropogenie*, even if he reflected ruefully, "I am so busy that I am afraid I should never have done it."[3] Significantly, Huxley used the impromptu review, which appeared in the January 1875 number of the *Academy*, to relinquish his intellectual leadership of the still hugely contentious issue of humanity's evolutionary origins and development.

Huxley announced that "in 1863, I summed up the then state of the question in a little book, entitled *Man's Place in Nature*, which did its work in several languages beside my own." A decade later, as he acknowledged with seemingly genuine humility, the book was now "out of print and gone to the limbo of forgotten things: which is its proper place." Huxley conceded that the "position I took up . . . was a very guarded one, as the state of knowledge at that time demanded," but he was now willing to accept the "more or less justifiable speculation" that characterized Haeckel's new book. In *Anthro-*

pogenie, Huxley enthused, his German successor "stoops at much higher game . . . —the tracing of the actual pedigree of man—from its protoplasmic root . . . to its climax and perfection." Although hesitant about some of the finer details, Huxley was ready to acclaim Haeckel's "real live book, full of power and genius," as heralding the future of the study of human evolution.[4]

In *Anthropogenie* Haeckel endeavored to reconstruct what he called the "Phylogeny of Apes." Insisting that "Man is a genuine Narrow-nosed Ape" closely related to the gorilla, chimpanzee, orangutan, and gibbon, he avowed that humans could indubitably "be traced from a parent-form common to all." In the absence of any tangible paleontological evidence, however, Haeckel relied on new methods of verification. The ontogeny, or "germ history," of the individual organism provided, he averred, a "thread of Ariadne" that charted a path through the "complicated labyrinth" of phylogeny, or "tribal history." With the human embryo putatively recapitulating the morphologies of more primitive creatures, it was possible, Haeckel proclaimed, to "safely infer the nature of the ancestral animal form" from which humans had evolved.[5]

To demonstrate how humans were merely a "special branch" of the anthropoid apes, *Anthropogenie* was profusely illustrated with images of "our family tree" that, as the lengthy volume progressed, became elaborately arboreal. The book's final plate, drawn by Haeckel and lithographed by Julius Geissler, depicted the "Pedigree of Man"—the more expressive "*Stammbaum des Menschen*" (human family tree) in the original German—as a gnarled and mature Teutonic oak (fig. 4.1). Its trunk ascends from single-celled organisms to the airy pinnacle of the slender twigs representing humanity. While the extant species of anthropoid apes branch out as discrete offshoots just below the human apex, they all emanate from the same apelike ancestors who appear earlier on the trunk. If, as Haeckel conceded in the text of *Anthropogenie,* this conception of "our animal pedigree," proceeding through

Fig. 4.1. Lithograph of an original drawing by Ernst Haeckel entitled "*Stammbaum des Menschen.*" It depicts the human family tree as a gnarled German oak. Although the image shows that humans are descended from the same ancestors ("Anthropoiden") as living apes, the perpendicular trunk of the tree implies that evolution is a progressive ascent with humans as its inevitable endpoint. In Ernst Haeckel, *Anthropogenie* (Leipzig: W. Engelmann, 1874), plate XII. (The Bodleian Libraries, University of Oxford, 18917 d. 25. CC-BY-NC 4.0.)

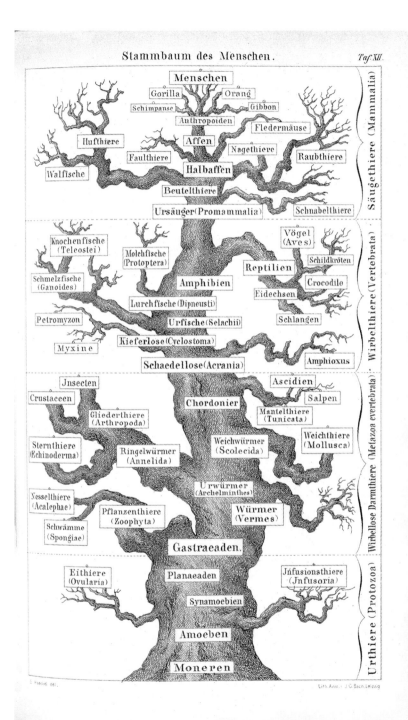

Menschen

Gorilla · Orang

Schimpanse · Gibbon

Anthropoiden

Fledermäuse

Hufthiere · Affen · Nagethiere · Raubthiere

Faulthiere · Halbaffen

Walfische

Beutelthiere

Ursäuger (Promammalia) · Schnabelthiere

Säugethiere (Mammalia)

Knochenfische (Teleostei) · Vögel (Aves)

Molchfische (Protoptera) · Schildkröten

Schmelzfische (Ganoides) · Reptilien · Crocodile

Amphibien · Eidechsen

Lurchfische (Dipneusti)

Petromyzon · Urfische (Selachii) · Schlangen

Myxine · Kieferlose (Cyclostoma)

Schaedellose (Acrania) · Amphioxus

Wirbelthiere (Vertebrata)

Jnsecten · Ascidien

Crustaceen · Chordonier · Salpen

Gliederthiere (Arthropoda) · Mantelthiere (Tunicata)

Sternthiere (Echinoderma) · Ringelwürmer (Annelida) · Weichwürmer (Scolecida) · Weichthiere (Mollusca)

Urwürmer (Archelminthes)

Nesselthiere (Acalephae) · Pflanzenthiere (Zoophyta) · Würmer (Vermes)

Schwämme (Spongiae)

Gastraeaden.

Wirbellose Darmthiere (Metazoa evertebrata)

Eithiere (Ovularia) · Planaeaden · Jnfusionsthiere (Jnfusoria)

Synamoebien

Amoeben

Moneren

Urthiere (Protozoa)

E. Haeckel del.

Lith. Anst. v. J.G. Bach, Leipzig

twenty-two stages, was predicated on some "very uncertain conjectures," the realistically rendered image of an oak tree, long a symbol of strength and stability, inevitably made it seem more securely established.[6] The oak had a special resonance in Germany, where it had been the sacred tree of ancient Teutonic tribes and, since the eighteenth century, had become a symbol of German unity.[7] The totemic tree was frequently depicted by nineteenth-century German artists, and Haeckel's lithographed drawing has particular echoes of several paintings by Caspar David Friedrich that, departing from compositional conventions that placed trees at the periphery, focus on a solitary oak at the center of the image (plate 2). In Friedrich's romantic evocations, the tree symbolizes the steadfastness and historical continuity of a nascent German nationalism.[8] Haeckel's oak likewise emphasizes the deep rootedness of the broader human tribe whose highest manifestation, as he elsewhere insisted, was the "Germanic branch."[9]

The thick and resolutely perpendicular trunk of Haeckel's "*Stammbaum,*" made more conspicuous by its wintry lack of leaves, also appears to imply that the process of human evolution was a progressive ascent with a clear direction and endpoint that, like the ontogenetic development of an embryo, had been evident since the oak was just an acorn. This anthropocentric apotheosis seems at odds with Haeckel's insistence, in the text of *Anthropogenie*, on demoting humans to mere simian status. The depiction of humanity's uninterrupted ascension to the summit of the "*Stammbaum,*" however, expressed a central, if somewhat contradictory, strand in Haeckel's conception of evolution. This immensely influential illustration has been hailed as the "first really tree-like phylogenetic tree," and, along with Haeckel's comparative images of embryos, it became one of his infamous "secular icons."[10] But the celebrated "*Stammbaum*" had its roots in another iconic depiction of humanity's proximity with apes, one that was reproduced a few pages earlier in *Anthropogenie*.

Haeckel had been able to urge Huxley to overcome his aversion to reviewing because, as the latter observed, they had the "good fortune to be on terms of personal friendship," having first met in 1866.[11] Haeckel later recounted that this initial "tie of scientific . . . comradeship" subsequently became "still closer, when . . . I undertook to prove the ape-descent of man, as Huxley had propounded it."[12] This intellectual affinity was not as strong as

Haeckel implied, but one thing the two men did share was a distinctively acerbic sense of humor.[13] Huxley would "chuckle . . . most sympathetically" at "how naughty" Haeckel was in his polemical advocacy of evolution, while the German admired Huxley's own "wonderfully fine irony" and incisive "Attic wit."[14] In particular, Haeckel shared the mordant disdain with which Huxley regarded humanity's arrogant insistence on its superiority and regal uniqueness, notwithstanding the overtly progressive imagery that he drew for the "*Stammbaum*" plate. With a radical political tone, Haeckel had earlier mocked how members of the "aristocracy" would consider the "noble blood which flows in their privileged arteries" when they discovered that "all human embryos, those of nobles as well as commoners," were initially indistinguishable from the early development of dogs or apes.[15] In *Anthropogenie*, his allusions to "Man, the so-called 'Crown of Creation,'" evidently took their lead from Huxley's own barbed comments on humanity's perception of itself as the "crown . . . of the animal creation."[16] It was in the frontispiece to *Man's Place in Nature* that Huxley had most defiantly articulated his scathing attitude toward such vaunted majesty. It is therefore unsurprising that Haeckel reproduced the same demotic and darkly sardonic sequence of primate skeletons in the section of *Anthropogenie* that concluded with the "*Stammbaum*."

Haeckel seems not to have asked Huxley's permission to reprint the wood engraving, and German copyright law at this time permitted unrestricted reproductions of single images so long as the original source was acknowledged.[17] The illustration of primate skeletons in *Anthropogenie* was dutifully captioned "(After HUXLEY)," but the image that appeared in Haeckel's book, while ostensibly identical to the original frontispiece, was fundamentally altered by its replication in a new context.[18] This had particularly profound implications for the image's complex relation to race. As the multiple twigs representing humanity at the summit of Haeckel's "*Stammbaum*" suggest, he did not share even Huxley's tentative belief in the unity of the human race. Instead, the placement of the erstwhile frontispiece to *Man's Place in Nature* alongside Haeckel's own explicitly polygenist and often egregiously racist illustrations reversed the more positive connotations that abolitionists had discerned when the original image was reengraved in America at the height of the Civil War.

If, as Huxley modestly acknowledged, *Man's Place in Nature* was now in the "limbo of forgotten things," this was certainly not the case for its frontispiece. The pervasive process of detaching the image from the rest of Huxley's book was exacerbated by its reproduction in Haeckel's volume. Over the next four decades, *Anthropogenie* went through six editions, as well as two separate English translations, all of which, while often being radically revised for different readerships, retained the illustration of primate skeletons. Notwithstanding Huxley's earlier reservations over the lucidity of Haeckel's prose, many of these editions were pitched specifically at popular audiences and sold for unprecedentedly cheap prices. In fact, by the close of the nineteenth century Haeckel was by far the most famous proponent of evolution in the world. He was also the most notoriously bellicose, and his scientific works were deeply embroiled in the *Kulturkampf* (culture war) between liberals and conservatives in the newly unified Germany. The popularization of Huxley's series of skeletons in successive editions of *Anthropogenie* ensured that the image became increasingly imbued with not only the progressive conception of evolution embodied in the ascending trunk of the "*Stammbaum*" but also with Haeckel's polygenist attitudes to race and with his strident secularism.

This repurposing of Huxley's former frontispiece was augmented when, at the beginning of the twentieth century, Haeckel and the artist Adolf Giltsch deployed modern photographic techniques to create their own modified and updated version of the sequence of primate skeletons. Notably, this new iteration of the image became entangled in the same accusations of forgery and deliberate misrepresentation that had long dogged Haeckel's comparative depictions of human and animal embryos. Ironically, some religious commentators now praised Huxley's original wood-engraved illustration as a more trustworthy counterpart to Haeckel's fraudulent imposture. By directly comparing the two images, they even seemed to intuit the anti-evolutionary elements that Hawkins had surreptitiously incorporated in *Man's Place in Nature*'s frontispiece.

It was in the United States, then emerging as the world's leading center for the study of human evolution, that the consequences of Haeckel's appropriation of the image were most acute. In the 1920s, Haeckel's potentially fraudulent iteration of the illustration was conflated—and sometimes just

plain confused—with Huxley's original, even by leading scientists, who, in the new era of mass media, could perpetuate their views in the pages of leading newspapers. Indeed, the distrust that surrounded both versions of the series of primate skeletons was even perceptible in Hollywood, where, exactly seventy years after the creation of Huxley's frontispiece, it was utilized in horror movies as a lurid symbol of scientific transgression and malevolence.

The Monkeys Are Flattered

Rather than being the very first thing that readers saw in *Anthropogenie*, the illustration that opened *Man's Place in Nature* appeared two-thirds of the way through its 732 pages. No longer a frontispiece, nor even one of the book's separate lithographic plates, the not-quite-full-page woodcut image was instead awkwardly incorporated into a typeset page (fig. 4.2). It was also divested of both the original caption acknowledging Hawkins's artistic contribution and Wesley's smaller engraver's inscription. The now unattributed series of skeletons, which had been photographically reduced in order to fit the demy octavo size of Huxley's book, was expanded slightly to suit *Anthropogenie*'s more generous royal octavo dimensions. Despite this increased page size, only two inconspicuous lines of text could be accommodated at the top of the page, where they were liable to be missed by inobservant readers.

The rest of the page was taken up with two sets of captions, running vertically and horizontally, that repeated almost the same information. The duplicate captions reformatted the illustration—albeit without any alteration to the actual image—as five separate figures, running from the gibbon at "Fig. 127" to the human at "Fig. 131." As this continuous numbering indicates, these discrete figures were now amalgamated with the many other images in Haeckel's profusely illustrated book. In particular, they became merely an adjunct of its next lithographic plate, which was interleaved directly facing the skeletal series (fig. 4.3). This plate was entitled "A Catarrhine Quartet," and it depicted the Old World apes who shared narrow and downward pointing noses.[19] The four members of this taxonomic group, in which Haeckel pointedly included humans, were portrayed perching in branches that, with the addition of a few leaves, resembled those of the gnarled German oak in the "*Stammbaum*" that readers first encountered eight pages later. That

488 Skelet der Menschenaffen und des Menschen. XIX.

geringer, als die entsprechenden Unterschiede derselben vom Menschen. Das lehrt Sie schon ein Blick auf die hier folgenden Skelete

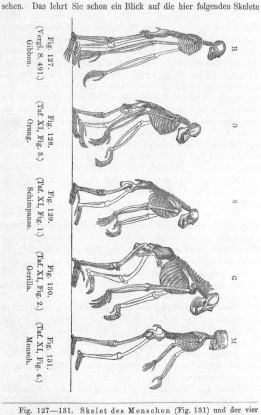

Fig. 127—131. Skelet des Menschen (Fig. 131) und der vier Anthropoiden-Gattungen: Fig. 127 Gibbon. Fig. 128 Orang. Fig. 129 Schimpanse. Fig. 130 Gorilla. (Nach Huxley.)

Fig. 4.2. Wood engraving entitled "Skeleton of Man and the Four Anthropoid Genera" based on the frontispiece to Huxley's *Man's Place in Nature*. The image has an attribution, "After Huxley," and remains ostensibly identical to the original picture, but it is fundamentally altered by its replication in a new context. In Ernst Haeckel, *Anthropogenie* (Leipzig: W. Engelmann, 1874), 488. (The Bodleian Libraries, University of Oxford, 18917 d. 25. CC-BY-NC 4.0.)

final plate was lithographed in Leipzig by the firm of J. G. Bach, which had been directed by Julius Geissler since the death of its founder three decades earlier.

The only lithographs in *Anthropogenie* not entrusted to Geissler were a plate showing two human embryos at different stages of development and "A Catarrhine Quartet," which, despite the latter's foreshadowing of the arboreal imagery of the "*Stammbaum*," were lithographed by Eduard Giltsch with the assistance of his son Adolf. Haeckel, as he later rather patronizingly recalled, had "found" Giltsch in the early 1860s in a "small print shop" in Jena and admired the determination of this former "servant in the botanical garden" who, "by talent and hard work, had worked himself up to a modest position." Having himself joined the faculty of the University of Jena in 1862, Haeckel commissioned Giltsch's family firm to produce lithographic illustrations for both his *Generelle Morphologie* and the more popular *Natürliche Schöpfungsgeschichte* (1868). By Haeckel's own account, however, there was a hiatus in his dealings with the "small lithography workshop" after 1872.[20] It is therefore all the more notable that, two years later, Haeckel returned to Giltsch for two of *Anthropogenie*'s twelve plates.

Beneath the oak in the "*Stammbaum*" Haeckel proudly proclaimed his artistic proprietorship by placing his signature, "E. Haeckel del.," in the plate's bottom left corner.[21] "A Catarrhine Quartet," by contrast, just carried Giltsch's corporate inscription, "Lith. Anst. v. E. Giltsch, Jena," in the bottom right corner, as was the established practice.[22] Such institutional signatures were ambiguous; they could signify anything from the creation of an original image in wax on a lithographic stone to the copying or even just the printing of an artist's own composition. But if the four narrow-nosed primates depicted in "A Catarrhine Quartet" were drawn by Giltsch and his son, the result would have done little to augment their professional reputations. For one thing, the bottom half of the plate is manifestly inferior to the top half. This is because the chimpanzee and gorilla were both simply copied, without attribution, from two separate plates (plate 3 and fig. 4.4). Although these hand-colored lithographs were both the work of the celebrated natural history artist Joseph Wolf, they had originally been published four years apart, in 1861 and 1865, and were drawn at very different scales. In "A Catarrhine Quartet" the purloined images of the apes were both reversed and—especially

2
Gorilla.

1. Schimpanse.

3. Orang.

4. Neger.

Lith. Anst v. E. Giltsch, Jena.

the gorilla, whose rear foot was planted firmly on the ground in the original drawing—awkwardly superimposed on the upper branches of an incongruous German oak. Wolf's carefully delineated images, already denuded of both their color and the more authentic flora of their original backgrounds, were juxtaposed with markedly less skillful and naturalistic drawings of an orangutan and a human, which seem to be original compositions by the Giltsches. This crude conflation creates disjunctions of tone that, along with the equally glaring disparities of scale, endow "A Catarrhine Quartet" with an inadvertently comic aspect.

Haeckel's scientific colleagues were concerned that the plate's shoddy imagery would play into the hands of his enemies. On receiving a copy of *Anthropogenie*, the anatomist Johann Carl Hasse assured Haeckel that most of the illustrations "gave me real pleasure." However, he confessed that "I would have preferred not to have, forgive my sincerity . . . the one in which you depict the negro sitting on the tree." While readers of the book who were already sympathetic to evolution did not require this "superfluous" illustration to be persuaded, Hasse warned that the "figures offer those who are not at all to be convinced a handle for cheap jokes." He advised, therefore, that the plate "should either be omitted" altogether or instead "arranged in the individual figures" so that each drawing would be presented separately, not juxtaposed with the others.[23] After all, when placed together, the bottom two figures in "A Catarrhine Quartet," an orangutan and a human, were uncomfortable echoes of the "rather sensational picture" that Haeckel had himself drawn for the frontispiece to *Natürliche Schöpfungsgeschichte* (fig. 4.5). In this lithographic plate depicting "The Catarrhine Family Group," the "monkeys are flattered and the men caricatured," as a notice in the *North American Review* complained.[24]

There was nothing remotely uncomplimentary in the depiction of the "Indo-Germanic" man (number 1) in the series of twelve lateral heads. In-

Fig. 4.3. Lithograph by Eduard Giltsch entitled "A Catarrhine Quartet." It contains figures of two apes, the chimpanzee and gorilla, copied without attribution from drawings by Joseph Wolf (fig. 4.4 and plate 3). These are amalgamated, somewhat awkwardly, with original images, created by Giltsch and his son Adolf, of an orangutan and a human. In Ernst Haeckel, *Anthropogenie* (Leipzig: W. Engelmann, 1874), plate XI. (The Bodleian Libraries, University of Oxford, 18917 d. 25. CC-BY-NC 4.0.)

TROGLODYTES GORILLA mas adult.

Fig. 4.4. Lithograph by Joseph Wolf entitled "Troglodytes Gorilla, mas adult." Although the male gorilla has its left foot firmly on the ground in Wolf's drawing, the creature's feet were awkwardly superimposed on the upper branch of a tree when the image was copied in figure 4.3. In Richard Owen, "Contributions to the Natural History of the Anthropoid Apes," *Transactions of the Zoological Society* 5 (1865): plate 4. (Wellcome Collection CC BY 4.0.)

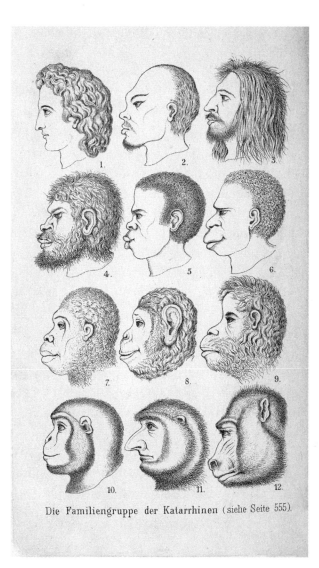

Die Familiengruppe der Katarrhinen (siehe Seite 555).

Fig. 4.5. Lithograph of an original drawing by Haeckel entitled "The Catarrhine Family Group." In this series of twelve lateral heads, which begins with an idealized "Indo-Germanic" man, Haeckel deliberately exacerbates the apelike features of certain of the human races while making some of the apes appear more human. In Ernst Haeckel, *Natürliche Schöpfungsgeschichte* (Berlin: Georg Reimer, 1868), plate I. (© The British Library Board 7004.cc.6.)

deed, his almost perpendicular profile is reminiscent of that of the Greek god Apollo, the idealized apex of similar diagrams created in the eighteenth century (see fig. 3.1). With the putatively lower human races in the hierarchical sequence, on the other hand, Haeckel himself conceded to Charles Lyell: "I think I may have drawn the Alfuru [Australian], Negro and Papua [Tasmanian] too *'pithecoid.'*" In mitigation, Haeckel insisted that his drawings were relatively benign in comparison with the "portraits in older travel books," which had *"even more* ape-like faces." He also implied that it was the unusual decision to draw his "portraits of savages . . . in *profile"* that made them appear particularly prognathous.[25] However, directly below the crude and willfully ugly profiles of two Black women (labeled as African and Tasmanian; numbers 5 and 6), Haeckel had drawn similarly lateral views of anthropoid apes. They, in contrast, were portrayed with strikingly empathetic and, in the case of a female chimpanzee (number 8), even comely countenances.

The analogous images of bestial humans and seductively humanlike apes corroborated what Haeckel, later in *Natürliche Schöpfungsgeschichte,* termed the "very important fact" that the "lowest humans" were "much nearer" to the "highest apes" than they were to Europeans.[26] He nevertheless insinuated, in a letter to Huxley, that the issues that rendered the frontispiece so contentious, and about which Lyell complained, were actually "due to the fault of the lithographer," Gustav Müller.[27] To create "A Catarrhine Quartet" six years later, Haeckel replaced Müller with the Giltsches, but the orangutan that was newly drawn for this lithographic plate, who turns its high-browed countenance to stare knowingly at the viewer, was once again decidedly anthropomorphic.

While Haeckel had the weirdly wizened orangutan substantially redrawn in subsequent editions of *Anthropogenie,* the other figure in "A Catarrhine Quartet" that was an original composition and not merely plagiarized from one of Wolf's more refined plates, remained unchanged. This was the drawing of a young Black man sitting opposite the orangutan, who, in contrast to the astute ape, looks out from the picture with an expression of seemingly ingenuous vacuity (see fig. 4.6). Even if his features, although hardly naturalistic, are not as crudely caricatured as those of the African woman in *Natür-*

liche Schöpfungsgeschichte's frontispiece, his bent knees and outstretched arms still suggest the iconographic tradition in which enslaved people were depicted as kneeling supplicants (see fig. 2.5). The nakedness of the man's lithe torso and the correspondence of his sitting posture to that of the chimpanzee diagonally above him confirm, moreover, that he is just as much a subject of disinterested natural historical scrutiny as the simians surrounding him. Indeed, all are labeled with the same analytical detachment as equivalent specimens, in numerically ordered captions running from "1. Chimpanzee" to "4. Negro," with no sense that the human has any claims to priority.

A Slight Stretch of the Imagination

The numerical labels in "A Catarrhine Quartet" were cross-referenced in the illustration on the preceding page of *Anthropogenie*, the erstwhile frontispiece to *Man's Place in Nature* (see fig. 4.2). Here the plate and figure numbers appear in parentheses in the vertical captions, on the left long edge of the page, directly below each of the primate skeletons. But their order (excluding that of gibbon, whose caption relates to a textual discussion) is not that of Huxley's skeletal sequence; instead the series of figure numbers runs from chimpanzee—"(Taf. XI, Fig. 1.)"—to gorilla to orangutan to human, disrupting the familiar arrangement of the original image. More significantly, for readers of *Anthropogenie* who looked across from these osseous primates to the drawings of living examples of the same species on the facing page, the striding human skeleton at the front of Huxley's series was directly indexed—with the parenthetical caption "(Taf. XI, Fig. 4.)"—to the sedentary "Negro" at the bottom right of "A Catarrhine Quartet."[28] Hawkins had drawn the skeleton of what was almost certainly a European man from the collections of the Hunterian Museum while making life-sized lecture diagrams for Huxley in the early 1860s. When the drawing was subsequently repurposed in *Man's Place in Nature*, no mention was made of its particular origins, and the skeleton was used to represent all humans regardless of race. This made the image particularly potent for abolitionists and advocates of monogenism during the American Civil War. In *Anthropogenie*'s paired

pictures, however, Haeckel for the first time explicitly identified the human in Huxley's frontispiece with a specific racial identity, even if, ironically, it was not that of the actual skeleton.

Initially, in the text of *Anthropogenie*, the book's reproduction of *Man's Place in Nature*'s frontispiece was deployed merely to confirm the by-now-familiar claim that anthropoid apes differed more from each other than they did from humans. This, as Haeckel advised his readers, could be "seen by a glance at the skeletons represented here, as arranged by Huxley (fig. 127–31)." The racial diversity that, for Haeckel, complicated this argument was not mentioned until Huxley's osseous arrangement was brought into conjunction with the inconsistent drawings in the "Catarrhine Quartet" plate. Discussing the gorilla and chimpanzee and referring to "(fig. 130) . . . (fig. 129). Taf. XI, Fig. 1, 2," Haeckel observed: "Both the African Man-like Apes are black in color, and like their countrymen, the Negroes, have the head long from back to front (dolichocephalic)."[29] The convoluted system of cross-referencing directed readers to two images each of the gorilla and chimpanzee, in skeletal and living iterations, drawn, respectively, by Hawkins and Wolf.

Haeckel's spiteful and deliberately provocative reference to "their countrymen, the Negroes," would, almost inevitably, have induced those same readers to also examine the Giltsches' much less subtle drawing of the young Black man, whose head is identifiably long and narrow. The dolichocephalous configuration that he apparently shared with the gorilla and the chimpanzee was not evident in the human skeleton in the illustration on the preceding page. Its skull, as is clear from the cranial measurement "index of breadth 753" recorded in William Henry Flower's catalogue of the Hunterian's specimens, was instead of the mesaticephalic or oval shape—with an index above 29.5 inches (750 millimeters)—that was purportedly characteristic of Europeans.[30] Disregarding any pretensions to anatomical accuracy, Haeckel blithely conflated Hawkins's precise wood-engraved drawing of this skeletal European with the Giltsches' crude lithographic depiction of an African.

Despite his malicious insinuations about the gorilla and chimpanzee's "countrymen," Haeckel did not agree with his own compatriot Carl Vogt that different human races had evolved separately from distinct ape species

with which they shared the same geographical locations. Instead, Haeckel elaborated his own less uncompromisingly polygenist conception of human evolution in *Natürliche Schöpfungsgeschichte*. In the book's second edition, published in 1870, he averred that "all the human species arose only by differentiation from a single species of primitive man," designated "Homo primigenius." This "common primary species," which had itself evolved from the slightly more primitive *Pithecanthropus*, was "now long since extinct." By a process of both natural selection and linguistic variation, humanity had gradually diverged into what Haeckel classified as "twelve species of men."[31] Unsurprisingly, these discrete human species were not deemed to have evolved at the same rates. Haeckel had earlier declared that the "woolly-haired long-headed (dolichocephalic) family . . . belonging to the negro stock, have remained, down to the present day, at the lowest stage of human development, and made the smallest advance beyond the ape."[32] While Haeckel posited that a now submerged "south Indian continent" was the most likely location for "man's primæval home," he suggested that Africa was the other potential candidate and, throughout his career, depicted the continent's current Indigenous peoples as scarcely more than partially developed apes.[33]

Haeckel acknowledged that his novel interpretation of humanity's origins relied on conjecture rather than paleontological evidence, for there were "as yet . . . no fossil remains of the hypothetical primæval man." Even the vaunted recapitulation of phylogeny by ontogeny seemed unable to yield the necessary clues as to the appearance of *Homo primigenius*. Haeckel nevertheless adumbrated a less empirical method by which his readers could picture to themselves this speculative ancestor: "Considering the extraordinary resemblance between the lowest woolly-haired men, and the highest man-like apes, which still exist at the present day, it requires but a slight stretch of the imagination to conceive an intermediate form connecting the two, and to see in it an approximate likeness to the supposed primæval men." The transitional "ape-like men" who might be envisioned, Haeckel advised, would have skulls that were "probably very long, with slanting teeth; their hair woolly; the color of their skin dark, of a brownish tint."[34] Although he conceded that his description of the putative physiognomy of *Homo primigenius* demanded a "stretch of the imagination," it was also remarkably precise.

In the second edition of *Natürliche Schöpfungsgeschichte*, the book's con-

tentious frontispiece was expanded and extensively redrawn, with the excessively pithecoid heads of the African and Tasmanian women replaced by less caricatured male profiles. The plate was also rendered less conspicuous by being demoted to the back of the volume; it was removed altogether from the book's nine subsequent editions. After its elimination, the only pictorial equivalent of Haeckel's imaginary intermediate form was the depiction of the "Negro" in *Anthropogenie*'s "Catarrhine Quartet." The young Black man drawn in wax by the Giltsches was already considered to have evolved from humanity's apelike ancestors much less than other races. More particularly, his appearance, even down to the overbite of his visibly slanting teeth, corresponds exactly to every detail in Haeckel's itinerary of the features of *Homo primigenius*. In the composition of "A Catarrhine Quartet," moreover, the young man is ensconced in the lower branches, below even the gorilla and chimpanzee, of a tree that anticipates the German oak in which, in the "*Stammbaum*" plate only a few pages later, humans are located at its lofty pinnacle. It would hardly have been surprising if readers of *Anthropogenie* got the distinct impression that this youth represented merely the penultimate "stage in our ancestral series" rather than a "true 'Man.'"[35]

By directly indexing the human in Huxley's series of primate skeletons on the preceding page to this ambiguous African, Haeckel ensured that it, too, could be viewed in the same light. Having been lauded by some reviewers of *Man's Place in Nature* as resembling a classical deity, the striding skeleton that led the book's frontispiece was now reconfigured, in *Anthropogenie*, as a potential missing link between apes and humans.

Not Entirely English

Despite Huxley's warm words in the *Academy*, Haeckel feared that *Anthropogenie* would "find few friends in England." As he told Huxley, "Your compatriots don't want to spoil it [i.e. fight] with priests; the culture war appears superfluous there!"[36] This contrasted with the situation in the newly unified Germany, where Haeckel's stridently secular account of human origins afforded potent ammunition to liberals in their *Kulturkampf* with reactionary Catholic clerics. With the controversy inevitably boosting sales, the book's publisher, Wilhelm Engelmann, as Haeckel told his wife, was soon announc-

ing "with a smile that the first edition . . . was already out of print (14 days after publication!)."[37] While *Anthropogenie*'s original German edition also excited attention and healthy sales elsewhere in Europe, it was, Haeckel lamented, "bought very little in England." Apathy toward the ideological conflict in Germany was not the only problem. As Darwin reflected consolingly, the "reason that so few copies have been sold in England is . . . that very few Englishmen read German with ease."[38] The need for an English translation was therefore pressing.

Haeckel had granted "special and exclusive permission" to translate *Anthropogenie* to an American freelance writer, Gustav Van Rhyn, who "started immediately after" the book's publication in Germany in September 1874.[39] But Van Rhyn, as the publisher, Charles Kegan Paul, noted haughtily, was "not entirely English," and his defective translation required corrections that delayed publication for four years.[40] When the book finally appeared, as *The Evolution of Man*, at the beginning of 1879, the redrawn orangutan from the "Catarrhine Quartet" plate, reprinted from *Anthropogenie*'s revised third edition, was now decidedly less anthropomorphic, although Joseph Wolf's once refined chimpanzee had been given an incongruous grin (fig. 4.6). The erstwhile frontispiece to *Man's Place in Nature* that was indexed to this much-modified plate remained unchanged, albeit reproduced from inexpensive stereotypes that Engelmann supplied to Kegan Paul.[41]

It was this rendering of Huxley's sequence of ascending primate skeletons that remained in circulation in Britain and America in the final decades of the nineteenth century. Between 1883 and 1903, *The Evolution of Man* was reprinted twice in London and seven times in New York.[42] As this suggests, Haeckel's bold, progressive conception of evolution was particularly potent in America. By contrast, *Man's Place in Nature* was, as Huxley conceded in 1875, "out of print and gone to the limbo of forgotten things," and this disparity between the availability of Haeckel's and Huxley's respective tomes soon became even more pronounced.

If Kegan Paul's initial printing of the *Evolution of Man* was notably expensive at thirty-two shillings, a new translation, based on *Anthropogenie*'s fifth edition from 1903, was markedly cheap. Indeed, it was advertised as "one of the cheapest scientific books ever published."[43] It was issued by the freethinking publisher Charles Albert Watts as part of the Rationalist Press

1. Chimpanzee

2. Gorilla.

3. Orang.

4. Negro.

Association's "Cheap Reprints" series and was published in two volumes, issued successively in the summer of 1906, priced at just six pence each. Such unprecedented cheapness was achieved by discarding many of the book's numerous illustrations, including all of the expensive lithographic plates. The translator, Joseph McCabe, regretfully acknowledged how much had to be "omitted . . . in order to bring out the work at our popular price," and he urged the plebeian "reader to consult, at his free library perhaps . . . the beautiful plates of the complete edition."[44] "A Catarrhine Quartet" had already been cut by Haeckel from the fifth German edition, and the "*Stammbaum des Menschen*" was not included in the more expensive version of McCabe's translation that Watts had brought out in 1905. *Man's Place in Nature*'s frontispiece, by contrast, survived even the extreme frugality of Watts's abbreviated reprint, where the wood-engraved image was incorporated into two columns of densely printed text.

The Rationalist Press Association also included *Man's Place in Nature* in its "Cheap Reprints" series. Tellingly, Huxley's book was not added to the list—with its frontispiece now demoted to an internal illustration—until 1908, two years after the association's translation of Haeckel's *Evolution of Man*. The German, now in his seventies, was the most celebrated and recognizable proponent of evolution in the world, and it has been proposed that in the late nineteenth and early twentieth centuries "more people learned of evolutionary theory through Haeckel's popular works than through any other source."[45] With the successive editions and translations of *Anthropogenie* each retaining the same familiar image of primate skeletons despite the otherwise radical revisions that they underwent, Haeckel did far more to popularize *Man's Place in Nature*'s frontispiece than Huxley, who died in 1895, ever had.

At the height of his fame, Haeckel was invited to address the International Congress of Zoology held at Cambridge University in August 1898. Speaking, in halting English, on "our present knowledge of the descent of

Fig. 4.6. Lithograph entitled "Four Catarrhines." In this revised version of figure 4.3, the orangutan in the bottom left has been substantially redrawn while the chimpanzee is given an incongruous grin. In Ernst Haeckel, *The Evolution of Man*, 2 vols. (London: Charles Kegan Paul, 1879), 2:plate XIV. (Wellcome Collection CC BY 4.0.)

man," he traced the mammalian phylogeny "from the Monotremata up-wards to Man." Humanity's gradual evolution from such oviparous ancestors, Haeckel asserted, was "at present no more a vague hypothesis, but a posi-tively *established fact*." To help his audience visualize the process, Haeckel displayed an innovative "spectral diagram" in which the colors of the spec-trum were placed in parallel columns with a phylogenetic procession of animal forms, concluding with apes and humans alongside a column of brilliant red.[46]

When the lecture came to focus on this far end of the spectrum, how-ever, Haeckel deployed a much more traditional visual aid. As a reporter for the American journal the *Nation* recorded: "Illustrating the descent of man, he showed a series of skeletons, beginning with the lemurs (after Huxley) and coming up to man."[47] Another American who attended the address later explained that Haeckel, upon arriving in Cambridge, had visited the univer-sity's Museum of Comparative Anatomy and Zoology. He "took out of it all the anthropoid ape skeletons and a human skeleton, and before his learned audience raised them all alike into an erect position," placing them "upright in line . . . across the great platform."[48] On this prestigious podium, Haeckel opted to re-create, in three dimensions, the famous parade of standing pri-mate skeletons that he had reproduced in *Anthropogenie*, which itself had its origins in life-sized diagrams Huxley had displayed in his own lectures in the early 1860s.

There was, as the *Nation* reported, a "certain extravagance attaching to many of Haeckel's opinions" during his address in Cambridge.[49] In particu-lar, Haeckel assured his auditors that what he termed "*progressive heredity*," impelled by the inheritance of acquired characteristics, was the vital explan-atory factor behind "all of transformism," driving an inexorable ascent "from the unicellular Protista upwards to the chimpanzee and to man."[50] This bold vision of evolution as a hierarchical progression toward ever higher forms was articulated, in the peroration to Haeckel's lengthy address, while he stood beside the series of ascending skeletons he had just used to demon-strate humanity's intimate proximity to apes. At the close of the nineteenth century, the image that Huxley had devised as the frontispiece to *Man's Place in Nature* was now firmly associated with Haeckel's own distinctive concep-tion of evolutionary progress.

Reduced to a Common Size

The particular iconographic potency that Haeckel evidently still perceived in this forty-year-old wood-engraved illustration was facilitated by what, in the early 1860s, had been the brand-new technological innovation of photographic reduction. In the opening decades of the twentieth century, the development of newer and more flexible methods of photomechanical reproduction, allowing more precise calibrations of scale and the adjustment and retouching of halftone photographs, helped rejuvenate the image.[51] It had, as Haeckel reflected in 1910, been a "very happy idea . . . to place pictures of the skeletons of man and the four surviving anthropoid apes on the front page of . . . 'Man's Place in Nature,'" and he acknowledged that he had "copied the pictures in my 'Anthropogenie.'" But when preparing the published version of lectures he had given in Berlin in 1905, Haeckel considered that it was now time for a new version using "pictures of the same five skeletons, but from specimens in my own collection."[52] His personal "collection of anthropomorphs" had in fact only recently been assembled. Haeckel excitedly told a friend in March 1905 that his "skeletons of the other man-like apes" were now complemented by a "colossal skeleton of a male giant gorilla" for which he "had sought in vain for a long time."[53] The newly assembled skeletons, as Haeckel related, were "photographed by my tried collaborator, Mr. Adolf Giltsch," the artist who, with his father, Eduard, had earlier created the "Catarrhine Quartet" plate.[54]

Since inheriting his father's small lithographic workshop in Jena, Giltsch, as Haeckel noted approvingly, had opted to "preserve the merits of a medium-sized sphere of activity, with full personal freedom," and spent much of his career working almost exclusively for Haeckel.[55] Despite refusing to "expand his modest business . . . into a large modern lithographic institution," Giltsch was still in a position to utilize the process of photographic reduction, though not in Jena.[56] As he explained to Haeckel in March 1904, he sent the "technical reproductions to be carried out" to the much larger Bibliographisches Institut in Leipzig, where Giltsch was regarded as a "simple provincial."[57] It was presumably the institute that produced the "photogram" that, as Haeckel explained when sending it to a friend in May 1904, was a "scaled down copy of a large votive board that my local artist, . . . Adolf

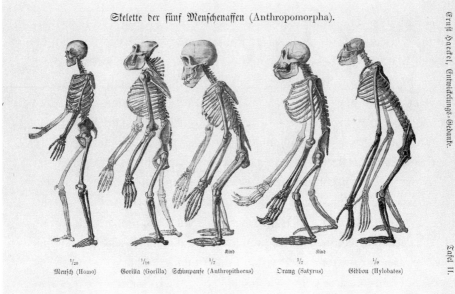

Skelette der fünf Menschenaffen (Anthropomorpha).

Ernst Haeckel, Entwickelungs-Gedanke.

Tafel II.

| Menſch (Homo) | Gorilla (Gorilla) | Schimpanſe (Anthropithecus) | Orang (Satyrus) | Gibbon (Hylobates) |

Fig. 4.7. Composite image made from five photographs of primate skeletons entitled "*Skellette der fünf Menschenaffen* [Skeletons of Five Man-Like Apes] (Anthropomorpha)." The photographs, taken by Adolf Giltsch, were reduced at different scales, giving the skeletons in the sequence a uniform size. Haeckel deliberately selected younger specimens of the orangutan and chimpanzee, although the larger size of their skulls gives the composite image a distorted appearance. In Ernst Haeckel, *Der Kampf um den Entwickelungs-Gedanken* (Berlin: Georg Reimer, 1905), plate II. (Author's collection.)

Giltsch, made to celebrate my seventieth birthday."[58] A year later, Giltsch again collaborated with the institute to undertake the complicated procedure of transforming the five separate photographs he had taken of Haeckel's collection of primate skeletons into a composite image that both echoed and amended Huxley's frontispiece (fig. 4.7).

The sequence of anatomical photographs that Giltsch fused together, which appeared as the second of three plates in Haeckel's *Der Kampf um den Entwickelungs-Gedanken* (1905), reversed the order of Huxley's original figures, running across the page from right to left. More importantly, the five skeletons were, as Haeckel explained, "reduced to a common size." This uniformity was achieved by shrinking each of the images separately to

different scales, with the "human skeleton . . . 1/20th natural size, the gorilla 1/18th, the chimpanzee 1/7th, the orang 1/7th, [and] the gibbon 1/9th."[59] The corresponding primates in the frontispiece to *Man's Place in Nature* had all been reduced to the uniform scale of approximately 1:27. Haeckel's skeletal surrogates were therefore individually larger than their prototypes, filling the space of the plate in the royal octavo volume and even threatening to rupture its margins if they were to lift their arms or stand fully erect.

While otherwise replicating the postures of the skeletons in Huxley's original, these new osseous primates were depicted at almost exactly the same height. Haeckel conceded that he had purposely selected "young specimens of the chimpanzee and orang . . . because they approach nearer to man than the adult," meaning that a smaller variation of scale was required in "raising their size to correspond with the other three skeletons."[60] The skulls of the two younger apes, especially that of the chimpanzee in the middle of the series, were nevertheless considerably larger than those of the gibbon, gorilla, and human. This gives the composite image a distorted, almost grotesque appearance reminiscent of the incongruous disparities of scale in "A Catarrhine Quartet."

The standardization that created such aesthetic defects was necessary, Haeckel insisted, "in order to show better the relative proportions of the various parts" in the five skeletons. It would enable a "candid comparison" of them that would verify that they were "not only very like each other generally, but are *identical* in the structure, arrangement, and connection of all the parts." Haeckel dismissed the "few salient differences in the size of the various parts" that would be apparent if the primate skeletons were depicted at a uniform scale as "purely quantitative." He was instead more concerned that such an arrangement might induce only a "superficial comparison of our skeletons." The photomechanical calibration of these differential dimensions, on the other hand, disclosed the "uninterrupted . . . morphological chain" linking humanity with the apes. In fact, Giltsch's revised sequence of primate skeletons, Haeckel avowed, now afforded one of the clearest "anatomical proofs of the pithecoid theory."[61]

The uniform height of each of the differentially scaled skeletons removed the sense that the apes were successively ascending to the height and uprightness of the human at the end of the series. Successive ascension had

been integral to the potency of Huxley's original image, which Haeckel had himself augmented by reproducing it in *Anthropogenie* alongside the unmistakably progressive arboreal imagery of the "*Stammbaum*" plate. Forty years later, however, there were clear reasons why Haeckel might now wish to temper this particular aspect of the image. Back in the 1880s, Edwin Ray Lankester, who had earlier translated Haeckel's *Natürliche Schöpfungsgeschichte*, warned that there was a "very widespread notion that the existing anthropoid apes, and more especially the gorilla, must be looked upon as the ancestors of mankind, if once the doctrine of the descent of man from ape-like forefathers is admitted."[62] By the beginning of the twentieth century, even ostensible experts such as the anthropologist Hermann Klaatsch were attempting to refute Haeckel's conception of human evolution on the grounds that "none of the living apes can be the ancestor of humanity." Haeckel was adamant that "no competent scientist had ever said anything so foolish," but he was evidently aware that certain visual images could convey precisely such an impression. In his explanation of the plate in *Der Kampf um den Entwickelungs-Gedanken* Haeckel gave an imperative caution concerning the four "living anthropoid apes" that were portrayed: "None of them are direct ancestors of man."[63] The newly standardized heights of the different skeletons in the plate, which converted the original image's distinctive upward curve into a nearly flat line, helped reinforce the message.

Five Anthropoid Apes

Der Kampf um den Entwickelungs-Gedanken was translated into English by Joseph McCabe, who ignored its literal meaning (The Struggle for the Development Theory) and instead adopted the considerably less bellicose title *Last Words on Evolution*. This reflected his assumption that the three lectures on which the book was based, given in Berlin in April 1905, were the final "public deliverance that the aged professor will ever make." Haeckel's "enfeebled health," McCabe predicted, would condemn him to "remain a passive spectator of the tense drama in which he has played so prominent a part for half a century."[64] Despite the more peaceable title, McCabe's translation, and particularly its construal of the text accompanying the book's second plate, helped exacerbate a controversy in which Haeckel was far from

passive. Indeed, this new dispute revived and even intensified the hostilities of the original *Kulturkampf* over evolution in the mid-1870s.

Haeckel had given the plate of Giltsch's rescaled anatomical photographs the German title "*Skellette der fünf Menschenaffen* (Anthropomorpha)." In the original edition of *Anthropogenie* the reproduction of Huxley's frontispiece had been labeled "*Skelett des Menschen und der vier Anthropoiden-Gattungen* [Skeleton of Man and the Four Anthropoid Genera]," and in the book's phylogenetic tables Haeckel was similarly careful to distinguish between "*Menschen*" and "*Menschenaffen*," between humans and the "man-apes" that came immediately below humanity.[65] Thirty years later in *Der Kampf um den Entwickelungs-Gedanken,* he now included humans along with the other four primates as "*Menschenaffen*" while also invoking, in parentheses, the eighteenth-century taxon Anthropomorpha in which Linnaeus had grouped humans, apes, and sloths.

Still more contentiously, McCabe, in translating this title, simplified it to "Skeletons of Five Anthropoid Apes," discarding any mention of man.[66] This made Haeckel's intimations that humans were merely apes of exactly the same taxonomic status as gorillas and chimpanzees daringly explicit. McCabe had been a Catholic priest until the mid-1890s, but after renouncing his faith he had quickly become as acerbic in his secularism as Haeckel. He later tempered his audacity, explaining that he had given his own title to the "fine plate showing the skeletons of man and the four anthropoid apes . . . in unconscious humour."[67] Even if unintended, such debasing drollness seemed to confirm the qualms of Haeckel's detractors at the same time that secularists and conservatives in Germany were creating formal organizations to consolidate their antagonism.

In 1906 Haeckel's supporters formed the Monist League and installed him as the honorary president. A year later, in June 1907, he invalidated the plaintive title of McCabe's translation of his Berlin lectures by giving another valedictory address on evolution in Jena. Among a multitude of visual aids, Haeckel exhibited, as he had in Cambridge a decade before, a series of actual skeletal specimens, positioned facing the audience, on the capacious lecture platform (fig. 4.8). But if Haeckel, as has been proposed, had the numerous specimens and diagrams "arranged like elaborate altarpieces around the stage," then the exalted position conventionally assigned to im-

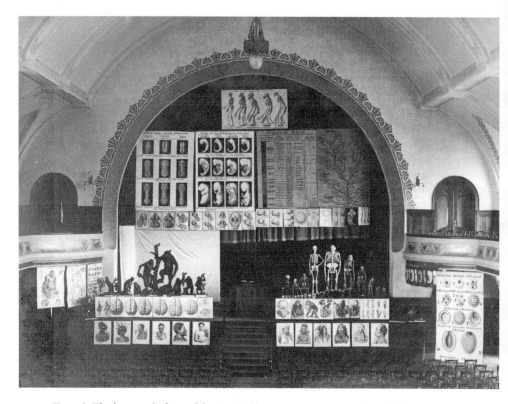

Fig. 4.8. The lecture platform of the Jena *Volkhaus* on June 18, 1907, ahead of Haeckel's lecture on *"Das Menschen-Problem."* An enlarged version of the composite image of five primate skeletons in figure 4.7 appears at the top. Photograph, 1907. (Archiv des Ernst-Haeckel-Haus, Friedrich-Schiller-Universität, Jena.)

ages of Christ at the top of a reredos—the decorative screen behind an altar—was given to a decidedly secular icon.[68] The composite image that, in Huxley's initial incarnation, had been created by photographically reducing life-sized lecture diagrams was now, in Haeckel's final lecture, enlarged back to its original dimensions. From the more than fifty illustrations that were arrayed on the podium in Jena, Haeckel selected only three as halftone plates in the published version of his lecture, a cheap pamphlet entitled *Das Menschen-Problem* (1907). The first plate was a reprint of Giltsch's skeletal series, which retained its bold title referring to *"fünf Menschenaffen."*

Five months after Haeckel's lecture in Jena, conservative German scientists formed their own Kepler League to rebut the materialistic views propa-

gated by the Monist League. The new organization's official lecturer, Arnold Brass, soon launched a blistering attack on the rival league's honorary president in a lecture that was published, in a direct rebuke to Haeckel's own recent pamphlet, as *Das Affen-Problem* (1908). Commenting on the provocative "heading" given to the first plate in *Das Menschen-Problem*, Brass thundered: "So Haeckel does what no zoologist has done before, including humans directly with the apes." Even other advocates of evolution, Brass opined, had never "dared to do such a thing," and Haeckel's unique recklessness ensured that his "whole philosophy of nature" was singularly offensive to conservative and Christian beliefs.[69]

Neither *Das Menschen-Problem* nor Brass's indignant riposte were translated into English, but the title that Haeckel gave to Giltsch's plate was even more incendiary for anglophone supporters of the Kepler League, who responded to McCabe's translation of it in *Last Words on Evolution*. The Jesuits Joseph Assmuth and Ernest Reginald Hull observed contemptuously that the "plate is headed 'Skeletons of Five Anthropoid *Apes*'—thereby embodying Haeckel's favourite contention that man is a true ape." It was, they insisted, "dead against the systematic usage in zoology" to "place man as *one* of the apes," even if he might be "classed *with* the apes" as part of the taxonomic order of primates. Assmuth and Hull, who were based in India, conceded that they did not have "Haeckel's original plate to refer to." They were nevertheless unrepentant when informed that the plate's problematic title was "not the work of Haeckel" and that instead the "mistake was inadvertently made by Mr. McCabe, the translator." It was, Assmuth and Hull remarked, a "strange mistake to be made inadvertently," and they concluded, with ironic Jesuitical forbearance, that "to err is human; to forgive divine."[70] The audacious title given to Giltsch's reworking of the series of primate skeletons, and especially McCabe's imprudent translation of it, had given Haeckel's enemies the upper hand.

Intentional Falsifications

In a second edition of *Das Affen-Problem*, Brass proposed that the plate's distasteful title had resulted in a still more egregious problem with the image itself. The pictures of the five primate skeletons, he alleged, had required

"intentional falsifications to uphold the false caption!" Brass itemized the ways the individual figures had been manipulated to bring a specious consistency to the composite image: "The uprightness of man's carriage is concealed. The gorilla's knee has been pressed to make it appear to be standing straight. The walking posture of all the apes is false." Even the gorilla's jaw had been forced shut to ensure that its teeth were pressed together in a "purely manlike way" that, according to Brass, the creature would never assume naturally.[71]

Such charges of deliberate falsification were particularly awkward for Haeckel because similar accusations of forgery had dogged his comparative illustrations of embryos since the late 1860s. The initial allegations—that Haeckel reused the same engraved blocks to create composite diagrams that appeared to prove that embryos of widely different creatures were indistinguishable—had reached a peak during the *Kulturkampf* of the mid-1870s. Forty years after the original controversy, Brass made the charges of distortion and forgery once again. Even if Haeckel threatened legal action against such malicious slander, Brass's insinuations threatened to tarnish the plate showing the close correspondences between primate skeletons as much as they would damage the diagrams of interchangeable embryos.[72]

Haeckel responded to Brass in a further pamphlet, *Sandalion* (1910), which would be his final publication. He rebuffed the "untruths" regarding the contrived postures of the human and simian skeletons by pointing out that they were based on "clear, absolutely faithful photographs" taken by Giltsch. Haeckel asserted that "neither he nor I made any change whatsoever in their form or position."[73] Giltsch, his patron later enthused, combined both the "keen eye and skillful sure hand of the fine artist" and the "knowledge of the real naturalist" with a willingness to utilize the precision afforded by "all the tools of modern technology."[74] McCabe too deemed that the photomechanical objectivity of Giltsch's image absolved Haeckel of all Brass's malicious imputations, insisting that "they are *photographs* of the actual skeletons."[75] Brass had goadingly questioned Haeckel's "monistic courage," claiming that he preferred to "hide behind . . . a draughtsman" whom he could blame for any errors in his illustrations (as indeed he had with the lithographer Gustav Müller back in the 1860s).[76] With the halftone plate of

skeletal simians, Haeckel again abnegated responsibility, this time assigning it to the lens of Giltsch's camera.

While Haeckel flaunted his use of modern technology, his opponents adopted the now decidedly old-fashioned wood-engraved frontispiece to *Man's Place in Nature* as a more trustworthy counterpart to Giltsch's photographic version of its skeletal sequence. Brass condemned the latter as a "willful falsification of Huxley's plate," one that provided a telling "example of how Haeckel misuses the works of other people."[77] For the Jesuits Assmuth and Hull, the contrast between the two illustrations was even more salient. Referring to the youthful chimpanzee and orangutan skeletons with which Haeckel had supplemented his image, they complained that "he acknowledges the substitution of two new figures, but leaves the reader under the impression that the other three are those of Huxley. In point of fact, they are enormously changed. Any reader who likes to compare the two drawings will be struck with the differences both in general appearance and in many details."[78] To facilitate such a comparison, Assmuth and Hull reprinted the two diagrams, at the same scale and with Huxley's frontispiece reversed, in their 1915 pamphlet *Haeckel's Frauds and Forgeries* (fig. 4.9).

The most conspicuous disparity that was revealed, Assmuth and Hull suggested, was that Haeckel's skeletons were "drawn . . . to widely different scales," which had been done solely "in order to make them look more alike." The spurious similarities meant that "Haeckel's row gives the impression of a *progressive sequence*." By contrast, "Huxley's row," notwithstanding the upward curve created by the skeletons' differential heights, merely gave the "impression of a rather heterogenous set of beings." Haeckel, the two Jesuits alleged, deceitfully tried to pass off his own image as virtually identical to *Man's Place in Nature*'s frontispiece. In reality, it had been "studiously worked out . . . to give a better support to his theory than that given by Huxley's plate," which, in comparison with Haeckel's "shameless frauds and forgeries," was admirably naturalistic.[79]

Even more damning, for Assmuth and Hull, were the smaller details in which the respective rows of primate skeletons diverged. They contended that "Huxley's apes are shown more or less correctly walking on the outer edges of their hind extremities," whereas "Haeckel's apes all walk on the flat

PLATE II.
SKELETONS OF APES AND OF MAN.
(See Page 85.)

I. HUXLEY'S ORIGINAL PLATE (REVERSED.)

Man. Gorilla. Chimpanzee Orang. Gibbon.

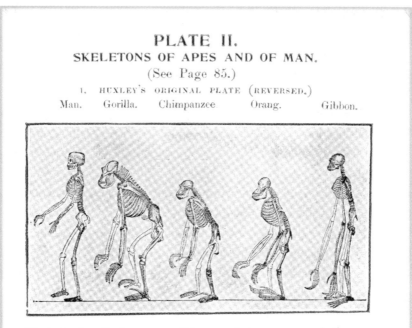

Huxley's plate displays many differences between man and the apes; e. g., the bent posture of the apes, the turned-up position of their feet, etc.

II. HAECKEL'S MODIFICATION OF THE ABOVE.

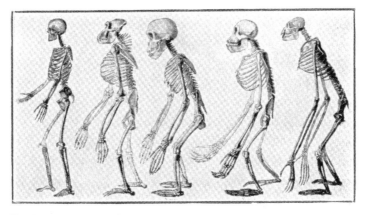

Haeckel substitutes two new figures, makes the feet of the apes flat like those of man, straightens up their backs, cuts off the neckbones of the gorilla, and creates an impression of sequence altogether untrue to nature, so as to support his theory of descent.

sole as man does" and had been falsely given the "gait of man." Such dis-crepancies were especially evident in one specific simian, and Assmuth and Hull urged their readers to "notice particularly the gorilla next to man." It was with the awkward gait of the gorilla in the frontispiece to *Man's Place in Nature* that Hawkins had been able to surreptitiously express his own defiance of Huxley's account of the same creature. More than half a century later, Assmuth and Hull now seemed to intuit the covert resistance to evolu-tion that Hawkins had secreted in his drawing of the gorilla skeleton totter-ing on the sides of its feet (see fig. 1.8). They certainly considered that the existence of an insuperable morphological "gulf" between humans and apes was "clearly shown in Huxley's original plate, but willfully obliterated in that of Haeckel."[80] The version of the frontispiece reprinted by Assmuth and Hull did not retain the caption acknowledging Hawkins's integral in-volvement in the image. In any case, they could have had no inkling of the private tensions from which it emerged. They nevertheless appropriated Hawkins's drawings of the five primate skeletons as an exemplar of their own Jesuitical conception of human uniqueness.

Haeckelophobia

Haeckel was now in his eighties, but, according to Assmuth and Hull, he remained an "incorrigible sinner in his old age" whose persistent "trifling with the facts of nature" would long sully his reputation.[81] The rapid de-cline in the German's scientific standing was especially acute in the United States, where his vision of evolutionary progress had once been hugely pop-ular. By the early 1930s, some observers were even diagnosing the outbreak of a "regular epidemic, which may be named *Haeckelophobia*." American "public confidence in Haeckel's conclusions" was undermined in particu-

Fig. 4.9. Plate entitled "Skeletons of Apes and of Man" comparing a reversed version of the frontispiece to Huxley's *Man's Place in Nature* (fig. I.2) with Haeckel's modification of it (fig. 4.7). According to the captions, the comparison reveals that Haeckel's image is based on a deception, whereas Huxley's original frontispiece, which apparently shows the differences between humans and apes, is regarded as a truthful representation. In J. Assmuth and Ernest R. Hull, *Haeckel's Frauds and Forgeries* (Bombay: Examiner Press, 1915), plate II. (© The British Library Board 7006.aaa.51.)

lar by the recantation of a former admirer who had been in the audience for his address to the International Congress of Zoology back in 1898.[82] Thirty years later Henry Fairfield Osborn recalled that "I myself was present at Cambridge," although he now considered that the series of primate skeletons which Haeckel had "raised . . . all alike into an erect position" constituted an "unintentional falsification of evidence." Following Haeckel's death in 1919, Osborn was among the most prominent proponents of evolution in the world, and the American Museum of Natural History in New York, of which he was the president, was fast becoming the leading center for the study of humanity's evolutionary development. Osborn had long been a "firm believer in the anthropoid ape theory of ancestry," but in 1924 he experienced a moment of revelation in which, as he later recounted, an entirely new understanding of human origins "flashed across my mind."[83] As a result of this sudden conversion, Osborn now viewed the attempts of earlier naturalists to portray the parallels between humans and simians in a very different light.

In what Osborn termed "my present Dawn Man theory," he proposed that primitive humans had begun to diverge from the common ancestor they shared with apes considerably earlier than previously believed.[84] Humanity, in Osborn's account, had developed entirely separately from living anthropoid apes, who could therefore offer no clue whatsoever about the appearance or habits of our evolutionary precursors. For the patrician Osborn, this "new idea of the aristocracy of man" would expunge the taint of what Huxley had mordantly dubbed a "pithecoid pedigree" and restore man's respectable lineage.[85] Haeckel, too, had indulged in egalitarian irony when revealing that "nobles as well as commoners" shared the same apelike ancestry. Osborn presented paleontological evidence that seemed to refute such distasteful sarcasm and affirm his own view of humanity's inherent nobility, especially the recently discovered remains of the so-called Piltdown Man. But he also resorted to less principled means of buttressing his new theory. In particular, Osborn sought, as he freely admitted, to "stigmatize the ape-man theory as a myth."[86] To do this, he targeted all his considerable institutional and personal resources on what he peevishly called "deceptive representations of apes as bipedal," in which standing simians were presumed to share their ancestry with humans.[87]

The only problem was that Osborn, who had studied under Huxley in London at the end of the 1870s, had long revered him as "my chief teacher in comparative anatomy." Indeed, only months before his Damascene conversion to the Dawn Man theory in 1924, Osborn had lauded his former tutor as a "master not only in the search for truth but in the way in which he presented it." Huxley's most famous presentation of his insights into human evolution was indubitably the frontispiece to *Man's Place in Nature*, precisely the image whose bipedal primates Osborn now perceived as grievously misleading. Before his apostasy on the issue of ape ancestry, Osborn had proudly considered himself a beneficiary of the "battles fought by such men as Huxley and Haeckel," although it was clearly the former to whom he felt most loyalty.[88] Even when, by 1925, he could no longer "agree with my great master of 1879–80," Osborn suggested that this was simply because recent discoveries had enabled scientists to "know far more about the actual evolution process than Huxley did." Such retrospective lenience was not extended to the erstwhile "great proponent of Darwinism on the Continent of Europe." Osborn concluded curtly that Haeckel's "theories of the origin and evolution of man have crumbled."[89]

Whether intentionally or not, Osborn mistakenly attributed the offending illustration of erect apes to the now discredited German and was therefore able to absolve "my great teacher Huxley" of any responsibility.[90] In exposing the "ape-man myth," Osborn exclaimed that "Haeckel . . . grossly exaggerated the ape-human resemblances in his 'Anthropogenie' by placing ape skeletons all alike in a false erect position." The six editions of *Anthropogenie* published between 1874 and 1910 had all reproduced Huxley's wood-engraved sequence of primate skeletons with the legally required attribution to the original source. This remained the case even after Haeckel switched, in 1905, to his own photographic version of the same image in other publications. When condemning the illustration in *Anthropogenie*, Osborn also alluded to what he called the "masterly 'Man's Place in Nature,'" but he conveniently ignored the book's conspicuous frontispiece and instead blamed Haeckel for its apparent falsity and exaggeration.[91]

Osborn's strategic subterfuge seems to have confused even himself when he was preparing the published version of a paper he gave at the New York Academy of Medicine in 1927. Before this specialist audience, Osborn be-

rated the prevalent "misrepresentations of ape and human resemblance" that falsely depicted "apes and gorillas as walking erect." This grievous "error," he lamented, was to be "found even in the works of such a relatively cautious scientist as Haeckel."[92] To illustrate this passage in the published paper, Osborn had the staff of the American Museum of Natural History produce two glossy photographs. One was of the series of skeletons reproduced in *Anthropogenie* and the other was of Huxley's original version of the image, which was clearly labeled "Frontispiece of 'Evidence as to Man's Place in Nature,'" taken from the book's American edition (see fig. 3.4).[93] Oddly, it was the latter photograph, which even showed the inscription of the abolitionist engraver Jocelyn, that Osborn chose to print in the *Bulletin of the New York Academy of Medicine* with the patently erroneous caption "Skeletons of anthropoid apes placed sub-erect in line with man in an entirely unnatural standing position by Haeckel."[94] Osborn's own misrepresentation was no less flagrant than that for which he castigated Haeckel. And his confusion had important implications for the credibility of the image that he saw as emblematic of the "scientific mythology" of the "ape-human theory."[95]

Brass and the Jesuits Assmuth and Hull had commended the veracity of the frontispiece to *Man's Place in Nature*, reserving their criticism for Haeckel's photographic manipulation of the same skeletal sequence. Osborn, however, seemed not to recognize the differences between the two and applied the same egregious epithets of falsification and deception to Huxley's original image, even if he mistakenly attributed it to Haeckel. To make matters worse, Osborn's scientific and social standing enabled him to propagate these charges in the pages of mass-circulation newspapers. In a full-page article in the *New York Times* in July 1925, Osborn denied that any "anthropoid ape is even remotely related to the stock which has given rise to man." He announced that the "diagrams of Haeckel representing them walking on their hind feet are myths or gross misrepresentations of the gaits and postures of these tree-living apes."[96] It was, of course, Huxley's image of bipedal simians that Osborn was actually traducing as a gross misrepresentation to the *New York Times*'s more than half a million readers. Despite presenting himself as Huxley's protégé, Osborn did far more to damage the reputation of his mentor's frontispiece than any of its more obvious detractors.

The Shadow of Erik

Given Osborn's urgent endeavor to show that the "ape-ancestry hypothesis is entirely out of date," he was perturbed, as he complained in another contribution to the *New York Times*, that the misconception still "lingers . . . in movies."[97] But in the newly influential medium of cinema, it was actually Osborn's own antipathy toward earlier theories of human evolution that had the most tangible impact. Only months before the diagnosis of America's "*Haeckelophobia*," Universal Pictures released another of the horror movies that struck a chord with audiences during the economic depression of the early 1930s. Following the success of *Dracula* and *Frankenstein* in the previous year, *Murders in the Rue Morgue*, another adaptation of a nineteenth-century Gothic classic, opened in cinemas in early 1932. The Hungarian-born actor Bela Lugosi, who had become a star as the eponymous vampire in *Dracula*, was now cast as the equally enigmatic Doctor Mirakle.

This mad scientist, who did not feature in Edgar Allan Poe's original story, is an ardent evolutionist who keeps a large ape, of indeterminate species, named Erik. He displays Erik at a carnival sideshow in order to show the close affinities of humans and simians, declaring, "I am not exhibiting a freak, a monstrosity of nature, but a milestone in the development of life. The shadow of Erik the ape hangs over us all. The darkness before the dawn of man."[98] Osborn was just then presenting his own Dawn Man theory as an antidote to the Great Depression, with the *New York Times* announcing, in August 1932, his determination to "defeat defeatism." There was, the newspaper reported, "no depression" in Osborn's scientific research, which "elevates the Piltdown Man . . . as the oldest known human fossil."[99] In *Murders in the Rue Morgue*, however, the malevolent Doctor Mirakle was far from sharing Osborn's concern with human nobility.

During a speech at the sideshow, Mirakle, pointing with menacing intensity, directs his hearers' attention to two diagrams. On his left, mounted on an easel, is an enlarged version of the series of five primate skeletons that originally served as the frontispiece to *Man's Place in Nature*. More conspicuously, on Mirakle's right is a much larger diagram, painted on a canvas sheet hanging from the roof of the circus tent in which he delivers his lecture. Crude copies of Hawkins's drawings of the chimpanzee, gorilla, and

Fig. 4.10. Bela Lugosi as Doctor Mirakle, a mad scientist who keeps an ape called Erik and, in a lecture at a carnival sideshow, uses diagrams based on the frontispiece to Huxley's *Man's Place in Nature* to prove Erik's close relation to humans. In *Murders in the Rue Morgue*, directed by Robert Florey (Universal Pictures, 1932), 00:09:07. (© 1932 Universal Pictures. Courtesy of Universal Studios Licensing LLC.)

human from Huxley's frontispiece have been transposed to the bottom corner of this new image, creating a strange pictorial duplication on either side of Mirakle, whose own looming shadow intensifies the effect of Gothic doubling (fig. 4.10). The large composite diagram depicts, in three continuous rows, the ascending stages of humanity's phylogenetic lineage, beginning with magnified protozoa and progressing through fish, amphibians, and apes up to man. With the exception of the three skeletal primates, all the other creatures are portrayed with their flesh and external coverings intact, although the disparate figures are given some cohesion by the circled numbers attached to each of them. The twelve successively more advanced organisms seem to transmute into each other before finally arriving at their evolutionary telos: a rough approximation of Hawkins's human skeleton.

The first time that any element of the frontispiece had been explicitly

aligned with an image that depicted human evolution as an inexorable hierarchical ascent was, then, in a Hollywood movie. And the presentation did more than imply that humans had evolved directly from living anthropoid apes. Haeckel had linked the series of primate skeletons with his progressive phylogenetic trees in *Anthropogenie* and used his own versions of the skeletal sequence, deploying either actual specimens or Giltsch's photographic proxies, in his lectures in Cambridge and Jena. But it was not a scientist nor even an adherent of evolutionary progress who finally made manifest what so many viewers of the frontispiece to *Man's Place in Nature* had inferred from the upward curve of its procession of primate skeletons. The person responsible was instead the art director who created the characteristic visual style of Universal's depression-era horror movies, Charles D. Hall.[100] As Lugosi's mad scientist insists, the painted diagram—made by Hall for *Murders in the Rue Morgue*—presented nothing less than the transmutative "dawn of man."

As well as confirming all of the putatively progressive resonances of Huxley's frontispiece, Mirakle's eager appropriation of it had still more problematic implications. The image was tarnished by its very appearance in a horror movie, which transformed it into a lurid symbol of scientific transgression and malevolence. At this time there was considerable concern about the influence of the cinema on its mass audience, particularly since the advent of sound at the end of the 1920s. It was feared that the seeming realism of these "talking pictures" might help to propagate controversial doctrines such as human evolution even if, as in *Murders in the Rue Morgue*, the topic was broached only to induce fear. The film was initially banned in many parts of North America because, as one regional censor tersely decreed, "Theme of the story of Man's descent from ape objectionable and anti-religious, action macabre in the extreme."[101]

There was nevertheless a worse fate for the diagram featured in Mirakle's lecture than being branded offensive or heretical. The lecturer is adamant that he is not a "sideshow charlatan" spouting the "usual carnival hocuspocus," and he urges that there is an empirical basis for his claims about human descent.[102] But *Murders in the Rue Morgue* was only finally released in cinemas nationwide when the organization that enforced the Motion Picture Production Code persuaded local censors that the scientific ideas pre-

sented in the film were, as an official put it, "so imaginative and fantastic" that they could not be taken seriously.[103] The seventy-year-old image had already been traduced by Osborn as a deliberate distortion of established scientific facts, and it had been implicated earlier in the allegations of fraud that besmirched Haeckel's reputation. Now, in the early 1930s, the frontispiece to *Man's Place in Nature* received the ultimate snub: its sequence of analogous primate skeletons was dismissed as a harmless Hollywood fantasy that had no relation to actual science.

Notwithstanding the influence of Osborn's views on popular culture, they held less sway among his professional peers. Many experts on human evolution still saw a scientific and pedagogical value in the familiar image that was initially created by Huxley and then appropriated and adapted by Haeckel. Ironically, although Osborn had fashioned himself as Huxley's protégé, it was his own chief acolyte at the American Museum of Natural History who, in the 1920s and 1930s, became the latest champion of the linear series of primate skeletons. The rivalry between mentor and protégé, friendly but fierce, was fought out in competing exhibits that embodied very different conceptions of human evolution as well as antithetical political ideologies. As a consequence, it was in three-dimensional museum displays, rather than illustrations to printed books, where the iconic imagery of apes ascending to the apex of humanity now became most prevalent.

A Museum of Ideas

In December 1925, Yale University's Peabody Museum of Natural History reopened in a brand-new building. Construction had begun in 1917, but America's entry into the First World War caused delays that kept the museum's collections in storage for eight years. During this inadvertent interlude, the issue of evolution, human evolution in particular, had assumed a dramatic new significance. As *Scientific Monthly* noted of the Peabody's prolonged closure, "Before the exhibits could be reinstalled in a new building, the anti-evolutionary crusade set in, to culminate at Dayton." The trial in the Tennessee town of John Thomas Scopes for violating a prohibition on teaching human evolution in state-funded schools had concluded, amid intense publicity, only five months earlier. The Peabody's timely reopening, the journal urged, was "not only a new opportunity but a new responsibility."[1] The museum's pristine neo-Gothic building could show, as the *Literary Digest* proposed, that "evolution has its temples as well as its trials."[2] The rebuilt Peabody was expressly designed to fulfill this obligation, and the arrangement of its collections was a direct response to the resurgence of religious fundamentalism, prompted by the upheavals of the war, in the 1920s. As the official guidebook declared, the museum's exhibits "demonstrate the steady progression of life upward . . . in other words, that process known as Organic Evolution." When "read in the proper order," these exhibits took visitors along an ascending "evolutionary series" that, in a final room dedicated to primates, reached apes before "culminating in man."[3]

To mark the completion of this new evolutional edifice, Henry Fairfield

Osborn was invited to deliver an inaugural address. Although he was per-haps the most famous proponent of evolution in the world, his views on humanity's origins had changed considerably shortly before the Peabody's reopening. In his address, Osborn did not mention his recent conversion to the Dawn Man theory, which maintained that humans had developed en-tirely separately from apes. He did, though, propose his own teleological conception of "creative evolution," which was preferable to the "chance explanations of adaptation" advanced by advocates of an apelike ancestry.[4] Osborn gave his address amid the Peabody's newly arranged collections, with a newspaper reporter reflecting that "as he spoke he was looking out over . . . abundant evidence of evolution."[5] He "opened Yale's million-dollar 'Tem-ple of Evolution,'" another correspondent remarked, "surrounded by fossils and skeletons which illustrated his story as he went along."[6] At the culmina-tion of these displays, however, was an exhibit that was anathema to Osborn, given his latest views on human evolution.

Only five months earlier, in July 1925, Osborn had denounced scientific illustrations that showed the "bipedal progression" of simians. In "represent-ing them walking on their hind feet," he claimed in the New York Times, such images were "gross misrepresentations of the gaits and postures of these tree-living apes." Osborn wrongly attributed the diagrams to Haeckel, al-though he actually had in mind the frontispiece to Huxley's Man's Place in Nature. The procession of anthropoid skeletons depicted there epitomized what Osborn termed the "monkey-ape theory of human descent" (see fig. I.2). And this, Osborn alleged, was a "pure fiction . . . entirely set aside by modern anatomical research."[7] Yet at the Peabody, its "story of evolution" concluded with a tangible replica, in three dimensions, of Man's Place in Nature's frontispiece (see fig. I.1).[8]

The replica "series of skeletons" captivated the newspaper reporters who flocked to the reopened museum, with one declaring, in a droll pun, that it represented nothing less than a "boneified history of man."[9] But the exhibit had a serious scientific purpose, and the Peabody's director, Richard Swann Lull, explained that the "living man-apes . . . aid us somewhat in our visual-izing of human ancestry."[10] Rather than "imagine hypothetical stages as yet unrevealed," Lull proposed that "structural ancestors" such as the gorilla and the chimpanzee could be used to "show characteristics to be looked for in

the direct line of descent."[11] Lull was hopeful that such innovative means of "scientific visualization" would make the Peabody a "museum of ideas illustrated by specimens, and not merely a curiosity shop, as was the old conception."[12] These novel views on museum display intrigued Lull's professional peers, with Frederic Augustus Lucas telling him shortly before the Peabody's reopening, "I am very much pleased, but not at all surprised, that you are making it a museum of *ideas*."[13] Lucas had recently retired from his position as director of the American Museum of Natural History, and he was gratified to hear that Lull was "planning an exhibit . . . showing the relations of, or between, animals and man." This, he lamented, "museums do not do" — or had not done hitherto.[14] The exhibit that Lucas had heard about was presumably the mounted sequence of primate skeletons that was just then being assembled in the Peabody's Hall of Man. If so, there was a very clear reason why the institution Lucas had directed until 1924 had not attempted something similar in its own Hall of the Age of Man, which had opened three years before under Osborn's superintendence.

Osborn's reaction to the Peabody's three-dimensional reproduction of Huxley's frontispiece is not on record, although he did send Lull "copies of my recent papers presenting my views on the ape and man theory."[15] As the president of the American Museum of Natural History, however, Osborn was Lucas's superior and could ensure that his own often idiosyncratic opinions, on human origins as well as political issues, were reflected in the Hall of the Age of Man. Osborn sought to expunge any hint of humans' putative apelike ancestry from the hall's exhibits, which instead focused on the early humans that Osborn proudly designated Dawn Men. No less than Lull's reopened Peabody, Osborn's much larger institution was a museum of ideas, utilizing the very latest museological methods, even if it embodied an entirely different conception of humanity's evolutionary development.

Despite the innovative techniques deployed in these modern museums, visitors did not always respond in the mandated manner. At the Peabody, the majority entered by the culminating Hall of Man and took a "route . . . the reverse of that planned." In fact, the visitors who thronged to the reopened museum proceeded through its "history of life on earth during the past 5,000,000,000 years" in an average of just "21.40 minutes."[16] Even worse, in New York visitors to the Hall of the Age of Man still perceived it as pre-

senting an egregious evolutionary sequence implicating humans with apes, notwithstanding Osborn's manifest curatorial intentions. The confusion was attributable, in part, to Osborn's increasing delegation of the work required to keep the hall abreast of the latest scientific developments to colleagues who did not share his views on human evolution.

His protégé William King Gregory introduced new exhibits that contested the interpretations Osborn presented in other displays in the same hall. Though remaining deferential to his mentor, Gregory, by the mid-1920s, had become the leading proponent of humanity's apelike ancestry, identifying himself explicitly with Huxley and even the much-maligned Haeckel. Working with the artist Helen Ziska, Gregory created illustrations for his scientific publications that consciously invoked Huxley's series of simian skeletons, adapting the original imagery to incorporate new understandings of primate anatomy and an extended trajectory of human development. Osborn had a particular aversion to precisely this imagery, and it was only when Gregory established a separate Hall of the Natural History of Man that he and Ziska could transform their distinctive skeletal illustrations into three-dimensional models that flatly contradicted Osborn's rival Dawn Man theory. Like his mentor, Gregory recognized the necessity of "transforming a Museum of Things into a Museum of Ideas."[17] But the American Museum of Natural History, as visitors could hardly fail to notice, was now a museum of competing ideas.

The rivalry between Gregory and Osborn was, as the latter insisted, a "friendly controversy"; it had none of the rancor of the intellectual duel fought by Huxley and Hawkins.[18] Like that earlier dispute, however, it was a contest of competing visual representations of evolution, though now principally focused on museum exhibits rather than book and lecture illustrations. Nor were these exhibits any less implicated in questions of race. Osborn's virulent concerns with immigration, and his growing interest in eugenics and even fascism, soured his relationship with Gregory and had significant implications for his former protégé's depictions of human ancestry.

The Zigzag Line of Man's Descent

Interviewed by a newspaper reporter shortly after the Peabody's reopening, Lull maintained that the museum's "method of depicting evolutionary de-

velopment . . . by a series of skeletons" was "unique in the United States."[19] Across the Atlantic, such exhibits had been in existence for several decades, albeit only in a select number of regional institutions. In Scotland, since the 1870s, the University of Aberdeen's anatomy museum had contained a "'static procession' of graded skeletons" ascending "through the higher apes . . . to man."[20] At the beginning of the twentieth century, the Welsh Museum in Cardiff (now the National Museum of Wales) issued plans for a new introductory hall in which visitors would "gain some insight into the gradual rise and evolution" of vertebrates. As the plans specified, "Right at the end . . . will be seen an interesting group of skeletons, to show 'the gradation from the horizontal to the erect posture.' The idea of this has been taken from Huxley's so-called 'Procession,' which includes the gibbon, ourang-outang, chimpanzee, gorilla, and last of all man."[21] By the 1920s, when the Peabody's similar exhibit was being heralded as a marvel of museological modernity, such self-conscious invocations of Huxley's skeletal procession were, in British eyes, coming to seem decidedly dated.

Arthur Keith would have been familiar with the graded primate skeletons in the University of Aberdeen's anatomy museum, having studied medicine there in the 1880s. He subsequently assumed both the Royal College of Surgeons' Hunterian Professorship, earlier held by Huxley, and William Henry Flower's erstwhile role as conservator of the Hunterian Museum. In using the museum's still expanding collections to reassess the "evidence of man's evolution from an ape-like being," Keith soon concluded that the "process has been infinitely more complex than was suspected" by his predecessors. In his presidential address to the British Association for the Advancement of Science in 1927, he said, "Our older and discarded conception of man's transformation was depicted in that well-known diagram which showed a single file of skeletons, the gibbon at one end and man at the other. In our original simplicity we expected, as we traced man backwards in time, that we should encounter a graded series of fossil forms—a series which would carry him in a straight line towards an anthropoid ancestor." Instead of proceeding through an "orderly file of stages" that, successively, "become a little less ape-like, a little more man-like," humans evolved, Keith averred, in a considerably more convoluted and unpredictable way. As recent discoveries of a "welter of extinct fossil forms" had revealed, there had existed "numer-

ous and separate species" of primitive humans far more diverse and distinct than the "separate races . . . in the world of to-day." The development of their divergent anatomical forms, moreover, tended to fluctuate between progress from and regression to an original apelike ancestor. This propensity, which Keith labeled "discordant evolution," was shown most clearly by the human skull and anthropoid jaw, seemingly from the same individual, discovered near the Sussex village of Piltdown in 1912. The old linear representation that resembled the "links of a chain" would therefore have to be replaced by what Keith termed the new "zigzag line of man's descent."[22]

Keith also used his platform as president of the British Association to acquaint his audience with the perplexing news from America that Osborn, notwithstanding his "brilliant capacity," had recently come to "believe that man broke away from the simian stem at a pre-anthropoid stage." Like most of his peers, Keith was fully convinced that "man has arisen . . . from an anthropoid ape not higher in the zoological scale than a chimpanzee." At the same time, his views on the protracted timescale necessary for the evolution of the brain led him to grant a "respectable antiquity" to humans, dating back to the end of Oligocene epoch.[23] This was compatible with Osborn's own calculations regarding humanity's long prehistory separate from simians.

Osborn, unsurprisingly, was delighted with Keith's deferral of potentially anthropoid progenitors to a far distant past. Only a month before the latter's presidential address to the British Association, he wrote to Keith, jubilantly declaring, "I am perfectly confident that when our Oligocene ancestor is found, it will not be an ape, but it will be surprisingly pro-human."[24] Osborn would have been equally appreciative of Keith's no less authoritative refutation, in his presidential address, of "that well-known diagram which showed a single file of skeletons." Since the beginning of the 1920s, Osborn had been stressing the purportedly human characteristics of fossil specimens like those from Piltdown to create new visions of evolutionary development more in accordance with his own views than the famous skeletal sequence.

Osborn was now championing his own explicitly orthogenetic doctrine of "creative evolution." A preordained capacity to adapt inventively to new environmental challenges stimulated irreversible changes of form that were passed on to direct descendants, he argued, which tended to separate spe-

cies into parallel lineages. As Osborn excitedly declared, it was possible to "assemble and place in order line after line of animals in their true evolutionary succession."[25] That was how the development of other creatures, such as horses and titanotheres, were depicted elsewhere in the American Museum of Natural History.[26] Yet in the Hall of the Age of Man, the exhibits were carefully arranged to avoid instilling the same sense of linear succession. Instead, plaster models of four putative Dawn Men—"*Pithecanthropus*," "Piltdown Man," "Neanderthal Man," and "Crô-Magnon Man"—were seen by visitors separately, in discrete glass-fronted cases alongside casts of the fossil remains on which the hypothetical restorations were based.[27] This discontinuous arrangement helped to rid the hall of any vestige of the earlier visual representations of evolution that implied a progressive ascent from apes to humans.

But even after Osborn's much-heralded repudiation of the "myth and bogie of our ape-ancestry," some visitors to the hall still discerned the imprint of precisely this egregious idea in its exhibits.[28] As one told Osborn in a private letter in January 1930, "Now that you have boldly discarded the ape from your concept of the evolutionary origin of man may we not look forward to an elimination—or at least a rearrangement—of some of the glass cases in the 'Hall of the Age of Man'? . . . Too long have the eyes of visitors . . . been centered upon the misleading arrangement of figures intended to prove that man learned to walk upright by passing through a stooping stage in the monkey days of his existence." The same correspondent offered an alternative: "If such cases are to remain . . . may I suggest that signs be placed in the glass cases with the following words—FREAK CONCEPTS OF THE PAST WHICH DARWINISTS AT ONE TIME DECLARED TO BE SCIENTIFIC."[29] Osborn might have been amenable to such signs, having himself declared the idea of ape ancestry "out of date."[30] Not many of his colleagues at the American Museum agreed, however, including some who were intimately involved with the Hall of the Age of Man.

The Family Tree of Man

Gregory, who had been a student of Osborn's at Columbia University, came to work for him at the American Museum in 1911. In their working relation-

ship they referred to each other as "Aeneas" and "fidus Achates," finding in the legendary friendship of the Trojan exiles a reflection of their own.[31] But as Osborn's identification with the heroic leader Aeneas implied, their relationship was far from equal. At Osborn's behest, Gregory specialized in both the study of primate anatomy and the nascent discipline of paleoanthropology. In 1913 he also became involved with Osborn's plans to construct a new hall in the museum dedicated to human evolution, which came to fruition eight years later. By this time, Gregory was less reliant on Osborn's patronage, and he was far less perturbed than his mentor at the perception that the Hall of the Age of Man's exhibits disclosed a progressive sequence connecting apes with humans. In 1924 he pledged that, if given sufficient "money and time," he could personally "make it absolutely beyond criticism in clearness and accuracy of arrangement."[32] Although Gregory made his request to George Herbert Sherwood, who had just taken over from Lucas as the museum's new director, Osborn must have been aware of it. Even so, the alterations that his avowed acolyte had in mind would take the hall in a very different direction from Osborn's own vision.

Gregory used the resources provided by Sherwood to complete a new display on the "Family Tree of Man" (fig. 5.1). It consisted of a plaster bas-relief depicting what an accompanying label announced as "important milestones along the immensely long road of man's evolution." This "visualization of the genealogical relationships of man," as Gregory described it, consisted of sixteen models of anthropoid and human skulls superimposed on the branches of a tree.[33] Unlike the depiction in Haeckel's "*Stammbaum des Menschen*" (see fig. 4.1), here the tree's trunk is seen only partially at the far left, and ten leafless branches of varying girths proceed diagonally across a plain background divided by vertical lines into eight geological epochs. In this literal representation of the "great branching out into different lines on the part of the primitive anthropoid stock," the ancestry of humans and living apes diverges at the beginning of the Miocene period some twenty million years ago.[34] This was considerably more recent than was suggested elsewhere in the Hall of the Age of Man, where other exhibits upheld Osborn's view that "man has a long, independent history of his own, branching off probably in Upper Oligocene time from the . . . 'anthropoid' stock."[35] The

Fig. 5.1. The "Family Tree of Man" exhibit in the Hall of the Age of Man at the American Museum of Natural History. The bas-relief model, made of plaster, shows the branching out of the evolutionary lines of humans and apes in accordance with the views of William King Gregory. However, the third skull from the left, that of *Dryopithecus*, ought to come before the divergence of the human and ape lines and may have been misplaced. Photograph, 1924. (Image #310692, American Museum of Natural History Library.)

queasy quotation marks indicate Osborn's increasing reluctance to countenance any kind of anthropoid ancestry, no matter how distant.

Osborn's apprehensive punctuation appeared in the fifth edition of the hall's official guidebook, published in 1929. A few pages later, Gregory, in an explanation of the "exhibit called THE FAMILY TREE OF MAN," urged visitors to recognize that, regardless of when the human and the ape lines diverged, "man is constructed upon the same general anatomical plan as . . . the gorilla and the chimpanzee, and . . . is connected with them by a very large

number of anatomical marks of distant kinship." In fact, in Gregory's arboreal bas-relief, the main branch that leads to modern humans included, halfway across its span, the restored skull of a "primitive anthropoid" whose predominantly simian jaw also exhibited "certain pre-human characters."[36] The skull belonged to a newly discovered species of the genus *Dryopithecus*, which, as Gregory had claimed in 1924, was prompting "exceptional interest" because of its "close kinship . . . not only to the existing great apes but even to the forerunners of man."[37] But in the "Family Tree of Man," which was installed in the same year, the restored skull's placement did not correspond with this assessment.

The "*Dryopithecus* . . . of Miocene age" instead appeared on the diagonal branch showing the direct line of humanity shortly after its divergence from the lineage of living apes.[38] Oddly, a preceding knot, at the very point where the branches separated and the *Dryopithecus* skull presumably ought to have been, remained conspicuously empty. The knot was actually included, at number 3, when the skulls were assigned numbers in the guidebook's photograph of the exhibit, although its number was hurriedly excised in the following edition, which required the renumbering of *Dryopithecus* and all subsequent skulls to divert attention from the anomalous knot.[39] Unlike the guidebook, which was successively revised, expensive plaster models could not feasibly have significant amendments. Inconsistencies in their arrangement were an almost inevitable result of using permanent materials to depict rapidly changing scientific developments. Gregory had been intent on incorporating the very latest findings from both comparative anatomy and paleoanthropology in his model. It was, he assured visitors, an "attempt to present in a simple graphic form what is accepted by the best scientific authorities."[40]

In the 1929 edition of the guidebook, Osborn insisted on a small addition to this line, which now concluded: " . . . the best scientific authorities in the year 1924."[41] This was not mere pedantry, nor a gloating reminder of the enduring discrepancy in the position of the *Dryopithecus*'s skull. After all, the year mentioned was precisely when Osborn had experienced his sudden conversion to the Dawn Man theory. His addendum to Gregory's sentence insinuated that Osborn's conversion had prompted a wholesale reappraisal among experts in the field, even if almost all of them, like Keith, were non-

plussed by what Gregory mockingly called his mentor's "famous vision" of the dawn of humanity.[42] With supreme self-confidence, Osborn remained oblivious to his own intellectual isolation on the question of human origins, often seeming to assume that it was Gregory who had departed from scientific orthodoxy. This was the tenor of another note added to the description of the "Family Tree of Man" in the 1929 guidebook. In it Osborn warned visitors that the "explanation of the admirable model prepared entirely under the direction of Professor Gregory . . . differs somewhat from that given" in the Hall of the Age of Man's other displays. Although the differences, as Osborn acknowledged, were "largely matters of individual opinion and interpretation," the hall contained, from 1925 onward, exhibits that represented the "direct ancestry of man" in entirely contradictory ways.[43]

In the "Family Tree of Man," this ancestry was portrayed, as Gregory explained, in "stages of ascent" along the bough that eventually branched out to modern humans. The arrangement of the model as an ascending series did not seem to overly concern Osborn. There were also aspects of it that tallied with his own predilections, especially the way the smaller branches seemed to represent several parallel lines of succession. He would certainly have approved the separation of recent humans into four discrete races, ranging from what Gregory described as an "Australian black-fellow" to, at the farthest point of the main branch, a "Caucasian . . . American."[44] This arrangement recalled the multiple twigs representing different human species at the summit of Haeckel's polygenist "*Stammbaum*," and Osborn's and Gregory's own views on race are extremely significant and often rather complex, as will be discussed further shortly.

Osborn even appropriated the design of the "Family Tree of Man" for a diagram, published in *Forum* magazine in 1926, that presented a view of human origins antithetical to what Gregory had depicted in the original model (fig. 5.2). He not only inserted an arrow to draw attention to the distant point at which the separate branches of human and ape lineage diverge but also removed the vertical lines demarcating the earliest geological periods, from the Cretaceous to the Pliocene. These six epochs had taken up almost two-thirds of Gregory's plaster model; they were dramatically truncated in Osborn's two-dimensional adaptation and collectively labeled "Age of the 'Dawn Man' and Early Separation of the Human Family." The pre-

Summing up these irrefutable facts, the case for human evolution rests upon direct and overwhelming evidence. The races of Foxhall and Cromer have left hundreds of humanly fashioned flints on the east coast of Britain; the erect Trinil race of Java and the large-brained Sussex race of Piltdown are revealed through four individuals; the great low-brained Heidelberg-Neanderthal race rests upon more than fifty individuals; the fine large-brained Crô-Magnon and related races include eighty-two individuals. We cannot excommunicate these primitive ancestors of ours; whether we will or no we are obliged to welcome them into the great human family.

EXISTING FACTS OF HUMAN ASCENT

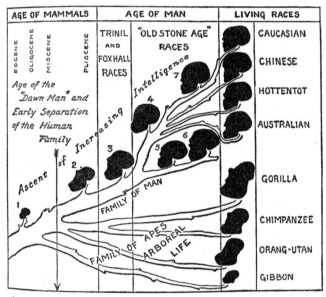

1, 2, *Dawn stage of human prehistory.* 3, *First known walking stage, the erect Trinil race of Java.* 4, *Piltdown race of Sussex.* 5, 6, *The low-browed Heidelberg-Neanderthal race.* 7, *Crô-Magnon and related races of high intelligence. The races* 3, 4, 5, 6, 7 *are scattered throughout the entire period of the Age of Man, conservatively estimated at 500,000 years. Altogether, upwards of 130 skulls and skeletons of the fossil men of this period are known.*

human species from this period were not individually named, so no mention was made of *Dryopithecus*. Instead, Osborn's diagram shifted the chronological focus to the Pleistocene, where silhouettes of the skulls of the "'OLD STONE AGE' RACES" who were nearest to modern humans now appeared at the center of the main branch rather than on its right-hand side. A rising diagonal inscription, meanwhile, indicated the "Ascent of Increasing Intelligence" that this arboreal imagery, and its hierarchical series of appended skulls, represented.[45] As this playful typographic calligram suggests, Osborn had little problem with the progressive design of Gregory's "Family Tree of Man," only with what, in the original model, it implied about anthropoid ancestry. He would be considerably less sanguine about a new set of diagrams, depicting a much longer scale of evolutionary ascent, that his acolyte was just then having made.

Back to Huxley

The profound intellectual differences between the self-styled "Aeneas" and "fidus Achates" had been evident, at least in private, since the beginning of the 1920s. In a confidential letter from November 1920, Gregory told Osborn, "I fear that we have reached opposite conclusions." The point at issue was whether "anthropoids are man's nearest relatives" and, accordingly, whether the human skeleton had been "readapted . . . from [a] *specialized* arboreal stage" or, as Osborn posited, there were instead grounds for "deriving man from a primitive terrestrial stage." At this early point in their dispute, Gregory still "hope[d] to convince" his mentor to abandon his supposition that, from an inconceivably remote period, humanity's ancestors had always walked erect and had never shared the quadrupedal posture of tree-dwelling apes. He concluded his missive to Osborn by telling him: "'Back to Huxley

Fig. 5.2. Magazine page with a diagram entitled "Existing Facts of Human Ascent." The diagram appropriates and revises the design of Gregory's "Family Tree of Man" exhibit (fig. 5.1) to instead articulate Henry Fairfield Osborn's rival views of human evolution. The revisions shift the chronological focus from earlier geological periods to the more recent Pleistocene, so the early humans whom Osborn termed Dawn Men (here called "'OLD STONE AGE' RACES") appear at the center of the image. In Henry F. Osborn, "Facts of the Evolutionists," *Forum* 75 (1926): 851. (© The British Library Board P.P.6359.)

and Darwin' is the motto of my conclusions."[46] In his letter Gregory seems to have made a strategic omission in the hope of persuading Osborn, who had studied under Huxley, to adopt the same slogan. When Gregory later publicly acknowledged that "I can not follow my honored leader" on the question of human origins, he instead professed: "I deem it rather my duty to defend the old and always unpopular view of Darwin, Huxley, [and] Haeckel."[47] Osborn had long shown symptoms of what Gregory diagnosed as the "epidemic, which may be named *Haeckelophobia*."[48] Gregory himself was immune to this disorder. Though too deferential to admit it in his earlier letter, he felt compelled to uphold the evolutionary views of the discredited German just as much as those of his more reputable British contemporaries.

Gregory had a particular admiration for the illustrations used by his nineteenth-century predecessors to elucidate their arguments, no matter how old-fashioned these images might now appear. He commended, for instance, some "neat little cut[s], taken . . . from T. H. Huxley's" published work on comparative anatomy.[49] He had a similarly high regard for Haeckel's influential but hugely controversial visual representations of evolutionary ascent and defended them against misapprehensions. Reprinting a copy of the original lithograph of the "*Stammbaum des Menschen*" in *Scientific Monthly*, Gregory reassured readers: "In Haeckel's chart . . . man is for convenience placed at the center of the tip of the tree, although Haeckel was anything but anthropocentric in his teachings."[50] More importantly, he suggested that this image might be preferable to more modern depictions of human evolution despite its apparently teleological focus.

Gregory conceded: "We may be inclined to smile at first at the simplicity of Haeckel's picture of the tree of life, which might now be condemned as 'monophyletic' and rejected in favor of a 'polyphyletic' diagram with innumerable lines." It was becoming increasingly apparent, however, that what the "cumulative experience of modern paleontologists" really showed was that, while the "tree of vertebrate life has a fairly large number of minor twigs," the "number of major branches is quite limited."[51] For this reason, Gregory proposed abandoning the modern penchant for ever more complex genealogical diagrams, such as Keith's zigzagging lines of descent and Osborn's multitude of parallel lines. The "tangled polyphyletic creeping vine," as Gregory told his mentor in a private letter, needed to be "dismem-

bered and laid out in a serial order" to be intelligible.[52] Gregory therefore determined to revive the nineteenth-century tradition of simpler images showing, in a progressive linear sequence, the "main line of ascent to man." With recent discoveries affording actual ancestors to "substitute for the more or less hypothetical stages postulated by Haeckel," this "new anthropogeny," as Gregory called it, would combine the very latest scientific knowledge with an older visual clarity.[53]

Huxley's wood-engraved sequence of ascending primate skeletons was the most enduring illustration in the successive editions of Haeckel's original *Anthropogenie* (see fig. 4.2). In 1928 Gregory commissioned two "huge folding plates" to illustrate the published version of an address he had given to the American Philosophical Society.[54] Notably, both plates drew explicitly on the familiar iconography of Huxley's much reprinted image. The first of these "Structural Series of Skeletons," concluded with the same distinctive upward curve progressing through the analogous osseous forms of a "Proto-anthropoid (Gibbon)," a "Typical anthropoid (Chimpanzee)," and, finally, "Man" (fig. 5.3).[55] Like Huxley, Gregory did not mean to imply that humans had evolved directly from these particular simians. He did, though, propose that the "remote 'common ancestor'" shared by humans and living apes had been a "pro-anthropoid, in many respects . . . like a young female chimpanzee."[56] In fact, he urged, in insistent italics, that *even if we did not have the chimpanzee we should have to infer its existence as a sort of half-way station in the long road of ascent.*"[57] Accordingly, the chimpanzee in Gregory's ascending depiction of the "anthropoid-human series," though clearly drawn from a real skeleton, also served as a hypothetical approximation of one of humanity's actual evolutionary ancestors.[58]

The remainder of this skeletal sequence offered a still more noteworthy departure from Huxley's original image. Growing successively more erect before the final three stages were a series of living and extinct vertebrates that began, as far back as the Devonian period, with a primitive "lobe-fin" fish. Gregory did not consider that these particular creatures, which also included amphibians, reptiles, and primitive mammals, constituted humanity's "direct line of ancestry." He was nevertheless adamant that this "long sequence . . . has every appearance of exhibiting the main stages of evolution." In particular, it demonstrated the "profound rearrangement and twist-

Fig. 5.3. Fold-out plate by Helen Ziska entitled "Structural Series of Skeletons from Fish to Man." This ink drawing combines arboreal imagery borrowed from the "Family Tree of Man" exhibit (fig. 5.1) with, toward the end, an upward curve that deliberately echoes the frontispiece to Huxley's *Man's Place in Nature* (fig. I.2). In William K. Gregory, "The Upright Posture of Man," *Proceedings of the American Philosophical Society* 67 (1928): plate I. (© The British Library Board 6630.500000.)

ing" of the skeletal structure that, over millions of years, eventually enabled humans to stand upright.[59] By the "elimination of thousands of other verte-brates" from the "residual line," this uncluttered and linear diagram created a "procession of fossil and recent forms" that echoed the design of Huxley's own skeletal procession.[60]

At the same time, Gregory's deliberately simplified diagram added imag-ery that also recalled his own plaster model, the "Family Tree of Man" (see fig. 5.1). Below the ascending skeletons is a diagonal branch that, as with the skulls in the original model, marks their positions with successive buds and twigs. In addition, the primate skeletons immediately preceding the striding

human are shown stretching to climb their own vertical branches. This depiction revealed the anthropoid "habit of brachiation" or "upright progression in trees" that, according to Gregory, was integral to the evolution of humanity's bipedal posture and the consequent development of the human hands and brain.[61] The close resemblance to the arboreal imagery molded in plaster for Gregory's museum exhibit was hardly surprising, for the artist who drew the diagram was an employee of the American Museum of Natural History.

In 1920 Gregory had founded his own institutional subdivision, the Department of Comparative Anatomy, or DCA, as a counterpart to Osborn's influential Department of Vertebrate Paleontology, known internally as the DVP. Like their respective understandings of evolution, the two men's approaches to artists were very different. When Osborn occasionally held dinners for the DVP staff at his imposing family home in the Hudson Valley, there were always, as one invitee later recalled, "two tables . . . one upstairs . . . for the scientific staff; the other, downstairs in a sort of basement . . . for the technicians, secretaries, artists, and the like."[62] The working environment of the DCA was much less hierarchical, and Gregory regularly invited his principal staff artist to stay at his own rural residence during hot summers.[63] The recipient of this hospitality was Helen Ziska, whom a male colleague condescendingly described as a "middle-aged German lady . . . rather short and plump, who talked with a strong . . . accent" (fig. 5.4).[64] Gregory himself had a high regard for the many women he employed in the DCA, including his secretary, Clara Meadowcroft, and his curatorial assistant, Marcelle Roigneau. It was Ziska whom he entrusted with the task of creating the two fold-out plates that embodied his long-standing plan to return to Huxley and the nineteenth-century iconographic tradition of simple linear progress.

The Supplicant Posture

Gregory, one of his students later reflected, was himself "essentially an artist by disposition," and he seems to have provided preliminary drawings to Ziska, who once exclaimed: "I am eager to see your sketches."[65] Even while she "skilfully executed" the final drawings, Ziska continued to receive what

Fig. 5.4. Helen Ziska in her workspace at the American Museum of Natural History's Department of Comparative Anatomy. The artist was praised by Gregory for her indefatigability, but she sometimes had to work at the museum on weekends, and from home late into weekday nights, to meet his exacting demands. Photograph, 1939. (Image # 299907, American Museum of Natural History Library.)

Gregory called his "constant advice and supervision."[66] His directions were evidently very exacting, and Gregory publicly lauded Ziska for being such a "willing and indefatigable artist."[67] A confidential missive from Gregory's secretary revealed the reality behind this diligence: it warned that Ziska could only complete the "illustrations for . . . Doctor Gregory's articles by coming in on Sunday for several weeks and by working from home at night."[68] What assuaged the intensity of their working relationship was their mutual sense of humor. Gregory indulged in parodic poetry to express his frustrations with Osborn, to whom he gave the comic soubriquet "imperial mammoth."[69] Ziska, meanwhile, was a "jolly sort," according to her colleagues, and she reveled in performing "vaudeville skits." Although Ziska endeavored to keep "her serious side and her humorous side in two separate mental compart-

ments," she was reportedly "in spite of her efforts . . . much more a jewel than a dual personality."[70] Gregory's wit similarly inflected his scientific work, and one of his books, with illustrations by Ziska, began by warning the reader that "if he have no sense of humor he will not understand it."[71] As with Huxley and Haeckel, who shared an acerbic humor that was evident in their illustrations, Gregory and Ziska shared a distinctly mordant sense of irony, which imbued their own linear images of human evolution.

The second of the fold-out plates that Ziska drew for the *Proceedings of the American Philosophical Society* retained the sweeping upward curve of the first diagram and again concluded with the skeletons of a chimpanzee and a human (fig. 5.5). But rather than striding forward with left leg extended and head held aloft, as in the initial skeletal series, the culminating figure was presented from behind, in a distinctly unbecoming posture. According to the dry explanation in the caption, each of the eight vertebrate skeletons, once more ranging from the earliest prehistoric fish to primates, had been "posed in primitive tetrapod position in order to show man's inheritance from lower vertebrates of every bone in the skeleton." In this incongruous pose, the human resembled, at best, a frog preparing to jump. It demonstrated, Gregory observed, how "man is an uptilted and only partly refashioned four-footed animal."[72] This conclusion was in itself deeply provocative and anathema to both Osborn and religious fundamentalists. Still worse, in the posture in which Ziska had drawn the human skeleton, the ignominy was exacerbated by the rearview perspective; indeed, the figure appeared to be pleading in abject desperation.

Understandably, Gregory did not mention the negative connotations of the splayed figure to the members of the American Philosophical Society. When addressing a less august audience, however, he could be more candid. Reprinting a reduced version of the same image in *Scientific Monthly*, Gregory provided the following gloss: "Our friend *Homo sapiens* is seen in the daily line-up, divested of his god-like exterior and forced to assume the supplicant posture of his humbler brethren."[73] Ironically distancing himself from his own species, Gregory both mimicked the idiom of Christian brotherhood and mockingly invoked Old Testament injunctions regarding suitably abased positions for prayer. The prostrate human skeleton drawn by

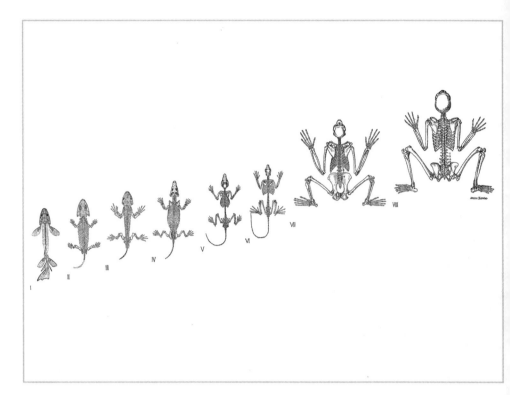

Fig. 5.5. Fold-out plate by Ziska entitled "Man's Debt to the Lower Vertebrates." In this ink drawing Ziska depicts the culminating human in a distinctly unbecoming posture that not only reveals its anatomical inheritance from quadrupedal ancestors but places it in what Gregory called a supplicant posture. Gregory also sardonically compared the skeletal series in the image to a police line-up. In William K. Gregory, "The Upright Posture of Man," *Proceedings of the American Philosophical Society* 67 (1928): plate II. (© The British Library Board 6630.500000.)

Ziska was, like Abram, fallen "on his face" (Genesis 17.7) and, akin to Solomon, had "his hands spread up to heaven" (1 Kings 8.54). Already lacking the "god-like exterior" of its flesh, the skeletal figure had been compelled— "forced" as Gregory robustly put it—to adopt this meek and demeaning posture, suggesting an absence of agency and subjection to a more formidable power, whether divine or not. The parallel between the diagram's sequence of skeletons and a "daily line-up" also mentioned in Gregory's gloss was, by contrast, entirely secular and considerably more contemporary. "Line-up" was a newly coined term referring to the police practice of assembling po-

tential suspects to enable the identification of criminals. It was reported, for instance, that the New York Police Department had instituted "daily 'line-ups'" during which "prisoners . . . are 'lined-up' so that the detectives may recognize any familiar faces."[74] This juxtaposition of both scriptural and strikingly modern imagery in the diagram heightened its intrinsic incongruity.

Amid the growth in organized crime precipitated by Prohibition and the traffic in illicit alcohol, Gregory had particular reason to liken Ziska's ascending linear series to a modern police line-up. As he commented in the early 1930s, "For untold millions of years the line of vertebrates that led toward man were unblushing thieves and robbers . . . Such being the case, it is no wonder that we suffer from grafters, racketeers and gunmen. The wonder is not that so many of us find ourselves in prison but that any of us ever learned to keep out."[75] Humanity, for Gregory, was far more culpable than this long sequence of "nefarious ancestors," as humans, unlike their forebears, had evolved a brain capable of moral reasoning. This, however, had resulted in "selfishness and above all, self-esteem," which became "magnified and distorted into folly and wickedness."[76] Such iniquity reached its inevitable conclusion in the First World War, the violence and devastation of which had had a particularly profound impact on Gregory.[77]

More than a decade after the conflict's end, he still despaired "that for sheer mass stupidities the like of *Homo sapiens* has never before been seen in an astonished world of reasonably straightforward and honest animals."[78] Initially, Osborn shared the sentiment. As he told the *New York Times* in 1922, "Since 1914 man has become more humble" and "not quite so confident of his superiority over the rest of God's creation."[79] But soon after his conversion to the Dawn Man theory two years later, Osborn cast off what he regarded as the baleful "influence of the shock of the great World War."[80] With recovered optimism, he affirmed that "even in the inconceivably remote past man was a relatively superior being . . . directed by a very superior order of brain."[81] Modern humans, by implication, had advanced still further in their almost immeasurable superiority over all other creatures.

With Osborn doubtless in mind, Gregory complained of "man's colossal and impregnable superiority complex."[82] This neurotic condition, involving an overcompensation for actual feelings of inferiority, had only recently been defined by psychotherapists. Gregory had a particular, if rather sardonic,

interest in the new approaches to mental health that were being developed in the 1920s. In 1927 he took the opportunity, when addressing an audience containing "many distinguished psychiatrists," to apprise them of a "new kind of phobia that is now widely prevalent." This, he averred, "may be named pithecophobia, or the dread of apes—especially . . . as relatives or ancestors."[83] Tactfully, Gregory did not identify Osborn as a victim of the disorder, although in private he joked that his mentor's ardent assertions of human distinctiveness from simians should be "subject . . . to analysis (and psychoanalysis)."[84] Ziska's unflattering depiction of the human skeleton as a mere supplicant, distinguishable from the other less vaunted vertebrates only "by his swollen head," helped provide what Gregory called "therapeutic measures" against delusions of superiority.[85]

As with the juxtaposition of imagery from the Bible and the newest police procedures, Gregory also combined modern psychotherapy with much older methods of restraining what he regarded as the "almost hopeless egocentrism of man."[86] In showing apes to be "man's next of kin," he claimed that, "like the slave in the classical story whose unpleasant and doubtless risky duty it was to remind royalty '*Memento te hominem esse*,' I conceive it as my hard duty to remind mankind that these poor relations of ours . . . are still with us."[87] This is the same thing that Huxley, in *Man's Place in Nature*, had termed "Roman severity." Huxley had likened the apes in the book's frontispiece to "slaves, admonishing the conqueror that he is but dust"; anatomical similarities presented an insuperable riposte to the "arrogance of man."[88] The two fold-out plates that Ziska drew for Gregory purposely resembled the frontispiece to *Man's Place in Nature* and similarly upbraided humanity, with more debasing imagery, for its sense of majestic superiority. But in Gregory's recourse to the same "classical story," it was he, rather than the skeletal simians, who assumed the role of the slave whispering admonishments to the triumphant Roman emperor. Over the past two decades, Gregory had grown increasingly exasperated with the arrogance of his own "honored chief," who self-identified with the Roman hero Aeneas and dominated the American Museum of Natural History like an "imperial mammoth."[89] Ministering to Osborn clearly helped Gregory empathize with the slave's hard and risky duty.

The Great Financial Crash

Even at the height of Gregory and Osborn's discord over human origins, Osborn retained an "imperturbable good nature and courtesy." This, Gregory confided to a friend, was "all very fine from the sporting point of view," and it helped to maintain a convenient public façade. In private, however, Gregory admitted to "getting a bit fed up" with how his mentor "used every opportunity his great position gives to him" to tout his conjectural Dawn Man while "brush[ing] aside all the mountain of evidence" for humanity's "consanguinity with the anthropoid apes."[90] These frustrations came to the surface in the two fold-out plates that Ziska drew in 1928. After all, Osborn had been decrying Huxley's famous series of ascending primate skeletons for the previous three years, albeit misattributing the image to Haeckel. Ziska's progressive sequences of skeletons from fish to humans deliberately echoed the iconography that Osborn considered so objectionable. Her second diagram went further and exacerbated the offensiveness of Huxley's original by depicting the human skeleton in a degrading posture.

Gregory had long wished to create exhibits similar to Ziska's diagrams for the American Museum of Natural History. In February 1922, only ten months after the opening of the Hall of the Age of Man, he was insistent that there was still "great need of an exhibit which will answer the question which are the nearest relatives of man on the anatomical side." To provide the answer, Gregory was developing "plans for an exhibit" that, as he told a colleague, would "include a series of skeletons illustrating the ascending grades of evolution from the earliest tetrapods to man."[91] Osborn, inevitably, would not have been willing to countenance installing such an ascending skeletal series.

Following the completion of Ziska's plates in 1928, Gregory returned to his plans to create an equivalent procession of skeletons to guide museum visitors through the main stages of evolution. Osborn continued to veto such displays in the Hall of the Age of Man, but Gregory was now determined to establish a separate exhibition space of his own, using the resources of the Department of Comparative Anatomy. Work on a new Hall of the Natural History of Man began in early 1929. Later that year, Ziska was hired to transform the line drawings in both of her sequential diagrams, which had been

executed in ink, into three-dimensional plaster models. As an internal report noted, "She is preparing two series of full-sized models of vertebrate skeletons representing successive structural stages." As in the respective configurations of the two fold-out plates, these models would be "shown in the top view and . . . in the side view."[92] Ink drawings were relatively inexpensive to create, and Ziska had been able to complete her onerous commissions by working from home. Modeling in plaster, as the "Family Tree of Man" had shown, was more expensive, and it also required specialist equipment, making its practitioners more vulnerable to the constraints of institutional budgets, as Ziska soon found to her cost.

In January 1930 Gregory told the American Museum's director that he recognized how difficult it was to "keep this vast institution running, especially this coming year, after the great financial crash." The sudden collapse in the value of the stock market three months earlier had important implications for the resources available to Gregory, and he expressed his "deep disappointment at the outlook for substantial progress" with the forthcoming Hall of the Natural History of Man. He recorded proudly that "Mrs Ziska has been doing most skillful work on the reconstruction and modelling of a series of skeletons." But there was now only a pittance to fund her activities, and Gregory reflected that the "situation would be laughable if it were not so depressing."[93] Ziska's earnings as an artist were often barely above subsistence level, and throughout the Great Depression of the 1930s her salary remained frozen at the same rate it was at the start of the decade.[94] Moreover, whether or not Ziska earned less than her male equivalents at the museum— the information is unclear—female scientific illustrators were traditionally paid less than men and were rarely considered professional artists.[95] Certainly, the women staff artists employed in Osborn's Department of Vertebrate Paleontology were "underpaid" and not given the same recognition as men like Charles Knight.[96]

As with the First World War, the economic situation had an impact on Gregory's skepticism regarding the evolutionary superiority of humans. He joked gloomily that "*Homo sapiens* will eventually muddle through this depression and survive to endure others in the future."[97] Ziska herself muddled through. She continued working on the skeletal models, though at a much slower pace. When the Hall of the Natural History of Man finally opened in

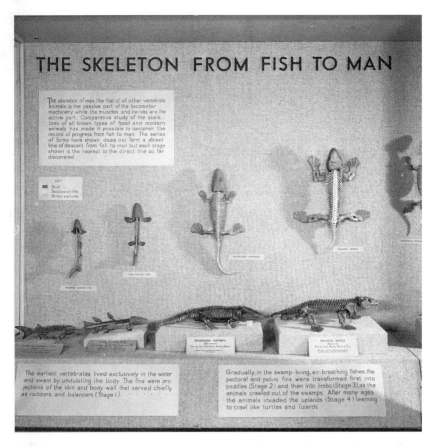

Fig. 5.6a. "The Skeleton from Fish to Man" exhibit in the Hall of the Natural History of Man at the American Museum of Natural History. The three separate photographs, made to be spliced together to form a single image in museum guidebooks, indicate the length of the glass-fronted display case needed to accommodate replicas, made in plaster and mounted on the base and back of the case, of Ziska's two fold-out diagrams showing the evolutionary development of humans (figs. 5.3 and 5.5). Photographs, 1932. (Images # 314253–55, American Museum of Natural History Library.)

July 1932, Gregory acknowledged, in an internal memorandum, that the opening had been "delayed, owing to lack of funds," and that much of the work was still "not entirely completed."[98] One of the few exhibits that visitors could see in its finished form was a display case, labeled "The Skeleton from Fish to Man," containing two ascending series that were almost identical to those in Ziska's earlier diagrams (fig. 5.6).

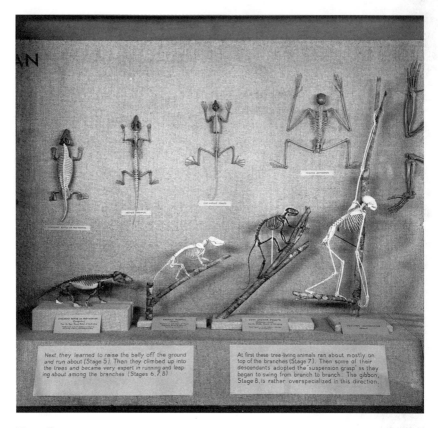

Fig. 5.6b.

The skeletons were mounted on the base and back of the glass-fronted display case, so the two rows, positioned laterally and from a top-down perspective, could be viewed simultaneously. They were not exact replicas of the original plates, for the sequence now began earlier in the Devonian period with a more primitive ganoid fish. More conspicuously, the chimpanzee in the first of Ziska's diagrams, which had been shown climbing a branch, was replaced by a gorilla skeleton mounted as if arising from a crouching position behind the upright human. This arrangement showed the final "series of stages" through which, as Gregory advised visitors in a guidebook, "we can follow the main changes of posture as our ancestors learned . . . to crawl . . . to climb and finally to walk erect."[99] It also enhanced the resemblance of the series of skeletal models to the frontispiece to *Man's Place in*

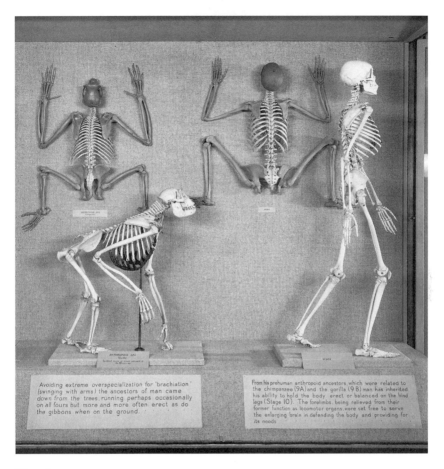

Fig. 5.6c.

Nature, even if there was a pragmatic gap between gorilla and human to ensure the visibility of the splayed and suppliant skeletons fixed to the back of the display case.

In the hall's guidebook, Gregory acknowledged that the "series of forms . . . does not form a DIRECT line of descent from fish to man." The species whose skeletons Ziska had modeled were nevertheless the "nearest to the direct line so far discovered."[100] Even if the conjunction of the human with the gorilla, chimpanzee, and gibbon at the end of the line was not meant to suggest that any of the "types shown is the direct descendant of its predecessor," the "series of 'living fossils'" were convenient proxies for humanity's

actual anthropoid ancestors.[101] This explanation was similar to Lull's justi-fication for using "structural ancestors" in the Peabody Museum's three-dimensional replica of Huxley's frontispiece, which enabled the "visualizing of human ancestry."

The preparation of the Peabody's exhibit had been delayed by America's entry into the First World War. Ziska's skeletal sequence was similarly put on hold a decade later by the Wall Street Crash of 1929. But by the early 1930s, the American Museum of Natural History finally had its own equivalent to the "boneified history of man" that, in the mid-1920s, had garnered so much attention at the Peabody.

One-Hundred Percent Americans

Osborn had authorized the construction of the Hall of the Natural History of Man, and, to Gregory's chagrin, he continued to meddle even after infor-mally relinquishing most of his museum responsibilities in 1930. The reason for the hall's precipitous opening two years later, when many of the exhibits were still incomplete, was that Osborn wished it to be available for the Third International Eugenics Congress, to be held at the American Museum of Natural History in August 1932. In April that year, he wrote to Gregory from Europe thanking him for "pushing forward the exhibit." Osborn told his still dutiful acolyte: "In Rome I hope to see Mussolini and secure a thoroughly representative Italian delegation to the Eugenics Congress."[102] Osborn ad-mired what he called the "marvellous" political transformation that the fas-cist dictator Benito Mussolini was enforcing in Italy and had himself long advocated for similarly uncompromising social policies in America.[103] The Hall of the Age of Man had, soon after its own opening, been used, in Sep-tember 1921, for the Second International Eugenics Congress, which Osborn considered the "most important scientific meeting ever held in the Mu-seum."[104] The principal objective of this earlier congress was to show the need to safeguard the national gene pool and thus the scientific necessity for severe restrictions to immigration, especially on what Osborn perceived to be inferior races.

The Immigration Act introduced three years later, which put strict quo-tas on immigrants from anywhere other than northwest Europe, was her-

alded by Osborn as "one of the most important steps taken in the whole history of our country."[105] Its draconian strictures conformed with his ostensibly scientific view that the "genus *Homo*" was "subdivided into . . . absolutely distinct stocks," some of which had evolved more fully than others.[106] The most advanced race was the "original Nordic stock" from which Osborn himself claimed descent, and arrivals from Germany and Scandinavia were encouraged by the provisions of the new Immigration Act.[107] Those races whose entry was now restricted or refused altogether, on the other hand, remained in what Osborn called a "state of arrested development," caused by the purportedly easier environmental conditions closer to the equator.[108]

This flagrantly racist outlook was intimately connected with the contemporaneous Dawn Man theory, which enabled Osborn to deny that the first humans had come from Africa, as recent fossil evidence for an anthropoid ancestry increasingly suggested.[109] Pushing back the origins of recognizable humans into extreme antiquity also allowed him to create a similar temporal distance between current races, which, he claimed, had "diverged from each other before the beginning of the Pleistocene."[110] Such assurances, especially from a scientist of Osborn's status, did not go unnoticed by those who administered the new Immigration Act. As Ethelbert Stewart, a government official who calculated the strict quotas of admissible immigrants, told Osborn in a private letter: "Your statement that 'man came along a path of his own and never passed through the ape stage' is just the statement we have been needing from a man in your position."[111] As the American Museum's president, Osborn could transform his personal prejudices into official institutional policy.[112] These prejudices were also closely related to his penchant for particular styles of visually representing evolution, with his preferred polyphyletic parallel lines enabling the segregation of different races. In fact, it has been proposed that "Osborn had no interest in the image of a single ladder of progress precisely because it would have undermined his sense of the white race's unique character and destiny."[113] The conspicuous absence of such a progressive linear series from the Hall of the Age of Man was a direct outcome of Osborn's highly partisan views on race and immigration.

Although the model of the "Family Tree of Man" did not affirm the Dawn Man theory, it, too, separated recent humans into four races on what seemed

to be hierarchically ranked branches. Gregory certainly shared many of the casual racist assumptions of the time, and he had a particular blind spot regarding the Indigenous inhabitants of Tasmania. He nevertheless felt no motivation, as he told Osborn, to "labor for the protection of this country against the invasion of 'barbarians.'"[114] Gregory also disputed the significance that Osborn attributed to distinct racial stocks, instead maintaining that such classifications were inherently unstable. Rather than "typical negroes . . . and blond, long-headed whites," he reflected, the "world abounds in innumerable human beings of intermediate or mixed characters."[115] This view, articulated in 1925, controverted the very principle of precise national quotas, designed to curtail the prevalence of certain races, that was integral to the previous year's Immigration Act.

Gregory's enduring despondency over the First World War, as well as the new conflicts that belligerent leaders like Mussolini were starting to provoke, also made him less confident of the presumed superiority of Western civilization. Indeed, he foresaw an evolutionary future in which "not all the human race will succeed in slaying each other with gas or germs and there will still be relatively honest and unsophisticated folk in Asia or Africa whose descendants will move in and possess the land in their turn."[116] Nor were such impending arrivals the only thing that advocates of immigration restriction and racial purity would find unpalatable, with the past no more reassuring than the future. Gregory reveled in the prospect of "telling one-hundred percent Americans that they are not the descendants of the god-like Adam but are sons and daughters of *Dryopithecus*, or of some nearly allied genus of anthropoid apes."[117] This lesson was precisely what the exhibits that were being hurriedly completed in time for the opening of the Hall of the Natural History of Man would instill in their viewers.

Writing in the 1940s, the sociologist and civil rights activist W. E. B. Du Bois recalled "once in a museum, coming face to face with a demonstration: a series of skeletons arranged from a little monkey to a tall well-developed white man, with a Negro barely outranking a chimpanzee." Which museum Du Bois had visited is not clear, nor exactly when he encountered this exhibit, which, as he reflected, forced him to "face scientific race dogma."[118] It was certainly not the sequence of skeletons modeled by Ziska for the Hall of the Natural History of Man, nor was it the similar series previously in-

stalled in the Peabody Museum's Hall of Man. As with Huxley's original image, which both exhibits intentionally resembled, the displays used a single skeleton to represent all humans of whatever race. Most visitors, already imbued with the dogma that confronted Du Bois, would still have assumed that the culminating skeleton, like that originally drawn for Huxley by Hawkins, was that of a White person. Such expectations, however, only heightened the disconcerting impact of Ziska's exhibit. After all, the supplicatory posture of its human figure, alongside the other prostrate skeletons affixed to the back of the display case, was even more degrading than the submissive kneeling position assumed by enslaved people in early nineteenth-century abolitionist art that Hawkins drew on in his own images (see figs. 2.3, 2.4, and 2.5).

The Truth About Germany

What the delegates at the Third International Eugenics Congress made of Ziska's ascending sequence is not known. With fewer than a hundred of the five thousand invitees attending, and Osborn's anticipated Italian delegation numbering only four, the meeting was far from the success of the previous congress, which, a decade earlier, had inaugurated the Hall of the Age of Man.[119] The Great Depression made the same strictures against the hereditary weakness of the poor now seem misplaced or inappropriately callous. According to the meeting's official report, Gregory's "permanent Museum exhibit," whose completion had been delayed by the economic conditions, was "inspired by the same purpose that inspired the temporary exhibits of the Eugenics Congress."[120] Those included busts of purportedly great men like Francis Galton, the founder of eugenics, with charts showing their illustrious family networks.[121] Ziska's skeletal models, by contrast, graphically revealed the ignobility of the osseous frame that all humans—of whatever race or caste—shared with the lowest vertebrates. As even the most ideologically blinkered delegates must have realized, this particular exhibit in the Hall of the Natural History of Man had, at best, a highly ambiguous relation to the principles being expounded at the Eugenics Congress.

Osborn himself wished that the hall had more "beautiful" and "idealized" representations of the human body, and he remonstrated, in a private

letter to Gregory, "against the materialism of . . . yours." Later in the same missive, written in May 1935, Osborn addressed the concerns of his previously loyal acolyte about his newest political enthusiasm. Having traveled in Europe the previous year, he knew, he told Gregory, that "the American press, especially that controlled by the Jews, is not free to tell the truth about Germany . . . The only way to learn the truth . . . is to spend a summer there and freely mingle with these wonderful people who have so much to teach us."[122] Gregory had until now been willing to countenance the discussion of certain eugenic ideas, but he was repulsed by Osborn's endorsement of what he called "Hittlerism [sic] in America."[123] In March 1935 Gregory resigned from the Galton Society, of which Osborn was one of the founders, and, after three decades, finally severed his relationship with his erstwhile mentor.

Although some of Ziska's colleagues considered her German, she was born in New York, but she had spent much of her childhood in Austria. In an interview she reflected wistfully that "Vienna was such a comfortable city in those days," before adding, "I fear it has changed greatly since then."[124] Ziska made this portentous comment at the end of 1938, only months after German soldiers had annexed Austria and barely weeks since the persecution of Vienna's Jewish population had climaxed with the *Kristallnacht* pogrom in November. Though more subtly than Gregory, Ziska, too, in an inhouse publication of the American Museum, made clear her abhorrence for the views that the institution's president had found so compelling.

Osborn himself never saw the genocidal consequences of his preferred political ideology, having died in 1935 with Gregory still not having responded to his despairing entreaty: "If I have erred in anything I have said about Germany I hope you will forgive me."[125] Soon after Osborn's death, the socialist journal *New Masses* alleged that "under his administration, the Museum of Natural History could have been transported to Nazi Germany and been at home."[126] While this might have been true of Osborn's own Hall of the Age of Man, it was certainly not the case for the Hall of the Natural History of Man. Ziska's skeletal models showing humanity's ascent from apes and even fish, in which the culminating figure was positioned as a subjugated supplicant, hardly accorded with the Nazis' valorization of racial purity and the potency of the Aryan physique. Although Osborn, when preparing to meet Mussolini, had pushed for the hall's completion to accom-

modate the needs of the International Eugenics Congress, the progressive series to be displayed there, as Gregory and Ziska must have known, was the perfect riposte to fascism.

With Ziska's skilled and dedicated assistance, Gregory revitalized the nineteenth-century iconographic tradition of linear progress in the exhibit that, delayed by the Wall Street Crash and then hurried by Osborn's enthusiasm for fascism, was finally completed in the summer of 1932. In that year, the American Museum of Natural History attracted almost 800,000 visitors.[127] As Osborn in particular knew only too well, their responses could not be mandated, even when the most modern and innovative museological methods were deployed. Beyond the walls of the museum, popular publications with similarly large readerships had long continued to find new uses for the still familiar image of an ascending series from apes to humans. Even less than museum visitors could they be relied on to interpret the series in ways that either Osborn or Gregory would approve. Indeed, the image was appropriated both for satirical purposes and in support of religious fundamentalism. Gregory, having established his own autonomy within the museum, felt compelled to respond and turned to popular science writing to regain control of the iconography of progress.

Raisins in the Pudding

G regory returned to New York on July 30, 1925, after a six-month ocean-ographic expedition. Only nine days earlier, the jury in the Scopes trial had found the eponymous teacher guilty of breaching the ban on teaching human evolution in Tennessee's publicly funded schools. The preparations for the celebrated legal proceedings in Dayton had dominated the news for several weeks, especially on the new medium of radio.[1] Even in the remotest parts of the Pacific Ocean, Gregory had kept abreast of the intense publicity, using the "powerful radio set" installed on the SS *Arcturus*.[2] His purpose in joining the ship, as the *New York Times* reported, was "studying deep-sea life" and "tracing . . . their evolution," and he became increasingly perturbed, while on board, at the exposure given to "fiery zealots" touting specious anti-evolutionary views.[3] These "radio orators," Gregory protested, "feel no embarrassing doubts as to their own competence to dispose of the subject of the evolution of man after they have read a few popular works on the subject."[4] Listening thousands of miles away, Gregory realized the vital necessity of providing forms of popular science that were both accurate and authoritative.[5]

When the *Arcturus* briefly docked in Panama at the end of June, he posted an urgent missive to George Herbert Sherwood, the director of the American Museum of Natural History. In it, Gregory urged that the "need for exhibits to supply information on Evolution is most pressing, in view of the Tennessee trial."[6] Three years earlier, he had presented plans for an exhibit

featuring a series of skeletons showing humanity's evolution from anthro-
poid progenitors, but Osborn, the museum's president, had vetoed it. Even
worse, Osborn, following his conversion to the Dawn Man theory in 1924,
had begun to "trumpet abroad a series of popular attacks on the 'myth . . . of
man's ape ancestry.'" Osborn had privileged access to newspapers such as
the *New York Times*, and Gregory warned that he was "supplying the anti-
evolutionists with the choicest ammunition that has ever been given them."[7]
In light of the impending Scopes trial, Gregory knew that once he returned
to America he would have to move beyond exhibits to bring his conception
of human origins to audiences outside the museum.

While aboard the *Arcturus*, Gregory contemplated what methods of pop-
ularization would be most effective. As he wrote to Sherwood from Panama,
"I don't want to jam scientific knowledge down people's throats. I want to let
them swallow it without knowing it, by approaching them through the lines
of thought that they are familiar with."[8] Science, in this ingestive metaphor,
was to be consumed effortlessly, almost surreptitiously, rather than being
force-fed. Gregory had long been accustomed to maintaining what he called
a "smiling hypocrisy" in his dealings with Osborn, and his proposal for mak-
ing anthropoid ancestry acceptable to the public similarly involved an ele-
ment of artifice.[9]

Like Osborn, the mentor with whom he was so profoundly at odds, the
nonscientific public retained deep-seated sensitivities that, as Gregory rec-
ognized, could not be brusquely disregarded. Instead, popular science, to
be successful, had to accommodate itself to conventional attitudes. A par-
ticular concern for Gregory was the pervasive distaste for skeletons, whose
"dry bones," as he acknowledged, had "long been a symbol of Death." He
lamented that if the "popular interest in the science of osteology could be
measured and plotted in such units as . . . two minutes of radio time, then
the score . . . would be almost zero." With radio already harnessed by anti-
evolutionary religious zealots, as Gregory knew only too well, aural accounts
of the "evolution of different types of skeleton" would have limited appeal
on the airwaves.[10]

That particular subject was integral to Gregory's specialist scientific pub-
lications, whose diagrams featured rows of ascending skeletons, from fish to

apes, with the culminating human likewise "divested of his god-like exterior."[11] In presenting these skeletal series to the American Philosophical Society, Gregory was gleefully unapologetic that they would be "deemed impious and even blasphemous by many accredited spokesmen of millions of people in . . . Dayton, and points west and south."[12] The same sardonic provocation was also evident in the exhibit, based on the skeletal diagrams from his specialist publications, that Gregory was finally able to create at the American Museum of Natural History once he was free from Osborn's institutional constraints. In his popular publications, however, Gregory conspicuously eschewed osseous imagery, replacing skeletons with more elevated and reassuring representations of the human form. In so doing, he also introduced tentative reconstructions of prehistoric humans that, like earlier more conjectural images, emphasized their nobility and grace.[13]

Gregory, as a colleague later reflected, was a "scholar in the classic sense of the word . . . a habitué of library and laboratory."[14] He was clearly uncomfortable in the brash world of commercial publishing. When asked for entertaining details that might be used in a publisher's marketing campaign, he responded: "I have no favorite jokes or anecdotes, except possibly the semi-fossilized ones I work off each year on my long suffering classes in Palæontology."[15] As this reticence implies, Gregory considered the mordant irony that was so evident in his specialist writings, and especially in their unseemly skeletal images, inappropriate for a broader audience. Certainly, the illustrations in his overtly popular works lack the same dry wit and sardonic disdain for human vanity, even if they were once more drawn by Ziska, who shared Gregory's sense of humor. In fact, the images of evolutionary progress that Gregory and Ziska prepared for such publications were explicitly teleological and, unlike the equivalent specialist diagrams, seemed to affirm the presumed racial superiority of their readers. Gregory's personal views on race were very different from those of Osborn, who embraced both eugenics and fascism. But in endeavoring to win the support of ordinary Americans "through the lines of thought that they are familiar with," as he put it to Sherwood, he was less willing to challenge conventional prejudices.

Gregory knew that he would have to compete not just with fundamentalists on the radio but also with the profit-driven authors of what he derisively termed "semi-popular, semi-scientific articles," written to "record something

new and startling" regardless of the actual facts.[16] Osborn, too, was peddling his Dawn Man theory in mass-circulation books that, as he instructed his publisher, featured "very large type and a cover designed to catch the eye on newsstands, railroad stations, etc."[17] In this crowded and gaudy marketplace for popular science, Gregory had to put aside his donnish diffidence and ensure that his own commercial publications were equally novel and eye-catching. His solution was to prioritize images over text. He commissioned Ziska to create original and striking illustrations that, deployed at conspic-uous junctures in a book or article alongside a few key sentences, would exemplify its overall message for general readers. Having already compared popularization with the consumption of food in his letter to Sherwood, Gregory likened these salient components to the tasty pieces of fruit in a pudding.

While Gregory was on board the *Arcturus*, the familiar iconography of apes ascending upward to the apex of humanity became a recurrent motif in the publicity surrounding the so-called monkey trial in Dayton. Both be-fore and after Scopes's conviction, the image was appropriated for satirical purposes. More surprisingly, it was also used in support of religious funda-mentalism. After all, as the Lutheran creationist Byron C. Nelson acknowl-edged in 1927, the "visual impression" of "such evolutionary illustrations" could have a "hypnotic influence."[18] The method of strategically illustrated popularization that Gregory developed following his return to New York was, in part, an attempt to regain control of this particularly potent represen-tation of evolution. He clearly felt that he could succeed only by denuding the image of many of the starker attributes that—ever since Huxley first assembled a row of primate skeletons as the frontispiece to *Man's Place in Nature*—had rendered it so teasingly ambiguous about human progress and superiority. Gregory reveled in this ambivalence in the illustrations for his specialist writings and in the museum exhibit he developed with Ziska, both of which invoked Huxley's original image. His popular publications, by contrast, steered the imagery of evolutionary progress away from the wood-engraved frontispiece to *Man's Place in Nature*.

Not all popularizers of science agreed on the need to avoid skeletal re-minders of this famous sequence of primates. Across the Atlantic, H. G. Wells, who had studied under Huxley, recruited his former tutor's grandson,

Julian Huxley, to contribute to an ambitious attempt at doing for science what his own best-selling *Outline of History* (1919–20) had done for popular interest in the past. Their serialized *Science of Life* (1929–30) began with a colored lithographic plate that, in a modern style, once more returned to the familiar iconography of a row of ascending skeletons. Although Wells carped at his coauthor for failing to match his grandfather's lucid, accessible style, he delegated to him the crucial task of selecting further images that might help elucidate the text. Unlike Gregory, Julian Huxley was not able to commission original illustrations, and, notably, he reused one of the skeletal series that Ziska had drawn for Gregory's specialist publications to illustrate his own ostensibly popular discussion of evolutionary progress.

Huxley wrote much of his contribution to *The Science of Life* while staying in Switzerland with his brother, Aldous, and their mutual friend D. H. Lawrence, who were both working on their latest novels. From this fortuitous gathering of modern intellectuals came a remarkable conjunction of competing views on evolution and its visual representation that were articulated in fiction as much as in illustrated popular science.

The Monkey Trial

A fortnight before Gregory's return on the *Arcturus*, newsstands in New York were dominated by the bright red cover of a topical "Evolution Number" of *Judge*. This satirical magazine, which proclaimed itself "The World's Wittiest Weekly," cultivated an audience that was distinctly metropolitan and urbane.[19] Its response to the impending trial in Tennessee was a flurry of cartoons lampooning the religious fundamentalists who were prosecuting Scopes, images that often attributed simian characteristics to their credulous followers. Such anthropoid imagery, even when deployed in support of evolution, could be counterproductive. Shortly before the legal proceedings began, Osborn felt an urgent need to "persuade our friends in the press to cease talking of this as 'the monkey trial.'"[20] He would have been especially concerned about one cartoon, drawn by Paul Reilly, at the beginning of *Judge's* evolution special, which was published on July 18, 1925. Only six days earlier, Osborn had used the *New York Times* to "vigorously protest" against those "lowering the seriousness" of the "present Tennessee case." The flip-

pancy was exacerbated by "diagrams" of anthropoid apes "walking on their hind feet," which perpetuated an erroneous conception of human ancestry.[21] Perturbingly, Reilly's cartoon mimicked the familiar arrangement of bipedal simians who stand upright in a linear series that culminates in a striding human (fig. 6.1).

This ostensibly progressive sequence satirized not the doltishness of provincials in Dayton, but the modish mores of sophisticated New Yorkers. As in the original frontispiece to *Man's Place in Nature*, each primate species is labeled below its feet, but the human is now classified as a "CAKE-EATER."[22] That slang term, which became fashionable in the 1920s, signified a louche young man who frequented parties to take advantage of free food. It was used especially by liberated female "flappers" to describe their dates.[23] The primates in Reilly's cartoon no longer have the skeletal equality of Huxley's originals, and the cake-eater who leads them is stylishly dressed, smoking a cigarette in a holder while also seeming to whistle. He appears blithely unaware of anything around him, and his elegant conceitedness prompts the gorilla to exclaim to his fellow apes, *"We ain't even holding our own."*[24] The joke is presumably that the evolutionary zenith which the ingenuous simians despair of reaching is, as represented by one of New York's fashionable socialites, a state of egotism and ignorance more bestial than any ape could achieve. In this cartoon series, in which the gorilla is taller than even the hat of the cake-eating human, the customary curve of evolutionary ascent comes to an abrupt halt before the final, human stage.

The same imagery was soon appropriated to support a still more pessimistic, and resolutely uncomic, conception of human destiny. The geological theories of George McCready Price, who claimed that the fossil record provided clear evidence of the earth's recent creation, came to prominence during the Scopes trial, where their validity was a matter of legal dispute. Price was unable to accept an invitation to come to Dayton on behalf of the prosecution, but his numerous creationist publications benefited from the publicity.[25] Unsurprisingly, a popular distillation of his complex arguments against evolution was brought out in the wake of the trial's conclusion. *The Predicament of Evolution* (1925) articulated Price's belief, as a Seventh-day Adventist, that Christ's Second Coming was imminent and that, correspondingly, the trajectory of human history was the antithesis of an evolutionary ascent.

Fig. 6.1. Magazine page with cartoon by Paul Reilly entitled "We Ain't Even Holding Our Own." Reilly's cartoon, which uses the familiar imagery of a series of ascending primates to lampoon New York's fashionable socialites, appeared alongside jokes satirizing anti-evolutionists during the famous Scopes monkey trial in Tennessee. In *Judge* 89, no. 2 (1925): 2. (Beinecke Rare Book and Manuscript Library, Yale University.)

Evolutionists Disagree on Evolution

That this phase of the general subject is not by any means as definitely settled as some people have long supposed it to be, will appear from the following statement made by Dr. Wm. Emerson Ritter, professor of zoology in the University of California:

"If one scans a bit thoughtfully the landscape of human life for the last few decades, he can hardly fail to see signs that the whole battle ground of evolution will have to be fought over again; this time not so much between scientists and theologians, as among scientists themselves."—*Science, April 4, 1922, p. 598.*

I believe that this statement very accurately represents the present situation from the point of view of the believers in organic evolution. They feel that the old proofs on which they have been relying are now failing them; they must begin again to lay other foundations for their theory, if they wish to have a theory of organic development that is strictly up to date and fit to be classed as scientific.

Not all scientists are reactionaries or standpatters; the really big ones are progressives, and are willing to follow wherever the real facts lead them. Such men as J. P. Lotsy, of Holland, William Bateson of England, and Thomas Hunt Morgan of this country, are very far from being satisfied with the evidences hitherto relied upon to prove the methods or even the fact of organic evolution. The botanists especially are discarding most of the older views regarding the methods of organic development; among them may be mentioned Dukinfield Henry Scott, H. B. Guppy, John C. Willis, and A. G. Tansley, all leaders among the scientists of England. But some of the zoologists are

not far behind, as for instance, Arthur Willey, J. T. Cunningham, and E. W. MacBride. All of these men still profess to believe in the general doctrine of organic development; but they are in hopeless disagreement among themselves as to *how* this development has come about; and almost every one of them has openly repudiated those subsidiary theories that were taught by Charles Darwin and on which the latter made the general doctrine of organic evolution "a going concern," as J. Arthur Thomson puts it.

But if the science of biology is to-day hopelessly entangled in disagreements regarding the value of natural selection or the inheritance of acquired characters, or regarding the facts of genetics and of embryology as supports for organic evolution, the science of geology has ceased to be the strong supporting foundation on which Darwin constructed his theory. The New Geology is no longer evolutionary at all; it has become the New Catastrophism; and it is safe to say that this collapse of the evolutionary form of geology is one of the chief reasons for the present predicament of the general doctrine of organic evolution.

The ascent of man according to evolution.

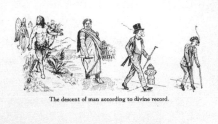

The descent of man according to divine record.

Fig. 6.2. Book pages with paired ink drawings entitled "The Ascent of Man According to Evolution" and "The Descent of Man According to Divine Record." This anti-evolutionary diptych presents the Seventh-day Adventist belief that Christ's Second Coming is imminent and that, correspondingly, the trajectory of human history is the antithesis of an evolutionary ascent. In George McCready Price, *The Predicament of Evolution* (Nashville: Southern Publishing Association, 1925), 10–11. (Author's collection.)

This millenarian pessimism was consistent, according to Price, with both Scripture and the annals of human history, and the point was illustrated by two contrasting diagrams, forming an anti-evolutionary diptych, on facing pages of *The Predicament of Evolution* (fig. 6.2). The first, entitled "The ascent of man according to evolution," shows the wonted upward curve but with the novel addition of a landscape background. The linear sequence moves from a squatting and fierce gorilla to a hunched figure, arising from a kneeling position, who has a simian physique and a head like the controversial Piltdown Man's, with a prognathous jaw conjoined with human facial

characteristics. The gorilla and the Piltdown Man–like figure are succeeded by a brawny primitive human wearing a loincloth and supporting himself with his flint spear and a boulder. The final figure has lost some of the preceding musculature and seems a little effete; he is wearing a leopard-skin tunic and dainty, lace-up boots. His longbow implies that his hunting or combat practices have become correspondingly more refined.

On the opposite page is a reversed diagram demonstrating "The descent of man according to divine record." This image begins with an angel brandishing a fiery sword who floats at Jesus's shoulder and compels him forward on his mission to redeem humanity. But the following figures, becoming successively shorter, are the unrighteous who, throughout history, have been oblivious to Christ's teaching. First is a gluttonous Roman emperor whose pagan cruelty and its inevitable result are symbolized by the ruins of the Colosseum, the scene of the persecution of early Christians. Next—with a fire hydrant abruptly replacing the Colosseum in the background—comes a smartly dressed figure who resembles the cake-eater in Reilly's cartoon for *Judge*. Attired in the formal evening wear of a metropolitan socialite, he strides forward carrying a cane and smoking a cigarette. It is unclear whether he is callously indifferent to the still more diminutive figure tottering on crutches at the end of the series. Perhaps instead this youth's physical impairment is a manifestation of his distance from Christ's exemplar. Though addressing extremely different audiences, both Reilly and Price adapted, within weeks of each other, the familiar imagery of evolutionary progress to show the degeneration of modern urban society.

The Noisy Court of Public Opinion

In 1927 Gregory confided to Osborn's wife, Lucretia, that his mentor's "statements to the press regarding the 'myth' of man's ape origin have long filled me with *grave apprehension*." They were, he warned, "invaluable ammunition for the Anti-Evolutionists" and had helped precipitate an "enormous popular verdict against evolution." Gregory concluded his letter by saying, "I feel bound to continue to do what little I can to counteract the great mischief already done."[26] He was by now a "bit fed up writing and publishing laborious defenses" of his position in "long papers" for scientific journals.

Such specialist articles were increasingly ineffectual, he lamented to a colleague, now that the "matter has unfortunately been transferred from the quiet precincts of the laboratory to the noisy court of public opinion."[27] To be heard amid this tumult, Gregory knew that he would have to forsake the tranquility of laboratory research and produce a popular book.

He approached the leading commercial publisher George Palmer Putnam at the beginning of 1927 and had completed a manuscript entitled *Our Face from Fish to Man* by October. But Gregory did not submit it then, as he was still "supervising the making of the illustrations," and the book, as he told Putnam, was "intended to be read only with the illustrations."[28] It would be almost another year before Gregory signed a contract, and even then the precise nature of the book's pictorial content was evidently still unresolved. As Gregory informed Putnam in September 1928, he would "rather have fewer but 'bigger and better' illustrations than the opposite" if it meant the cover price could be kept down.[29] The delay was occasioned, in part, by Ziska's frail health, which left her unable to work in the summer of 1927. More significant, however, was Gregory's conviction that the illustrations were the book's most important component, and he continued to exercise fastidious control over how they were used.

In a long letter to Putnam's editorial assistant, he gave precise instructions for the design and marketing of *Our Face from Fish to Man*. The main consideration, he insisted, was that the "text is extremely brief," and, as a consequence, the illustrations should be prioritized over efficient typesetting. Indeed, they "should be reduced in size as little as possible," even if this meant that "some pages have to be left blank at the bottom." The very format of the book was to be determined by its illustrations, and Gregory urged that it was necessary "to give room for numerous comparative drawings." While the final book contained 119 such drawings, some were more integral than others to Gregory's plans for attracting readers. As he explained, he "hoped to sell the book on the basis of the jacket, the Table of Contents, the Frontispiece," and certain "key sentences . . . written with the 'general reader' and the newspaper reviewers especially in mind." These, he proposed, would be "raisins in the pudding" that could whet the appetite even of a satiated public.[30]

Mindful of the need to engage those who would not agree with him,

Gregory proposed that "both evolutionists and antievolutionists should be stimulated" by *Our Face from Fish to Man*. As was evident from Price's *Predicament of Evolution*, "prominent 'Antis,'" as Gregory called them, were well aware of the potency of the linear imagery of evolution even as they appropriated it for their own theological objectives.[31] With his own book's most conspicuous illustrations, Gregory clearly determined to reclaim the image and establish it, once more, as the iconic representation of evolutionary development. He appreciated the visual clarity of a simplified arrangement of complex phylogenetic lineages in his specialist works, and simplification was, of course, still more important when addressing nonscientific audiences. Like the tasty pieces of fruit that made a pudding more tempting, simple and eloquent images of linear progress, as Gregory realized, could help make evolution more appetizing to the public.

For this purpose, he seems to have considered using the two fold-out diagrams showing the ascending "Structural Series of Skeletons" that Ziska was just then drawing for the *Proceedings of the American Philosophical Society* (see figs. 5.3 and 5.5).[32] Gregory soon changed his mind and instead assured Putnam that the "folding plates . . . will do just as well in 'Why We Walk Upright.'"[33] This was presumably another popular book that was proposed to the publisher but never written. While the circumstances of the book's abandonment are not known, there were obvious reasons why the plates, which invoked Huxley's original image and whose skeletons expressed an ironic disdain for human egotism, were unsuitable for popular publications. Rather than recycling diagrams from his specialist articles, Gregory recognized that the illustrations for the jacket and frontispiece of *Our Face from Fish to Man* had to be specially designed for the purpose. To create the new images, he once more commissioned Ziska, who benefited from the

Fig. 6.3. Composite image of eleven heads made from ink-wash drawings and a photograph entitled "Our Face from Fish to Man." The S-curve of the branch invests the image, created by Ziska, with a powerful sense of progress, while the final two heads—of a Tasmanian Aboriginal and a Roman athlete—create a sense of racial hierarchy absent from the images that Ziska drew for Gregory's more specialist publications (figs. 5.3 and 5.5). Frontispiece to William K. Gregory, *Our Face from Fish to Man* (New York: G. P. Putnam's Sons, 1929). (Author's collection.)

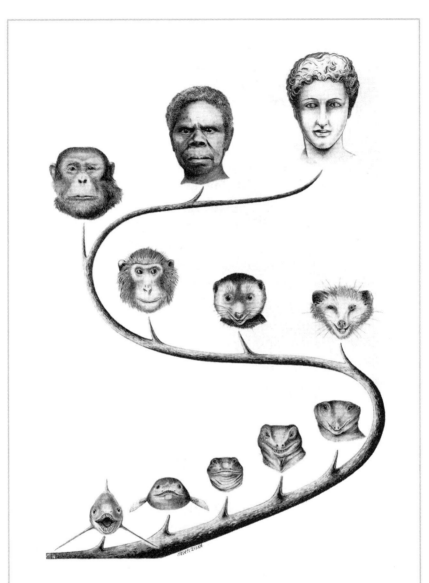

OUR FACE FROM FISH TO MAN.

1. Devonian shark; 2. Upper Devonian air-breathing, lobe-finned fish;
3. Lower Carboniferous amphibian; 4. Permo-Carboniferous reptile; 5. Triassic
mammal-like reptile; 6. Cretaceous mammal; 7. Lemuroid primate; 8. Recent
Old World monkey; 9. Chimpanzee; 10. Tasmanian; 11. Roman athlete.

For details see p. xiii.

freelance income that supplemented her meager salary at the American Museum of Natural History.

Among the numerous "pen and ink, wash and pencil drawings" Ziska created for the book was a series of eleven frontal portraits, ranging from an open-mouthed Lower Devonian shark to a classical bust, that were executed, as discrete individual images, in diluted ink brushed over a pencil outline.[34] These wash drawings were used, in slightly different arrangements, for both of the illustrations that, in Gregory's plan, were to play such a vital role in attracting a popular audience. For the frontispiece, Ziska reverted to the arboreal imagery she had borrowed, in the first of her fold-out plates, from the bas-relief branches molded in plaster for Gregory's "Family Tree of Man" (see fig. 5.1). In Ziska's plate, which was a line drawing in ink, the branch does not curve upward until the end of the skeletal sequence and even then quite gently (see fig. 5.3). In her new wash drawing, by contrast, the equivalent branch, which once more has buds marking the position of each of the faces, ascends dynamically in two sinuous curls (fig. 6.3). These, pragmatically, enable the full extent of the branch to be accommodated within the dimensions of a single vertical page. More importantly, the S-curve was a standard compositional device used by artists to direct viewers' attention in a particular direction, so it invests Ziska's frontispiece with a powerful sense of progress.

Such progress was still more evident in the jacket of *Our Face from Fish to Man*, where the sequence was abridged to just seven heads, beginning with a "lobe-finned fish" from the Upper Devonian rather than the frontispiece's antecedent shark (fig. 6.4). The other three omissions, a "Lower Carboniferous amphibian," "Triassic mammal-like reptile," and "Cretaceous mammal," were all from the more primitive end of the hierarchical scale. The remaining faces, five of which came from living primate species, were placed within a sideways chevron that was printed in red against the cover's otherwise pale background. This strikingly modern design, which extends onto the jacket's spine (where the face of a "Recent Old World monkey" appeared), was presumably devised by Putnam's production team rather than Ziska herself.[35] The dynamic diagonal lines, which lead the eye rapidly upward through the streamlined series to the classical countenance at its apex, created a representation of evolutionary progress that was more attuned to

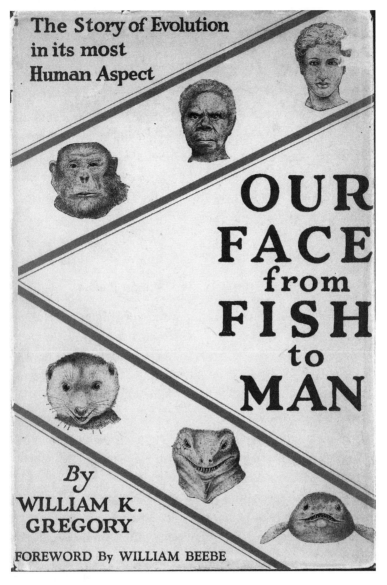

Fig. 6.4. Composite image of seven heads—one not visible here—made from ink-wash drawings and a photograph. An abridged sequence of the heads in fig. 6.3 is positioned within dynamic diagonal lines that lead the eye rapidly upwards and that extend onto the jacket's spine, which features the head of a monkey. Book jacket of William K. Gregory, *Our Face from Fish to Man* (New York: G. P. Putnam's Sons, 1929). (Author's collection.)

the needs of the commercial marketplace than any previous incarnation of the same ascending sequence.

Despite his own scholarly predilections, Gregory seemed to embrace the new, more vivid arrangement of Ziska's wash drawings. In December 1928, four months before the publication of *Our Face from Fish to Man*, he eagerly proposed to Putnam's marketing department that "we could install a shop window exhibit . . . with the jacket design and an appropriate blurb." The overtly progressive imagery, made more conspicuous "against a dark cloth background," would, he maintained, excite and stimulate consumers accustomed to modern advertising techniques.[36] As Gregory realized, only bold, direct, and uplifting images would resonate with an increasingly distracted public.

The Lowest of All the Human Races

The folding plates that Ziska created for the *Proceedings of the American Philosophical Society* seem to have been drawn, in early 1928, shortly before she made the frontispiece to *Our Face from Fish to Man*. The frontispiece must have been completed by November, when it appeared, as a promotional foretaste of the "promised book," on the front cover of the journal *Evolution*.[37] Although the linear sequences of evolutionary progress were ostensibly similar in the frontispiece and the folding plates, they differed in several important respects, most strikingly in their contrasting depictions of the human form, especially in relation to race.

In both of Ziska's specialist plates, a single skeleton at the end of the ascending series represented all humans of whatever race, a significant choice amid growing political concerns with racial purity. Ziska's avowedly popular frontispiece, on the other hand, featured two human heads that, as the penultimate and final stages of the transition "FROM FISH TO MAN," were labeled with dispassionate brevity as "Tasmanian" and "Roman athlete."[38] While many of the animals representing earlier evolutionary stages have benign, almost friendly smiles, the Tasmanian woman who succeeds them appears to scowl.[39] As was characteristic of classical statuary, at least that portraying high-status men, the expression of the idealized Roman countenance that concludes the series is no less somber, if also somewhat pensive. In the sec-

ond of Ziska's folding plates, the lone human skeleton was compelled to assume what Gregory, with his customary subversive irony, called the "supplicant posture of his humbler brethren."[40] Such humor was conspicuously absent from the two humans in *Our Face from Fish to Man*'s frontispiece and was instead confined to the enigmatic smiles of the animals earlier in the scale.

The plaster model of the "Family Tree of Man" had likewise divided modern humans into separate races, ranked in hierarchical order beginning with what Gregory termed an "Australian black-fellow." No further information was provided about the precise ethnicity of this cranial cast except that it came from "one of the most primitive of existing human races."[41] The designation "Tasmanian" given to the female head in Ziska's similarly arboreal frontispiece was more terse but also more specific. Since Tasmania's early colonization, the island's Indigenous population had been considered a singularly primitive form of humanity, more so even than the Aboriginal peoples of mainland Australia. The perception, which implied that extinction was the inevitable fate of this supposedly doomed race, vindicated the brutal violence that, by the end of the nineteenth century, had almost completely destroyed a society that had existed for millennia.[42] Gregory shared the long-standing assumption that, as he affirmed, "Tasmanian aboriginals were the lowest of all the human races."[43] He also seemed to take it for granted that their apparently total extinction was a natural occurrence rather than the result of colonial genocide.

When he visited Tasmania in 1921, Gregory was keen to find "unique specimens" of this lost people who resembled the "most ancient known members of the human races." Disappointed at how "few of their skeletons had been preserved," he was relieved to discover that a "large collection of photographs of these aboriginals had been made."[44] They had been amassed by the photographer John Watt Beattie, from whom Gregory purchased a set of prints. Most of the photographs collected by Beattie had been taken in the 1860s by Charles Alfred Woolley to provide a record of the few remaining Indigenous Tasmanians then living in government settlements. They were portrayed in European clothing and in accordance with the same ethnological conventions for photographing racial types that Huxley helped to establish.[45] The photographic portraits nevertheless depicted particular in-

dividuals at a specific moment in their lives, albeit in varying states of senes-
cence, and this information was evidently recorded on the prints that were
sold to Gregory. After his return to New York, he apprised a colleague of the
"photographs of the Tasmanians which I purchased," noting that "names
and dates will be found on the back of each photograph."[46] Yet when one of
the photographs from the collection was included in the frontispiece for *Our
Face from Fish to Man,* any indications of the individuality of this anony-
mous "Tasmanian," who confronts the viewer with a rheumy gaze, had been
expunged.

In an initial version of the image, Ziska had drawn the head in the pho-
tograph by hand, making its features seemingly younger but also coarser
and potentially more pithecoid, especially by thickening the brow ridge (fig.
6.5). This distasteful drawing was evidently rejected, possibly by the artist
herself, and the actual photograph was incorporated into the frontispiece
instead. The face whose photographic realism contrasts with the rather
whimsical wash drawings preceding it was that of a particular woman, Tru-
ganini, who had been in her mid-fifties when the photograph was taken.
Woolley's head-and-shoulders portrait of Truganini, which was widely re-
produced as an engraving, had become emblematic of the putative extinc-
tion of her entire race (fig. 6.6). Besides omitting the details of Truganini's
identity that were available to Gregory, the version of the same image that
was incorporated into *Our Face from Fish to Man's* frontispiece was also
cropped below the neck. This ensured that the format and size of the pho-
tograph was consistent with the format and size of the other faces in the se-
ries. Significantly, however, the cropping denuded Truganini of the shell
necklace that she had worn in Woolley's portrait of her. Such ornamenta-
tion was an important part of Tasmanian Aboriginal culture, particularly for
women, and its removal rendered Truganini a natural history specimen be-
reft of personal, cultural, or gender identity.[47]

For Gregory, the face in the cropped photograph typified the "projecting
muzzles, very large mouth, broad flat nose and retreating chin of . . . the
Tasmanians."[48] The term "muzzle," usually employed only in relation to an-
imals such as dogs, was clearly used pejoratively, and such distasteful de-
scriptions were generally reserved in Gregory's writing for these Indigenous
people he considered especially benighted. Their features, he had argued in

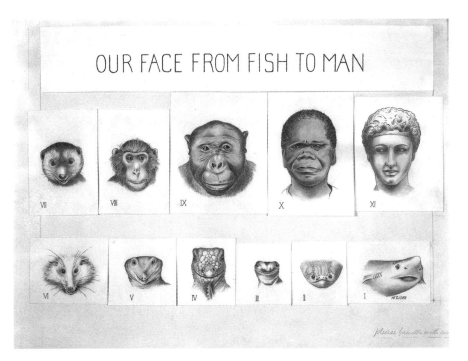

Fig. 6.5. Eleven drawings by Ziska entitled "Our Face from Fish to Man." These are the original drawings that Ziska made for the frontispiece to *Our Face from Fish to Man* (fig. 6.3). The drawing of the penultimate head (X), in which Ziska emphasizes the thickness of the brow ridge, was replaced in the published version with the photograph on which the drawing was based. Ink wash on paper, ca. 1927. (Image # 311813, American Museum of Natural History Library.)

an earlier work, "retain much of the gorilloid heritage" and therefore "reinforce the conclusion that the relationship of the chimpanzee-gorilla stock is relatively close to man."[49] In the frontispiece to *Our Face from Fish to Man*, Truganini's depersonalized physiognomy was positioned, as an intermediate link, between the face of a chimpanzee and the purportedly more advanced human countenance, inevitably that of a male, which concludes the ascending series. The implications of this arrangement were already egregious enough, even if Ziska's initial drawing exacerbating the Tasmanian's pithecoid features had been rejected for the relative realism of Woolley's photographic portrait. But the decidedly unrealistic nature of the final face in the frontispiece insinuated that, in comparison with its pallid perfection, Truganini was closer to the simian side of the scale.

Fig. 6.6. This head-and-shoulder portrait of Truganini, who by her death in 1876 was regarded as the last person solely of Aboriginal Tasmanian descent, shows her wearing a shell necklace. The adornment was an important part of Tasmanian Aboriginal culture, especially for women. The detail was cropped out of the version of the photograph used in the frontispiece to *Our Face from Fish to Man* (fig. 6.3), thus erasing Truganini's individual identity and rendering her a natural history specimen. Charles Woolley, "Truganini." Photograph, 1866. (Private Collection © Look and Learn / Bridgeman Images.)

Normal White Faces

Like the anonymous "Tasmanian" face that precedes it, the head of the "Roman athlete" had a specific history that remained unacknowledged in *Our Face from Fish to Man*. The image was based on a sculptural fragment

from the second century AD, itself a copy of an earlier Greek statue; the fragment was purchased by New York's Metropolitan Museum of Art in 1911.[50] From her office in the neighboring American Museum of Natural History, Ziska had presumably crossed Central Park to sketch the head, correcting, as she drew, the imperfections of the marble original, especially its badly damaged nose. Notwithstanding the convenience of its location, this idealized classical countenance, rendered still more flawless in Ziska's drawing, was an odd choice to represent what Gregory, in an explanation of the frontispiece, designated the "Alpine, European type" of face. For one thing, the statue's antiquity contrasted with the striking modernity of the book's jacket, on which it also appeared. More significantly, Gregory was adamant in vouching for the verisimilitude of Ziska's depictions of "successive structural stages," assuring readers that the "story told in these illustrations has not been invented by the writer."[51] Such claims, however, were hardly corroborated by the illustration that readers encountered first—which, as Gregory had long planned, was one of the book's chief selling points.

Using a classical exemplar to represent actual European characteristics, which even eighteenth-century anatomists like Camper had refrained from doing, also seemed at odds with Gregory's more nuanced appreciation of the inherent instability of racial classifications. He privately told Osborn that the "human races have crossed with each other for centuries so that most individuals show mixed characters," and even in public he cast doubt on how many "typical negroes, Mongolians, and blond, long-headed whites" were in existence.[52] While this realization perhaps ought to have suggested to Gregory that the supposed extinction of Tasmanian Aboriginals was a convenient colonial myth, it certainly made him wary of blithe assumptions of racial superiority.[53] He remonstrated against the "false pride . . . which is taken for granted by most of the white race," and suggested that, as with Osborn, it prevented an honest acknowledgment that "man is a made-over ape."[54] Even in the preface to *Our Face from Fish to Man*, Gregory mocked those who considered themselves "one-hundred-percent Americans" and proposed that the book would "hold a magic mirror up to proud man and bid him contemplate his own image."[55] But the idealized image of the human face that readers contemplated in the frontispiece was very far from tempering their racial pride.

The book's text, as Gregory always intended, was secondary to the illus-
trations, and frequently it seemed in tension with them. The distinctive
characteristics of the "European type" represented by the frontispiece's clas-
sical head were, as Gregory put it when describing the sculpture, a "narrow,
forwardly-projecting, pointed nose and pointed chin." Tellingly, however, his
equivalent description, slightly earlier in the book, of the "modernized white
human face" was much less complimentary: it consisted of a "small mouth,
weak jaws . . . projecting chin, delicate projecting nose and pale skin." Nor
could these rather flaccid features be considered a physiognomic type. As
Gregory willingly acknowledged, there was "great . . . diversity in normal
white faces." Gregory appeared to assume that the readers he was addressing
in *Our Face from Fish to Man* possessed what he called an "average adult
white person's face."[56] The book's flattering frontispiece, which implied that
such a perfect countenance was the telos of a long evolutionary ascent, was
designed to attract a normatively average audience. But if it served as an en-
ticing raisin, the rest of the pudding, where the illustration's reassuring racial
typologies were often invalidated, would have been far less appetizing.

When Gregory was planning the "shop window exhibit" advertising *Our
Face from Fish to Man* that he proposed to Putnam's marketing department,
he had a "fine series of models made, showing faces in series."[57] The pub-
lisher's sales manager was eager to know "how many models there are" and
agreed to "transport them from one place to another" so that they could be
utilized in a "good many displays in the prominent bookstore windows in
various parts of the United States."[58] In these displays, based on the design
of the book's jacket, the models were approximate replicas of most of Ziska's
successive drawings. There were some alterations, with the antepenultimate
chimpanzee replaced by a gorilla, and the bust of a bearded Aboriginal man,
which does not seem to be based on a specific individual, substituting for
Truganini. The idealized Roman athlete, on the other hand, remained at the
zenith of the series.

Gregory greatly admired the presentational skills of "window-dressers in
the better department stores"; he considered that they "often show a great deal
more about the art of exhibition than do many old-fashioned museums."[59]
In fact, his models, having traveled the country as props in promotional
shop window displays, were reassembled to create an exhibit for the new

Hall of the Natural History of Man that opened at the American Museum of Natural History in 1932. They together showed, as Gregory noted in the hall's guidebook, a "general progress from fish to man," and the concluding "classic Greek head emphasizes the characteristics of the civilized European."[60] The heedless transition from Roman to Greek origins suggests that, for Gregory, the putatively European face represented by the head was a flattering ideal rather than a real physiognomic type. In any case, he was far from sure, in the wake of the First World War and more recent conflicts, what being civilized might entail, and had few qualms about a future in which the "unsophisticated folk in Asia or Africa" would prevail over self-destructive Europeans.[61] These ambivalences would have been particularly evident given that the exhibit was positioned in the Hall of the Natural History of Man alongside the display based on Ziska's two fold-out plates, which presented the human skeleton in a deliberately ignoble and supplicatory posture (see fig. 5.6).

The arrangement of the exhibit's model heads replicated the sideways chevron, in reverse, of *Our Face from Fish to Man*'s jacket cover (fig. 6.7; see fig. 6.4). This design seems to have been devised by Putnam's production team, and the jacket, as Gregory proposed, was intended to entice general readers. While Gregory clearly approved of the jacket's striking design, its reproduction as a three-dimensional exhibit, using props previously deployed in promotional shop window displays but now with the imprimatur of the American Museum of Natural History, had inherent dangers. For one thing, it obscured the distinction between the contrasting approaches to human pride and race that he adopted in his specialist and popular writings. This pragmatic variation could be discerned even within a single publication. In *Our Face from Fish to Man* it was shown by the discrepancy between the reassuring illustrations and the rather more barbed text. The variation was, in fact, a key element of the plan for popularization that Gregory described in his culinary analogy of raisins in the pudding: the tasty fruit of flattered pride would induce mass audiences to swallow more nutritious but less palatable scientific realities. However, when the exhibit based on the book's jacket went on display during the Third International Eugenics Congress in August 1932, such strategic subtleties were lost. Instead, its idealized Greco-Roman head seemed unambiguously to confirm the same assumptions of

Fig. 6.7. "The Face from Fish to Man" exhibit in the Hall of the Natural History of Man at the American Museum of Natural History. This display replicates, in reverse, the sideways chevron of *Our Face from Fish to Man*'s jacket cover (fig. 6.4) and uses model heads that Gregory had made to promote the book in shop window displays. The jacket cover's photograph of Truganini is replaced by the bust of a bearded Aboriginal man. Photograph, 1932. (Image # 314251, American Museum of Natural History Library.)

racial superiority that, to Gregory's distress, had led Osborn and several other of the congress's delegates to embrace fascism.[62]

Amazing Steps in the Chain

Reviews of *Our Face from Fish to Man* were positive. Given Gregory's insistence that its text was ancillary to the images, he must have been gratified that reviewers noted that the "numerous illustrations, most of them done by

Fig. 6.8. Composite image showing the evolution of humans made from two photographs and a large ink-wash drawing. In the photograph in the left corner, Gregory directs the attention of a journalist to humanity's evolutionary ascent. This is represented both in a photograph, along the bottom, of the model skeletons in figure 5.6 and in a new ink-wash drawing in which ten creatures, including a quasi-Neanderthal and an early human, climb boulders amid a rocky landscape. In William K. Gregory and Michel Mok, "How Man Was Created," *Popular Science Monthly* 118, no. 6 (1931): 17. (Author's collection.)

Helen Ziska, really illustrate."[63] Buoyed by the acclaim for her part in this success, Ziska undertook her most ambitious commission for Gregory yet: an illustration combining two separate photographs with a large semicircular wash drawing. The elaborate image was integrated into the masthead of *Popular Science Monthly*, where it was published in June 1931 (fig. 6.8). For the lower part of the illustration, Ziska returned to one of her drawings that

would soon be converted into an exhibit for the Hall of the Natural History of Man (see fig. 5.3). Although Gregory had been wary of reusing Ziska's folding plates of ascending skeletal series in his book, a photograph of the replica models that she subsequently created now ran across the bottom of her illustration for the magazine. A caption explained that the "photos of skeletons show changes from fish to man," and the linear sequence, like Ziska's original drawing, invoked the familiar imagery of Huxley's frontispiece to *Man's Place in Nature*.[64] This was especially evident in the four primates at the end of the line, although their postures are slightly different from the postures of the same skeletons the following year, when they went on display at the American Museum of Natural History (see fig. 5.6).

Since Gregory realized that skeletons were likely to repel a popular readership, the rest of Ziska's composite illustration offered a more reassuring representation of evolutionary progress. The upper parts of the culminating anthropoid skeletons are superimposed over a wash drawing within a semicircular border that contains another overlaid photograph at its bottom left corner. In 1928 the journal *Evolution* opined that the "man in the street" would be hard pushed to "place Professor W. K. Gregory."[65] To counteract this anonymity, his image, albeit mostly the back of his pinstriped suit, was incorporated into the illustration. Touching the shoulder of a journalist and directing his attention to Ziska's drawing, Gregory appears both friendly and, as suggested by his bespectacled profile, authoritative. What he points toward are equivalents of the same animals whose skeletons feature in the series below, now drawn by Ziska with their flesh and external coverings, piscine scales, reptilian skin, and mammalian fur, restored.

The vitality of these creatures, most conspicuous in the chimpanzee, who turns to look out directly at the viewer, contrasts with the austerity of their skeletal counterparts below. In that photographic sequence, as had been the case since Huxley's original image was created, a uniform baseline and stark white background, devoid even of shadows, afford important visual signifiers of empirical objectivity.[66] Ziska's wash drawing, on the other hand, introduces an elaborate landscape background whose mountainous scenery provides a rocky path on which the ten figures climb successively higher, starting from a fish shown swimming under water. They ascend in an S-curve similar to that formed by the branch in *Our Face from Fish to Man's*

frontispiece. Rather than concluding with a Tasmanian Aboriginal and a Roman athlete, Ziska's new drawing eschewed any obvious indications of racial hierarchy. Instead, its final two figures are a stooping quasi-Neanderthal, wearing a loincloth and lugging a disproportionately large club, following a more upright figure sporting an animal skin that covers his whole torso and brandishing a smaller, presumably more efficient, cudgel. This culminating early human has reached the end of the rocky ascent and gazes into the distance at a sublime vista of mountain peaks.

Lacking the usual clarity of Ziska's line drawings, this rather saccharine wash drawing recalls, especially in the final figure's serene graciousness, the pious imagery of the paired linear sequences in Price's *Predicament of Evolution*. But instead of degeneration from the exemplar, Christ, it shows, as an accompanying caption effused, the "amazing steps in the chain that leads from the lowest forms to man."[67] Language evoking the ancient conception of the great chain of being, and its habitual depiction as a ladder or stairway, was not incidental.[68] Indeed, Gregory considered that what he called the "precious doctrine of the '*Échelle des Êtres*,' or scale of beings . . . still functions well" as a means of representing evolutionary development.[69] As he told *Popular Science Monthly*'s readers of their evolution from animal ancestors, "You can visualize this line of succession best by picturing it as a staircase. You stand on the top step. The ape stands on the first step below you, the monkey on the second step, and so on down."[70] The ascending boulders climbed by the equivalent simians in Ziska's drawing form a natural staircase, and tellingly, it seems to begin at the very point where the row of skeletons at the bottom of the illustration ends, offering a direct counterpoint to that austere series. This rocky chain of being, replete with endearing animals and a reassuringly handsome prehistoric human, provided Gregory with a new image of evolutionary progress, one more attuned to the tastes of popular audiences in twentieth-century America than the forbidding frontispiece to *Man's Place in Nature*.

Fated to Association

As Gregory must have been aware, other popularizers of science, with far more experience and success than his own, were less concerned about the

public's apparent distaste for skeletons and certainly did not abstain from osseous reminders of Huxley's famous sequence of progressing primates. In January 1931 the publicity department of New York's largest commercial publishers, Doubleday, Doran, sent Gregory a new book that it considered of "genuine importance in bringing to popular knowledge and use the findings of science as applied to human life."[71] Gregory read his advance copy and, in a review, acclaimed its "leisurely thoroughness," which would ensure that "Mr. Everyman" could "range with unflagging interest through . . . chapter after chapter." What was particularly impressive, for Gregory, was the caliber of the writers. As he noted, the "senior author began his scientific career . . . in the laboratory of the elder Huxley" and had now "wisely associated himself" with his erstwhile tutor's "brilliant grandson."[72] These two were, respectively, the novelist H. G. Wells and the zoologist Julian Huxley, who, together with Wells's son Gip, had "joined forces" to create a "*précis* of biological knowledge" that "ordinary busy people" could read.[73]

Wells père haughtily regarded himself as the "senior partner" in this writing team and sometimes even as "God the Father" in the authorial "trinity."[74] He had already attracted a huge popular audience with his *Outline of History*, which, since 1920, had sold over a million copies altogether on both sides of the Atlantic. The new collaborative book, *The Science of Life*, would perform the "same clearing up and simplifying" of evolutionary biology that its best-selling predecessor had done for the "story of the past," whose progression it had traced from what Wells called the first "quasi-human beings of half a million years ago."[75] The success of *The Outline of History* was attributable, in part, to its initial appearance in cheap fortnightly parts, and *The Science of Life* was similarly serialized, beginning in March 1929, ahead of its publication in the "stately volumes" that Gregory was sent.[76]

Like Gregory in his negotiations with Putnam over *Our Face from Fish to Man*, Wells, too, recognized that in popular publications it was necessary to "use pictures as well as words."[77] Accordingly, the contract that he agreed on with the Amalgamated Press, a British publisher specializing in mass-market illustrated magazines, stated that the thirty-one parts of *The Science of Life* would, between them, "contain approximately 400 illustrations." In practice, even this proved insufficient, and just over a thousand had been included by the time of the final installment in May 1930. With such a pro-

tracted and potentially expensive serialization, cultivating a sufficiently large readership with the opening installments was imperative. In the contract, the Amalgamated Press insisted that "all details as to the manner of producing, publishing and advertising the said parts . . . shall be left to the sole discretion of the publisher."[78] Its plan was to have an enticing color picture on the wrappers of each part directly below the names of the three authors—with Wells's name having a larger typeface—and with the inexpensive price, a key selling point, superimposed in the top right corner. These cover illustrations, especially in the initial part that would set the tone for the thirty still to come, were equivalents to the metaphorical raisins in the pudding that were integral to Gregory's own strategy for popularization.

Wells, chafing at his lack of control, was concerned about the tone that might be set by the wrapper of the opening installment. As he told his literary agent in November 1928, "I am foisting something very serious on the world on the pretext that it is shallow, popular, meretricious stuff. But I want as much dignity as possible in the publication . . . I hope the part publishers will realize that it is to their interest as much as to mine that dignity should be present. The buyers of The Science of Life ought to be sought among the readers of 'The Times' rather than among the readers of 'Tasty Bits' and 'Spicy Smacks of Knowledge.' I hope we will not be let down by vulgar publication . . . The Science of Life cannot be sold as trash."[79]

The trashy journals whose readers Wells wished to avoid were apocryphal, although their names are clearly based on the kind of overtly populist titles that were a mainstay of the Amalgamated Press. Wells's somewhat paradoxical plan to use the publisher to foist serious scientific information on the public in the guise of something more shallow resembled Gregory's own artifice in addressing popular audiences. His plan had been to avoid anything potentially distasteful or degrading, especially depictions of the human form as a mere skeleton. The Amalgamated Press chose a different tack for the illustration on the cover of the first number of The Science of Life.

Perhaps in response to Wells's demands for dignity, the publisher commissioned an original image from an artist whose "dexterity" and "magical sureness" of touch were just then being commended in the artistic press.[80] William Spencer Bagdatopolous, an Anglo-Greek painter, subsidized his aesthetic inclination for "bold impressionist" watercolors with commercial

lithographs that were used, in particular, to advertise railway companies. Al-though Bagdatopolous had no prior experience with scientific illustrations, he responded to the Amalgamated Press's commission with what the journal *Studio* called "his usual adaptability" and created an image that was imme-diately eye-catching but also aesthetically sophisticated (plate 4).[81]

In the foreground of the vividly colored lithograph that Bagdatopolous produced is a microscope whose individual components are delineated with such precision that it is identifiable as the latest Leitz instrument. The other scientific accoutrements surrounding it, including a rack of test tubes and an untidy stack of manuscripts and books beginning with a leather-bound volume whose spine bears the name of Aristotle, are sketched more loosely. The skull on top of the pile of books playfully evokes the memento mori symbolism of still life painting. Yet in an avowedly scientific image it also has a visual relation to the two extracted teeth strewn at the side of a test tube and, more obviously, with the row of skeletons looming in the background. The skeletons are drawn with an impressionistic attention to variations in light and are seen only hazily through the reflecting panes of what seem to be two glass cases, as well through an opaque lens affixed to the microscope. Though apparently split into two sequences, the skeletons, which become successively taller, are all part of a single ascending series that starts in the rear with what, from its raised elongated arm, appears to be a gibbon.

On the cover of *The Science of Life*'s opening installment, this lithograph was given the synoptic title "The Range and Nature of Life," which was al-tered to "The Key to the Knowledge of Life" when the image was repurposed as the frontispiece to the subsequent book edition.[82] This change, along with a new caption proclaiming that it was "not too much to say that all modern biological knowledge is founded on the microscope," increased the focus on the instrument in the picture's foreground.[83] At the same time, Bagdato-polous had good reason to include, though indistinctly amid the artistic play of light on various glass surfaces, a series of ascending primate skeletons in the background. As Gregory intuited in his review of *The Science of Life*, the authors' respective connections to the eminent Victorian who was inti-mately associated with this familiar imagery afforded a unique scientific im-primatur. From the perspective of the Amalgamated Press, the connections were also a commercial asset that could be utilized to help secure a remu-

nerative readership. As was customary for artists working on advertisements and other professional assignments, Bagdatopolous was presumably instructed to incorporate items redolent of Huxley's famous skeletal series in his still life compendium of scientific apparatus. Indeed, the image has recently been described as a "small homage to Thomas Henry Huxley."[84]

On the verso of the wrapper featuring Bagdatopolous's lithograph, a "PER-SONAL NOTE" regarding the new serial's authorship announced: "By a coincidence, Mr. H. G. Wells studied . . . under Professor T. H. Huxley, whose grandson is the second of the trio who are jointly responsible for THE SCI-ENCE OF LIFE."[85] On the second page of the installment's main text, readers were again informed that the authorial trio included the "grandson of Mr. Wells's own inspiring teacher."[86] Beyond this family relationship, however, many of the details given were either embellished or specious. In fact, Julian Huxley suspected that Wells's "choice of me as collaborator had something to do with his feeling for T.H.H."[87] And his wife, Juliette, later affirmed that, in Wells's view, "Julian . . . caught some of the glory which shone on T.H."[88] Whatever Wells's feeling for the bearer of those famous initials, it was certainly not based on personal contact. Regardless of what he claimed subsequently, back in 1895 Wells had acknowledged of his time as a student that "save for a rare 'good-morning,' I never spoke to . . . Huxley"; the "actual teaching" was "in the hands of (comparatively) unknown men."[89] Wells once disingenuously remarked, "I seem fated to association with Huxley," but, as with Osborn's attempts to fashion himself as Huxley's protégé, the seemingly inescapable connection Wells spoke of was largely his own invention.[90] Bagdatopolous's lithograph, with its hazy sequence of skeletons looming in the background, provided a visual means of reinforcing the same ersatz association.

Keep the Illustrations Lively

The hundreds of other illustrations that were to be included in *The Science of Life* risked making it exorbitantly expensive, and the contract that Wells made with the Amalgamated Press stipulated that the "drawings, photographs or other material . . . are to be selected and supplied by the Authors free of cost to the Publishers."[91] Wells delegated the "major burden of . . .

finding suitable illustrations" to Huxley's vaunted grandson, for whom, as the latter soon realized, "their selection involved very hard work."[92] Wells was already concerned that Julian Huxley's contributions to *The Science of Life* did not match his grandfather's famously pellucid prose and were "written in a style better adapted to sedulous students than to the . . . half-educated general public."[93] To compensate, he exhorted him to "keep the illustrations lively." But unlike Gregory, who was able to employ Ziska to create bespoke images for his popular books and articles, Huxley did not have the resources to commission original drawings. Instead, he "engaged two secretaries" to scour the scientific press for existing illustrations that might "illuminate the text" he was writing under Wells's exacting supervision.[94]

Despite Huxley's exasperation at "working under the direction of an amateur," he was able to develop a new and distinctive conception of evolutionary progress in his portions of *The Science of Life*.[95] Notably, the illustration that Huxley and his secretaries selected to accompany his discussion of how "it is permissible to say that one animal is higher than another, and to give the general name of progress to this tendency of Evolution," was one that, across the Atlantic, had recently been deemed unsuitable for the purposes of popularization. This was the first of the folding plates that Ziska had drawn for the *Proceedings of the American Philosophical Society* and that Gregory had opted not to reuse in *Our Face from Fish to Man* (see fig. 5.3). The gradually ascending succession of species finally culminating in a skeletal human now appeared, in *The Science of Life*, below a running header posing the question "IS THERE PROGRESS IN EVOLUTION?"[96]

The affirmative answer given in the text—that "evolutionary progress consists in . . . the raising of the upper level attained by life"—was confirmed visually by the upward sweep of the skeletons in Ziska's recycled plate. After all, the concluding human, striding forward beyond the end of a curving branch and looking ahead to a point beyond the image's confines, tallied with Huxley's prognostication that the ultimate end of evolution would be humanity's "independence from environmental influences." This could be achieved through a "control of environmental factors" that, as Huxley had hinted earlier, included developments in the "present phase of genetic science" that promised improvements to the human stock. Ziska's diagram, which was reproduced at a greatly reduced scale and given the prosaic title

"The evolution of man and his upright posture—nine stages," was not referred to directly in the text. Its portrayal of what Huxley termed "straight-line evolution," echoing the refracted background of Bagdatopolous's lithograph on the cover of the initial installment, nevertheless exemplified *The Science of Life*'s progressive vision of human destiny.[97]

There was a more pragmatic reason for adopting an image that Gregory himself considered surplus to requirements, at least in his popular publications. Its reproduction did not incur any cost; a parenthetical acknowledgment recorded that it was used "By courtesy of Dr. W. K. Gregory."[98] The use of the image must have been arranged by Huxley, who dined with Gregory when he visited America later, in October 1930.[99] It is unlikely that the same hospitality, or permission to use Ziska's illustration gratis, would have been extended to Wells, with whom Gregory, despite his favorable review of *The Science of Life*, had clashed on both human evolution and its popular exposition.

In *The Outline of History*, Wells had helped to popularize Osborn's nascent doubts about anthropoid ancestry, maintaining that apes "walk on the outer side of the foot . . . in an entirely different manner from the walking of man."[100] As a leading primatologist, Gregory bridled at this amateur intervention in a highly technical matter. Writing in *Nature* in 1923, he chided the "eminent persons (including Mr. H. G. Wells) who do not see that the human foot is an anatomical palimpsest" whose erstwhile simian structures, including a markedly "divergent hallux," were discernible only by experts.[101] Stung by this condescension, which was even more objectionable coming as it did from the New World, Wells took revenge with his novel *The World of William Clissold* (1926). In this lengthy roman-à-clef, the eponymous narrator remarks dismissively that "some American has been writing unwisely of the use of the ape's big toe in walking." Another character comments, "These Americans live too near the newspapers. They get the headline spirit. They want to make startling discoveries . . . in a hurry."[102] At this time, Gregory was still formulating his strategy for addressing popular audiences and had not yet ventured into commercial publishing. Once he had, he remained anxious about the potential for being "misinterpreted by . . . newspaper writers." Indeed, according to the journal *Evolution*, he was careful to offer "nothing to thrill the tabloid press."[103] To have Wells, himself a best-selling

popularizer, ascribing to Gregory precisely the kind of brash populism that he was intent on avoiding must have been extremely perturbing.

Wells's misplaced slights did not dissuade Gregory from providing, for free, *The Science of Life*'s defining illustration of evolutionary progress. His magnanimity did not, however, prevent a vexing use of Ziska's progressive imagery, without authorization, to help market the book. When Doubleday, Doran sent Gregory an advance copy of the American edition, he was asked to "tell us what you think of it."[104] Although Gregory reviewed *The Science of Life* positively, albeit insinuating that Wells's forte was really the "medium of the imaginative novel," he does not seem to have provided the effusive recommendation the publisher was clearly hoping for.[105] He was conspicuously absent from the roster of experts giving hyperbolic endorsements in a full-page advertisement that Doubleday, Doran took out in the October 1931 issue of *Popular Science Monthly*. These eulogies were included in an account of the book, in the voice of an imaginary reader, that bore the inviting headline: "*Last night*, I was guided through the SEVEN CIRCLES OF LIFE . . . with H. G. WELLS *pointing the way!*" An accompanying illustration depicted both Wells's guiding arm and parts of the concentric circles in which, as the fervid advertising copy related, the "stream of Life . . . without break of continuity, became four-footed, tailed and hairy . . . first as lemur, then as monkey, still later as man-ape, and finally as its most complete of animal organisms—Man!" (fig. 6.9).[106] This image mimicked the illustration that, only four months earlier, had accompanied Gregory's article in *Popular Science Monthly* in June (see fig. 6.8). Another of Gregory's contributions, entitled "How Man-Apes Became Men," appeared in the October issue just a few pages after the advertisement, and the parallels between the two images could hardly have been more apparent.

Perhaps as a riposte for his refusal to provide a puff, Gregory's precise position at the bottom left corner of Ziska's original drawing, clutching the shoulder of his besuited auditor and pointing to the right, was usurped by Wells in Doubleday, Doran's advertisement. There was a further irony in the culmination of this ascending series in the replica image: the series ends with an enthralled reader of *The Science of Life* sitting in an armchair as the smoke from a Stone Age campfire wafts around his feet. Gregory had embraced the commercially attuned depictions of evolutionary progress devised

Fig. 6.9. Magazine page containing an advertisement for *The Science of Life*. At the right side of the page, the image of evolutionary ascent that concludes with an enthralled reader of *The Science of Life* mimics the composition of figure 6.8, especially in the placement of the man at the bottom, presumably H. G. Wells, who clutches the shoulder of his besuited auditor and points right in the same manner as Gregory in the original. This was perhaps a riposte to Gregory, who had declined to provide a puff for *The Science of Life* that could be used, like the testimony of other experts, in the same advertisement. In *Popular Science Monthly* 119, no. 4 (1931): 15. (Author's collection.)

by the marketing team at Putnam's, but he would have been less apprecia-
tive of the equivalent imagery created by their counterparts at Doubleday,
Doran.

Outbursts of Fury

Overwhelmed by Wells's incessant demands to "have this *Science of Life* job
getting on," Huxley decided to "get right away, to concentrate on finishing
my part."[107] In January 1928 he "took a chalet" at Les Diablerets in the Swiss
Alps, where, amid the snow and in seclusion, he was joined by his younger
brother Aldous, himself "up to the eyes" in writing his new novel, *Point
Counter Point* (1928).[108] The Huxley siblings also invited a mutual friend to
join them, someone who, as Aldous conceded, was "difficult to get on with,
passionate, queer, violent."[109] This was D. H. Lawrence, who, while Julian
and Aldous "wrote hard" for their respective books, completed the latest,
expurgated, draft of his controversial novel *Lady Chatterley's Lover* (1928).
In respites from this intensive creativity, the three men relaxed with "tea
and talks."[110]

When their discussions turned to science, Lawrence, as Julian remem-
bered, invariably "exploded with a snort of impotent rage." In his contribu-
tions to *The Science of Life*, Julian was just then articulating his distinctive
conception of evolutionary progress, and it was evidently debated at Les
Diablerets. As Julian recollected, "Aldous and I discussed evolutionary and
physiological ideas, including the possibility of mankind's genetic improve-
ment. This particularly infuriated Lawrence."[111] Although Aldous occasion-
ally interjected, "But look at the evidence, Lawrence," he was himself am-
bivalent about many of his brother's views.[112] Indeed, Aldous, as he wrote in
January 1928 just before coming to Les Diablerets, considered that "evolu-
tionary progress . . . has not been perceptible within historical times and
may . . . be left out of account as non-existent."[113] For him, the principal in-
terest of the fiery disputes between Lawrence and his elder brother was the
invaluable material they afforded for the novel he was writing.

Lawrence was no less scathing about the instigator of the book Julian was
contributing to. A year earlier he had published a characteristically excori-
ating review of Wells's *The World of William Clissold*. This was the roman-

à-clef in which Gregory was mischaracterized as a reckless populist, but Law-
rence's concern was that parts of the novel were merely a "duller resumé
of Mr. Wells's *Outline of History.*" As he observed despairingly, "Cavemen,
nomads, patriarchs, tribal Old Men, out they all come again, in the long
march of human progress. Mr. Clissold . . . cannot help systematizing us all
into a gradual and systematic uplift from the ape."[114] Although Lawrence
conceded that his review was "probably too peppery," his loathing for this
particular scenario, which he scornfully dubbed a "march of human prog-
ress," intensified when he learned, at first hand, what Julian was writing at
Wells's behest for *The Outline of History*'s scientific successor.[115]

Lawrence may have been referring to the heated discussions at Les Dia-
blerets when he told a friend, "I hear that H. G. Wells thinks Sir Alfred
Mond about the highest specimen of extant homo sapiens."[116] Mond was an
influential industrialist who "flounders about in politics . . . rather absurdly,"
as the narrator of *The World of William Clissold* remarks. Clissold neverthe-
less concedes that Mond "rouses my curiosity greatly"; he desires to "know
what is his real philosophy, and if fundamentally he is anything coherent,"
in the hope that men such as Mond might help direct a future technocratic
state.[117] Mond's subsequent apotheosis as the apex of human development
confirmed Lawrence's revulsion at Wells's vision of the rise of industrial
modernity as an inexorable march of progress.

Juliette Huxley, who was at the chalet with her husband and his brother,
later reminisced, "Aldous was deep in *Point Counter Point* . . . Julian equally
deep in the *Science of Life.*"[118] Working in such close proximity, the brothers
conferred about the "anatomical drawings" and other illustrations that Wells
had tasked Julian with finding for what his brother called the "monstrous
opus."[119] At this time, Julian had not yet selected the image of an ascending
skeletal series to adorn his discussion of evolutionary progress; Ziska was
only just starting to draw it in New York. It is nevertheless notable that when,
in *Point Counter Point*, Aldous fictionalized Lawrence's furious response
to evolution, he did so by way of a similar—if luridly exaggerated—visual
representation of progress. As well as writing novels, Lawrence had recently
turned to painting, and it was this side of his friend that Aldous depicted in
Point Counter Point in the character Mark Rampion. This strident artist,
Aldous acknowledged, was "Lawrence's notions on legs," and his allegorical

drawings reflect Lawrence's extravagant "outbursts of fury," as Julian wearily described them.[120]

Point Counter Point satirized the intellectual innovations of the 1920s. In a key scene Rampion displays his latest "polemical and scandalous . . . drawings." Of two he declares: "Here are two Outlines of History, the one on the left according to H. G. Wells, the one on the right according to me." The "drawing on the left," as the narrator explains, "was composed on the lines of a simple crescendo. A very small monkey was succeeded by a very slightly larger pithecanthropus, which was succeeded in its turn by a slightly larger Neanderthal man. Paleolithic man, neolithic man, bronze-age Egyptian and Babylonian man, iron-age Greek and Roman man—the figures slowly increased in size . . . The crescendo continued uninterrupted . . . to come to a contemporary consummation in the figures of Mr. H. G. Wells himself and Sir Alfred Mond. Nor was the future neglected. Through the radiant mist of prophecy the forms of Wells and Mond, growing larger and larger wound away in a triumphant spiral clean off the paper." Rampion's alternative version of the same scenario, the narrator observes, has a "less optimistic composition of peaks and declines." In it, the "small monkey very soon blossomed into a good-sized bronze-age man, who gave place to a very large Greek." However, then the "Romans grew smaller again," while the succeeding medieval "monks . . . were hardly distinguishable from the primeval little monkeys." Thereafter, the "stature of the representative men declined" until finally, in the "mists of the future," Rampion depicts a "diminishing company of little gargoyles and foetuses with . . . the tails of apes."[121]

In this lengthy exercise in ekphrasis, *Point Counter Point* not only parodied the conventional imagery of evolutionary progress, with its stooping simians and implicit ascent "towards Utopian infinity" beyond the pictorial frame. The novel, whose title evoked both musical modulations and argumentative contrasts, also created a visual counterpoint. Rampion's own idiosyncratic outline of history symbolized Lawrence's conviction that the loss of a primitive and instinctual sexual vitality, beginning with the effete Romans, had precipitated a train of enervation and decline that was becoming worse. Intriguingly, Rampion's contrasting drawings, which are described as "parables as well as pictures," closely resemble, albeit textually, the paired pictures of ascent and descent that, three years earlier, George McCready

Price used to articulate his vision of the degeneration that would herald Christ's Second Coming (see fig. 6.2).[122] While Lawrence's phallic primitivism and Price's Adventist eschatology were decidedly odd bedfellows, both could be encapsulated in the same visual format.

Lawrence considered his fictional alter ego a "gas-bag," and exclaimed, "I refuse to be Rampioned."[123] But critics have suggested that the novel, rather than attacking Lawrence, endorses his point of view, and even that Rampion's parodic "sketches become *Point Counter Point* in miniature."[124] Instead, it was Wells's brash faith in what Lawrence dubbed the "march of human progress" that was resolutely Rampioned. Huxley's novel offers a potent rejoinder to the popular, bold, and dynamic visual representations of evolution that dominated commercial science publishing, on both sides of the Atlantic, in the late 1920s. These were devised by publishers' marketing departments as much as by scientists and scientific artists, and, as Gregory had proposed, were intended merely to be enticing raisins in a more nutritious pudding. The commercial imagery of this period had, however, a direct—and hitherto unrecognized—influence on a new and still more pervasive depiction of evolution as a linear ascent that came to prominence later in the twentieth century. More surprisingly, such imagery accorded with recent developments in the scientific understanding of human origins in the 1950s and 1960s.

March of Progress, 1944–1979

Battle of the Bones

H elen Ziska longed to be famous. As a child she saw the adulation re-
ceived by her father, the celebrated baritone singer Joseph Beck, at
opera houses on either side of the Atlantic.[1] She "inherited a very decided
talent for . . . singing" and regularly regaled her colleagues at the American
Museum of Natural History, but Ziska hoped it was her abilities as an artist
that would gain public recognition.[2] Artistic renown seemed within reach
in the early 1930s, when Ziska requested a leave of absence from the mu-
seum to deal with "press agents, photographers and 100 phone calls." All
that, she anticipated, would be the result of having a life-sized painting of an
Indian elephant put on display in the lobby of a prestigious movie theater.
As Ziska excitedly proclaimed: "For me this is *far* more valuable than any art
exhibit—to have ones [*sic*] work exhibited at one of the most famous theat-
rical concerns on Broadway." At the very least she expected to "get a bit of
publicity," which she hoped might provide a "stepping-stone for future suc-
cess." Sadly, there is no other record of Ziska's proboscidean portrait, sug-
gesting that its fate was, as she already feared, to "disappear in the fog." In
fact, Ziska was unnerved by her "happy interlude" of success, and she re-
flected plaintively, "I am so often and severely beaten by fate that a little
happiness seems so unreal to me."[3] But fate had not yet finished with Ziska.
Although she had long been afflicted by illness and privation, as well as
Gregory's exacting demands with the illustrations she drew for both his spe-
cialist and his popular publications, further indignities lay in store.

Gregory's retirement from the American Museum of Natural History in

the early 1940s left Ziska, who had worked with him since 1924, surplus to requirements. Her meager earnings from the museum, which remained frozen at the same rate throughout the Great Depression of the 1930s, meant she had been unable to save or even take up a pension scheme that Gregory had arranged for her. Having failed to find the fame she once hoped for, Ziska, as Gregory's secretary urgently informed him, now faced the prospect of having "literally, not enough to live on." At precisely this time, when Ziska was struggling to pay for "food and other expenses" and remained "anxious every month from beginning to end," an illustration she had drawn for one of Gregory's books had a profound effect on a young reader.[4] Its impact would lead, twenty years later, to the creation of an image whose enduring fame surpassed anything Ziska herself aspired to.

The reader, Elwyn LaVerne Simons, later recalled, "As a teenager in Texas, I had been interested in, and had sketched, a sequence of transitional forms leading from ancient lemur-like prosimians, through more advanced stages of monkey-like or ape-like forms, and eventually through fossil hominids to modern man. This was, perhaps, suggested by such works as W. K. Gregory's *Our Face from Fish to Man*."[5] Simons subsequently developed, as a colleague later remarked, a "first-hand knowledge of primate evolution, unmatched by any American since . . . W. K. Gregory."[6] The book by Gregory that prompted Simons's sequential sketch, which he drew in 1944, had a distinctive frontispiece. In it Ziska had depicted an ascending series of faces, ranging from prehistoric fish to primates before culminating in a classical sculpture (see fig. 6.3). Simons, who remembered taking "many years of art classes, when young," sketched his own version of the same sequence, omitting its piscine predecessors and adding fossil hominids. These included *Australopithecus*, whose admission to the human lineage had gained scientific acceptance long after *Our Face from Fish to Man*'s publication in 1929. This precocious updating of Ziska's frontispiece helped Simons to recognize the "visual, almost artistic, element" in understanding the past. His capacity for "visualizing . . . in science" contributed to his emergence, at the beginning of the 1960s, as a leading figure in the field of paleoanthropology.[7]

Simons's adolescent art came to his mind when, as a "young faculty member" at Yale, he was asked for advice by the artist-in-residence at the university's Peabody Museum.[8] Simons, who had an office in the museum, later

recounted how the "mural artist and illustrator, Rudolph Zallinger, asked for my assistance . . . when he was commissioned to prepare figures for a Time-Life series book on early man. Zallinger asked whether I had ideas about depicting human ancestral stages, and wanted my advice on the accuracy of the reconstructions we intended to prepare. I proposed a succession of drawings as I had done as a teenager."[9] Zallinger apparently accepted the recommendation to "draw such a sequence," and this, according to Simons, was the origin of the image of "forward marching apes and humans" that has become "one of the most famous and recognizable scientific illustrations ever produced."[10] More than that, printed over five fold-out pages in the best-selling book *Early Man* (1965), it is among the most iconic images of any kind from the second half of the twentieth century (plates 5 and 6).

Although Simons's reminiscences were published in the early twenty-first century, more than three decades after the events he describes, they are largely corroborated by archival records from the time. He certainly invoiced the books division of the Time-Life corporation for a "Half day Consulting with Mr. Rudolph Zallinger," for which he charged $25.[11] Simons submitted his bill on October 15, 1964, which suggests that his consultation with Zallinger occurred shortly before. Following this meeting, he prepared for Zallinger a chronological outline, entitled "Hominoidea," of the extinct primate species that might be drawn, as well as those, more tellingly, that should be excluded. He also appears to have continued offering advice, seemingly gratis, at subsequent stages in the illustration's production.

Simons's extensive involvement in the image that, as he noted ruefully, "came to be known as 'The March of Progress,'" was not acknowledged in *Early Man*, where Zallinger's illustration was given the title "The Road to Homo Sapiens."[12] In fact, with the sole exception of Simons's own reminiscences, all other commentary on the so-called march of progress, even that written by scientists who knew the individuals involved, has been based on the assumption that Zallinger was guided by Francis Clark Howell, a leading paleoanthropologist then at the University of Chicago who was the nominal author of *Early Man*.[13] While the actual writing of the text was delegated to Time-Life's editorial staff, Howell did offer advice on Zallinger's preparatory artwork. However, it was Simons, as all the available evidence attests, who made the more decisive contribution to the famous illustration.

His involvement had important, and hitherto unnoticed, implications for "The Road to Homo Sapiens." For one thing, its format as a linear ascent of successively more advanced simians and hominids was evidently influenced by earlier evolutionary images that Simons had seen as a youth, most particularly Ziska's frontispiece to *Our Face from Fish to Man*. His own attempt to sketch an equivalent sequence was made, in the 1940s, when a profusion of new fossil discoveries were each being classified as a unique taxon. This generated what Simons himself later termed "taxonomic prolixity," a confusing morass of names that obscured potential phylogenetic relations and precluded the creation of a "more lucid picture of the . . . antecedents to man." The confusion caused by the "questionable nomenclatural practices" may account for the seeming hiatus in new linear depictions of human evolution in the middle decades of the twentieth century.[14] It also explains Simons's preference, when a teenager, for Gregory's by then rather outmoded publications. In the 1920s Gregory had rejected his own contemporaries' penchant for increasingly "tangled polyphyletic creeping vine[s]."[15] With Ziska's artistic assistance, he had instead revived the nineteenth-century tradition, initiated by Huxley and then brought to fruition by Haeckel, of simpler images depicting progressive linear series. Recollecting his adolescent reading and drawing, Simons, in his office at the Peabody Museum, urged Zallinger to return to that tradition once again.

An emphasis on linearity also reflected modern practices within the rapidly developing field of paleoanthropology. Simons had arrived at Yale in 1960 determined to bring taxonomic order to the burgeoning primate fossil record. The insistence on grouping—or "lumping"—morphologically similar forms under a restricted number of classificatory names had hugely important consequences for Zallinger's illustration, not least in establishing a single, linear trajectory of human evolution. Lumping was not merely an arcane technical matter though. For many of his professional peers, Simons was a brash tyro pursuing a partisan agenda. In 1963 he acknowledged the "traditional atmosphere of controversy that has surrounded the question of hominid origins," but with Simons exacerbating tensions, the issue of origins was developing into what gleeful journalists dubbed a battle of the bones.[16] In particular, Simons persistently subsumed the new hominid taxa identi-

fied by the Anglo-Kenyan anthropologist Louis Leakey under existing names, including one, *Ramapithecus*, that Simons claimed was the earliest known hominid. Simons's rivalry with Leakey, who was himself haughtily dismissive of this "young scientist at Yale," was evident in the advice he gave to Zallinger.[17] Indeed, their bitter animosity was crucial to determining both the content and the format of the iconic image that, ironically, even became the logo of the foundation set up to further Leakey's legacy.

A Continuous Line of Development

Six years after Simons made his teenage sketch, the foremost authorities on "fossil man" were taken to task, at a symposium in Cold Spring Harbor on Long Island, by a speaker who was without "any first-hand knowledge of paleoanthropology."[18] Although Ernst Mayr was primarily an expert on avian taxonomy, his jeremiad on the classification of recent hominid discoveries, delivered in 1950, became "one of the most influential benchmarks ever in paleoanthropology," as a former student of Simons's later called it.[19] It was certainly integral to the transformation, a decade and a half later, of the speculative sequence Simons had drawn back in the mid-1940s into Zallinger's "Road to Homo Sapiens."

Mayr, in his study of birds, proposed that species were interbreeding populations that could encompass a high degree of physical and behavioral variation. This assumption had quickly become standard in zoological systematics in the wake of the new focus on genetics introduced, since the 1930s, by the Modern Synthesis of Darwinian evolution with Gregor Mendel's ideas on heredity.[20] With the fossil primate remains then being unearthed in Asia and Africa, by contrast, even the slightest morphological differences were held to warrant the creation of new species, generally in a genus of their own. This, Mayr contended, had resulted in a "simply bewildering diversity of names" that, with more than twelve current genera of hominids alone, was stymying paleoanthropologists' understanding of human evolution. Instead, Mayr proposed a radically "simplified nomenclature of fossil man" based on the "combining of genera," with hominids reduced to a single genus containing only three species. Such intensive taxonomic lumping

would make it possible, Mayr asserted, to discern a "continuous line of de-velopment from the primitive hominids to modern man" in which all the valid taxa were "members of a single line of descent."[21]

A decade after Mayr's speech, Simons, still in his twenties and in one his earliest publications, announced that the "years since 1950 stand as the most productive" for the study of fossil primates since the first specimens were identified in the early nineteenth century. During this short period, the "mists obscuring the past of the order to which man belongs" had finally begun to dissipate.[22] Indeed, new fossil discoveries since Mayr's necessary exposure of the "extreme oversplitting" of hominid varieties had made it pos-sible to trace what Simons, in 1963, described as the "evolutionary succes-sion" that led to modern humans. This, in line with the linear proclivities of Mayr's views, entailed a single chronological series of hominids gradually transforming—and, by implication, perfecting—into humanity. There nev-ertheless remained a pernicious propensity for the "oversubdivision" of some of the recent fossil finds, especially those made in East Africa. It was imper-ative to expunge such "bad taxonomic practice" for the sequence of "human forerunners" to become clear.[23]

Such a radical erasure was precisely the task that Simons undertook in the early 1960s, and it informed the list of "Hominoidea" that he made for Zallinger in October 1964. This remarkable document, a typescript with handwritten additions, provides an unprecedented insight into the creation of "The Road to Homo Sapiens" (fig. 7.1). In particular, it shows Simons's penchant for taxonomic lumping in action. The vertical outline was di-vided into three geological epochs, which Simons labeled as "MIOCENE—25 million yrs. ago," "PLIOCENE—10 million yrs. ago," and "PLEISTOCENE—from 1 million yrs. ago."[24] Within the outline, Simons recorded the names of twenty-four fossil primates, beginning with those considered ancestral to living apes and following with the hominids that preceded "Modern man," who came at the bottom of the descending list.[25] With the exception of *Homo erectus*, the list contained all of the names of the fifteen figures that would appear in Zallinger's published illustration, albeit sometimes in a slightly different chronological order. For instance, *Proconsul* came first in Simons's typed list, whereas "The Road to Homo Sapiens" would begin

HOMINOIDEA

MIOCENE - **25** million yrs. ago.

Proconsul
(Limnopithecus) (Pliopithecus)
Ramapithecus (Kenyapithecus) - only upper and lower jaws known
Sivapithecus - only upper and lower jaws known
→ *Dryopithecus*
PLIOCENE - 10 million yrs. ago.

(Bramapithecus) - only upper and lower jaws known
Oreopithecus

PLEISTOCENE - from 1 million yrs. ago.

†Homo habilis (an evolved Australopithecus, Olduvai Bed I) *Telanthropus*
Australopithecus
Paranthropus (Zinjanthropus)
Pithecanthropus (Sinanthropus, Atlanthropus, Chellean)

Steinheim (Swanscombe) = early homo sapiens
Solo (Neanderthal counterpart in S.E. Asia)
Rhodesian (Neanderthal counterpart in sub-Saharan Africa)
Neanderthal
Cro Magnon
Modern man

Peabody Museum contact = Elwyn Simons

In some cases, available material for purposes of reconstruction is extremely
fragmentary. Whole animal reconstructive efforts should only be made where the
material is adequate according to Dr. Howell. Where it is not, he says that it
is downright misleading to do any more than show the evidence itself and the
limited amount of information which it reveals.

Fig. 7.1. Typewritten document with handwritten annotations entitled "Hominoidea." This list contains the guidance that Elwyn LaVerne Simons provided to Rudolph Zallinger about which simians and hominids should, and should not, be included in "The Road to Homo Sapiens" (see plates 5 and 6). Annotated list of "Hominoidea," ca. 1964. (YPM VPAR.003547, Elwyn LaVerne Simons Archives, Yale Peabody Museum of Natural History. By permission of the Simons family; courtesy of the Yale Peabody Museum.)

with the gibbon-like *Pliopithecus*. More significant, however, are the names that were omitted.

In May 1964 Simons insisted on the continued need for "sharpening thinking on the taxonomy of . . . hominids and on the logical systems of interrelating fossils into evolutionary trees of descent."[26] Five months later, he deployed a particular graphic device to bring clarity and precision to the nomenclatural disorder that might otherwise have rendered Zallinger's proposed illustration an unwieldy array of polyphyletic branches. Simons's expedient of choice was the simple round bracket, or parenthesis. Parentheses were used extensively in the typed list to indicate junior synonyms of a taxon that could be subsumed within a prior name. Some instances of this typographic lumping were relatively uncontentious. The incorporation of the putative Pliocene ape *Bramapithecus* into *Ramapithecus* merely reflected Simons's recent realization, when exploring the Peabody's fossil collections, that "*Bramapithecus* mandibles are the lower jaws of *Ramapithecus*," and thus the two were actually a single animal.[27] On the list, Simons, or possibly Zallinger recording his verbal instructions, added an arrow linking the two names, with a succinct annotation stating "same thing."[28]

Even here, though, the parentheses around the erstwhile *Bramapithecus* were added subsequently by hand, suggesting that decisions about the status of variant names were often provisional and subjective. Classifications based on fragmentary fossils, as Simons observed in April 1965, were always "to some extent . . . a matter of taste." It was therefore inevitable, as he readily conceded, that "there's going to be disagreement."[29] In fact, in the list of "Hominoidea" he prepared for Zallinger six months earlier, Simons's seemingly innocuous parentheses, both typed and handwritten, were the vehicles of some extremely controversial taxonomic choices.

The Evil of Ill-Founded Names

If Simons, in his thirties, gained a reputation as the "lumper's lumper," then the sexagenarian Leakey was regarded as the "arch-splitter."[30] After years of dedicated toil in the Olduvai Gorge in Tanganyika (now Tanzania), Leakey, from the mid-1950s, had announced a series of sensational new fossil hominids. Although the actual excavations were often made by either his wife,

Mary, or his assistant, Heselon Mukiri, the discoveries brought Leakey international fame and the patronage of the National Geographic Society. Leakey assigned each of the fossils to either a new species or a new genus name. For Simons, these new taxa had "mistakenly founded names" that reflected a fundamental flaw in Leakey's nomenclatural practice. As he explained with evident exasperation, "Leakey is influenced in naming fossils by the notion that individual fossils need names which serve as 'labels' or 'handles' by which one can refer to the specimens." This contravened the requirement, stipulated by Mayr, that names should be reserved for established species populations and were almost never justified for solitary fossil fragments that were likely to be variants belonging in existing taxa. Though essentially a technical solecism, Leakey's invalid labels provoked Simons to fury; he alleged, in the midst of a long specialist paper, that the "evil of ill-founded names" would result in nothing less than "scientific anarchy."[31] As such hyperbolic language suggests, more was at stake than a mere difference in taxonomic tastes.

Long after his rival's death in 1972, Simons reflected on what he called the "Leakey Syndrome." This, he proposed, was the proprietorial presumption that the "fossils I find are the important ones and are on the direct line to man, preferably bearing names I have coined, whereas the fossils you find are of lesser importance."[32] Leakey's haphazard proliferation of hominid taxa, according to Simons, was a means of ensuring that his own specimens could be presented as the true and exclusive progenitors of modern humans. Such egotism risked obscuring the real relationships, for, as Simons warned, "splitting confuses the choice of ancestral candidates."[33] Simons, moreover, had a candidate of his own, which, he insisted, was the very first hominid and thus more noteworthy than any of Leakey's rival contenders. The winner of this dispute, a literal war of words over nomenclature, would hold the key to the origins of humanity.

Without naming Simons, Leakey chided him for "armchair juggling," implying that the "Yale scientist" lacked practical experience in the field and obsessed over minute morphological differences within the sterile confines of a laboratory.[34] Simons had been excavating the deserts of northern Egypt for several years, and even his laboratory, in Yale's geology department, was far from a sanctum of scientific detachment. Ian Tattersall, who

joined Simons as a graduate student in the mid-1960s, later recalled, "Upon entering Elwyn's amiably chaotic laboratory, I was mildly surprised to find him and his associates throwing darts at a board bearing Leakey's likeness."[35] In Simons's office in the adjoining Peabody Museum, the taxonomic barbs thrown at Leakey in the list of "Hominoidea" that he drew up for Zallinger were more discreet but just as deliberately aimed.

Leakey's colleague and biographer, Sonia Cole, subsequently observed that Simons was determined to "demolish" his rival's new taxa "one by one."[36] Certainly, the parentheses that he added to the typewritten list systematically demoted to the status of a mere synonym virtually every species or genus name that Leakey had coined or been associated with since the 1930s. His demotions, crucially, were omitted entirely from "The Road to Homo Sapiens," which was published in *Early Man* using only Simons's designated names below the figures drawn by Zallinger.

When Simons was asked to assist with Zallinger's commission from Time-Life Books, he was engaged, with his student David Pilbeam, in a major revision of the classification of Miocene primates. This, inevitably, involved lumping the names of multiple genera and species into a more restrained range of taxa within the single genus *Dryopithecus*. Leakey was aghast at what he perceived to be the creation of a "sort of dust bin" for the disposal of inconvenient specimens, principally his own.[37] As Pilbeam recalled, when he presented his and Simons's proposals at a symposium in Chicago in April 1965, "Louis started to yell at me, saying that . . . I was completely out of order and should shut up."[38] *Early Man* was published in May 1965, only weeks after the symposium, and early copies were likely already being received at Time-Life's Chicago fulfillment center just as Leakey was losing his temper at the city's university. The revised nomenclature that provoked his ire was reflected, as Simons had ensured, in the book's elaborate fold-out illustration. Leakey's Miocene apes were lumped out of existence from the start of the descending chronological list of "Hominoidea" on which "The Road to Homo Sapiens" was based.

Simons was still in the midst of what Pilbeam has called their "unscrambling of the Miocene hominoid mess" when, in October 1964, he compiled the list for Zallinger.[39] The complexities of their ongoing revisions are evident in the handwritten alterations made to the typescript. Initially, for in-

stance, Simons gave the name *Limnopithecus* priority over *Pliopithecus*, which was enclosed in typed parentheses. However, he corrected himself and, with a hand-drawn line, intimated that the order of the two taxa should be reversed. He reinforced this decision by adding parentheses to *Limno-pithecus*. Simons had already determined that, as he proposed in 1963, the "primitive gibbon-like genera *Pliopithecus* and *Limnopithecus* can no longer be considered distinguishable," despite being based on fossils from, respectively, Europe and Africa.[40] The latter generic name was coined in 1931 from materials discovered in Kenya on an expedition led by Leakey, and in 1949 Leakey himself had co-named one of the species within the genus.[41] As Simons's typed guidance to Zallinger and the subsequent handwritten revisions suggest, he initially remained hesitant about what to do with the two seemingly synonymous names.

Significantly, however, the scribbled alterations indicate that, in drawing up the list, Simons plumped for the position that he and Pilbeam would confirm early in 1965, that the "genus *Limnopithecus* must be regarded as a junior synonym of *Pliopithecus*."[42] The gibbon-like figure who begins the march of progress in Zallinger's illustration therefore stepped forward above the latter name. The naming of this jaunty *Pliopithecus* also commenced an almost total embargo of taxonomic names connected with Leakey.

Only Nuisance Value

There was a curious exception to the elimination of Leakey's nomenclature. In July 1964, Simons averred that "species of the genus *Proconsul* . . . should almost certainly be lumped together with the genus *Dryopithecus*," but three months later it was the former generic name that appeared at the top of the list he prepared for Zallinger.[43] Why, in this one instance, Simons went against his own publicly acknowledged inclination to purge *Proconsul* is unclear. The taxon had emerged from another of Leakey's Kenyan expeditions in the 1930s, and its inclusion in Simons's list ensured that it appeared, as the second figure, in "The Road to Homo Sapiens." With the following figure in Zallinger's sequence, however, Simons reverted to his lumper's instincts.

Rather than *Proconsul*, it was *Sivapithecus* that, in the typed list of "Hom-

inoidea," was subsumed into *Dryopithecus*, albeit with the latter name added later by hand. This classification entailed grouping fossils from different continents into a single cosmopolitan genus. Leakey, who had himself coined the species name *Sivapithecus africanus*, was adamant that it "would be much wiser to retain the generic name *Sivapithecus*" for many of the geographically diffuse specimens.[44] The alternative, he warned, was to make *Dryopithecus*, when used so indiscriminately, a "somewhat meaningless category."[45] But such concerns were disregarded in "The Road to Homo Sapiens," where the caption below Zallinger's third figure, the crouching *Dryopithecus*, stated that it had been "widely distributed" across several continents.[46]

With many of Leakey's Miocene taxa already expunged by what Simons jokingly called the "American school of extreme lumpers," the Anglo-Kenyan's vexation only increased with what he saw as a still more "extreme example of taxonomic lumping."[47] This especially irksome erasure of Leakey's nomenclature was conveyed to Zallinger, in Simons's typescript list, without any handwritten equivocations. The classification given was simply "Ramapithecus (Kenyapithecus)."[48] Behind the unambiguous positioning of the parentheses, however, lay a furious and still festering controversy that was the principal cause of the animus between Leakey and Simons.

In late 1961 Leakey had announced a new fossil primate that, as he excitedly proposed, would "bridge the gap between the numerous Lower Miocene higher primates . . . and the early Pleistocene Hominidae." It might even "represent an early member of the Hominidae" and thus be a forerunner of humans. Leakey named this "interesting fossil" *Kenyapithecus*, explaining that the "generic name is after Kenya Colony," the British imperial territory that would gain its independence only two years later.[49] At exactly the same time as Leakey's announcement, Simons was reappraising the fragmentary fossils at Yale's Peabody Museum that, three decades before, had been discovered in India, then also part of the British Empire. They had been named *Ramapithecus*, or Rama's ape, in honor of the Hindu deity Rama. Like Leakey's new African genus, this older Indian taxon, Simons concluded in November 1961, was also "ancestral to Pleistocene and subsequent hominids."[50] In fact, based on previously unappreciated aspects of the formation of its jaw, *Ramapithecus* seemed to show the "transition from ape to man" and might "be regarded as representing the earliest known hominid."[51] The two

specimens, from different parts of the now crumbling British Empire, seemed to represent precisely the same epochal moment in hominid evolution.

Soon after the initial generic diagnosis of *Kenyapithecus* was published in 1961, Simons discerned that in it "Leakey exactly describes . . . *Ramapithecus*."[52] This was because, in Simons's view, there was "not one *significant* character of difference" between the two sets of fossils. Rather than belonging to discrete animals, they were both, he proposed, from a "single species" that had "ranged all the way from northern India to East Africa, and perhaps further."[53] The cosmopolitan classification immediately removed the need for two separate names, and the long-standing convention of taxonomic priority, as Simons realized, played directly into his hands. At the 1965 symposium in Chicago at which Leakey became so enraged, Simons told him, to his face, that "if you're going to get names that people will accept as valid, you have to look for the prior types and try to cluster the new material around them."[54] In the case of *Kenyapithecus* and *Ramapithecus*, it was the latter name, coined back in 1932 by G. Edward Lewis, that had clear precedence, even if it had been ignored until Simons reassessed Lewis's fossils at the beginning of the 1960s. This meant, as Simons gleefully insisted, that Leakey's "supposed new genus" name must instead be considered merely a "junior synonym for *Ramapithecus*." *Kenyapithecus* was therefore a "redundant name" whose continued use had "only nuisance value."[55] It needed to be eradicated from the taxonomic record as quickly as possible.

Eradication was precisely what the parentheses achieved in the concise guidance, "Ramapithecus (Kenyapithecus)," that, in October 1964, Simons gave to Zallinger. Only two months before, Leakey had complained that there was "no scientific evidence" for conflating his new African genus with its Indian counterpart. He even insinuated that Simons had relied on morphological sleight of hand, deliberately intermixing unconnected fossils "in order to give a semblance of likelihood" to his specious claims.[56] Such allegations were not acknowledged in "The Road to Homo Sapiens," where Simons's partisan instructions were, once again, followed to the letter. It was *Ramapithecus* that was heralded, in the caption to the fifth figure in Zallinger's series, as the "earliest manlike primate found so far."[57] The disputed name *Kenyapithecus* was entirely absent from the illustration, nor did it appear anywhere else in *Early Man*.

The caption below Zallinger's reconstruction of *Ramapithecus* declared that it was "now thought by some experts to be the oldest of man's ancestors in a direct line."[58] The pluralized anonymity of these "experts," with only the hint of a lack of consensus indicated by the pronominal "some," deflected attention from Simons's almost exclusive role in reviving *Ramapithecus* and promoting it to the coveted status of the progenitor of humanity. The age of Lewis's *Ramapithecus* fossils, established by the potassium-argon technique of dating radioactive decay, made Simons's claim still more arresting. Indeed, human origins could now be traced back some fourteen million years.

From the beginning, as Simons conceded in 1961, there was a "polemical atmosphere surrounding" *Ramapithecus*.[59] Its inclusion in "The Road to Homo Sapiens," and especially at such a critical juncture in the image's ascending sequence (accentuated in the six-figure version before the fold-out pages were opened), was not without controversy (see fig. I.3). This was principally because of the paucity of the fossil remains on which the classification was based, and Simons, in his terse guidance to Zallinger, told the artist: "only upper and lower jaws known."[60] Simons would later disown Zallinger's inferential reconstruction of the rest of *Ramapithecus*'s head and body. But when "The Road to Homo Sapiens" was first published in May 1965, the prominence of this highly speculative figure was, no less than the absence of *Kenyapithecus*, a direct result of Simons's involvement in the image.

An Evolved Australopithecus

Zallinger's conjectural reconstruction raised concerns with some specialist readers of *Early Man*. In 1966 the Harvard paleontologist Alfred Sherwood Romer, in an otherwise positive review of the book, observed with evident disquiet that the "body of the sub-human *Ramapithecus* is figured in toto, although we know little of this ape except the teeth." Alongside this questionable choice for inclusion, Romer also perceived an equally conspicuous omission, although he assumed it must have been accidental. He noted ruefully that the "book appears to have gone to press too early to include discussion of Leakey's recent advocacy of . . . *Homo habilis*."[61] Another expert reviewer of *Early Man*, the anthropologist Creighton Gabel, was less

charitable: "Dr. Leakey and his protagonists probably will be upset by the failure to include *Homo habilis* by name, these fossils from Olduvai being treated as Australopithecines."[62] Gabel's instincts were right, and the failure to acknowledge *Homo habilis*, a new hominid species from the early Pleistocene that Leakey had named in April 1964, was a calculated slight rather than a mere contingency of Time-Life's publishing deadlines.

That the omission was intentional can be verified because *Homo habilis* was included in the typed list of "Hominoidea" that Simons prepared for Zallinger six months after Leakey had published the Latinate specific name that, by implying handiness or manual dexterity, indicated the specimen's distinctive status as the first "advanced tool maker."[63] In October 1964 Leakey stated: "I believe that *Homo habilis* represents a distinct branch of *Homo* possibly leading towards *Homo sapiens*."[64] In the same month, Simons—or, possibly, his secretary—typed "Homo habilis (an evolved Australopithecus, Olduvai Bed I)" at the start of the section on Pleistocene hominids in the list for Zallinger. Immediately afterward, "*Telanthropus*," another of the plethora of names given to the Pleistocene fossils found in South Africa in the 1940s, was added by hand.[65] The collation, on the same line, of three ostensibly separate taxa indicates the still unsettled status of Leakey's new classification. It is nevertheless notable that the placement of the parentheses seems to give precedence to the name *Homo habilis*. But as both Romer and Gabel noticed in their reviews of *Early Man*, Leakey's latest and most sensational discovery was conspicuously absent from the book and especially from "The Road to Homo Sapiens."

The equivalent figure in Zallinger's illustration was given a name that reflected the guidance that Simons had placed in parentheses, with "(an evolved Australopithecus . . .)" becoming "Advanced Australopithecus." Although Simons deployed parentheses principally to indicate the ranking of synonymous names and efface those without priority, he also used them, in the second half of the list, to provide further information about some of the later extinct primates, as with "Solo (Neanderthal counterpart in S.E. Asia)."[66] This dual purpose became rather confused with *Homo habilis*, at the list's midpoint, and it is only the published form of "The Road to Homo Sapiens" which confirms that, in this case, Simons's parentheses had the latter function. Until now in his career, Simons had specialized in the much

earlier Miocene fossils, of which the fourteen-million-year-old *Ramapithe-cus* was only the most recent. With Pleistocene hominids like *Homo habilis*, later members of the *Australopithecus* genus, and *Telanthropus*, which were presumed to date back no more than a couple of million years, he was more reliant on the findings of other paleoanthropologists. Simons's uncharacteristic reluctance, in his list for Zallinger, to prioritize the synonymous names may reflect a lingering uncertainty about the placement of Leakey's new species at the time the list was made in October 1964. After all, Simons had not actually seen the fossils in question, and, in the same month, Leakey was adamant that a morphological "diagnosis makes it quite clear that *Homo habilis* differs fundamentally . . . from any known australopithecine."[67]

By January of the following year, there was an authoritative verdict from John Talbot Robinson, who personally compared Leakey's *Homo habilis* specimens with the Australopithecine fossils he had himself discovered, with Robert Broom, in the 1940s. The original *Australopithecus* specimen had been named by Raymond Dart back in 1925, and it was he who, nearly four decades later, suggested the name *Homo habilis* to Leakey and his collaborators Phillip Tobias and John Napier. But for Robinson the new name was unnecessary, for "Leakey *et al.* . . . have by no means provided a reasonable case for establishing a new species of *Homo*." In accordance with the clear priority of Dart's earlier taxon, Robinson proposed that the *Homo habilis* fossils be regarded as "advanced representatives of *Australopithecus*."[68] Robinson's imprimatur seems to have resolved the matter for Simons, and by June 1965 he and Pilbeam were likewise proclaiming that they could find "no good reason for separating early species of the genera *Australopithecus* and *Homo*."[69] Robinson's decision also sanctioned Simons's clarification of his original typed guidance to Zallinger. Even if the verdict on Leakey's newest nomenclature had to be confirmed to the artist verbally, it was to be consigned, once more, to taxonomic oblivion.

Robinson conceded that the specimens from Leakey's invalid taxon came at the very "ends of a transitional sequence" and varied considerably, especially in their cranial capacity, from earlier members of *Australopithecus*.[70] In light of this variation, Simons did not advise, as he had with *Limnopithecus*, *Sivapithecus*, and *Kenyapithecus*, merely lumping *Homo habilis* into *Australopithecus*. Rather, Zallinger, following Simons's instructions, drew two

separate Australopithecine figures for "The Road to Homo Sapiens." The second was labeled, in accordance with the wording of Robinson's recent conclusion, "Advanced Australopithecus," while the former appeared, two places earlier, without the qualifying adjective.

Between those two Australopithecine figures, Zallinger inserted one called "Paranthropus," and here again "The Road to Homo Sapiens," at Simons's behest, markedly privileged Robinson's views over Leakey's. Following *Homo habilis* and *Australopithecus* in his list, Simons reverted to his original method of employing parentheses to indicate priority, typing, without equivocation, "Paranthropus (Zinjanthropus)."[71] The parenthetical name was that of another new Pleistocene genus, potentially directly ancestral to modern humans, that Leakey had created in 1959 and which Robinson had quickly declared "biologically unmeaningful." The fossil that Leakey proudly named *Zinjanthropus*, adopting an Arabic word that reflected its discovery in East Africa, was, for Robinson, merely a slightly "larger and more muscular" variant of the "known South African specimens of *Paranthropus*."[72] Simons agreed that "*Zinjanthropus* should not have subgeneric status apart from *Paranthropus*," so it was the latter name that appeared below the seventh figure in Zallinger's march of progress.[73] The labeling of its brawny form striding robustly between the two Australopithecines was yet another deliberate affront to Leakey.

Paranthropus, a term coined by Broom in the late 1930s, named one of the "various South African finds" that, as Mayr contended in 1950, were merely "age or sex stages of a few related tribes" and whose numerous sobriquets should therefore "not have any validity."[74] The inclusion of *Paranthropus* in the typed list prepared for Zallinger, and consequently in "The Road to Homo Sapiens," suggests that Simons's adherence to Mayr's directives on taxonomic lumping was less exacting when it was not Leakey's nomenclature that was at stake. Indeed, using *Paranthropus* as a senior synonym to *Zinjanthropus*, thereby expunging the genus that Leakey saw as specific to East Africa, created classificatory problems that would later necessitate revisions to Zallinger's illustration.

Whereas specialist reviewers of the first printing of *Early Man* in 1965 were struck by the curious omission of *Homo habilis*, with the book's second edition, published in 1970, a related modification was particularly conspic-

uous. As Simons's former student Tattersall noted, the "appellation *Paranthropus* [*sic*] has been dropped from the caption accompanying Zallinger's series of drawings."[75] The drawing itself remained unchanged, but it was now labeled "A. robustus," with the classification of its immediate precursor, previously "Australopithecus," similarly changed from a genus to a species; its new name was the binomial "A. africanus."[76] Whether Simons had any involvement in these revisions is unclear, but they seem to reflect an awkward dilemma that he outlined in 1967: "Should one . . . place *Australopithecus robustus* in a separate genus *Paranthropus*, no type-species for the genus *Australopithecus* remains, and the term would have to be dropped."[77] *Paranthropus* had to be sacrificed in order to save the *Australopithecus* taxon, which was now split between an earlier gracile form and a later robust variety. In fact, it was in an abridged "Young Readers Edition" of *Early Man*, brought out in 1968, that the changes were first made, with the initial parts of the two Australopithecine binomials given without abbreviations to aid the comprehension of children.[78] In both these amended versions of "The Road to Homo Sapiens," the "Advanced Australopithecus," which Simons, following Robinson, had preferred to *Homo habilis*, retained its original name.

Pleistocene Rumbles

One of the reasons for Simons's determination to rid Zallinger's march of progress of any trace of Leakey's recent Pleistocene discoveries was evident in a story that the influential magazine *Newsweek* ran in April 1965, only weeks ahead of *Early Man*'s publication. The article, entitled "Battle of the Bones," reported on the symposium at the University of Chicago at which Leakey vented his fury at Simons and Pilbeam. In another session, *Newsweek*'s correspondent noted, "Leakey galvanized some of his most eminent colleagues into vigorous disagreement when he asserted that not one or two, but actually three pre-men coexisted peacefully in Pleistocene Africa." Among the many "objections to Leakey's theory," *Newsweek* recorded a particular demurral: "'I am just asking,' said Elwyn L. Simons . . . 'but could three species of man coexist?'" The grounds for Simons's doubt were then summarized, presumably with a degree of journalistic license: "Pleistocene

rumbles over areas, or turfs, would inevitably lead to the elimination of at least one species." As a consequence, as *Newsweek* observed, Simons "drew a simpler picture of man's evolution" than the more complex arrangement proposed by Leakey.[79]

Back in 1950, Mayr had surmised that a characteristic "trait of the hominid stock" was to be "particularly intolerant of competitors," and Simons concurred that it would have been impossible for many "different kinds of hominids to coexist."[80] Leakey's Pleistocene taxa were not wiped out through primeval violence, however. The three separate hominids that Leakey viewed as peaceable neighbors were *Zinjanthropus, Homo habilis,* and another member of *Homo* that he nicknamed "Chellean Man" after the type of stone tools that were found alongside it in the Olduvai Gorge.[81] Like the more formal names of Chellean Man's supposed cohabitants in Pleistocene East Africa, Leakey's sobriquet was lumped into anonymity by the strategic parentheses in Simons's list for Zallinger. Arranging the various forms considered immediately anterior to early *Homo sapiens,* Simons typed: "Pithecanthropus (Sinanthropus, Atlanthropus, Chellean)."[82] When "The Road to Homo Sapiens" was published in *Early Man,* the senior synonym in Simons's list was itself lumped into "Homo erectus," one of only two binomial names used in the original version of Zallinger's illustration. This lumping facilitated a still more "simplified classification" in accordance with the recommendations of Mayr, who had insisted that the various specimens known in 1950 "must be called *Homo erectus.*"[83] Applying the same strictures to Leakey's myriad new discoveries a decade and a half later entailed a radically reductive approach to hominid evolution.

Rigorously lumping synonymous nomenclature eradicated all three of Leakey's putatively contemporaneous taxa, thereby enabling Simons to chart a "single line of but a few species, successive through time."[84] This simple linear arrangement, confirming Mayr's contention that all valid hominids were "members of a single line of descent," reflected Simons's endorsement of what he called "monophyletic hominid evolution."[85] In this view, discrete species lived in isolation, albeit with a broad range of geographic dispersal and consequently some variation, rather than existing simultaneously with other hominid species. Over time, younger members of the prevailing species would differ from their parent populations to such a degree that, at a

moment of speciation, they justified the status of a new classification; then the process began all over again. Simons argued for the "successive differentiation of these species, through time . . . with little branching or radiation" and hardly any instances of lineages becoming extinct.[86] He contended, with Pilbeam, that it "seems unlikely that in such a biologically successful group as the higher Primates very many taxa have ever become extinct except by time-successive transition into later species."[87] Mayr, too, had envisaged a similar process in which each "taxonomic entity" is successively "transformed into another one."[88] Significantly, this orderly, linear conception of evolutionary change resulted in precisely the kind of chronological "species-series" that Simons portrayed, by rudimentary typographic means, in the vertical list he made for Zallinger and that the artist depicted, more elaborately, in "The Road to Homo Sapiens."[89]

Leakey's polyphyletic view of multiple coexisting hominids, on the other hand, engendered a very different spatial arrangement of the human evolutionary tree, one that has been described as "very bush-like."[90] While Leakey himself did not give a visual form to this branching structure, one of his collaborators proposed a means by which it could be depicted. In designating *Homo habilis* a new species, Leakey relied on the anatomical expertise of John Napier, who had examined the specimen's all-important hands. In June 1964, two months after announcing the new taxon with Leakey and Phillip Tobias, Napier proposed that it was now "no longer meaningful to think of man's evolution in terms of a series of direct ancestors—a concept which . . . tends to give a false impression of simplicity." With numerous hominid species seemingly "distributed in space" as well as in time, Napier sought a means to "illustrate this approach" in a way that, as he put it, "shows the expanding nature of evolution."[91]

Napier's graphic solution was a "Cone of Hominoid Evolution," which he published in the British popular science magazine *Discovery* (fig. 7.2). This diagram, he asserted, "illustrates a more sophisticated way of looking at evolution" than that represented by a traditional "evolutionary 'tree'" or a still more facile linear sequence. In particular, it "eliminates the need to draw direct ancestral links." Instead, the hominoids spread out in four separate directions, portrayed in what might be a close-up view of the stems of a leafless plant, each terminating in a horizontal cross section. At the same

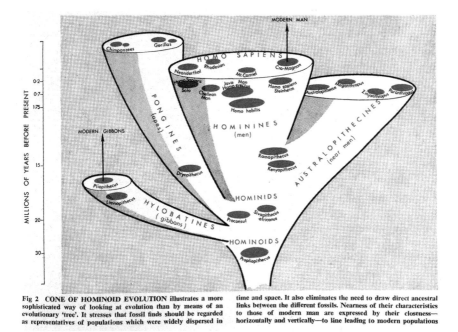

Fig 2 **CONE OF HOMINOID EVOLUTION** illustrates a more sophisticated way of looking at evolution than by means of an evolutionary 'tree'. It stresses that fossil finds should be regarded as representatives of populations which were widely dispersed in time and space. It also eliminates the need to draw direct ancestral links between the different fossils. Nearness of their characteristics to those of modern man are expressed by their closeness—horizontally and vertically—to line leading to modern populations

Fig. 7.2. Diagram entitled "Cone of Hominoid Evolution." The diagram's conical composition enables the inclusion of many of the simian and hominid taxa excluded from "The Road to Homo Sapiens." This design follows Louis Leakey's view that in cases such as *Ramapithecus* and *Kenyapithecus*, these taxa represented separate animals rather than being, as Simons argued, superfluous names for the same creature. In John Napier, "Five Steps to Man," *Discovery* 25, no. 6 (1964): 35. (Author's collection. By permission of Gremlin Napier.)

time, the shape of the seemingly organic structure resembles one of Henry Moore's abstract sculptural forms. Most of the taxa depicted appear alongside each other, labeled below irregular dots that seem to indicate population size; their side-by-side location implies that they existed simultaneously rather than successively. A further innovation is that the "HOMININES (men)" are separate from the "AUSTRALOPITHECINES (near men)," having diverged at an early stage. In the former stem, at the center of the diagram, is Leakey, Tobias, and Napier's own *Homo habilis*, which is shown as having "crossed the threshold between human and pre-human grades to become the earliest true man."[92]

As well as the pivotal *Homo habilis*, Napier's "Cone of Hominoid Evolution" includes all of Leakey's taxa—ranging from *Limnopithecus, Sivapithe-*

cus, and *Kenyapithecus* to *Zinjanthropus* and Chellean Man—that Simons, later in 1964, would dismiss as invalid synonyms in his guidance to Zallinger. Napier, though, did not omit the alternative names to which Simons gave priority, and instead the alleged synonyms are positioned alongside each other, implying that they each represent separate but coexisting animals. Their inclusion, side by side, accounts for the expansive breadth of the diagram's conical stems, especially the central one, which represents the polyphyletic branching of nine discrete species of early humans. The systematic exclusion of Leakey's nomenclature, by contrast, ensured a thin, linear configuration that, as Simons insisted just weeks after Napier published his conical alternative, formed the "exact line of man's ancestry." Simons, in July 1964, proposed that the straight "line to man" could be charted, without any diverging branches, by a select number of "taxonomic signposts."[93] Following his typed guidance to Zallinger three months later, this metaphor of lineal travel was given definitive visual form in "The Road to Homo Sapiens."

No Axe to Grind

If the format of Zallinger's now iconic illustration was a corollary of Simons's refusal to countenance any of Leakey's much vaunted discoveries, it seems remarkable that this has never previously been recognized. Romer and Gabel both noted the peculiar omission of *Homo habilis* in their specialist reviews of *Early Man*, and the latter considered that Leakey might be "upset" by it. Even this suggestion seems strangely muted given the ferocity of the scientific feuds in which Simons and Leakey, as well as other leading paleoanthropologists, regularly became embroiled. With experts like Romer and Gabel seemingly unaware of the full implications of the absence of *Homo habilis*, it is hardly surprising that general readers of *Early Man* failed to notice the hugely contentious exclusion of the rest of Leakey's nomenclature from "The Road to Homo Sapiens."

There are reasons for this pervasive oversight. First, as was noted earlier, Simons's contribution to the image was not known at the time. His name did appear, in miniscule type, in *Early Man*'s acknowledgments, but among a roster of more than thirty eminent experts, including Leakey himself, who were collectively thanked for having given "their time and special knowl-

edge" on unspecified subjects. Readers were left to assume that Zallinger was guided by Francis Clark Howell, *Early Man*'s nominal author. In reality, Howell, as was conceded in the book's front matter, had been commissioned to provide "professional direction"; the text was actually written by Maitland Edey and other members of the Time-Life editorial staff. Howell's guidance on matters "from planning and organization to final editing" did include advising Zallinger on the details of his reconstructions of hominid species known only from fragmentary fossil remains.[94] But it was Howell's imprimatur more than any practical involvement that helped to determine how "The Road to Homo Sapiens" was perceived by readers of *Early Man*.

In terms of taxonomic preferences, Howell considered himself "broadly in agreement with Mayr," thus more in accord with Simons's lumping and linearity than with Leakey's polyphyletic splitting.[95] Similarly, although he regarded *Homo habilis* as a "most interesting creature," he concluded, in 1965, that Leakey's classification was "not justifiable in my opinion . . . at least in the present state of knowledge."[96] The typed list of "Hominoidea" that Simons made for Zallinger may not have seemed unreasonable to Howell, if he ever saw it. But as his prudently equitable tone when pondering *Homo habilis* suggests, Howell, unlike Simons, did not relish the polemical disputes that attended almost every new hominid discovery. He instead bemoaned the propensity among his colleagues for "argument and controversy, rather than enlightenment and consensus."[97] In the perennial disagreements, as a student of Howell's later recalled, "Clark played the mediator — and because of his graciousness, and cautious, considered approach, most everyone trusted him." These qualities made Howell, or at least his name, a valuable commodity for Time-Life, and they were willing to pay liberally to secure his services. The same former student noted that "Clark was also a most pragmatic man, and in the mid-1960s he had a growing family," making him mindful that the "Time Life book project . . . helped to cover the family's ever growing bills."[98] Executives at Time-Life were no less aware that their standard fee of "$10,000 is usually the chief lure" for an "expert paid consultant," whose academic earnings inevitably paled in comparison.[99]

Time-Life, having bagged Howell with this considerable lure, went on to commission the eminent Harvard anthropologist William Howells to write a brief introduction to *Early Man*. In it, Howells assured readers of the near

namesake who was the book's putative author that "he does not write from any argumentative position; having no axe to grind in what he says, he will have no hatchet to bury later on."[100] This paragon of impartiality had not, of course, actually written the book's text, as the small print on the preceding page freely acknowledged. Nor had Howell been directly involved in the planning and configuration of its most prominent nontextual element, which Simons had ensured was far from impartial. The pictorial content of *Early Man* was crucial to its commercial prospects, and Gabel, in his review, observed that the "illustrations almost make the book worth the price by themselves."[101] Despite Howell's lack of involvement in the creation of "The Road to Homo Sapiens," his reputation for ecumenical moderation was integral to maintaining the value of the illustration, which otherwise might have been dismissed as an exercise in axe grinding.

In 1965 *Newsweek* noted that "Leakey is a loner," a trait that Simons chided him for, since it often resulted in the "total omission of the work of others" from reports of his discoveries.[102] While Leakey frequently fell out with his collaborators, including Napier and Tobias after they suggested that cultural factors could be employed in classifying *Homo habilis*, his irascibility seems to have been tempered by Howell's calming restraint. The two men enjoyed an enduring friendship after meeting in Kenya in 1954, and on Leakey's regular visits to the United States, he "often stayed with the Howells in their home just outside Chicago," as one of Howell's students at the time later recounted.[103] Indeed, Howell was likely hosting Leakey in the Illinois suburb of Homewood when he became so enraged with Simons and Pilbeam at the fractious symposium held at the University of Chicago in April 1965. Across the city, the initial runs of *Early Man* were just being received at Time-Life's Chicago fulfillment center, and Leakey's fretful mood would hardly have been improved if he encountered an advance copy of the book.

Whether Leakey saw the book or not, he clearly became worn down by Simons's persistent rebuttals of his discoveries. As *Time* reported in February 1967, "Leakey feels that he has little chance of finding the common ancestor of man and the apes," which was considered to have lived "some 40 million years ago, in the Oligocene epoch." Noting Leakey's rivalry with the "Yale paleontologist Elwyn Simons," the magazine recorded Leakey's "somewhat sad prediction: 'He will be the man who gets the common link.'"[104]

Leakey's rueful prediction never came to pass, but Simons had one last victory over his old foe, albeit not intentionally. The final insult, moreover, was delivered unwittingly by Howell and some of Leakey's most loyal supporters following his sudden death from a heart attack in October 1972.

Four years earlier, a group of Californian admirers had founded the L.S.B. Leakey Foundation to raise funds to support his fieldwork in East Africa. Howell served as chair of the science and grants committee and, after Leakey's death, took over his late friend's extensive lecture engagements organized by the foundation. He also helped steer the foundation into a new role furthering Leakey's legacy by supporting broad research into human origins.[105] By 1975 the foundation had adopted an emblem to embody this new mission, seemingly with Howell's permission; it appeared on the masthead of the first issue of the *L.S.B. Leakey Foundation News*.[106] The emblem featured seven of the reconstructed hominid figures from "The Road to Homo Sapiens," redrawn but virtually indistinguishable from Zallinger's originals and still arranged in the same distinctive upward curve. The redrawn figures included one that was immediately identifiable by the primitive tool, crafted from a bone, grasped in its left hand. In *Early Man*, the same figure had been labeled, at Simons's behest, "Advanced Australopithecus," thereby eliminating Leakey's prized new taxon *Homo habilis*. Remarkably, the Leakey Foundation's logo, which it continues to use on various digital platforms, was an image that, in its original form, was planned by his bitterest rival, and which deliberately and systematically excluded Leakey's nomenclature.[107]

The Wrong End of the Telescope

What diverted attention from the manifestly anti-Leakey bias of "The Road to Homo Sapiens" was not just Howell's friendship with Leakey, nor the veneer of even-handedness that Howell's imprimatur lent to *Early Man*. It was also the sheer visual potency of the image's ascending arrangement, over five pages, that seems to have beguiled even the most discerning readers. Another specialist reviewer of *Early Man*, the anthropologist Wilton Marion Krogman, declared in December 1965 that the "folded insert illustrating the road to *Homo sapiens* is sheer magic."[108] This is the first recorded in-

stance of the powerful affective impact that, over the next half century, would make the image so influential and so widely replicated. Much later, Howell himself said of Zallinger's illustration that the "graphic overwhelmed the text. It was so powerful and emotional."[109] Simons rebutted Leakey's taxonomic classifications primarily through the image's textual components, the names and captions below each of the figures. These elements, as Howell suggested, were easily overlooked given the emotive sweep of Zallinger's successive drawings.

But the illustration's anti-Leakey bias was not confined to its textual elements. Even the shape of "The Road to Homo Sapiens" was a corollary of its omission of Leakey's multiple coexisting taxa, an exclusion that ensured a thin, linear configuration. For Howell, the configuration was one of the things that gave the image its emotional power, and he commented, shortly before his death in 2007, that the "artist didn't intend to reduce the evolution of man to a linear sequence . . . but it was read that way by viewers."[110] Zallinger himself, according to his daughter Lisa David, "objected to the linear layout," although he did not join Howell in blaming readers of *Early Man* and subsequent audiences for that interpretation of the image. Instead, Zallinger, as David relates, had "drawn each figure separately and worried that presenting them as a continuous series misrepresented, 'from a scientific point of view, how this whole evolution occurred.'"[111] Simons later freely acknowledged that "I advised Zallinger to draw such a sequence," which, in light of David's account of her father's feelings, raises the fascinating prospect that the artist disagreed with the scientific instructions he was given.[112]

Some of Zallinger's preparatory artwork for the illustration suggests that he contemplated alternative formats. Discord between artist and scientist would hardly be unprecedented, in any case. Here it echoes the dispute, almost exactly a century earlier, between Huxley and Hawkins during the creation of the frontispiece to *Man's Place in Nature*, though without the rancor of that intellectual duel. It has been suggested that in "The Road to Homo Sapiens," modern paleoanthropological discoveries were "fitted . . . into the framework of the original Huxley diagram."[113] Simons's reminiscences show it was actually Ziska's illustrations from the late 1920s that provided the particular paradigm, although they were themselves part of Gregory's

endeavor to return to Huxley's and Haeckel's simple linear representations of evolution.

As with the frontispiece to *Our Face from Fish to Man*, the more self-consciously popular of Ziska's images departed from Huxley's sequence of skeletons and instead depicted an apparently hierarchical scale ascending to the idealized perfection of a classical statue (see fig. 6.3). While acknowledging the original influence of the illustrations in Gregory's book, Simons was adamant, in his recollections, that Zallinger's equivalent "sequence does not represent progression to a 'perfect' human form."[114] The advancement toward a telos of perfection has been the most enduringly controversial aspect of "The Road to Homo Sapiens," embodied in its alternative, and more pervasive, epithet, the march of progress. Simons's disclaimer notwithstanding, his involvement with the image, as with the linear format that resulted from his tidying of Leakey's classificatory clutter, was a crucial factor in the perception that "The Road to Homo Sapiens" endorses a progressive understanding of evolution.

Given Simons's explicit denial that there was any progress to perfection, this interpretation of his involvement with Zallinger's illustration might seem surprising. From the beginning of his career, Simons was alert to the tendency of even expert paleoanthropologists to privilege evidence that was "so fascinating in an anthropocentric world." This focus on humanity, he contended in 1960, was the outcome of "look[ing] through the wrong end of the telescope," of remaining fixated on hominid resemblances to humans and not recognizing that, more objectively, "men could be said to be *Australopithecus*-like and not the other way round."[115] But the metaphor of the telescope, whichever end of it is used, implies a linear relation between past and present. The implication, moreover, tallies with Simons's figurative suggestion that "evolutionary history is like a long, unilluminated corridor" in which it was possible "to strike lights" only at certain stages.[116] Linearity was already inherent in the particular understanding of hominid evolution elaborated by Mayr, which had such a decisive influence on Simons. And Simons's language, when describing these linear sequences, could also be surprisingly teleological.

In the same 1960 article in which Simons berated his colleagues for their

inherent anthropocentrism, he himself proposed that recent discoveries had yielded "evidence of a progressive morphological and temporal succession leading up to present-day man."[117] The placement of hominid fossils in chronological order, Simons appeared to suggest, revealed an absolute advancement in physical forms that was, as he put it elsewhere, "climaxed by the arrival of modern man." At other times, he was more cautious, for instance by adopting quotation marks to indicate the relative nature of the "many 'progressive' or advanced features" developed during primate evolution.[118] Nevertheless, Simons continued to use such evaluative terminology even while questioning its validity. Again, this seems in part a result of Mayr's seminal impact on Simons's thinking, for Mayr's linear conception of the emergence of modern humans, according to Tattersall, "to all intents and purposes consisted of the progressive modification of a single central lineage."[119] What Mayr himself termed a "continuous line of development from the primitive hominids to modern man" strongly implied a fixed scale of advancement.[120]

Simons's own language could, at times, be even more overtly hierarchical. In 1963 he seemed to invoke the great chain of being and its habitual depiction as a ladder or stairway when adumbrating what he called the "steps in evolutionary development leading up to the appearance of Man."[121] Such rhetorical vestiges were a feature of Simons's often sardonic prose, which was frequently based on oral presentations, and do not necessarily indicate an adherence to older conceptions of progress.[122] Some further instructions that he gave to Zallinger, however, clearly do.

The Rise of Humanity

In June 1965 Simons, with Pilbeam, observed of the Pleistocene epoch that "throughout this time, hominids were getting larger; this size increase was probably associated with increased speed and efficiency in running and walking."[123] A continuous growth in stature had been reflected, two months earlier, in "The Road to Homo Sapiens," where Zallinger's hominid reconstructions, several of which were based on partial skeletal remains that did not give a definitive sense of their height, became successively taller. Such an arrangement conformed with what in the 1940s had been named "Cope's

Rule," after the nineteenth-century paleontologist Edward Drinker Cope, which held that evolutionary lineages invariably increased in phyletic size over geological time.[124] This rule was far from infallible, though; there were other ways of interpreting the available fossil evidence.[125]

Since the 1940s, as Simons himself acknowledged two decades later, it had been proposed that the "forms *Gigantopithecus, Meganthropus, Pithecanthropus* represent a successive evolutionary series of decreasing size."[126] The last of these was included in "The Road to Homo Sapiens," under the name "Homo erectus," but the earlier two shared the same fate as Leakey's proposed taxa. Unlike his treatment of those superfluous synonyms, Simons did not deny the validity of either *Gigantopithecus* or *Meganthropus* as generic names; in fact, he took a strong interest in the former. By the late 1960s he came to consider that "*Gigantopithecus* may well tell us something about an early stage of man-like development, even though it might not itself be directly ancestral to humans."[127] This would have given it at least as strong a claim to inclusion in "The Road to Homo Sapiens" as other "likely side branch[es] on man's family tree," such as *Oreopithecus* and *Paranthropus*, that did appear.[128] Even in the second edition of *Early Man* in 1970, however, *Gigantopithecus* remained absent from Zallinger's illustration.

This is especially curious since Simons himself had commissioned from Zallinger, in early 1969, a reconstruction of *Gigantopithecus* in exactly the same style as the figures the artist had made for Time-Life four years earlier. The creature's colossal size in the image, as Simons explained, was "based on the assumption that the giant ape's body was in proportion to its massive jaw," which was the only part of its anatomy that was known.[129] Conjecturing that the rest of its body was like that of a huge gorilla, Zallinger drew *Gigantopithecus* at the midpoint of a sequential series of eight simians and hominids leading up to a modern man, who turns to look back at his potential ancestors rather than, as in the original march of progress, striding purposefully forward (fig. 7.3). Although the dimensions of the pasteboard on which the pencil drawings were made required the sequence to be split into two rows, the *Gigantopithecus*, at the right end of the top row, was conspicuously larger than the figure that followed it, a reprise of *Early Man*'s *Paranthropus*. Simons wanted these new figures for an article in the *Yale Alumni Magazine*, where they were printed across several separate pages in reverse

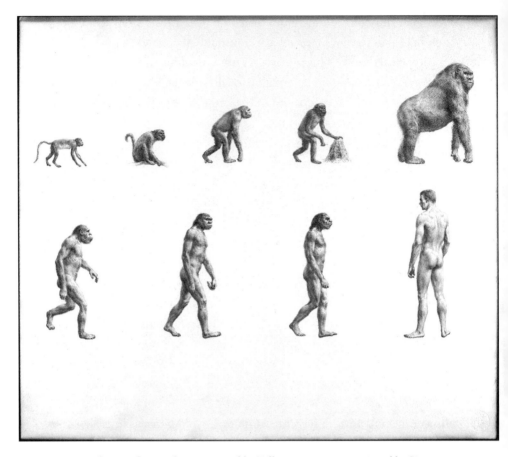

Fig. 7.3. The nine figures, drawn in pencil by Zallinger, were commissioned by Simons to accompany an article in the *Yale Alumni Magazine*. The *Gigantopithecus* at the right of the top row disrupts the gradually ascending curve that, four years earlier, was created by Zallinger's figures in "The Road to Homo Sapiens." Behind the *Gigantopithecus* is a *Ramapithecus* poking a stick into a termite nest, which reflects an informal conjecture made by Simons about the creature's use of tools. Rudolph Zallinger, original drawings for "In Pursuit of Man's Pedigree." Pencil on paper, ca. 1969. (YPM VPAR.002791, Elwyn LaVerne Simons Archives, Yale Peabody Museum of Natural History. By permission of Zallinger Family LLC; courtesy of the Yale Peabody Museum.)

chronological order.[130] This arrangement might reflect Simons's earlier comments about telescopes and not viewing the past from the perspective of the present, although it is unclear whether it was he who suggested the layout. More certain is what was shown by the original unpublished format of Zallinger's artwork. If *Gigantopithecus* had been included in "The Road

to Homo Sapiens," its anomalous stature would have wrecked the gradually ascending curve that was integral to the image's visual power.

Simons's determination to ensure a progressive sequence is evident from a surviving mock-up of the configuration of the figures Zallinger created for *Early Man*. Unlike those in his later commission, these were drawn individually. Separate photographs of each of the fifteen drawings were mounted on a black background attached to stiff cardstock (fig. 7.4). This moveable arrangement presumably allowed Simons and Zallinger to confirm the order of the figures before fixing them, with adhesive tape, in their respective positions. There would still be additional changes. In the second row the figures numbered eleven and thirteen, representing "Rhodesian Man" and "Early Homo sapiens," swapped places in the published image. More significantly, on the top row Simons added further instructions, with a felt-tipped marker pen, over the figures numbered three and four. What he wrote above the *Dryopithecus* is too faded to be fully legible but is possibly "Too small." The similarly curt annotation over the *Oreopithecus* is much clearer: "Too large."[131] In the mock-up, this figure was exactly the same height as the *Ramapithecus* that follows it.

The rationale for this directive to reduce the size of *Oreopithecus* in relation to the subsequent *Ramapithecus* is, at best, ambiguous. The former was known from an almost complete skeleton discovered in an Italian coal mine in 1958. It was, as Simons acknowledged in 1964, "of substantial size — some four feet tall." The skeleton's broad pelvis, moreover, indicated that *Oreopithecus* had assumed an "erect walking posture" that would make its height more manifest.[132] With *Ramapithecus*, by contrast, the absence of any fossil remains beyond teeth and jaws left Simons relying on "circumstantial rather than direct evidence" to infer that it was "at least, a partial biped."[133] In any case, Simons's insistence that *Ramapithecus*, unlike *Oreopithecus*, had indubitably humanlike characteristics meant that, as he explained, "relative to apes, its head was large compared to its body size." Extrapolating from the dimensions of its jaw, this meant that the putative hominid would have been "perhaps only three or four feet tall if standing erect."[134] *Oreopithecus* was, if anything, not smaller but slightly taller than *Ramapithecus* was presumed to be.

Zallinger nevertheless obeyed Simons's instruction, and in the published

Fig. 7.4. In this mock-up of the figures that Zallinger drew for the "The Road to Homo Sapiens," photographs of the fifteen individual drawings are mounted on a black background attached to stiff cardstock. The moveable arrangement enabled Zallinger and Simons to confirm the order of the figures before fixing them, with adhesive tape, in their respective positions. Simons's annotations above the third and fourth figures ensured that the published illustration was a progressive sequence in which the figures grew successively taller. This aspect of the image was later satirized when, long after his collaboration with Zallinger, Simons appended a cartoon by Bob Mankoff. Rudolph Zallinger and Elwyn LaVerne Simons, illustration mock-up for "The Road to Homo Sapiens," ca. 1965. (YPM VPAR.002792, Elwyn LaVerne Simons Archives, Yale Peabody Museum of Natural History. By permission of Zallinger Family LLC; the Simons family; Bob Mankoff; courtesy of the Yale Peabody Museum.)

version of "The Road to Homo Sapiens" the *Oreopithecus* had shrunk considerably from its original dimensions. This created a marked height differential between it and the subsequent *Ramapithecus*, which gave greater prominence to Simons's vaunted first hominid. It also gave the appearance, maintained through the rest of the sequence, of an inexorable march of progress. The uncertainty of the scientific rationale for a continual ascent is perhaps indicated by the fact that it was only in the "Young Readers Edition" of *Early Man*, where Zallinger's illustration was renamed "Creatures That Led to Modern Man," that it was asserted: "In general, man's ancestors have grown taller as they became more advanced."[135] This contentious claim was not repeated in any of the editions of the book aimed at adult audiences.

In charting the "story of the rise of humanity," as Simons reflected in 1960, "illustrations are particularly valuable . . . since knowledge of phylogenetic relationships derives basically from visual judgements about form."[136] The particular visual judgments facilitated by Simons's decisive contributions to "The Road to Homo Sapiens"—from his initial typed advice to Zallinger to his subsequent interventions with the mock-up of the final image—implied that the phylogenetic relationships it depicted were both linear and progressive. These are precisely the elements of the illustration that have rendered it both so influential and so hugely controversial, especially among scientists today, who bemoan its deleterious impact on the public understanding of evolution.

However, the image's endorsement of such outmoded concepts of evolutionary change is not attributable to artistic or commercial considerations taking precedence over scientific ones. Far from it. "The Road to Homo Sapiens" clearly reflects the profound impact that Mayr's deliberately reductive approach to hominid taxonomy and evolution had on Simons, as well as on several other paleoanthropologists, including Howell. Zallinger himself, by contrast, seems to have regretted the linear arrangement of his individual drawings that Simons's advice made inevitable. For Time-Life, meanwhile, the semblance of cautious moderation afforded by having Howell's name on the cover of *Early Man* was clearly of more commercial value than the more partisan approach that Simons, albeit without formal acknowledgment, instilled in the book's most prominent illustration. In fact, Time-Life seemed reluctant to pay the $25 Simons charged for his advice

to Zallinger, and he had to write indignantly to its directors: "Gentlemen: I have, until now been glad to help with advice and consultation, but my time is at a premium, and I have not yet been paid for a bill submitted on October 15, 1964."[137] While Simons's scientific guidance was crucial to determining both the content and the format of "The Road to Homo Sapiens," it was evidently not regarded as having much relevance to its potential popularity. Instead, Time-Life's unique corporate model of book production and marketing is what made the image a pervasive presence in the visual culture of the 1960s and established it as the ultimate icon of progress.

A Completely New Step

By the end of the 1970s, *Ramapithecus*, the extinct primate that for nearly two decades had been hailed as humanity's earliest ancestor, was starting to lose its luster. Its putative status as a fourteen-million-year-old hominid was controverted by new biochemical tests, which showed, with increasing certainty, that humans had diverged from apes only four to six million years ago. This realization compounded long-standing concerns with the paucity of the fossil remains, comprising merely teeth and jaws, on which *Ramapithecus*'s claim to its coveted status was based. Writing in *Natural History* in 1979, Adrienne Zihlman and Jerold Lowenstein reflected on how long the creature had retained the prestige of being the progenitor of humanity since having "latched onto the position by his teeth" in the early 1960s. *Ramapithecus*, they remarked, "has been hanging on ever since, his legitimacy sanctified by millions of . . . Time-Life volumes on human evolution."[1] Despite the humorous tone, Zihlman and Lowenstein's last comment disclosed a serious concern about the persistence of *Ramapithecus*'s tenuous reputation.

The endurance was partly attributable, they suggested, to the unprecedented circulation of a certain book, then being reprinted in a third edition, and in particular to "an artist's conception of our ancestry as a kind of parade" that was featured in its pages. This was, of course, "The Road to Homo Sapiens," drawn by Zallinger for *Early Man*, whose first edition had been published by Time-Life Books in 1965 (see plates 5 and 6). Zihlman

and Lowenstein did not register any objections to Zallinger's image itself—indeed, a new version of its distinctive ascending trajectory was reproduced in their *Natural History* article. However, given the huge influence that "The Road to Homo Sapiens" had exerted on perceptions of human evolution over the previous decade and a half, they raised an urgent question: "How did *Ramapithecus* . . . sneak into this manward-marching procession?"[2]

The answer, revealed in the last chapter, was almost certainly the involvement of Simons, who provided extensive guidance to Zallinger during the creation of the iconic illustration. This advice, both written and verbal, had ensured that "The Road to Homo Sapiens" strategically endorsed Simons's own paleoanthropological interpretations while negating those of his rivals, particularly Louis Leakey. It was Simons who, in 1961, proposed that the meager fossils from which G. Edward Lewis had three decades earlier named the taxon *Ramapithecus* represented the earliest known hominid. His guidance, which was integral to the published form of "The Road to Homo Sapiens," was not formally acknowledged in *Early Man,* and when, fifteen years later, the tide began to turn against *Ramapithecus,* Simons himself seems to have discreetly forgotten his own involvement.

Less than a year after Zihlman and Lowenstein's article in *Natural History,* a journalist at the *Philadelphia Inquirer* interviewed both Simons and Lewis, by then a septuagenarian who had long since left the field of primate paleontology, on the growing doubts over *Ramapithecus*'s hominid status. As the newspaper reported in 1980: "Some more intrepid accounts of the creature, which Simons and Lewis say they deplore, have taken great leaps from the scanty dental evidence . . . Some illustrations even depicted the animal walking upright. Such added details were complete fantasy." Just above this statement the newspaper reprinted, with the acknowledgment "Courtesy of Time-Life Books," the upright, walking *Ramapithecus* that Zallinger had drawn for "The Road to Homo Sapiens."[3]

The allegedly fantastical reconstruction that Simons now claimed to deplore conformed with his own conviction, articulated in 1965, that "in the case of *Ramapithecus* . . . its reduced snout and anterior teeth (premolars, canines, and incisors) may well correlate with . . . the incipient development of bipedality."[4] He had seen—and explicitly approved—the bipedal *Ramapithecus* drawing ahead of *Early Man*'s publication (see fig. 7.4). Far

from having reservations about Zallinger's representation, Simons person-
ally requested the artist, in 1969, to create a new depiction of *Ramapithecus*
that corresponded with his own "interesting speculation that these animals
may already have been ad hoc tool users."[5] In fact, Zallinger's drawing, com-
missioned by Simons for an article in the *Yale Alumni Magazine,* followed
his instructions so closely that it gave definite visual form to a verbal conjec-
ture, made by Simons during an informal discussion, that *Ramapithecus*
used sticks to procure food by "poking around in termitaries or something
like that" (see fig. 7.3).[6] Regardless of what he later told the *Philadelphia
Inquirer,* Simons clearly had no hesitation in sanctioning the kind of bold
artistic inferences on which Zallinger's controversial reconstruction of *Ra-
mapithecus* depended.

Simons had himself studied art in his youth, and he later recalled that "I
rather thought I could be a portrait painter" before opting instead to study
fossils. His artistic prowess and powers of visualization nevertheless remained
useful when analyzing the often scant remains of extinct primates. Simons
endeavored to understand "how they lived and moved, what made them
tick," and he reflected that "you have to extrapolate from what we know from
living relatives."[7] This was precisely the technique that Simons deployed
when collaborating with Zallinger. As he explained of another drawing that
he personally commissioned from the artist in 1969, "Reconstruction of an
adult male *Gigantopithecus* is conjectural . . . It is based on the assumption
that . . . except for its size and much higher face, *Gigantopithecus* was oth-
erwise like a gorilla" (see fig. 7.3).[8] With the earlier commission for "The
Road to Homo Sapiens," Simons had almost total control over which ex-
tinct primate species were drawn. But his views on the appropriate artistic
methods for depicting them were not the only ones that Zallinger had to
consider.

At the bottom of the typed list of "Hominoidea" that he made for Zallinger
in 1964, Simons gave this advice: "In some cases, available material for pur-
poses of reconstruction is extremely fragmentary. Whole animal reconstruc-
tive efforts should only be made where the material is adequate according
to Dr. Howell. Where it is not, he says that it is downright misleading to do
any more than show the evidence itself and the limited amount of informa-
tion which it reveals."[9] The circumspect counsel that Simons related had

come from the nominal author of *Early Man*, who was publicly implicated in the book's contents in a way that Simons, as his later disingenuous comments to the *Philadelphia Inquirer* indicate, never was. Yet Howell's caution, which in Simons's second-hand account was expressed in stridently emotive language, seems to have been overridden when Zallinger made the actual drawings.

Even in 1967, two years after *Early Man*'s publication, Howell remained concerned that "unfortunately, *Ramapithecus* is still known for certain only from upper jaws and teeth." In consequence, as he observed apprehensively, "there is really no structural evidence which bears . . . on the . . . locomotor adaptations of *Ramapithecus* (although suggestions . . . have been made)."[10] The speculative suggestions had come from Simons, and it was his more intuitive approach rather than Howell's insistence on sticking to the evidence that determined how the creature was portrayed in "The Road to Homo Sapiens." This was also the case with several of the other extinct primate taxa that were depicted, whose posture and movement were similarly inferred from only marginally more substantial fossil remains. Like the conspicuous omission of Leakey's nomenclature, the striding bipedal locomotion of Zallinger's reconstructed *Ramapithecus* confirms, once more, the huge significance of Simons's unacknowledged contribution to the illustration.

For all his influential advice, Simons charged just $25, and he had to complain to Time-Life's directors for the paltry payment to finally be made. Howell, by contrast, received a fee of $10,000 for his involvement in *Early Man*, even though the actual writing of the book's text was left to others.[11] He evidently overcame the distaste for inferential artistic reconstructions that Simons voiced on his behalf, and the lucrative remuneration provided by Time-Life obliged him to offer his own expert guidance to Zallinger. The preparatory artwork for "The Road to Homo Sapiens," which has never previously been examined, shows that Howell requested small alterations and additions to at least one of the drawings and that Zallinger asked him questions about the nature of the available evidence on specific points. Significantly, this dialogue, conducted in handwritten annotations on a sketch that was sent back and forth between the artist and scientist, also shows their mutual recognition of the need to conform with the requirements of Time-Life's production team.

If meeting a commercial publisher's demands was new for an academic like Howell, it was entirely customary for Zallinger, who had contributed several illustrations to *Life* since the mid-1950s and whose artistic style, especially in relation to photography, had been skillfully honed to suit the magazine's requirements. Time-Life had certain preconceptions about the gender and ethnicity of its target audience that shaped various aspects of *Early Man*. But the company's staff also had a more direct impact on the final appearance of "The Road to Homo Sapiens," particularly with an ostensibly minor alteration that enhanced the sense that the figures were striding purposefully forward. This sense of forward movement was one of the things that subsequently rendered the reconstruction of *Ramapithecus* so contentious to Zihlman and Lowenstein and the *Philadelphia Inquirer*. It also, still more controversially, helped create the perception that each of the extinct primates was part of a march of progress, taking steps, both literal and figurative, toward the apex of modern humanity.

The implicit association between forward footsteps and evolutionary advancement had been a familiar visual trope since the mid-1860s, inaugurated by the series of simian skeletons in the frontispiece to Huxley's *Man's Place in Nature*. With "The Road to Homo Sapiens" a century later, the connection finally became explicit. In fact, at the end of the 1960s perhaps the most celebrated single step ever taken, onto the surface of the moon, was frequently depicted as the commencement of a decisive new direction in human evolution, akin to the similarly pioneering steps of early bipedal hominids such as *Ramapithecus*. Time-Life utilized the moon landings in their marketing materials for the second edition of *Early Man* in 1970, which juxtaposed images of a "moon walker" with the striding human ancestors drawn by Zallinger. Such elaborate advertisements were integral to the company's unique model of mail-order publishing and helped ensure that "The Road to Homo Sapiens" became ever more ubiquitous. They also confirmed the illustration's reputation as an unequivocal exemplar of progress.

The Magic of Life

Zallinger's commercial commissions for *Life* magazine and, later, Time-Life's books division were closely connected with the positions he held at Yale's

Peabody Museum, where he was fellow in geology and artist-in-residence. He had first come to the Peabody in the early 1940s, soon after the museum's new director, Albert Eide Parr, began modernizing its exhibition spaces. The updates involved, among other things, removing the three-dimensional replica of the primate skeletons depicted in *Man's Place in Nature*'s frontispiece, which had been unveiled in 1925 as the culmination of an innovative sequence of exhibits charting the progress of organic evolution (see fig. I.1). Such simple, linear depictions of human evolution fell out of favor in the middle decades of the twentieth century, when a proliferation of new taxonomic classifications made it difficult to trace phylogenetic relations. The Peabody's series of skeletal simians seemingly striding toward humanity had already been dismantled when Zallinger arrived. As part of Parr's renovation of the museum, the artist, then in his mid-twenties, developed plans for another, much more ambitious evolutionary sequence, albeit for a period long predating the emergence of even the earliest ape.

The huge mural that he produced, covering an entire wall of the museum's Great Hall, presented what Zallinger described as a "panorama of time," spanning the "evolutionary history of the earth's life" up to the dinosaurs of the Mesozoic era.[12] Ironically, just as the installation of the Peabody's earlier evolutional exhibits had been put on hold by America's entry into the First World War, Parr's modernization plans, including Zallinger's mural, were similarly "long delayed" after the country became embroiled in the next global conflict.[13] Zallinger did not begin painting until late in 1943. During the hiatus he had received what he called a "crash course in animal and plant life of the distant past and in comparative anatomy" from the Peabody's scientific staff.[14] In particular, he consulted with G. Edward Lewis, whose *Ramapithecus* fossils, later to become so important in Zallinger's artistic career, were then gathering dust in the museum's storerooms.

With many of the Peabody's younger employees away fighting the war, Zallinger also relied on the guidance of retired staff, especially the erstwhile director Richard Swann Lull. Back in the 1920s, he had been instrumental in the creation of the mounted row of ascending anthropoid skeletons that had recently been dismantled. Lull was now, as Zallinger later remembered, "approaching 80," and Lewis was aghast at the older man's involvement with the mural.[15] This intemperate response contributed to Lewis's depar-

ture from the Peabody in 1943 and might explain his rather sour reaction to Zallinger's *Ramapithecus* drawing in the *Philadelphia Inquirer* four decades later. The mural, completed in the summer of 1947 and named "The Age of Reptiles," was painted using traditional fresco techniques that Zallinger had mastered at the Yale School of Fine Arts. The stately dinosaurian panorama nevertheless soon appeared in the pages of one of the principal arbiters of postwar modernity.

Life magazine, as a rival journalist noted in 1958, had for the previous two decades been the "most powerful single influence on American taste." Its publisher, Henry Luce, proclaimed in the same year that the "magic of *Life* is obviously connected with the magic of pictures," and the magazine prided itself on employing the best and most innovative photographers and artists to conjure its "picture-magic."[16] With a circulation of more than five million each week, *Life* was willing, as one of the editorial staff later observed, to "pay whatever it had to to get what it wanted."[17] In the summer of 1952, the magazine's science editor, Kenneth MacLeish, contacted the Peabody and offered a generous remuneration for permission to reproduce the museum's "Age of Reptiles" mural both in an article on evolution and on the magazine's cover.

This was a decisive juncture in Zallinger's career, and the request would lead, eventually, to the commission for "The Road to Homo Sapiens." *Life's* use of his mural, in an article entitled "The Pageant of Life," prefigured the format of that later illustration in several important ways. Because of the Peabody's floor plan, the mural's chronological evolutionary sequence, when seen in situ on the Great Hall's east wall, ran from right to left. In *Life*, it was not the actual mural that was reproduced, but a working drawing, painted in egg tempera, that Zallinger had used as a guide for the larger fresco. This image could be reversed by *Life's* production staff and printed in the more conventional left-to-right direction that, since the mid-nineteenth century, had given a sense of forward momentum to linear depictions of evolution. The mural's continuous panorama extending over hundreds of millions of years was too large, even in its preliminary version, to be accommodated in the two-page "centerfold" that MacLeish had originally envisaged.[18] Instead, reproducing it required a complicated and expensive insert of six fold-out pages. A similarly elaborate insert of five fold-out pages would later be de-

ployed in *Early Man*, enabling readers to see the expansive chronological sweep of "The Road to Homo Sapiens."

What was particularly significant about *Life*'s use of "The Age of Reptiles" mural was that it made Zallinger a "Lifer."[19] He was quickly requested to produce another panoramic sequence showing the evolution of the earliest mammals; it was published, in the same left-to-right gatefold format, in October 1953. Zallinger received several further commissions from *Life*, and it was for one of these, in late 1955, that he first began drawing, and imaginatively reconstructing, extinct early humans. Although *Life* covered a variety of topics, it was principally concerned with current affairs, and it deployed what Maitland Edey, a long-standing member of the editorial team, called a "visceral approach to pictures" that generated a "sense of newsiness, of timeliness, of immediacy and wallop."[20] This distinctive style of photojournalism required compositions that were vivid and spontaneous and that, as the managing editor, Edward Kramer Thompson, demanded, "put our readers right at the ringside."[21] Zallinger adopted the same punchy ethos in the paintings of prehistoric humans that he made for *Life*.

He captured, for instance, the initiation ceremony of a Cro-Magnon tribe at a particularly animated moment, presenting it from an unusually low and close-up perspective that enhanced the sense of motion in what the accompanying text called a "frenzied ritual dance." The painting that adorned the cover of the same issue of *Life*, from December 1955, was even more striking (plate 7). In "Neanderthal Bear Cult," Zallinger mimicked the dramatic cropping that gave a frisson of immediacy to the photographs more usually featured on the magazine's cover, and deployed foreshortening and chiaroscuro lighting to confront the viewer with a decapitated bear's head, which protrudes from the hand of an otherwise unseen Neanderthal. The article for which both these paintings were commissioned, "The Dawn of Religion" by Lincoln Barnett, concluded with a comparative section entitled "A Stone Age Faith Today." This consisted of photographs, taken specially for *Life*, of what were called the "Aborigines of modern Australia," who were pictured performing rituals purportedly indistinguishable from the prehistoric rites painted by Zallinger.[22] His portrayals of rapt Cro-Magnons and Neanderthals, though entirely hypothetical and inferred from limited archaeological evidence, were invested with exactly the same realism and spontaneity as

the modern ethnographic photographs were. While *Life* had initially had to accommodate itself to the requirements of the enormous mural that Zallinger had designed to be seen in a museum, he quickly adapted his own artistic approach to match the magazine's photojournalistic style.[23]

A New Kind of Book

Several of the *Life* articles to which Zallinger contributed artwork were installments in series that, even as they appeared in the magazine, were being prepared as separate volumes. One of *Life*'s first forays into book publishing, *The World We Live In* (1955), featured the Peabody's "Age of Reptiles" mural as well as the equivalent mammalian panorama Zallinger had been commissioned to create, both again printed on fold-out pages. The epic educational series on which the volume was based had been forecast to make a loss but was instead, according to *Life*'s managing editor, a "smashing success," with the book alone selling more than half a million copies.[24] The "charts-and-graphs people," as Zallinger later reflected, "couldn't have been more wrong. The American public was more intelligent than they thought."[25] The success of *The World We Live In* led to further similarly edifying volumes, and as *Life*'s own advertising revenues began to decline, partly due to the advent of television, the income from these compilations became increasingly vital. At the beginning of the 1960s, the magazine's owner, Time Inc., launched a separate books division that, using the same editorial techniques and personnel, was initially regarded as merely a "stepchild" of *Life*.[26] The offspring, however, quickly superseded its parent.

The initial success of Time-Life Books, Edey later observed, resembled a "gusher that had suddenly burst from the ground."[27] The secret behind this unexpected torrent was a pioneering method of selling books: mail order, utilizing the subscription lists already generated for *Life*. This retail revolution also required, as Time-Life's managing editor, Norman P. Ross, insisted, a "new kind of book." The type of volume that would be sent out to subscribers, Ross avowed, was "not a conventional 'illustrated' book, in which pictures are inserted as pictorial footnotes to a fully developed manuscript. It is rather a duet of word and picture in roughly equal parts, orchestrated from the start."[28] Artists would therefore be recruited at the very be-

ginning of a book's creation and would be no less integral to its development than the authors of the text. Their particular task, according to the effusive account in a Time-Life trade brochure, was to "graphically simplify, summarize and dramatize facts and ideas, displaying them in a format which is at once esthetically and pragmatically attractive."[29] In reality, as Edey pointed out, the books division's "spectacular start" meant that it was soon "threatened with engulfment by success."[30] To meet the unforeseen demand, new titles had to be produced to strict deadlines that would challenge even the most experienced artists.

Having previously worked at *Life*, Edey had been recruited by Ross to edit the books division's Life Nature Library. This series on natural history topics had begun with a broad, descriptive remit, reflected in its opening three titles: *The Forest, The Sea,* and *The Desert,* all published in 1961 at two-monthly intervals. After the palpable success of these initial books, Edey recounted, "subscribers were coming aboard in droves, and it seemed sensible to stretch the subject as far as it would go."[31] This expansion eventually included the altogether more contentious topic of human evolution. In 1964 the Nature Library's production team began working on a new volume called *Primitive Man,* whose title was only later switched to the less evaluative *Early Man.* Although the earlier environmental subjects had lent themselves to photography, especially in the nascent medium of color, prehistory inevitably required a different approach.

In the previous decade, *Life* had regularly turned to Zallinger for such assignments, and he had shown himself adept at maintaining high artistic standards while still meeting deadlines set by the requirements of advertisers. Indeed, *Life's* photographers had sometimes had to pragmatically capture only the parts of a painting that were already finished, enabling the magazine to go into production while Zallinger completed the rest of the image.[32] Eventually the artist had become disaffected with the magazine, coming to feel that "*Life* was coasting in the doldrums."[33] By the mid-1960s, Edey agreed that their mutual former employer was now "terminally ill, and its staff morale very low."[34] He still admired the qualities that had once made it so influential and commissioned his fellow erstwhile "Lifer" to bring his talents for depicting the primeval past to the more vibrant books division.

On receiving this commission, Zallinger initially asked Simons for guid-

ance on which particular simians and hominids he should include in "The Road to Homo Sapiens." Simons also offered advice on the relative dimensions of the figures, but the decision as to the artistic style of the drawings seems to have been Zallinger's own. He adopted the same approach that he had perfected while working at *Life*, though without the vivid backgrounds and idiosyncratic points of view that had enlivened his paintings then. *Early Man* did contain panoramic re-creations of prehistoric habitats and lifestyles, evidently much influenced by "The Age of Reptiles" mural and the mammalian equivalent in *Life* that, with financial backing from the magazine, Zallinger was then transferring onto a wall of the Peabody. Possibly because of the demands of creating this new fresco, on which Zallinger was engaged between 1961 and 1967, the more elaborate painted reconstructions in *Early Man* were provided by two other artists, Jay Matternes and Stanley Meltzoff. The former aspired to a level of "realism" by "combining the latest scientific evidence with a measure of his own intelligent artistic speculation," whereas the latter painted with a much more stylized and loosely sketched style.[35] The often exaggerated poses and elongated physiques of Meltzoff's hominids contrasted markedly with those that Zallinger drew for his own smaller commission. Notwithstanding the exacting requirements induced by a stark monochrome background, from which even the perfunctory illusionistic device of shadows was precluded, the figures in "The Road to Homo Sapiens" were rendered with an almost photographic verisimilitude.

Perceptional Realism

While painting "The Age of Mammals" mural at the Peabody, Zallinger often showed his re-creations of long extinct creatures to visiting schoolchildren, one of whom asked ingenuously: "Are you copying the animals from photographs?" This incident was reported in the *Washington Post* as one of "many amusing stories" told by a genial artist known to the children as "Mr. fossils."[36] But the child's question, presumably prompted by the mimetic precision of Zallinger's fresco, was not as naïve as the *Post*'s reporter assumed. In fact, when Zallinger drew the figures for "The Road to Homo Sapiens," which he did between late 1964 and early 1965 while also working on "The

Age of Mammals," he used photographs of living apes to infer details about extinct primates that were known from more limited fossil remains than many of the creatures included in his mural.

Among the preparatory artwork that Zallinger made for the commission for *Early Man* is a photograph taken in the mid-1950s by Wolfgang Suschitzky. It depicts two silvery gibbons, one of which is walking away from the camera on its hind legs, with its right arm raised and bent at the hand into a hook (fig. 8.1). Suschitzky, an accomplished documentary photographer who had initially specialized in natural history, considered that the "composition must be left largely to chance" when photographing animals, for their "movements are completely unpredictable."[37] Such fortuitous pictures did not provide a "complete representation of an animal, a perfect record, but . . . showed some of the animal's character," especially the "natural or unconscious humour that is to be found in many animals."[38] Suschitzky's photograph of the retreating gibbon, whose pose makes it seem drolly dismissive of the camera, helped invest one of Zallinger's drawings for *Early Man* with a naturalistic spontaneity and even a certain humor. *Pliopithecus*, the Miocene proto-ape that was described in the book as having the "look of a modern gibbon," was portrayed by Zallinger with the same distinctively hooked hand (fig. 8.2). The fleeting bipedal gait also captured in the photograph ensured, moreover, that the initial figure in "The Road to Homo Sapiens" began the "long march" with awkward but nonetheless jaunty strides.[39]

Another black-and-white photograph among Zallinger's preparatory artwork is of a female chimpanzee who is breastfeeding a baby while looking imperturbably toward the camera. This simian countenance may have provided a template for the facial structure in some of the drawings of early hominids. The use of such photographic guides reflected Zallinger's particular approach to artistic representation, for which he coined his own label: "perceptional realism." This, he insisted, was "not objectivity." Instead he acknowledged that objects could be known only through acts of sensory perception. Crucially, however, Zallinger considered that such acts were not merely subjective: "we mutually share in these perceptions."[40] The external world could be portrayed realistically by representing, in graphic form, this collective perceptual experience in the same way that a camera records a communal sense of reality.

Fig. 8.1. Photograph by Wolfgang Suschitzky entitled "Gibbons (*Hylobates spp.*)." Suschitzky's photographs of animals are, as here, spontaneous and seek to capture their individual characters and even an unconscious humor in their actions. Zallinger kept a copy of this photograph with his preparatory artwork for "The Road to Homo Sapiens." In Julian Huxley and W. Suschitzky, *Kingdom of the Beasts* (London: Thames and Hudson, 1956), plate 153. (Author's collection. © Suschitzky Estate.)

Zallinger's approach diverged from the subjectivism of most twentieth-century modern art, and when, at the beginning of the 1950s, the traditional Yale School of Fine Arts shifted its ethos to modernist abstraction, he had been abruptly dismissed from his teaching post. Only after three further decades did he feel that, finally, "conceptualism is on the wane."[41] The meticulous finish and unapologetic realism of the figures Zallinger drew in the

PLIOPITHECUS

Fig. 8.2. Zallinger's drawing of *Pliopithecus*, the initial figure in
"The Road to Homo Sapiens," has a bipedal pose and hooked
hand similar to the gibbon's in Suschitzky's photograph (fig. 8.1).
It also shares the naturalistic spontaneity and humor of that image,
of which Zallinger kept a copy, giving an individual character to
the *Pliopithecus*. In F. Clark Howell and the Editors of Time-Life
Books, *Early Man* (New York: Time-Life Books, 1965), 41. (Author's
collection. By permission of Zallinger Family LLC.)

mid-1960s for *Early Man* were, in part, a riposte to the prevailing aesthetic
doctrines of the time. Simons, providing scientific advice for the drawings,
would have been glad of this, as his own artistic aspirations had been sty-
mied when, as he later recounted, "my teachers said that modern art really
was non-representational, it should be like Jackson Pollock . . . just paint
dashed around in various directions."[42] Simons's reluctance to follow such
strictures had impelled him to employ his drawing skills for scientific pur-

poses instead, and his youthful rejection of modern art initiated the sketching of transitional apelike forms that would ultimately lead to "The Road to Homo Sapiens."

In the succession of drawings that Simons urged Zallinger to make for that illustration, the artist's credo of perceptional realism encountered a curious paradox. After all, the extinct simians and hominids he was tasked with re-creating had never been seen alive, and in many cases their precise forms and postures were, at best, a matter of scientific conjecture. As the art historian W. J. T. Mitchell has pointed out in relation to the dinosaurs in Zallinger's "Age of Reptiles" mural, the "more 'realistic' or 'illusionistic' or 'convincing' the restoration, the more it betrays the truth of the image as a constructed, made thing. The more illusionistic the . . . image, the more fraudulent it seems."[43] From this perspective, it was the very realism of Zallinger's inferential reconstruction of *Ramapithecus* that, once its status as a bipedal hominid was called into question, made it so suspect and even, to Simons himself, deplorable. Like the school of so-called photo-realist painters that emerged in the mid-1960s, whose meticulous detail and incessantly sharp focus actually served to undermine the illusion of realistic representation, Zallinger's artistic precision threatened, paradoxically, to make his hominid drawings too convincing to be credible.[44]

The realistic drawings themselves acknowledged their own unreality. Indeed, the meager remains on which they were often based, as the text introducing "The Road to Homo Sapiens" explained, were "indicated by the white highlights" that Zallinger added to the dun skin color of the figures. The same introduction to *Early Man*'s five fold-out pages also featured a color photograph, taken by Howell, of what the accompanying text called a "seemingly chaotic collection of bones." These consisted of a small number of vertebrae and a fragmentary pelvis from which it was possible, the text maintained, to "give quite a complete picture of how *Australopithecus* might have walked—a bipedal creature at the very dawn of man."[45] The adverb "quite" is notoriously ambiguous, having contrasting meanings depending on its placement in a sentence, and here it seems to hint at Howell's circumspection about "reconstructive efforts" to portray the "whole animal." He had nevertheless been intimately involved in the creation of this particular reconstruction, as Zallinger's preparatory artwork demonstrates.

Too "Hairy"?

Zallinger made provisional pencil sketches, on rectangular slips of paper of varying thickness, for each of the fifteen figures he drew for "The Road to Homo Sapiens." On only one of these did Howell make any annotations (fig. 8.3). The image was an early iteration of the figure that would, after several revisions, appear above the name "Australopithecus" in *Early Man* and then, more specifically, as "A. africanus" in the book's second edition.[46] The actual drawing has been labeled "A. afarensis," but this binomial was not coined until the late 1970s, following the discovery of the celebrated Australopithecine skeleton nicknamed "Lucy," and must have been added long after the sketch was made. Back in the mid-1960s, Zallinger had asked, in pencil on either side of the drawing, two concise questions: "Too 'hairy'?" and "Too upright?" He also requested Howell to "please specify the *exact skeletal remains*," which may have prompted him to take the color photograph of fragmentary vertebrae and pelvic bones that was used to introduce Zallinger's finished drawing in *Early Man*.[47]

The draft image was seemingly sent in the mail from New Haven, where Zallinger was working at the Peabody with in-person assistance from Simons, to Chicago, where Howell taught at the city's university and lived in the suburb of Homewood. At the bottom left of the sketch, the artist added an instruction, "(Please check and return as soon as possible)," which he signed "R. F. Zallinger." The polite formality of this subscript suggests that its signatory, known to his friends and colleagues as Rudy, was not acquainted with Howell; the two may never have actually met. Howell followed the parenthetical directive and returned the sketch, again seemingly by mail, with responses to Zallinger's questions. These annotations, made in red pencil, repeated the same simple affirmative "Fine" in answer to the queries

Fig. 8.3. This preliminary sketch of the *Australopithecus* in "The Road to Homo Sapiens" contains annotations in which Zallinger asks questions to Francis Clark Howell regarding the evidence on which the inferential reconstruction is based. In further annotations, Howell responds and also asks for revisions to the drawing. Rudolph Zallinger, "A. afarenis [*sic*]." Pencil on paper, ca. 1965. (C16, Rudolph F. Zallinger's Preliminary Drawings for "The Road to Homo Sapiens," Smithsonian National Museum of Natural History. By permission of Zallinger Family LLC; courtesy of the Human Origins Program, Department of Anthropology, Smithsonian Institution.)

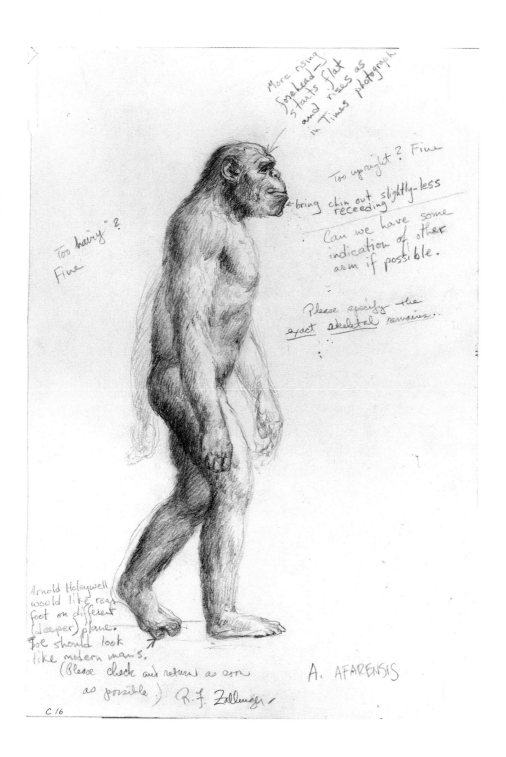

More rising
forehead —
starts flat
and rises as
in Times photograph

Too upright? Fine

bring chin out slightly-less
receeding

Can we have some
indication of other
arm if possible.

Too hairy"?
Fine

Please specify the
exact skeletal remains.

Arnold Holwywell
would like rear
foot on different
(deeper) plane.
Toe should look
like modern man's.
(Please check and return as soon
as possible) R.F. Zallinger.

A. AFARENSIS

C 16

regarding the hirsuteness and verticality of the Australopithecine physique.[48] The stance that Zallinger worried might be too upright was appropriate. The artist's depiction accorded with Howell's conclusion, in 1963, that what was known of the "skeleton of *Australopithecus* indicates adaptation for erect terrestrial bipedalism." Similarly, the level of body hair deftly delineated by Zallinger's pencil strokes was consistent with its living in what Howell surmised were "climates which were very likely colder . . . than present-day regional climates."[49] But while these aspects of the drawing, on which Simons may already have offered verbal advice, were readily ratified, there were other things that Zallinger was asked to amend.

A request for modifications did not necessarily indicate a problem; in commercial commissions making revisions was a customary part of an artist's creative process. In the version of *Australopithecus* Zallinger had first drawn, only its right arm was shown, hanging down with the hand, by the creature's thigh, seemingly clenched. This limp single limb made the figure appear both static and visually uninteresting, and Howell, apparently for aesthetic reasons, asked: "Can we have some indication of other arm if possible."[50] In response, Zallinger sketched two potential left arms extending before and behind the torso, although in the final version of the drawing, as published in *Early Man*, neither was retained. Instead, only an elbow gave an indication of the other arm that Howell thought necessary (fig. 8.4). More notably, Zallinger also altered the original right arm, which, rather than hanging limply, was now bent at the elbow, with the hand, still clenched, gripping a stone tool that had been chiseled to a sharp point. In 1963 Howell had proposed that, with *Australopithecus*, the "hand skeleton . . . was surely capable of a strong power grip," with a "structure to permit . . . eventually, the modification and fashioning of natural stones into sharp-edged tools."[51] He presumably asked Zallinger, in a further round of revisions, to rework the drawing to incorporate these suppositions, which, conveniently, also made the figure more dynamic and aesthetically appealing.

Howell also adjusted, with a pencil, the contour of Zallinger's sketch, drawing a new jawline and instructing the artist to "bring chin out, slightly-less receding [*sic*]." This small amendment, given additional emphasis by an arrow pointing to the exact part of the jaw, made the *Australopithecus*'s facial profile less like that of a chimpanzee. In the initial iteration of the

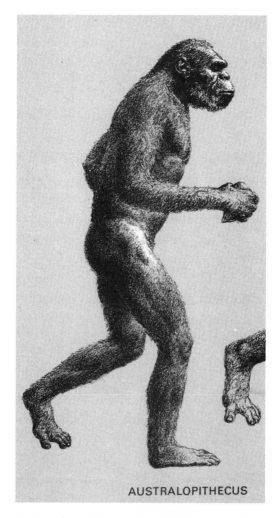

AUSTRALOPITHECUS

Fig. 8.4. The published version of Zallinger's drawing of *Australopithecus*, the sixth figure in "The Road to Homo Sapiens," is substantially different from the preliminary sketch of it in figure 8.3. There are changes to the forehead and the arms, and the introduction of a stone tool gripped by the right hand. The creature's trailing foot is also positioned much farther back, which had important implications for the sense that "The Road to Homo Sapiens" represents a march of progress. In F. Clark Howell and the Editors of Time-Life Books, *Early Man* (New York: Time-Life Books, 1965), 41. (Author's collection. By permission of Zallinger Family LLC.)

drawing, Zallinger may have copied aspects of the face from the photograph of the ape kept with his preparatory artwork. Howell was not averse to the use of such guides, and in requesting another alteration to the outline of the head, again with an accentuating arrow, he told Zallinger: "More rising forehead—starts flat and rises as in Times photograph."[52] The *New York Times* had published only two photographs of an *Australopithecus* head when Howell made this annotation in, presumably, late 1964; both had appeared in the newspaper's Sunday magazine in 1961.[53] Unlike the photographs of living simian species that Zallinger himself collected, which were integral to his realist style, these two pictures were of the same plaster model in a "series of sculptured heads—based on fossil skulls."[54] The heads, recreating hypothetical hominid physiognomies, had recently been installed in the American Museum of Natural History's newly opened Hall of the Biology of Man, where the *Australopithecus*, sculpted with a rising forehead, was the first thing that visitors encountered (fig. 8.5).

The Unities That Bind

The newspaper photograph from which Howell advised Zallinger to copy the forehead shape was, of course, itself a representation of an inferential artistic reconstruction. The sculpted heads had been made under the supervision of Harry Lionel Shapiro, the American Museum's curator of anthropology. They had a specific function within the larger context of the new Hall of the Biology of Man: Shapiro proposed that the "sculptured reconstructions . . . illustrate the striking changes in cranial structure over the ages."[55] The alterations helped show how modern humans, the subject of the succeeding displays, had gradually achieved their current appearance. In preparation since the end of the Second World War, Shapiro's new displays were intended to replace the anthropological exhibits that had remained on show since the 1920s and 1930s. Under the aegis of Henry Fairfield Osborn, these had endorsed his own idiosyncratic Dawn Man theory, which both denied that humanity had first evolved in Africa and, by deferring its origins— in central Asia—to extreme antiquity, suggested that racial differences had emerged long ago and were thus structural and profoundly consequential. Even Gregory's rival Hall of the Natural History of Man, which contested

Fig. 8.5. Plaster cast (front and lateral views) of *Australopithecus prometheus* in the Hall of the Biology of Man at the American Museum of Natural History. In Howell's annotations on figure 8.3 he requested Zallinger to revise the forehead in his drawing of *Australopithecus* in accordance with a photograph of this model head published in the *New York Times*. Photograph, 1961. (Image # 328589, American Museum of Natural History Library.)

Osborn's flagrantly racist understanding of human evolution, still reaffirmed hierarchical assumptions about race in some of its exhibits. The Hall of the Biology of Man, by contrast, was intended to finally eradicate such "ill-informed, mis-informed . . . 19th century illusions," as Shapiro called them.[56]

Reflecting the postwar repugnance at the racist ideologies that had precipitated the catastrophic conflict, the hall's long-planned displays would enable visitors, Shapiro proclaimed, to "discover the unities that bind all cultures."[57] The emphasis on unity began with the sculpted *Australopithecus* head, which showed that all humans shared the same initial ancestor, who, crucially, had lived in Africa. Even the small detail of the *Australopithecus*'s rising forehead, which contrasted with the receding of the same feature in apes, ensured that its facial characteristics were consistent with

its membership in a unified human family. Zallinger seems to have over-emphasized this detail in another iteration of his *Australopithecus* drawing, in which the forehead rises more steeply than in the final version published in *Early Man*.[58] But his zealous deployment, at Howell's behest, of a photo-graph of the Hall of the Biology of Man's sculpted head does not necessarily indicate an endorsement of the exhibit's ideological commitments.

In fact, "The Road to Homo Sapiens" has frequently been charged with being no less problematic, in terms of both race and gender, than Osborn's egregious representations of evolution. Zallinger's illustration, it has been claimed, makes a "very clear statement" about the superiority of the "white male of the species," with "other 'races'" reduced to mere "evolutionary backwaters whose most useful characteristics are as a measuring stick of the comparative achievements of Caucasian mankind."[59] The artist himself, ac-cording to some recent commentators, was personally implicated in the "pernicious bias out of which this image was made," although no evidence whatsoever is presented to corroborate this grave accusation.[60] Such un-equivocal accusations of racism, again without verification, have become a mainstay of both scientific and creationist criticisms of the march of prog-ress imagery. Certainly, the original conception for Zallinger's illustration was inspired by pictures in Gregory's *Our Face from Fish to Man*, in which an Aboriginal Tasmanian woman appeared at a lower evolutionary level than a pallid classical sculpture symbolizing putatively European characteristics. Like Gregory's own images, however, "The Road to Homo Sapiens" has a much more complex relation to issues of race than has usually been as-sumed. It was actually informed by some of the same postwar attitudes that motivated Shapiro's museum displays.

It was Simons who, as a teenager, had been inspired by the illustrations in Gregory's book. His later penchant for "lumping" multiple species names into larger taxonomic classifications, which helped give "The Road to Homo Sapiens" its distinctive thin, linear configuration, nevertheless emerged from an approach to variation within modern humans that avowedly rejected the racism of the past. This approach was especially apparent in Ernst Mayr's 1950 critique of paleoanthropologists' classificatory profligacy, which influ-enced Simons and the guidance he gave to Zallinger. Mayr urged that the "variation of primitive man," which had engendered such an array of super-

fluous species names, was no different from that of the "strikingly distinct
human populations" that now existed across the world. These "living pop-
ulations of man," Mayr insisted, were all "part of a single species," among
which, he pointed out, "there is much interbreeding between different
tribes and races."[61] The essential unity of the human race, which had been
so disastrously disregarded during the war, afforded a moral impetus for re-
fraining from needless taxonomic "splitting" when considering humanity's
evolutionary ancestors. Such classificatory practices, moreover, were partic-
ularly prevalent in South Africa, reflecting the concern with racial categori-
zation in the discriminatory apartheid laws instituted since the 1940s.[62] All
hominids, for Mayr, belonged to a single line of descent, and his "anti-racist
commitment to variation within a singular, progressive human lineage," as
it has recently been termed, was embodied, through Simons's influence, in
the very shape of Zallinger's illustration.[63]

Later, in a discussion with Simons about hominid classification, Mayr
questioned the validity of race as a taxonomic category. He asserted: "Race
is a merely descriptive item . . . No two individuals in the human species, or
any other, are the same. In fact, they're very different from each other and
so to lump people together as whites or blacks is a completely misleading
approach because every individual is unique . . . and has to be treated as
an individual."[64] Mayr's focus on population genetics—he was one of the
founders of the Modern Synthesis—meant that the external physical char-
acteristics so crucial in classifying racial difference since the mid-eighteenth
century were relatively unimportant. Simons himself eschewed the loaded
language of race, instead referring to "modern varieties of *Homo sapiens*,"
while Zallinger's artistic skills, supplemented by photographs capturing the
characters of living apes, imbued the figures in "The Road to Homo Sapiens"
with an individuality that prevented them from becoming mere classifica-
tory types.[65] Indeed, their potential for rebutting paleoanthropological inter-
pretations that, from the early 1960s, once more insisted on both the reality
and significance of race was certainly evident to contemporaries.

In 1972 William Howells, the Harvard anthropologist who seven years
earlier had contributed a brief introduction to *Early Man*, reused the book's
most prominent illustration in an article of his own. This appeared in the
UNESCO Courier, the journal of the scientific and cultural organization

of the United Nations that in the 1950s had led the way in denying the validity of race as a scientific category.[66] When Howells reprinted "artist Rudy Zallinger's impression of primate and human evolution" with the "kind permission of Time-Life Books," he rewrote the captions beneath each of the figures so they reflected the specific issues discussed in his article. Under the final figure, whose designation he amended to the more scientific "Modern Man: Homo Sapiens Sapiens," Howells wrote, "Two schools of thought today exist regarding modern man's ancestors: the monocentric believes that today's races had a common ancestor; the polycentric sees them descending from different ancestral lines."[67] The latter position had been articulated by Carleton Coon, an opponent of racial desegregation in the American South. In his controversial book *The Origin of Races* (1962), Coon proposed that different races had evolved separately, at varying rates of advancement, from distinct hominid species.[68] Howells believed that there had been more "kinds of Ice Age men" than lumpers like Mayr and Simons allowed, but he otherwise censured Coon's views. Although "living races seem very different" in their external characteristics, he explained, these differences were less important than their underlying anatomical structures, which were "really much alike." In making this point, Howells affirmed his own monocentric conviction—"I believe . . . that all must have had some common source"—and used Zallinger's human as an illustration of this point of view.[69]

The Ford Dealer in Wichita

The "Modern Man" whose striding figure concluded "The Road to Homo Sapiens" was, inarguably, a White male, even if he retained the same dun skin color, with small patches of lighter shading, as his immediate predecessors. His cropped straight hair and neatly trimmed beard, as well as a flawlessly muscular physique, embodied a normative conception of Western masculinity. Howells's use of this drawing in his refutation of Coon's polycentric approach to human evolution was, notwithstanding his own opposition to the latter's racism and the article's publication in the *UNESCO Courier*, highly complacent. After all, the image was intended to represent, in the logic of Howells's monocentric argument, all the different ethnicities, and genders, that currently constituted the human species, here blithely

subsumed into the form of an exemplary White man. This equation of European male characteristics with evolutionary progress had been a perpetual feature of visual depictions of biological development since at least the mid-eighteenth century. For critics of "The Road to Homo Sapiens," it too, more than two hundred years later, purveys the same "insidious progress messages."[70] Zallinger's decisions when drawing his "Modern Man," however, had as much to do with the commercial requirements of Time-Life Books as any pernicious iconographic traditions.

When the book publisher separated from *Life* magazine in early 1961, the managing editor, Norman P. Ross, proclaimed that its instructive illustrated volumes would be aimed at the "busy, intelligent layman." Ross was very particular in characterizing this intended audience, whom he envisioned as "the Ford dealer in Wichita and his family."[71] The choice of a midwestern middle-management ideal reader reflected the conservative values that the books division inherited from its parent magazine. Henry Luce, *Life*'s founder and now the editor-in-chief of Time Inc., had proudly proclaimed, "I am biased in favor of God, the Republican party and free enterprise," and the different components of his publishing empire all endorsed his personal prejudices implicitly and often explicitly.[72] Ross's choice of an ideal reader of whom Luce would approve was quickly vindicated by the rush of subscribers, from Kansas and elsewhere, who signed up for the initial Time-Life volumes.

By the time of the publication of *Early Man*, whose very title indicated its patriarchal presumptions, Ross's remunerative intuiting of the readership's outlook had become firmly entrenched. In the book's text, the putatively male reader was sometimes addressed directly, as when he was told to "look at the inside of his mouth in a mirror"; an accompanying instruction to examine the mouth of the "family dog" was based on an assumption of a particular domestic situation. Similarly, when the lifestyle of "modern man" was discussed, the example given was of a "businessman on his way from his home to an important conference," who "leaves the meeting at the end of the morning and sits down to a heavy lunch preceded by a couple of cocktails."[73] Zallinger's Westernized "Modern Man" provided a visual equivalent of such textual descriptions, even if the honed physique did not betray the same dietary excesses.

The vexed subject of race was broached directly in *Early Man* only in relation to the Cro-Magnons, during whose existence, it was noted, "differentiation into the living races of man undoubtedly was taking place." This statement was in itself a repudiation of the views of Coon, and of Franz Weidenreich and Osborn before him, who located the formation of races much earlier in evolutionary history. But the text of *Early Man* was unambiguous in affirming the relevance of racial differences, although there remained some ambivalences about how the supposed differences played out among the Cro-Magnons themselves. External features that Mayr and Howells regarded as insignificant were itemized with an odd insistence: "We do not know if Cro-Magnon man had straight or curly hair, thick or thin lips, or even if he had the 'slanted' eyes of a Mongoloid, for this is a fleshy attribute, not a bony one." The evidence of Cro-Magnon bones nevertheless implied a prominent chin and high nasal bridge, which suggested that these early humans "resembled today's Irish, Scandinavian and Anglo-Saxon types more closely than other living peoples." On this basis, it was pronounced of the typical Cro-Magnon, with more assurance than the equivocation seemed to warrant, that "logic suggests that he probably looked most like the people his skeleton most closely resembles today."[74] Zallinger's "Cro-Magnon Man" was distinguished from the modern human who succeeded him only by his slightly shaggier hair and beard, a spear slung over the left shoulder, and a penetrating glance to the side that revealed more of the face (see plate 6). Though without the text's quasi-eugenical specificity about racial typologies, this artistic reconstruction was precisely what readers of *Early Man* would have expected to see.

In a preliminary version of this drawing, the figure was even more conspicuously modern, with thinner eyebrows and a neat goatee (fig. 8.6). He also sported a high-waisted loincloth and held a small stone axe in his right hand instead of the spear, whose length, in the published picture, necessitated some expedient fading. Through several rounds of revisions, Zallinger evidently worked hard to perfect the appropriate "features and proportions that suit present Western ideals of beauty," which, according to the text of *Early Man*, characterized these "upstanding fellows."[75] Although the final iteration of "Cro-Magnon Man" has been mocked by modern commentators for its "rather 'swept back' locks," which are seen to equate certain ra-

Fig. 8.6. This preliminary sketch of Cro-Magnon Man, the fourteenth figure in "The Road to Homo Sapiens," makes him appear more modern than in the published version of the drawing (see plate 6). His face has thinner eyebrows and a neat goatee, and he also sports a high-waisted loincloth and holds a small stone axe. Rudolph Zallinger, "Cro-Magnon Man." Pencil on paper, ca. 1965. (C19, Rudolph F. Zallinger's Preliminary Drawings for "The Road to Homo Sapiens," Smithsonian National Museum of Natural History. By permission of Zallinger Family LLC; courtesy of the Human Origins Program, Department of Anthropology, Smithsonian Institution.)

cialized attributes with evolutionary advancement, a less attractive style of representation would have been out of synch with the rest of the book.[76] Commercial artists constantly dealt with detailed and exacting demands, and Zallinger was under great pressure to implement the requirements of his corporate patrons.

How much Zallinger himself earned from the drawings for "The Road to Homo Sapiens" is not known, but Time-Life generally paid its contributors handsomely. In the mid-1960s, as Edey later observed, the "editorial cost alone was running over $250,000 per book."[77] This was exorbitantly expensive, and the company acknowledged of its unique business model that "to offset the high cost of maintaining its editorial and physical standards . . . TIME-LIFE BOOKS must assure itself of very large sales. Whereas the sale of 30,000 copies of a book is extraordinary for a conventional publisher (and could earn it a place on the bestseller list), TIME-LIFE BOOKS must obtain sales many times as big for each of its publications."[78] It was therefore imperative that books appealed to the largest possible number of readers and contained nothing that might offend or even merely challenge their putatively conservative values. Edey, who wrote the text for *Early Man*, was acutely aware that any issues with a volume, whether missed deadlines or artwork that jarred with the rest of the contents, could mean "bingo—a million or two dollars down the drain."[79] Zallinger was adept at meeting even the tightest of deadlines, and he was clearly also willing to tailor his drawings to Time-Life's precise specifications.

The Art Director's Dictum

The extent of the company's involvement even with individual drawings was evident in another of the annotations Howell added to Zallinger's draft sketch of *Australopithecus* (see fig. 8.3). Alongside the left foot, Howell gave curt advice: "Toe should look like modern man's," with an arrow directed at the hominid's hallux. A more fundamental modification was also required, and just above his own instruction Howell wrote: "Arnold Holeywell would like rear foot on different (deeper) plane."[80] Howell drew a faint line on either side of the metatarsals of the foot in question to indicate where this new plane should be, and in the published image the *Australopithecus*'s trailing

foot is positioned much further back, both in terms of perspective and actual placement, than in the original sketch (see fig. 8.4). The directive that both Howell and Zallinger followed with such assiduousness had come from a watercolor painter who, while Zallinger was contributing to *Life* in the mid-1950s, had worked for magazines such as *Field and Stream*. Arnold Clark Holeywell then took a more commercial route, creating advertising materials for corporations like Ford, and in 1963 he was appointed the assistant art director of Time-Life Books.[81] It was in this influential role that, barely a year later, he superintended the creation of the drawings for "The Road to Homo Sapiens."

Holeywell's immediate superior, Edward A. Hamilton, issued edicts for all the company's artwork, one of which was laid out in a Time-Life trade brochure: "In portraying . . . those subjects which the camera cannot see, the artists are guided by the art director's dictum that 'our kind of book requires a unique approach to illustration, one that has the strength of magazine art but also the qualities of authority and refinement which are in keeping with the editorial characteristics of our books. Our obligation to the reader is to present good-looking art of distinguished quality and to make certain that it communicates with clarity and simplicity.'"[82] Holeywell evidently instituted these instructions at the level of individual volumes, and although the front matter of *Early Man* stated that "all phases of this book, from planning and organization to final editing, were under the direction of F. Clark Howell," it seems that, in the case of Zallinger's drawings, Howell took his lead from the assistant art director.[83] The "magazine art" to which Hamilton's dictum referred was a product of what *Life*'s staff had called "group journalism," which Zallinger would have experienced when working for the magazine. The same highly collaborative approach was transferred to the production of the volumes published by Time-Life Books, which were known to insiders as "journalism in hard covers."[84] "The Road to Homo Sapiens" was itself a product of the same process of collaboration, and Zallinger's drawings were shaped, often quite literally, by the artist's interactions with both Simons and Howell, as well as, crucially, with Holeywell.

In the published illustration, the ascending simian and hominid figures were supplemented not only by textual captions but also by a vibrant polychromatic timeline that spanned a conveniently neat period of precisely

twenty-five million years and appeared directly above Zallinger's drawings (see plates 5 and 6). It was designed and created, using an air brush, by the scientific illustrator George V. Kelvin, who excelled in what he called the "careful organization of information" and whose diagrams avoided "complicated pathways and lines crossing over each other." Kelvin recognized that, on commercial commissions, "art director . . . and artist must work together to establish reference guidelines," and it was likely the mediation of Holeywell that ensured that the design of the timeline so perfectly complemented the simplicity of the linear arrangement of Zallinger's figures.[85] A test printing of the fold-out pages from *Early Man* containing the two together, before any of the textual elements were added, shows how carefully the discrete images, which seem to have been made entirely separately, were synchronized.[86]

Unlike both Kelvin and Zallinger, Holeywell had no scientific background whatsoever and, in the terms of Hamilton's dictum, was charged with ensuring only the quality and clarity of a book's artwork. Significantly, Howell, in 1963, had acknowledged that the "morphology of the (incompletely known) lower limb skeleton of *Australopithecus* . . . suggest[s] that capabilities for walking were limited." Indeed, what could be deduced of the "foot skeleton" implied that, in accordance with the "(inferred) pattern of weight transmission," *Australopithecus* was more suited to running.[87] Holeywell's instruction, conveyed via Howell's annotation, to reposition the *Australopithecus*'s rear foot on a deeper plane, which enhanced the sense that the figure was walking without giving any indication of running, reflected merely an aesthetic preference. Admittedly, the treatment of perspective in the original sketch, with both feet seemingly on the same plane, had been a little awkward. Like Howell's own request for changes to the position of the arms, this corporate intervention gave the figure a more dynamic bearing. At Holeywell's bidding, the rather passive posture of Zallinger's draft *Australopithecus* was transformed, in the final version published in *Early Man*, to a more active stance in which the figure takes a decisive forward stride.

The dating of Zallinger's preparatory artwork is uncertain, but another of what seem to be his earliest drafts, on paper similar to that of the original *Australopithecus* drawing, though without annotations from Howell, again has both feet close together and on the same perspectival plane (fig. 8.7). This sketch of "Dryopithecus" was altered dramatically in subsequent iterations,

DRYOPITHECUS

Fig. 8.7. In this preliminary sketch of *Dryopithecus* in "The Road to Homo Sapiens," the creature stands upright in a bipedal posture with its feet close together and on the same perspectival plane. Rudolph Zallinger, "Dryopithecus." Pencil on paper, ca. 1965. (C5, Rudolph F. Zallinger's Preliminary Drawings for "The Road to Homo Sapiens," Smithsonian National Museum of Natural History. By permission of Zallinger Family LLC; courtesy of the Human Origins Program, Department of Anthropology, Smithsonian Institution.)

Fig. 8.8. The published version of Zallinger's drawing of *Dryopithecus*, the third figure in "The Road to Homo Sapiens," is substantially different from the preliminary sketch of it in figure 8.7. The creature's bipedal posture has been switched to a knuckle-dragging crouch, from which it appears to be just on the point of rising. Contributing to this impression is the placement of its feet, now much farther apart, with the rear one, on a deeper perspectival plane, providing the necessary propulsion. In F. Clark Howell and the Editors of Time-Life Books, *Early Man* (New York: Time-Life Books, 1965), 41 (Author's collection. By permission of Zallinger Family LLC.)

with its bipedal posture switched to a knuckle-dragging crouch, from which, in the published version, it appeared to be just on the point of rising (fig. 8.8). Contributing to this impression was the position of its feet, now much further apart, with the rear one, on a slightly deeper plane, providing the necessary propulsion. It therefore seems that Zallinger applied Holeywell's directive regarding his *Australopithecus* sketch to the other figures he subsequently drew, which, in "The Road to Homo Sapiens," all took the same conspicuously elongated stride. Only "Neanderthal Man," third from the

end, provided any variation by leading with its left leg rather than the right, although the stride was no less emphatic. The vigor and consistency of the strides was integral to the illustration's visual power, generating the impression, with the almost military uniformity in the repetition of fifteen forward steps, that it represented an evolutionary march of progress.

The modification of the *Dryopithecus*'s original upright posture to a kinetic crouch initiated the ascending curve whose continuance was ensured by Simons's instructions regarding the respective heights of the succeeding *Oreopithecus* and *Ramapithecus*. While the scientific rationale for that guidance was itself somewhat uncertain, the other advice that was decisive in giving "The Road to Homo Sapiens" its progressive potency was made on exclusively aesthetic grounds. Holeywell's intervention, on behalf of Time-Life Books, also reinforced the connection, previously only implicit, between evolutionary advancement and forward footsteps.

An Impossible Stance

In 1964 Howell identified "full-fledged adaptation to bipedalism . . . which permitted leisurely and prolonged walking" as the principal attribute of what he termed the "hominization process." The "singularity of the erect posture" necessary to "step off in walking" was, he insisted, an "impossible stance for any ape."[88] Yet this conclusion was not reflected in *Early Man*, where Zallinger's drawings of extinct apes were, with the exception of the crouching *Dryopithecus*, shown not only standing upright but, at Holeywell's behest, walking purposefully forward. These simians constituted at least four of the fifteen figures in "The Road to Homo Sapiens," so the book's text had to explain the discrepancy: "Although proto-apes and apes were quadrupedal, all are shown here standing for the purposes of comparison."[89] No mention was made of their ambulatory postures, even though Howell also doubted whether early hominids like *Australopithecus* were structurally suited to walking. The apocryphal strides of these initial figures were integral to the illustration's overall visual impact, in which the metaphorical suggestion, in the caption below the Cro-Magnon, that he was "only a . . . step away from modern man," was made literal.[90]

The comparative rationale for Zallinger's standing simians drew on the

same anatomical conventions that, a century earlier, had determined the arrangement of the osseous apes in the frontispiece to Huxley's *Man's Place in Nature*. In that wood engraving, the skeletons were both upright and—with the exception of the gibbon at the back of the series—articulated in poses that suggested they were stepping forward. While the lifting of their respective left legs facilitated the comparison of homologous anatomical structures, it also seemed to correspond with certain rhetorical passages in the book where Huxley alluded to less evolved animals moving a "step higher in the scale" and "progress[ing] . . . through a complete series of steps to man."[91] The ape's postures proved hugely controversial, and the "tripping forward" of the skeletons with "their best legs foremost" gave the appearance, as critics quickly pointed out, of a grotesque procession.[92] Even Hawkins, the artist who made the original drawings, protested bitterly at the insinuation that apes, and gorillas in particular, were able to walk upright.

Zallinger appears to have had similar concerns, if less vociferously expressed, with the linear presentation of his drawings in *Early Man*.[93] What seem to be his own alternative arrangements of the figures moderated the momentum of their forward strides. Among the artist's preliminary drawings are two mock-ups that, together, show a different conception of what "The Road to Homo Sapiens" might have been (fig. 8.9). This abridged version of the image featured five new drawings, beginning with *Australopithecus* and proceeding through *Homo erectus*, an early *Homo sapiens*, and a Neanderthal, before concluding with a human with wispy hair and beard, as well as an expression of beatific gentleness, who resembled traditional artistic representations of Jesus. The figures all step forward with their feet carefully positioned in relation to a ruled baseline, but, significantly, each is also accompanied by two further drawings. These provide an enlarged view of their respective heads, still in profile, both as skulls and with skin, hair, and external features intact. Besides giving a clearer sense of the actual cranial remains on which Zallinger's meticulous facial restorations were based, the additional drawings break the flow of the successive walking figures, diverting the viewer's attention from their legs and feet, which were, in many cases, the parts of their anatomy about which least was known.

This potential replacement for "The Road to Homo Sapiens," which tempered its overtly progressive elements, was evidently considered unsuitable

Fig. 8.9. In these paired mock-ups, made when Zallinger was creating the figures for "The Road to Homo Sapiens," the artist presents an alternative conception of how human evolution might be depicted. The five figures all step forward in the same manner as the fifteen figures in the published illustration, but each is also accompanied by two further drawings, enlarged views of their respective heads and skulls. The additional drawings break the flow of the successive walking figures, making the mock-ups seem less like a march of progress than the published illustration does. Rudolph Zallinger, "[Untitled Mock-Ups of Five Figures with Heads and Skulls]." Pencil on paper, ca. 1965. (C1–2, Rudolph F. Zallinger's Preliminary Drawings for "The Road to Homo Sapiens," Smithsonian National Museum of Natural History. By permission of Zallinger Family LLC; courtesy of the Human Origins Program, Department of Anthropology, Smithsonian Institution.)

for *Early Man*, and Zallinger's alternative drawings were never published. But when, almost a decade later, he reused some of the figures that had appeared in the book, he configured them in a similar manner to the rejected mock-ups. In *Evolution* (1974), a brief primer on the subject by Frank Rhodes in which Zallinger's contribution was acknowledged on the title page, seven of the figures from "The Road to Homo Sapiens" were integrated into a new illustration (fig. 8.10). Here they appeared alongside new

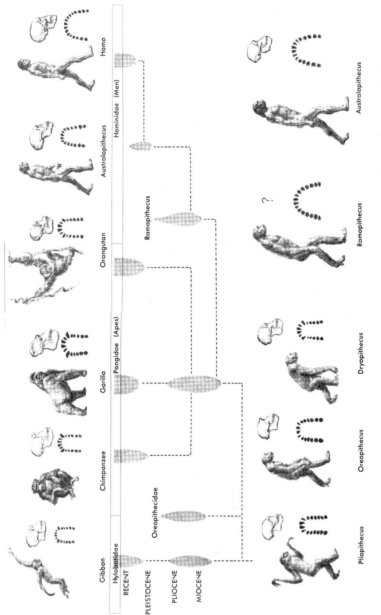

Fig. 8.10. To make this diagram, Zallinger integrated seven of the figures he had drawn for "The Road to Homo Sapiens" with new images, drawn in the same style, of a gibbon, an orangutan, a chimpanzee, and a gorilla. The apes, with the exception of the brachiating gibbon, are stationary, meaning that the striding postures of the figures Zallinger had previously drawn no longer seem part of a general movement of evolutionary progress. In Frank H. T. Rhodes et al., *Evolution* (New York: Golden Press, 1974), 42–43. (Author's collection. By permission of Zallinger Family LLC; © 1974 by Penguin Random House LLC. Used by permission of Golden Books, an imprint of Random House Children's Books, a division of Penguin Random House LLC. All rights reserved.)

drawings of a gibbon, an orangutan, a chimpanzee, and a gorilla. Apart from the brachiating gibbon, these living apes remained stationary and gave no suggestion, unlike their skeletal counterparts in Huxley's frontispiece, of having the capacity to walk upright. Zallinger drew them in exactly the same style as his reused hominid figures, whose striding postures now no longer seemed part of a general movement of evolutionary progress. To further stymie the sense of progress, he altered the order of some of the figures, so the upright *Oreopithecus* came before the crouching *Dryopithecus*.

As in his mock-ups, Zallinger supplemented the figures, both simian and hominid, with drawings of their skulls as well as an impression of their respective dental arches. Notably, with *Ramapithecus*, the skull of this "still poorly known hominid" was replaced by an enigmatic question mark. On the following page, Zallinger nevertheless provided a "very tentative . . . reconstruction" of two Ramapithecines, amid a rocky landscape, in both bipedal and quadrupedal poses (fig. 8.11).[94] The former, in contrast to the equivalent drawing in *Early Man*, stood resolutely still, thereby revealing the genitals—male, inevitably—that were discreetly obscured in all the striding figures in "The Road to Homo Sapiens" by their raised right legs.

A Small Step

Even if Zallinger himself was unenthusiastic about the emphatic forward stride instigated by Holeywell's intervention on the positioning of feet, the assistant art director's employers certainly recognized its value. Time-Life Books, as the company acknowledged, was an "enterprise which only faintly resembles that of a conventional publisher." The model of mail-order subscriptions meant that its titles could not be bought through "traditional bookstore channels," and instead, as a trade brochure explained, the "availability of a book is made widely known to the public by direct mail and by magazine and newspaper advertising."[95] The elaborate promotional materials, including expensive brochures that were mailed out to existing customers and distributed to potential new ones as supplements in the press, were integral to Time-Life's approach to publishing.

With the second edition of *Early Man*, published in early 1970, "The Road to Homo Sapiens" was utilized in advertisements as the book's main

Fig. 8.11. In this illustration, Zallinger depicts two Ramapithecines, amid a rocky landscape, in both bipedal and quadrupedal poses. Unlike the striding *Ramapithecus* in "The Road to Homo Sapiens," the bipedal figure in this new image remains stationary. In Frank H. T. Rhodes et al., *Evolution* (New York: Golden Press, 1974), 144. (Author's collection. By permission of Zallinger Family LLC; © 1974 by Penguin Random House LLC. Used by permission of Golden Books, an imprint of Random House Children's Books, a division of Penguin Random House LLC. All rights reserved.)

selling point. It even appeared, above a photograph of Richard Nixon at his presidential desk, on the cover of a newspaper supplement promoting all aspects of Time Inc.'s corporate activities.[96] In similar supplements dedicated just to *Early Man*, the advertising copy drew attention to Zallinger's artistic style and made an enticing promise to purchasers of the book: "In realistic artists' renderings—based on the latest evidence—you'll see what early man looked like in his various stages." In particular, the copywriters capitalized on the distinctive posture of these realistically rendered hominid figures, which, it was claimed, would bring to life "man's step-by-step advance over 25 million years."[97] But it was not only the visual dynamism en-

sured by Holeywell's intervention that determined this particular focus. At the end of the previous decade, such evolutionary footsteps had been given a dramatic new significance that Time-Life's marketing materials could not ignore.

The rapid advances in paleoanthropology made in the 1950s and early 1960s had coincided with initial developments in the exploration of space. The juxtaposition of these new insights into human origins with the visionary sense of the future induced by the prospect of interplanetary travel became a mainstay of 1960s popular culture, most notably in Stanley Kubrick's film *2001: A Space Odyssey*.[98] It was released in 1968, and in the summer of the following year, during the preparations for the historic Apollo 11 mission to the moon, the evolutionary past assumed even greater pertinence. Shortly before the launch in July 1969, Wernher von Braun, designer of the Saturn V rocket that would propel the spacecraft beyond earth's orbit, observed: "What we will have attained when Neil Armstrong steps down upon the moon is a completely new step in the evolution of man." The astronaut himself famously reflected on the magnitude of his "small step" when setting foot on the lunar surface, and Norman Mailer, having recorded von Braun's words for *Life* magazine, was prompted to "wonder at the origin of Armstrong's first speech on the moon."[99] Its evolutionary resonances were apparent to other journalists. A day after Armstrong's moonwalk, the *New York Times* reported: "In the long evolution of the human race up from the primeval ooze, no more significant step has ever been taken than yesterday's."[100] It was, the newspaper maintained, "more than a step in history; it is a step in evolution . . . a *willed* step in the evolutionary process."[101]

In the same report, entitled "Evolution into Space," the *Times* remarked that "language seems too impoverished to encompass . . . the era that begins with man's first walk on the moon."[102] Faced with this linguistic paucity, many journalists, as well as von Braun and possibly even Armstrong himself, resorted to the familiar imagery equating evolutionary progress with forward footsteps. In 1965 "The Road to Homo Sapiens" had visually reaffirmed this long-standing conception of evolution, and Time-Life's advertisements for *Early Man*'s second edition, which was published only weeks after the second moon landing made by Apollo 12, directly connected the illustration

with the momentous steps just then being taken by astronauts. Indeed, purchasers of the book, as the effusive copy asserted, would "see emerging all those qualities that make us what we are today . . . that enabled us to descend from the trees and walk on the moon." With the tagline "Follow the progress of man from tree-dweller to moon-walker," the same advertisement reproduced a silhouette of Zallinger's drawing of *Pliopithecus*, the Miocene proto-ape whose jaunty stride began "The Road to Homo Sapiens," alongside the iconic photograph of Buzz Aldrin, taken on the moon by Armstrong (whose reflection appears in Aldrin's visor), as he steps tentatively on the lunar surface (fig. 8.12).[103] This pairing—echoing the celebrated match-cut in Kubrick's *2001* in which a bone thrown by an *Australopithecus* is switched to a similarly shaped spacecraft—had a clear implication. The striding figure of "Modern Man" at the culmination of Zallinger's illustration had been supplanted by Armstrong taking his own small step onto the moon. The sophisticated spacesuits he and Aldrin wore while walking on the moon were the culmination of the long series of technological innovations that began with the sharpened stone gripped by Zallinger's *Australopithecus*. The sculptural representations of the Greek god Apollo with which earlier progressive evolutionary sequences had climaxed were now replaced by a photograph of the intrepid crew of Apollo 11 (see fig. 3.1).

For critics of America's colossally expensive space program, this image of "Whitey on the moon," as the poet and musician Gil Scott-Heron trenchantly described the Apollo 11 astronauts, reaffirmed the same equation of European male characteristics with progress and advancement that the Greek divinity had epitomized since the eighteenth century.[104] This equation was less problematic to *Time* magazine, which considered that even though the successful moon landing was an "accomplishment shared by all America and indeed by the world . . . it was especially an accomplishment of 'middle America.'" After all, "solid, perhaps old-fashioned American virtues" had made it possible to "convert abstract scientific theory into awesome, tangible technological achievement." Regardless of the carping by what were dismissively termed "liberals (along with radicals, many blacks, many of the young)," it was evident, the magazine avowed, that "Middle America does not seem discontented . . . and strongly backs the U.S. space program."[105] *Time* was no less integral to Time Inc.'s publishing empire than

Fig. 8.12. Buzz Aldrin walking on the surface of the moon, with the reflection of Neil Armstrong in his visor, during the Apollo 11 extravehicular activity on July 20, 1969. This photograph was juxtaposed with Zallinger's drawing of *Pliopithecus* (fig. 8.2) to represent the beginning and culmination of human evolution in advertisements for *Early Man*'s second edition in the early 1970s. Photograph (by Armstrong), 1969. (NASA AS11–40–5903.)

the similarly conservative *Life,* and the company's books division had targeted an embodiment of middle American values, the "Ford dealer in Wichita," as its intended audience. Even as the counterculture's criticisms of the Apollo missions and consequent rejection of technological rationalism grew increasingly influential, Time-Life's advertising materials explicitly aligned "The Road to Homo Sapiens" with the ethos of progress that the moon landings exemplified.[106]

Incessant Bombardment

Notwithstanding Time-Life's ideological commitments, its advertisements for *Early Man* had a much more practical impact given the company's need to secure extremely high sales. In 1969 it was proudly claimed that "TIME-LIFE BOOKS consistently sells more copies per title than any other publisher in the world."[107] But even amid such unparalleled success, *Early Man* stood out. Following the publication of the heavily advertised second edition, sales of the first two editions, according to Edey, were "on their way to two million," making *Early Man* one of Time-Life's best-selling volumes. For Edey, the "real key to success in this business was repeat sales," which meant that copies of *Early Man* remained in circulation, and were being touted to new mail-order subscribers, for much longer than a conventional book.[108] The claim made by Zihlman and Lowenstein about "millions of . . . Time-Life volumes on human evolution" sanctifying the specious status of *Ramapithecus* was not an exaggeration. "The Road to Homo Sapiens" was continually sent, within the covers of *Early Man*, in the mail to millions of households over a period of more than a decade and a half. As Howell later commented, the "Time-Life book is the reason this image became so ubiquitous."[109] Like the frontispiece to *Man's Place in Nature* a century before, Zallinger's foldout illustration was also reproduced separately from the book it appeared in, further enhancing its ubiquity.

Part of the reason for Time-Life's phenomenal success was that the company targeted juvenile as well as adult readers. It had acquired the textbook publisher Silver Burdett specifically to distribute Time-Life books to schools, and it was under this imprint that the "Young Readers Edition" of *Early Man* was published in 1968. This abridged version not only retained "The Road to Homo Sapiens" in full over four pages but, when the book was re-issued two years later, featured on its paperboard covers the initial four of Zallinger's drawings on the back and three of the final four figures on the front, concluding rather oddly with the penultimate Cro-Magnon rather than the modern human. The growing prominence of the illustration was also reflected in Time-Life's expensive advertising supplements, which were clearly designed to appeal to all members of the families that received them. In one, all fifteen of Zallinger's ascending figures were reproduced on a

single page, across three successive tiers, along with a recommendation to school-age readers: "Here on this page you can see, step by step, man's 25-million-year history. You can follow our ancestors as they progress from gibbon-like creatures to modern man. You may cut out this page and use it for school or for reference."[110] This personalized instruction to extract the page seems to have been heeded, though probably more by educators than by Time-Life's intended addressees.

There were, as one observer with a particular interest in hominid fossils later recalled, "few social studies classrooms and school library bulletin boards where the parade was not prominently displayed." Indeed, this "visually powerful parade," the same observer insisted, "was so successful in advancing human evolution because it received a far greater distribution and viewing than did the *Early Man* book. Worldwide mailings for advertising purposes were made of the particular pages featuring the parade. The posting of these pages in classrooms and libraries meant that far more people saw the parade than possessed the book." These reflections, from Marvin L. Lubenow, are inevitably colored by his perspective as a Young-Earth Creationist who rejects the idea of evolution and considers "The Road to Homo Sapiens" a falsified "illustration of outrageous evolutionist artistry."[111] Lubenow's memories nevertheless correspond with the actual advertising materials produced by Time-Life in the early 1970s, and even Edey, *Early Man*'s editor and de facto author, complained about the company's "incessant bombardment of mailing pieces."[112] Lubenow's recollections were also corroborated in the United States Congress by a politician who would later become the country's vice president, albeit partly on account of the electoral support garnered by his own evangelical beliefs.

Speaking in the House of Representatives in 2002, Mike Pence, then a new Republican congressman seeking a common point of reference with his fellow legislators, told them: "We can all see in our mind's eye that grade school classroom that we all grew up in with the linear depiction of evolution just above the chalkboard. There is the monkey crawling on the grass. There is the Neanderthal dragging his knuckles and then there is Mel Gibson standing in all of his glory."[113] Although this putatively collective memory was somewhat misremembered, with Zallinger's modern human assuming the form of a hirsute Hollywood actor, it was clearly "The Road to Homo

Sapiens" that Pence recalled seeing in his school classroom. This, he sup-
posed, was a virtually universal educational experience, at least for Ameri-
cans of a certain age. Detached from *Early Man*, the illustration, dissemi-
nated in Time-Life's ceaseless marketing campaigns, became ineradicably
fixed in the mind's eye of an entire generation.

Every Artist Is a Scientist

W hen Elwyn LaVerne Simons died in 2016, an obituary in the *New York Times* noted the eminent paleoanthropologist's "constitutional puckish humor."[1] Although Simons's guidance as principal scientific advisor to Zallinger when he drew "The Road to Homo Sapiens" was not publicly acknowledged, it was crucial in determining the linear, ascending format of the now iconic image. A mock-up of Zallinger's simian and hominid figures, annotated with scrawled instructions, has been preserved in the Simons archives at Yale. At some point Simons indulged his mischievous humor and attached to the mock-up, with adhesive tape, a cartoon depicting a crouching ape, at the rear of a similarly progressive row of figures, who throws a banana skin under the striding foot of the modern human at the front (see fig. 7.4). This ironic addendum carried the signature of Bob Mankoff, who did not begin publishing his cartoons until the mid-1970s, so Simons must have appended it to the mock-up long after his collaboration with Zallinger.[2] By this time, Simons's own feelings about "The Road to Homo Sapiens," especially its controversial reconstruction of *Ramapithecus*, had become somewhat ambivalent. More significantly, the illustration, disseminated in Time-Life Books' best-selling *Early Man* and the extensive advertisements for the book's subsequent editions, had become an established element of what has been called the "cartoon lexicon."[3] As Simons's puckish postscript seemed to acknowledge, the ascending image was now most widely replicated in cartoons that, for a multitude of comedic purposes, satirized its evolutionary march of progress.

Such skits have proliferated exponentially since the beginning of the twenty-first century as internet memes, peaking during Donald Trump's presidency, which was portrayed as a nadir or reversal of human evolution. The march of progress has even received the accolade of being parodied in an episode of the animated television series *The Simpsons*, the promotional materials for which included a sequence drawn by Matt Groening showing the developmental stages between "Monkius eatalotis," whose binomial name is validated by a half-eaten banana, and "Homersapien," who negates any sense of progression by himself munching the same fruit with a characteristically fatuous expression.[4] Such wry appropriations of the imagery of the ascent from apes to humans had actually begun in the early twentieth century and were particularly prevalent during the celebrated Scopes trial in the summer of 1925.[5] Nor does the ubiquity of these facetious imitations vitiate the impact of the original image in shaping understandings of evolution. In fact, as Stephen Jay Gould contended in his influential critique of the march of progress, "its prominent use in humor" affords "our best test of public perceptions," revealing how engrained the problematic iconography has become.[6]

Although the image is an instantly recognizable visual cliché, it would be wrong to assume that it has become merely a droll comic trope. Instead, its two most important manifestations, in the frontispiece to Huxley's *Man's Place in Nature* and in "The Road to Homo Sapiens," have been redeployed for more serious purposes by both contemporary artists and modern scientists. Art and science are not stable categories, and there are numerous intersections, evinced in the eventful history of the march of progress, between their respective practices and personnel.[7] This is no less true of the most recent avant-garde art and specialized scientific disciplines, although the ways that they have utilized the iconic imagery from a nineteenth-century frontispiece and a 1960s fold-out illustration is nonetheless both surprising and significant.

At the close of the 1990s, the conceptual sculptor Zadok Ben-David reflected: "Every artist is a scientist. We take materials and make them into new things. We engage in experimentation. Science, like art, prompts so many questions. People question where science or art will take us. But the only truth we continue to 'discover' is that we cannot stop this natural develop-

ment."[8] Ben-David's own artistic experiments in the past three decades have involved transforming the fifteen figures from "The Road to Homo Sapiens" into flat steel or aluminum sculptures, with the shading of the original drawings rendered by intricate hand-cut incisions in the metal. These sculptural silhouettes are then positioned in various configurations, some of which, as in *Walking Back* (1997), re-create the original ascending arrangement, although the figures stride up the back of another, much larger plaster figure as if scaling a mountain. The metal sculptures in *The Man Who Never Ceased to Grow* (1995) similarly replicate the same distinctive upward curve. When viewed closely, however, it becomes apparent that the sculptures are all repetitions of a single figure, the "Neanderthal Man" drawn by Zallinger, whose gradually increasing size engages with questions of individual development rather than the evolution of whole species.

In other installations, Zallinger's figures from "The Road to Homo Sapiens" are, as Ben-David himself observes, "juxtaposed, seemingly at random."[9] Most strikingly, in *Evolution and Theory* (1998) they are positioned, without any order or narrative, in a thin layer of sand—which conceals their bases, thus making them seem to float—alongside smaller sculptures based on nineteenth-century wood engravings of laboratory apparatus (fig. E.1). The purpose of the cluttered arrangement remains deliberately ambiguous, so any sense of progress is removed. The delicate sculptural forms, black silhouettes like shadow puppets that are made up of empty spaces, instead render the various simian and hominid figures as ephemeral traces. Ben-David says that the "installation deals with the danger of human achievements," and commentators on his work have suggested that it provides a "deftly ironic commentary on conservative, linear theories of human and industrial progress."[10] Like the artist's other sculptural appropriations of the march of progress, *Evolution and Theory* was conceived in the final years of the twentieth century and reflects a certain premillennial anxiety about humanity's future. Such concerns continue to resonate, and the artwork has been exhibited on numerous occasions in the twenty-first century. In 2015 it was installed at the Israel Museum in Jerusalem.

The installation's dichotomous title seems to pit scientific seriousness against postmodern irony, and the ambivalence of its arrangement replaces the "continuous narrative" of evolutionary progress with what one critic has

Fig. E.1. Sculptural installation by Zadok Ben-David entitled *Evolution and Theory.* It positions figures from "The Road to Homo Sapiens," which are re-created as flat aluminum sculptures, alongside similar sculptures based on nineteenth-century wood engravings of laboratory apparatus. The different sculptures are juxtaposed, apparently at random, in a cluttered arrangement that remains deliberately ambiguous and from which any sense of progress is removed. Zadok Ben-David, *Evolution and Theory.* Hand-cut painted aluminum and sand, 1998. Beelden aan Zee, Holland. (Photography credit: John C. Steenwinkel, 1998. By permission of Zadok Ben-David.)

called "patterns of curiosity and surprise."[11] Back in the mid-1960s, "The Road to Homo Sapiens" was, in part, a riposte to the conceptual art of the postwar period, for which both Zallinger and Simons shared a profound distaste. It was the latter's guidance that gave the illustration its ascending, linear design. Zallinger's alternative arrangements of the figures he had drawn, both in rejected mock-ups for *Early Man* and in other publications, disrupted their continuous succession (see figs. 8.9 and 8.10). Though far removed from the postmodern playfulness that Zallinger so disliked, his preferred formats for "The Road to Homo Sapiens," revealed here for the first time, prefigure Ben-David's rearrangement of the figures and show that the potential for questioning linear progress was always inherent in the original image.

Ben-David's decision, in *Evolution and Theory,* to combine sculptures

based on Zallinger's figures with metal reproductions of wood engravings of Victorian laboratory apparatus restores "The Road to Homo Sapiens" to its roots in the artistic methods of the mid-nineteenth century. The wood-engraved primate skeletons in the frontispiece to *Man's Place in Nature*, which initiated the linear representation of an ascent from apes to human, have themselves been disaggregated and reconfigured in new arrangements that, as with Ben-David's installation, challenge the original connotations of progress. This is not another exercise in ironic postmodern recontextual-ization though; instead, the skeletal primates, originally drawn in 1862, were utilized in the announcement of the most momentous paleoanthropological discovery of the early twenty-first century.

In October 2009, the journal *Science* dedicated an entire issue to the re-sults of an analysis of a set of fossils excavated in Ethiopia. The four-million-year-old skeleton belonged to a new hominid species, *Ardipithecus ramidus*, that provided an unprecedented insight into "what the last common ances-tor we shared with chimpanzees was like." *Ardipithecus* was a descendent of this "elusive common ancestor," on the phylogenetic branch that would eventually lead to humanity, but its own skeleton was "so rife with anatom-ical surprises" that it invalidated many previous assumptions about the evo-lutionary affinities of apes and humans. Most importantly, *Ardipithecus*'s skeletal structure revealed that the "last common ancestor had limb propor-tions more like those of monkeys than apes," so "its locomotion did not re-semble that of any living ape."[12] In particular, the remarkably well-preserved hands showed that neither *Ardipithecus* nor the putative common ancestor walked with the assistance of its knuckles. Therefore, walking on the knuckles was not the adaptive process by which humans developed an upright bi-pedal posture.

To indicate just how transformative this conclusion was, the multinational team of researchers that, led by Tim D. White, excavated and analyzed *Ar-dipithecus* began their paper in *Science* with the original source of what they called the "knuckle-walking → bipedality . . . 'suspensory paradigm.'" After invoking Huxley's *Man's Place in Nature*, they noted: "Its frontispiece fea-tured a human skeleton and four suspensory adapted apes, each posed up-right and each obviously more human-like than any pronograde Old World monkey." This ascending series represented a conception of humanity's

shared anatomical heritage with living apes, and its emergence from ances-
tors who had resembled them, that, with the discovery of *Ardipithecus*, was
now decisively refuted. Remarkably, however, the diagram that visualized
the new understanding of the "very different evolutionary trajectories of early
African apes and hominids" reused three of the wood-engraved skeletons
from Huxley's frontispiece. It also added a new one, in exactly the same style
and pose, reconstructing *Ardipithecus*'s partial remains (fig. E.2).[13]

This new figure was drawn by Jay Matternes, who, almost half a century
earlier, had contributed panoramic paintings of hominid habitats and life-
styles to *Early Man* that complemented the realistic style of the figures in
"The Road to Homo Sapiens." He subsequently created an updated version
of Zallinger's iconic illustration, published in the *National Geographic* in
1985, which incorporated the recently discovered *Australopithecus afarensis*,
as well as the snubbed *Homo habilis*, and substituted a more dynamic run-
ning posture for the ambulatory strides in the original.[14] The illustration
in *Science*, by contrast, was, as its caption explained, a "cladogram adding
Ar. ramidus to images of gorilla, chimpanzee, and human, taken from the
frontispiece of *Evidence as to Man's Place in Nature*." Cladograms, a delib-
erate antithesis of the conventional march of progress imagery, explicitly
preclude any indications of evolutionary advancement and instead chart
branching patterns of speciation. The cladistical arrangement entailed by
Ardipithecus's unexpected anatomy consigned the chimpanzee and the go-
rilla to their own separate clades, signaling an absence of the ancestral char-
acters possessed by hominids and humans. These "adaptive cul-de-sacs" were
represented by drawings of the respective apes extracted from *Man's Place
in Nature*'s ascending skeletal series, although, as the caption clarified, with
the "positions of *Gorilla* and *Pan* reversed to reflect current genetic data," in-
dicating that it was chimpanzees who were more closely related to humans.
Rather than the gorilla, *Ardipithecus* was now situated directly behind the
human skeleton, reflecting its newly conferred position at the "basal adap-
tive plateau of hominid natural history."[15] The drawing of its reconstructed
skeleton was nevertheless placed below that of the striding human, thereby
forestalling the progressive connotations of the original frontispiece's linear
sequence.

The depiction of *Ardipithecus*'s skeleton that, in this cladogram, was

Cladogram adding *Ar. ramidus* to images of gorilla, chimpanzee, and human, taken from the frontispiece of *Evidence as to Man's Place in Nature,* by Thomas H. Huxley (London, 1863) (with the positions of *Gorilla* and *Pan* reversed to reflect current genetic data). Numerous details of the *Ar. ramidus* skeleton confirm that extant African apes do not much resemble our last common ancestor(s) with them.

Fig. E.2. Cladogram integrating three wood engravings of human, gorilla, and chimpanzee skeletons from the frontispiece to Huxley's *Man's Place in Nature* (fig. I.2) with a new drawing by Jay Matternes of *Ardipithecus ramidus.* The reconstructed *Ardipithecus* skeleton, which is the most momentous paleoanthropological discovery of the early twenty-first century, is depicted by Matternes in exactly the same style and pose as the skeletons drawn a century and half earlier by the anti-evolutionist Benjamin Waterhouse Hawkins. In C. Owen Lovejoy, Gen Suwa, Scott W. Simpson, Jay H. Matternes, and Tim D. White, "The Great Divides: *Ardipithecus ramidus* Reveals the Postcrania of Our Last Common Ancestors with African Apes," *Science* 326, no. 5949 (2009): 73. (Reprinted with permission from AAAS; by permission of Jay H. Matternes.)

added to the mid-nineteenth-century wood engravings was initially drawn by Matternes at "full-scale (life-size)"; he considered it necessary to "work out the drawing on a one-to-one scale," making it "just over three feet ten inches tall."[16] This was precisely the scale at which the gorilla, chimpanzee, and human had originally been drawn by Benjamin Waterhouse Hawkins back in 1862, when they were first deployed as life-sized illustrations in one of Huxley's lectures. Later the illustrations were photographically reduced

and then engraved for inclusion in *Man's Place in Nature*. Matternes's life-sized *Ardipithecus* was similarly reduced, using more recent digital imaging technologies, to match the dimensions of Hawkins's drawings.

To enhance the correspondence, Matternes also had to ensure that in his own lateral reconstruction of *Ardipithecus* the figure was posed in exactly the same posture, even down to the raised left leg, now positioned on a branch, and the extended arm, that had given the skeletons in the frontispiece the appearance of striding purposefully forward. Notwithstanding the huge advances in technology and scientific knowledge at his disposal, Matternes replicated the precise gait and posture in which Hawkins had drawn his primate skeletons, at the Royal College of Surgeons' Hunterian Museum, almost one hundred and fifty years earlier. However, Hawkins, who virulently rejected the notion that humans had any ancestral relation with apes, had placed the gorilla skeleton in an awkward pose to surreptitiously express his own anti-evolutionary sentiments. While the cladogram published in *Science* revised previous assumptions about the precise proximity of apes and humans, it nonetheless posited a shared progenitor, inelegantly called "CLCA" (or "chimpanzee/human last common ancestor").[17] The inclusion, alongside such specialist jargon, of Hawkins's deliberately ungainly gorilla, and the positioning of *Ardipithecus* in an equivalent pose, shows that the history of the march of progress, with all its unexpected twists and turns, still has implications for even the most modern visual representations of evolution.

NOTES

Introduction

1. Liz Halloran, "Partisan Evolution Gap? Politically Insignificant, GOP Says," *NPR*, January 2, 2014, https://www.npr.org/sections/itsallpolitics/2014/01/02/259151167/partisan-evolution-gap-politically-insignificant-gop-says.

2. "I'm with the GOP. I Don't Believe in Evolution If That's What It Is," *The Mermaid's Tale*, January 4, 2014, http://ecodevoevo.blogspot.com/2014/01/im-with-gop-i-dont-believe-in-evolution.html.

3. B. Waterhouse Hawkins, *A Comparative View of the Human and Animal Frame* (London: Chapman and Hall, 1860), 27; Duke of Argyll, "The Reign of Law," *Good Words* 6 (1865): 272.

4. Julia Voss, *Darwin's Pictures: Views of Evolutionary Theory, 1837–1874* (New Haven: Yale University Press, 2010), 145; Adrian Desmond, *Huxley: The Devil's Disciple* (London: Michael Joseph, 1994), 312.

5. D. H. Lawrence, "Notes and Reviews: *The World of William Clissold*," *Calendar of Modern Letters* 3 (1926): 256.

6. Stephen Jay Gould, *Wonderful Life: The Burgess Shale and the Nature of History* (New York: W. W. Norton, 1989), 31 and 32.

7. See Peter J. Bowler, *Progress Unchained: Ideas of Evolution, Human History and the Future* (Cambridge: Cambridge University Press, 2021), 27–68.

8. Gould, *Wonderful Life*, 28.

9. Jonathan Wells, *Icons of Evolution: Science or Myth?* (Washington, DC: Regnery, 2000), 211.

10. Martin Kemp, *Christ to Coke: How Image Becomes Icon* (Oxford: Oxford University Press, 2012), 3.

11. Richard Swann Lull, "Connecting and Missing Links in the Ascent to Man," in *Creation by Evolution*, ed. Frances Mason (New York: Macmillan, 1928), 263, 262, and 255.

12. On the principle of historical symmetry, see David Bloor, *Knowledge and Social Imagery*, 2nd edn. (Chicago: University of Chicago Press, 1991), 175–79.

13. On transnational circulation, see James A. Secord, "Knowledge in Transit," *Isis* 95 (2004): 654–72.

14. See Steven Shapin, "The Invisible Technician," *American Scientist* 77 (1989): 554–63.

15. On the controversies over these embryo diagrams, see Nick Hopwood, *Haeckel's Embryos: Images, Evolution, and Fraud* (Chicago: University of Chicago Press, 2015).

16. Stephen Jay Gould, "Ladders, Bushes, and Human Evolution," *Natural History* 85, no. 4 (1976): 26.

17. Stephen Jay Gould, "Evolution Wins Again," *New York Times*, January 12, 1982, A:15. On the status of the conflict thesis in the late twentieth century, see Erika Lorraine Milam, "The Stigmata of Ancestry: Reinvigorating the Conflict Thesis in the American 1970s," in *Rethinking History, Science, and Religion: An Exploration of Conflict and the Complexity Principle*, ed. Bernard Lightman (Pittsburgh: University of Pittsburgh Press, 2019), 19–36.

18. Gould, "Ladders," 30.

19. J. David Archibald, *Aristotle's Ladder, Darwin's Tree: The Evolution of Visual Metaphors for Biological Order* (New York: Columbia University Press, 2014), 19.

20. Niles Eldredge and Stephen Jay Gould, "Punctuated Equilibria: An Alternative to Phyletic Gradualism," in *Models in Paleobiology*, ed. Thomas J. M. Schopf (San Francisco: Freeman, Cooper, 1972), 82–115.

21. Stephen Jay Gould, "Life's Little Joke," *Natural History* 96, no. 4 (1987): 18 and 25.

22. On Gould's preference for cladograms, see Stephen Jay Gould, "Redrafting the Tree of Life," *Proceedings of the American Philosophical Society* 141 (1997): 47–49.

23. Niles Eldredge and Ian Tattersall, "Evolutionary Models, Phylogenetic Reconstruction, and Another Look at Hominid Phylogeny," in *Approaches to Primate Paleobiology*, ed. F. S. Szalay (Basel: Karger, 1975), 218–42.

24. On the controversies over punctuated equilibrium, see David Sepkoski, "Stephen Jay Gould, Darwinian Iconoclast?" in *Rebels, Mavericks, and Heretics in Biology*, ed. Oren Harman and Michael R. Dietrich (New Haven: Yale University Press, 2008), 321–37.

25. Gould, "Life's Little Joke," 20.

26. Gould, *Wonderful Life*, 36, 47, 136, and 23.

27. Nicholas Hune-Brown, "A MicroInterview with Adam Goldstein," *Believer* 11, no. 7 (2013): 20. For other examples, see Brian Switek, "The Misrepresentation of S. J. Gould," *Wired* (2008), https://www.wired.com/2008/06/the-misrepresentation-of-s-j-gould; Brian Switek, "The March of Progress Has Deep Roots," *Wired* (2009), https://www.wired.com/2009/11/the-march-of-progress-has-deep-roots; Riley Black, "Breaking Our Link to the 'March of Progress,'" *Scientific American* (2010), https://

blogs.scientificamerican.com/guest-blog/breaking-our-link-to-the-march-of
-progress.

28. Ian Tattersall, "Stephen J. Gould's Intellectual Legacy to Anthropology," in *Stephen J. Gould: The Intellectual Legacy*, ed. Gian Antonio Danieli, Alessandro Minelli, and Telmo Pievani (Milan: Springer, 2013), 118

29. Tim D. White, "Ladders, Bushes, Punctuations, and Clades: Hominid Paleobiology in the Late Twentieth Century," in *The Paleobiological Revolution: Essays on the Growth of Modern Paleontology*, ed. David Sepkoski and Michael Ruse (Chicago: University of Chicago Press, 2009), 138 and 139.

30. Tim White, "Paleoanthropology: Five's a Crowd in Our Family Tree," *Current Biology* 23 (2013): 114. Although White suggests that the iconography has been "proven wrong," some evolutionary biologists have recently tried to rehabilitate it. See, for instance, Ronald A. Jenner, "Evolution Is Linear: Debunking Life's Little Joke," *BioEssays* 40, no. 1 (2018): 1700196 (1–3).

31. Quoted in Myrna Perez Sheldon, "Claiming Darwin: Stephen Jay Gould in Contests over Evolutionary Orthodoxy and Public Perception, 1977–2002," *Studies in History and Philosophy of Biological and Biomedical Sciences* 45 (2014): 139.

32. Wells, *Icons*, vii, 210, 211, 226, 215, and 216.

33. Jerry A. Coyne, "Creationism by Stealth," *Nature* 410 (2001): 745.

34. Wells, *Icons*, 211.

35. Coyne, "Creationism," 745.

36. See Ronald L. Numbers, *The Creationists: From Scientific Creationism to Intelligent Design*, 2nd edn. (Cambridge, MA: Harvard University Press, 2006), 376–79.

37. On Wells's career, see Numbers, *Creationists*, 380–81.

38. Barbara Forrest and Paul R. Gross, *Creationism's Trojan Horse: The Wedge of Intelligent Design*, 2nd edn. (Oxford: Oxford University Press, 2007), 98.

39. Jerry Bergman, *Evolution's Blunders, Frauds and Forgeries* (Powder Springs, GA: Creation, 2017), 207, 209, 216, and 215.

40. See Forrest and Gross, *Creationism's Trojan Horse*, 12.

41. Bergman, *Evolution's Blunders*, 207 and 217. On the putative route from Darwinism to Nazism, see Jerry Bergman, *Hitler and the Nazi Darwinian Worldview* (Kitchener, Ontario: Joshua Press, 2012).

42. Stephen Jay Gould, "A Sea Horse for All Races," *Natural History* 104, no. 11 (1995): 74. Gould's comments are discussed further in chapter 3.

43. Hune-Brown, "MicroInterview," 1 and 78.

44. "[Book Reviews]," *New-York Daily Tribune*, July 6, 1863, 10.

45. Both Bergman's *Evolution's Blunders* and Marvin L. Lubenow's *Bones of Contention: A Creationist Assessment of Human Fossils*, 2nd edn. (Grand Rapids, MI: Baker, 2004), contain some valid historical information about "The Road to Homo Sapiens," and the latter's account of it is discussed in chapter 8.

46. Gould, *Wonderful Life*, 51.

47. Gould, *Wonderful Life*, 50; Stephen Jay Gould, *The Structure of Evolutionary Theory* (Cambridge, MA: Belknap Press of Harvard University Press, 2002), 191.
48. Gould, *Wonderful Life*, 48.
49. Stephen Jay Gould, "Eight (or Fewer) Little Piggies," *Natural History* 100, no. 1 (1991): 29.
50. Stephen Jay Gould, "Ladders and Cones: Constraining Evolution by Canonical Icons," in *Hidden Histories of Science*, ed. Robert B. Silvers (New York: New York Review of Books, 1995), 41.
51. S. J. Gould, "Contingency," in *Palaeobiology II*, ed. Derek E. G. Briggs and Peter R. Crowther (Oxford: Blackwell, 2001), 196; Gould, "Little Piggies," 29.
52. For examples of rhetorical analysis and ideological scrutiny, see Cameron Shelley, "Aspects of Visual Argument: A Study of the *March of Progress*," *Informal Logic* 21 (2001): 85–96; and Melanie G. Wiber, *Erect Men / Undulating Women: The Visual Imagery of Gender, "Race" and Progress in Reconstructive Illustrations of Human Evolution* (Waterloo, Ontario: Wilfrid Laurier University Press, 1998).
53. See, for example, Stephanie Moser, *Ancestral Images: The Iconography of Human Origins* (Ithaca, NY: Cornell University Press, 1998); Camilla Matuk, "Images of Evolution," *Journal of Biocommunication* 33 (2007): 54–61; Theodore W. Pietsch, *Trees of Life: A Visual History of Evolution* (Baltimore: Johns Hopkins University Press, 2012); and Archibald, *Aristotle's Ladder*.
54. See, for example, David Bindman, *Ape to Apollo: Aesthetics and the Idea of Race in the 18th Century* (Ithaca, NY: Cornell University Press, 2002); Jonathan Smith, *Charles Darwin and Victorian Visual Culture* (Cambridge: Cambridge University Press, 2006); Constance Areson Clark, *God—or Gorilla: Images of Evolution in the Jazz Age* (Baltimore: Johns Hopkins University Press, 2008); Voss, *Darwin's Pictures*; Phillip Prodger, *Darwin's Camera: Art and Photography in the Theory of Evolution* (Oxford: Oxford University Press, 2009); and Hopwood, *Haeckel's Embryos*.
55. Clark, *God—or Gorilla*, 142.
56. On the historical usage of "hominid" and "hominin," see Erika Lorraine Milam, *Creatures of Cain: The Hunt for Human Nature in Cold War America* (Princeton: Princeton University Press, 2019), 286–87.
57. Archibald, *Aristotle's Ladder*, 13.
58. E. B. T., "Anthropology," in *Encyclopædia Britannica*, 11th edn., 29 vols. (Cambridge: Cambridge University Press, 1910–11), 2:109. On the gendered implications of the image, see Londa Schiebinger, *Nature's Body: Gender in the Making of Modern Science*, 2nd edn. (New Brunswick, NJ: Rutgers University Press, 2004), 82–83; on its racial implications, see Christina Skott, "Human Taxonomies: Carl Linnaeus, Swedish Travel in Asia and the Classification of Man," *Itinerario* 43 (2019): 218–42.
59. Thomas Henry Huxley, *Evidence as to Man's Place in Nature* (London: Williams and Norgate, 1863), 12.

60. On similar assumptions in relation to authorship, see James A. Secord, *Victorian Sensation: The Extraordinary Publication, Reception, and Secret Authorship of "Vestiges of the Natural History of Creation"* (Chicago: University of Chicago Press, 2000), 515–18.

61. On the typical arrangements of such collaborations, see Klaus Hentschel, *Visual Cultures in Science and Technology: A Comparative History* (Oxford: Oxford University Press, 2014), 206–32; and Valérie Chansigaud, "Scientific Illustrators," in *A Companion to the History of Science*, ed. Bernard Lightman (Oxford: Wiley-Blackwell, 2016), 111–25.

62. Aldous Huxley, *Point Counter Point* (London: Chatto & Windus, 1928), 289.

1 Lions in the Path

1. "Huxley on the Skeleton of a Glyptodon," *Medical Times and Gazette*, no. 661 (1863): 205.

2. Thomas Henry Huxley, "Description of a New Specimen of *Glyptodon*," *Proceedings of the Royal Society* 12 (1862): 316.

3. See Adrian Desmond, *Huxley: Evolution's High Priest* (London: Michael Joseph, 1997), 97.

4. B. W. Hawkins to Council of the Royal College of Surgeons, March 9, 1863, Museum Letter Book Series 2, RCS-MUS/5/2/1, Royal College of Surgeons, London.

5. T. H. Huxley to W. H. Flower, August 29, 1862, Thomas Henry Huxley Papers, Mss.B.H98, American Philosophical Society [hereafter APS].

6. Frederick H. Burkhardt et al., eds., *The Correspondence of Charles Darwin*, 30 vols. (Cambridge: Cambridge University Press, 1985–2023), 12:458.

7. Hawkins to Council of the Royal College of Surgeons, March 9, 1863, Museum Letter Book Series 2, RCS-MUS/5/2/1.

8. Burkhardt et al., *Correspondence of Charles Darwin*, 11:148.

9. Huxley to Flower, August 29, 1862, Huxley Papers, Mss.B.H98, APS.

10. "Mr. Van Amburgh's Public Entry," *Spectator*, no. 754 (1842): 1188.

11. John Tryon, *The Grand Caravan of Van Amburgh & Co.* (New York: Jonas Booth, 1846), 5, 9, and 29.

12. Duke of Argyll, "The Reign of Law," *Good Words* 6 (1865): 272; [John Roby Leifchild], "*Evidence as to Man's Place in Nature*," *Athenæum*, no. 1844 (1863): 287.

13. B. Waterhouse Hawkins, *A Comparative View of the Human and Animal Frame* (London: Chapman and Hall, 1860), 26.

14. Huxley to Flower, August 29, 1862, Huxley Papers, Mss.B.H98, APS.

15. On the role and status of scientific illustrators, see Valérie Chansigaud, "Scientific Illustrators," in *A Companion to the History of Science*, ed. Bernard Lightman (Oxford: Wiley-Blackwell, 2016), 111–25.

16. "Fine Arts," *New Sporting Magazine* 10 (1835): 125.

17. "New Prints," *Spectator*, no. 387 (1835): 1139.

18. "New Prints," 1139.

19. See Laura Brown, *Homeless Dogs and Melancholy Apes: Humans and Other Animals in the Modern Literary Imagination* (Ithaca, NY: Cornell University Press, 2010), 53–58.

20. "New Prints," 1139.

21. On Hawkins's early career, see Valerie Bramwell and Robert M. Peck, *All in the Bones: A Biography of Benjamin Waterhouse Hawkins* (Philadelphia: Academy of Natural Sciences, 2008), 7–15 and 57–63.

22. Adam White, *A Popular History of Mammalia* (London: Reeve and Bentham, 1850), viii, 9, and 10.

23. Richard Owen, "On the Anthropoid Apes," in *Report of the Twenty-Fourth Meeting of the British Association for the Advancement of Science* (London: John Murray, 1855), 111 and 112.

24. "British Association for the Advancement of Science," *Morning Post*, September 25, 1854, 2.

25. B. Waterhouse Hawkins, "On the Preservation of Natural History Specimens for Museum Purposes," *Journal of the Society of Arts* 13 (1865): 375.

26. "British Association," 2.

27. On Hawkins's collaboration with Owen at the Crystal Palace, see Gowan Dawson, *Show Me the Bone: Reconstructing Prehistoric Monsters in Nineteenth-Century Britain and America* (Chicago: University of Chicago Press, 2016), 183–89.

28. Hawkins, *Comparative View*, [iv].

29. Richard Owen, *Memoir on the Gorilla* (London: Taylor and Francis, 1865), 5; Richard Owen, "On the Gorilla," *Proceedings of the Zoological Society* 27 (1859): 8.

30. Owen, *Memoir*, 5.

31. Owen, "Gorilla," 2.

32. Owen, *Memoir*, 5.

33. Hawkins, *Comparative View*, [iv].

34. "Mr. Hawkins on the Gorilla," *Norfolk Chronicle*, November 30, 1861, 3.

35. A. D. Bartlett, *Life Among Wild Beasts in the "Zoo"* (London: Chapman and Hall, 1900), 3.

36. Owen, "Gorilla," 22; Owen, *Memoir*, 5.

37. "Arrival of a Live Gorilla," *The Times*, November 14, 1862, 7.

38. Thomas J. Moore, "The Gorilla," *Annals and Magazine of Natural History* 10 n.s. (1862): 473–74.

39. "The Gorilla [I]," *Birmingham Daily Post*, November 5, 1861, 2.

40. "Mr. Waterhouse Hawkins on the Gorilla," *Ipswich Journal*, October 26, 1861, 6; "The Gorilla," *Lancet* 78 (1861): 76.

41. "Waterhouse Hawkins," *Ipswich Journal*, 6.

42. "Hawkins on the Gorilla," *Norfolk Chronicle*, 3.

43. "[Editorial]," *Morning Advertiser*, May 23, 1861, 4.

44. "The Gorilla [II]," *Birmingham Daily Post*, November 12, 1861, 3.

45. J. E. Gray, "On the Height of the Gorilla," in *Report of the Thirty-First Meeting of the British Association for the Advancement of Science* (London: John Murray, 1862), 144.

46. B. Waterhouse Hawkins, *The Science of Drawing Simplified* (London: Smith, Elder, 1843), 6. On Fenton's artistic approach to photographing museum artifacts, see Pam Roberts, "Fenton and the Still-Life Tradition," in *All the Mighty World: The Photographs of Roger Fenton, 1852–1860*, ed. Gordon Baldwin, Malcolm R. Daniel, and Sarah Greenough (New Haven: Yale University Press, 2004), 94.

47. "Gorilla [I]," *Birmingham Daily Post*, 2.

48. "Waterhouse Hawkins," *Ipswich Journal*, 6.

49. "Hawkins on the Gorilla," *Norfolk Chronicle*, 3.

50. Hawkins, *Science of Drawing*, 5 and 6.

51. Hawkins, *Comparative View*, [v], [iv], and 10.

52. Quoted in Adrian Desmond, *Huxley: The Devil's Disciple* (London: Michael Joseph, 1994), 241.

53. Hawkins, *Comparative View*, 9.

54. Bramwell and Peck, *All in the Bones*, 67.

55. Hawkins, *Comparative View*, [v] and 10.

56. Hawkins, *Comparative View*, [iv].

57. "Announcements," *Bookseller*, no. 52 (1862): 262.

58. "Mr. Waterhouse Hawkins on the Gorilla," *Bury and Norwich Post*, February 18, 1862, 5. The awkward syntax is presumably that of the shorthand reporter who hurriedly recorded Hawkins's lecture for the following day's newspaper.

59. C. Lyell to T. H. Huxley, June 25, 1861, Thomas Henry Huxley Papers 6.49, Imperial College London Archives [hereafter Imperial College].

60. Thomas Henry Huxley, *Evidence as to Man's Place in Nature* (London: Williams and Norgate, 1863), 86.

61. Charles Lyell, *The Geological Evidences of the Antiquity of Man* (London: John Murray, 1863), 478.

62. C. Lyell to T. H. Huxley, August 9, 1862, Huxley Papers 6.66, Imperial College.

63. Lyell to Huxley, August 9, 1862, Huxley Papers 6.66, Imperial College.

64. "Advertisements," *Saturday Review* 11 (1861): 568.

65. "Gorilla [II]," *Birmingham Daily Post*, 3; "Man's New Cousin—The Gorilla," *Hampshire Advertiser*, July 6, 1861, 3.

66. "Gorilla [II]," *Birmingham Daily Post*, 3.

67. "Waterhouse Hawkins," *Bury and Norwich Post*, 5.

68. T. H. Huxley, *On Our Knowledge of the Causes of the Phenomena of Organic Nature* (London: Robert Hardwicke, 1862), 22–23.

69. Huxley, *Man's Place*, [iii].

70. "Waterhouse Hawkins," *Ipswich Journal*, 6.

71. Huxley to Flower, August 29, 1862, Huxley Papers, Mss.B.H98, APS.

72. Burkhardt et al., *Correspondence of Charles Darwin*, 10:579.

73. Lyell to Huxley, August 9, 1862, Huxley Papers 6.66, Imperial College.

74. C. Lyell to T. H. Huxley, October 11, 1862, Huxley Papers 6.76, Imperial College.

75. See Luisa Calé, "Frontispieces," in *Book Parts*, ed. Dennis Duncan and Adam Smyth (Oxford: Oxford University Press, 2019), 27–37.

76. "Mr. Hawkins's Lectures," *Morning Post*, May 17, 1861, 6.

77. "Mr. Waterhouse Hawkins on the Gorilla," *Daily Telegraph*, September 24, 1861, 2; "Waterhouse Hawkins," *Bury and Norwich Post*, 5.

78. "Waterhouse Hawkins," *Daily Telegraph*, 2; Hawkins, *Comparative View*, 27.

79. William Miller, *The Heavenly Bodies* (London: Hodder and Stoughton, 1883), 208.

80. "Mr. Hardhack on the Derivation of Man from the Monkey," *Atlantic Monthly* 19 (1867): 302 and 301.

81. "[Editorial]," *Morning Post*, May 13, 1861, 4. On misconceptions of the Crystal Palace models, see Dawson, *Show Me the Bone*, 95.

82. "Hawkins's Lectures," *Morning Post*, 6.

83. "Waterhouse Hawkins," *Ipswich Journal*, 6; "Hawkins's Lectures," *Morning Post*, 6. On Owen's vertebral archetype, see Nicolaas A. Rupke, *Richard Owen: Victorian Naturalist* (New Haven: Yale University Press, 1994), 161–219.

84. Hawkins, *Comparative View*, [v].

85. "Unity in Creation" newspaper clipping [March 3, 1874], Benjamin Waterhouse Hawkins Sketch Collection, Series IV, 2.12, Academy of Natural Sciences, Philadelphia; Huxley, *Our Knowledge*, 24.

86. Huxley, *Our Knowledge*, 25. On Huxley's conception of the unity of plan, see Matthew Stanley, *Huxley's Church and Maxwell's Demon: From Theistic Science to Naturalistic Science* (Chicago: University of Chicago Press, 2015), 63–65.

87. Huxley, *Our Knowledge*, 24.

88. Huxley, *Our Knowledge*, 152.

89. "Gorilla [II]," *Birmingham Daily Post*, 3.

90. "Hawkins on the Gorilla," *Norfolk Chronicle*, 3.

91. Huxley, *Man's Place*, 91 and 92.

92. "Science and Inventions," *Critic* 22 (1861): 817.

93. "Monsieur Blondin Crossing Niagara," *Frank Leslie's Illustrated Newspaper*, August 6, 1859, 155.

94. Noelle Paulson, "Natural Disorder: The Animal Image in French and British Art Before Darwin, 1790–1859" (PhD diss., Washington University in St. Louis, 2009), 279.

95. "The Latest Blondinisms," *Vanity Fair* 4 (1861): 71.

96. "Divine Philosophy!" *Chatham News*, March 7, 1863, [3].

97. Huxley to Flower, August 29, 1862, Huxley Papers, Mss.B.H98, APS.

98. On Huxley's reading of Dante, see Desmond, *Huxley: Devil's Disciple,* 99–101.

99. T. H. Huxley, "Agnosticism," *Nineteenth Century* 25 (1889): 183.

100. Huxley, *Man's Place,* 59.

101. T. H. Huxley and B. Waterhouse Hawkins, *An Elementary Atlas of Comparative Osteology* (London: Williams and Norgate, 1864), [iii].

102. Huxley, *Man's Place,* 75 and 67.

103. On writers, see Gowan Dawson, "Science in the Periodical Press," in *The Routledge Research Companion to Nineteenth-Century British Literature and Science,* ed. John Holmes and Sharon Ruston (London: Routledge, 2017), 179–82; on artists, see Chansigaud, "Scientific Illustrators," 112.

104. B. W. Hawkins to R. Kippist, May 30, 1860, Domestic Archives, Linnean Society of London.

105. See Bramwell and Peck, *All in the Bones,* 51n93, 11, and 15. Hawkins's first wife, Mary, seems to have believed that Louisa was her husband's mistress, and tolerated the situation, albeit unhappily.

106. Leonard Huxley, *Life and Letters of Thomas Henry Huxley,* 2 vols. (London: Macmillan, 1900), 1:159.

107. John Fiske, *Edward Livingston Youmans: Interpreter of Science for the People* (New York: D. Appleton, 1894), 251 and 252.

108. Huxley, *Man's Place,* [clxi].

109. "Science," *Westminster Review* 27 n.s. (1865): 300.

110. "Comparative Osteology," *Popular Science Review* 4 (1865): 221.

111. "Science," 300.

112. On Hawkins's early adoption of lithography, see Bramwell and Peck, *All in the Bones,* 60.

113. On the development of lithographic techniques, see Michael Twyman, *Breaking the Mould: The First Hundred Years of Lithography* (London: British Library, 2001).

114. "Eighteenth Ordinary Meeting," *Journal of the Society of Arts* 11 (1863): 380.

115. "Eighteenth Ordinary Meeting," 380.

116. Huxley to Flower, August 29, 1862, Huxley Papers, Mss.B.H98, APS.

2 Throwing Down the Gauntlet

1. T. H. Huxley to W. H. Flower, August 29, 1862, Thomas Henry Huxley Papers, Mss.B.H98, American Philosophical Society [hereafter APS].

2. "Wood Engraving," *Bookseller,* no. 56 (1862): 605. On Wesley's apprenticeship, see "William Henry Wesley," *Observatory* 45 (1922): 354–55.

3. See Gary Beegan, *The Mass Image: A Social History of Photomechanical Reproduction in Victorian London* (Basingstoke, UK: Palgrave Macmillan, 2008), 49–52.

4. On the division of labor in wood-engraving workshops, see Ruth Richardson, *The*

Making of Mr. Gray's Anatomy: Books, Bodies, Fortune, Fame (Oxford: Oxford University Press, 2008), 161.

5. T. H. Huxley to P. L. Sclater, June 12, 1878, Huxley Papers, Mss.H891.598, APS; T. H. Huxley to P. L. Sclater, August 6, 1878, Huxley Papers, Mss.H891.598, APS.

6. Quoted in Richardson, *Gray's Anatomy*, 162.

7. "Wesley," *Observatory*, 354.

8. W. H. Flower to T. H. Huxley, August 25, 1862, Thomas Henry Huxley Papers 121.56, Imperial College London Archives [hereafter Imperial College].

9. On Huxley's artistic abilities, see Klaus Hentschel, *Visual Cultures in Science and Technology: A Comparative History* (Oxford: Oxford University Press, 2014), 155–56.

10. Huxley to Flower, August 29, 1862, Huxley Papers, Mss.B.H98, APS.

11. Flower to Huxley, August 25, 1862, Huxley Papers 121.56, Imperial College.

12. W. H. Wesley, "On the Iconography of the Skull," *Memoirs Read Before the Anthropological Society* 2 (1866): 193 and 194.

13. E. S. Williams to T. H. Huxley, December 5, 1864, Huxley Papers 121.20, Imperial College.

14. Thomas Henry Huxley, *Lectures on the Elements of Comparative Anatomy* (London: John Churchill, 1864), vi.

15. Thomas Henry Huxley, *Evidence as to Man's Place in Nature* (London: Williams and Norgate, 1863), [iii].

16. Richard Owen, "Osteological Contributions to the Natural History of the Anthropoid Apes," *Transactions of the Zoological Society* 5 (1862): 24–25.

17. Huxley, *Man's Place*, [iii].

18. "Engraving," in *Chambers's Information for the People*, 4th edn., 2 vols. (London: W. & R. Chambers, 1857), 2:771.

19. Huxley, *Man's Place*, [iii].

20. "Photo-Zincography and Photo-Lithography," *Saturday Review* 15 (1863): 60.

21. A. De C. Scott, *On Photo-Zincography* (London: Longman, Green, 1862), 5, 7, 4, 6, and vi.

22. See Beegan, *Mass Image*, 62–64.

23. On the artistic credentials of mid-nineteenth-century wood engraving, see Paul Goldman, *Victorian Illustrated Books, 1850–1870: The Heyday of Wood-Engraving* (London: British Museum, 1994).

24. W. J. Linton, *Some Practical Hints on Wood-Engraving* (Boston: Lee and Shepard, 1879), 73.

25. "Fourth Ordinary Meeting," *Journal of the Society of Arts* 14 (1865): 58.

26. Huxley, *Man's Place*, 67–68.

27. Quoted in Phillip Prodger, *Darwin's Camera: Art and Photography in the Theory of Evolution* (Oxford: Oxford University Press, 2009), 72.

28. Huxley, *Man's Place*, 72 and [iii].

29. Wesley, "Iconography," 189 and 192.

30. Wesley, "Iconography," 191.

31. Huxley, *Man's Place*, [iii]. "Sc." was a conventional abbreviation for *Sculpsit*, Latin for "he sculpted it."

32. "March 6th, 1866," *Journal of the Anthropological Society* 4 (1866): cxxi.

33. See Julia Voss, *Darwin's Pictures: Views of Evolutionary Theory, 1837–1874* (New Haven: Yale University Press, 2010), 136–37.

34. A. H. Lane Fox, "Primitive Warfare," *Journal of the Royal United Service Institution* 12 (1868): 409, plate xvii, 410, 411, and 412.

35. A. H. Lane Fox, *Catalogue of the Anthropological Collection Lent for Exhibition in the Bethnal Green Branch of the South Kensington Museum* (London: Eyre and Spottiswoode, 1874), xi.

36. W. H. Wesley to R. Owen, December 9, 1869, Richard Owen Papers, 26:266, Natural History Museum, London.

37. "Trade and Literary Gossip," *Bookseller*, no. 77 (1864): 308.

38. "[Editorial]," *Morning Advertiser*, March 6, 1863, 4.

39. W. H. Wesley, "The Way of the Happy Life" (London: W. Wesley, [1864]), British Library 1897.c.19.(25).

40. "Literary Notices," *Primitive Methodist Magazine* 45 (1864): 702.

41. "William Henry Wesley," *Monthly Notices of the Royal Astronomical Society* 83 (1923): 256. On evangelicals and evolution, see David N. Livingstone, "Situating Evangelical Responses to Evolution," in *Evangelicals and Science in Historical Perspective*, ed. Livingstone, D. G. Hart, and Mark A. Noll (New York: Oxford University, 1999), 193–219.

42. Wesley, "Happy Life."

43. Herbert Spencer, "Prefatory Note," in *A System of Lucid Shorthand*, by William George Spencer (London: Williams and Norgate, 1894), 4.

44. Robert Skeen, *Autobiography of Mr. Robert Skeen, Printer* (London: Wyman, 1876), 28–29.

45. T. H. Huxley, "Agnosticism: A Rejoinder," *Nineteenth Century* 25 (1889): 495.

46. B. W. Hawkins to W. K. Parker, December 22, 1878, Augustus Hamilton Papers, MS-1256-2, Alexander Turnbull Library, Wellington, New Zealand. On Hawkins's religious beliefs, see Valerie Bramwell and Robert M. Peck, *All in the Bones: A Biography of Benjamin Waterhouse Hawkins* (Philadelphia: Academy of Natural Sciences, 2008), 6–7.

47. "Literary and Scientific Association," *Gloucester Journal*, October 26, 1867, 5.

48. B. W. Hawkins to H. Lee, February 12, 1868, MS. 5383/4, Wellcome Trust Library, London.

49. T. H. Huxley, "On the Animals Which are Most Nearly Intermediate Between Birds and Reptiles," *Notices of the Proceedings of the Royal Institution* 5 (1866–69): 283 and 285.

50. On Huxley's conception of the affinities between prehistoric reptiles and birds, see Gowan Dawson, *Show Me the Bone: Reconstructing Prehistoric Monsters in Nineteenth-Century Britain and America* (Chicago: University of Chicago Press, 2016), 315–16.

51. John Fiske, *Edward Livingston Youmans: Interpreter of Science for the People* (New York: D. Appleton, 1894), 251.

52. B. Waterhouse Hawkins, "On the Pelvis of Hadrosaurus," *Proceedings of the Academy of Natural Sciences* 26 (1874): 90–91.

53. See Adrian J. Desmond, "Central Park's Fragile Dinosaurs," *Natural History* 83, no. 8 (1974): 65–71.

54. Fiske, *Youmans*, 252.

55. "Natural History," *New York Herald*, January 18, 1871, 5.

56. Charles Darwin, *The Descent of Man, and Selection in Relation to Sex*, 2 vols. (New York: D. Appleton, 1871), 1:183–84.

57. In the drawing's title, Hawkins seems to have mistaken physiography, the study of physical (i.e. inanimate) natural objects and phenomena, for physiology.

58. "Physiographical Illustration of Darwin's Descent of Man," 1871, Benjamin Waterhouse Hawkins Album, Collection 803:11c, Academy of Natural Sciences, Philadelphia.

59. Darwin, *Descent of Man*, 1:132.

60. "Physiographical Illustration," 1871, Hawkins Album, Collection 803:11c.

61. "Physiographical Illustration," 1871, Hawkins Album, Collection 803:11c.

62. "Physiographical Illustration," 1871, Hawkins Album, Collection 803:11c.

63. On such abolitionist art, see Marcus Wood, *The Horrible Gift of Freedom: Atlantic Slavery and the Representation of Emancipation* (Athens: University of Georgia Press, 2010), 58–89.

64. "Physiographical Illustration," 1871, Hawkins Album, Collection 803:11c.

65. See Bramwell and Peck, *All in the Bones*, 83–84.

66. "The British Association," *Nature* 10 (1874): 413.

67. B. W. Hawkins to E. Nolan, August 29, 1874, ANSP. Correspondence 1812–1920, Coll. 567, Academy of Natural Sciences.

68. "Mr. B. W. Hawkins on the Darwinian Theory," *Manchester Guardian*, January 11, 1875, 3.

69. David Duncan, *The Life and Letters of Herbert Spencer* (London: Methuen, 1908), 172.

70. B. W. Hawkins to H. Lee, October 20, 1879, MS. 5383/9, Wellcome Trust Library.

71. Fiske, *Youmans*, 334.

72. Thomas H. Huxley, *American Addresses* (London: Macmillan, 1877), 87.

73. Huxley, *Man's Place*, 67.

74. T. H. Huxley, "On the Application of the Laws of Evolution to the Arrangement of the Vertebrata and More Particularly of the Mammalia," *Proceedings of the*

Zoological Society 43 (1880): 661 and 662. On the iconographic implications of Marsh's diagram, see Stephen Jay Gould, "Life's Little Joke," *Natural History* 96, no. 4 (1987): 16–25.

75. "Mr. Waterhouse Hawkins on the Gorilla," *Daily Telegraph*, September 24, 1861, 2.

76. "Prof. Hawkins Opposed to Darwin's Theory," *New York Times*, April 12, 1878, 2.

77. "Chester Society of Natural History," *Cheshire Observer*, February 26, 1881, 8.

78. "Chester Society," 8.

79. B. Waterhouse Hawkins, *Comparative Anatomy Applied to the Purposes of the Artist* (London: Windsor & Newton, 1883), 45–46 and 15.

80. Edward B. Tylor, *Anthropology* (London: Macmillan, 1881), 40.

81. Hawkins, *Comparative Anatomy*, 9.

82. Hawkins, *Comparative Anatomy*, 18 and 21.

83. On the propensity for images of emancipated slaves to replicate the postures of enchainment and supplication, see Wood, *Horrible Gift*, 61.

84. Hawkins, *Comparative Anatomy*, 21.

85. Hawkins, *Comparative Anatomy*, 21 and 46.

86. Hawkins, *Comparative Anatomy*, 21, 25, 18, and 27.

3 The Dance of Death

1. T. H. Huxley to F. Dyster, March 12, 1863, Thomas Henry Huxley Papers 15.125, Imperial College London Archives.

2. [John Roby Leifchild], "*Evidence as to Man's Place in Nature*," *Athenæum*, no. 1844 (1863): 287.

3. Thomas Henry Huxley, *Evidence as to Man's Place in Nature* (London: Williams and Norgate, 1863), 105.

4. On the classical sources for the motif, see Mary Beard, *The Roman Triumph* (Cambridge, MA: Belknap Press of Harvard University Press, 2007), 85–92.

5. Huxley, *Man's Place*, 105–6.

6. T. H. Huxley, "On the Zoological Relations of Man with the Lower Animals," *Natural History Review* 1 n.s. (1861): 70. On Owen's social connections, see Adrian Desmond, *The Politics of Evolution: Morphology, Medicine, and Reform in Radical London* (Chicago: University of Chicago Press, 1989), 351–58.

7. Huxley, "Zoological Relations," 68.

8. Quoted in Edward Clodd, *Grant Allen: A Memoir* (London: Grant Richards, 1900), 112.

9. C. Lyell to T. H. Huxley, July 5, 1861, Huxley Papers 6.36.

10. Leonard Huxley, *Life and Letters of Thomas Henry Huxley*, 2 vols. (London: Macmillan, 1900), 2:268; T. H. Huxley to H. Heathorn, July 17, 1850, T. H. Huxley Correspondence with Henrietta Heathorn 112, Imperial College London Archives.

11. Huxley, *Man's Place*, 69.

12. See Gowan Dawson, *Show Me the Bone: Reconstructing Prehistoric Monsters in Nineteenth-Century Britain and America* (Chicago: University of Chicago Press, 2016), 345–48.
13. [T. H. Huxley], "Science and 'Church Policy,'" *Reader* 4 (1864): 821.
14. T. H. Huxley, "Professor Tyndall," *Nineteenth Century* 35 (1894): 3; L. Huxley, *Life*, 1:9.
15. [Thomas Carlyle], *Sartor Resartus* (London: Saunders and Otley, 1838), 211.
16. Thomas H. Huxley, "Autobiography," in *Methods and Results* (London: Macmillan, 1893), 16.
17. W. T. Thiselton-Dyer, "Huxley," *Nature* 64 (1901): 148.
18. Previous accounts of Carlyle's influence on Huxley include James G. Paradis, *T. H. Huxley: Man's Place in Nature* (Lincoln: University of Nebraska Press, 1978), 47–71; and Frank M. Turner, "Victorian Scientific Naturalism and Thomas Carlyle," in *Contesting Cultural Authority: Essays in Victorian Intellectual Life* (Cambridge: Cambridge University Press, 1993), 131–50.
19. [Carlyle], *Sartor Resartus*, 211, 3, 281, 21, 65, and 28.
20. Plato gave this definition of humans, which was probably meant to be sardonic, in his Socratic dialogue *Politicus*.
21. [Carlyle], *Sartor Resartus*, 229.
22. Huxley, *Man's Place*, 70.
23. [Carlyle], *Sartor Resartus*, 224 and 300.
24. Huxley, *Man's Place*, 84 and 105.
25. Thomas H. Huxley, "A Lecture on the Study of Biology," in *American Addresses* (London: Macmillan, 1877), 143–44.
26. Huxley, *Man's Place*, 86.
27. Thomas Carlyle, *The French Revolution*, 3 vols. (London: James Fraser, 1837), 1:24 and 3:342.
28. Huxley, "Study of Biology," 145.
29. Huxley, *Man's Place*, 94, 78, 95, and 148.
30. See David Bindman, *Ape to Apollo: Aesthetics and the Idea of Race in the 18th Century* (Ithaca, NY: Cornell University Press, 2002), 208.
31. On the charts of Camper and Lavater, see Bindman, *Ape to Apollo*, 202–21.
32. See Bindman, *Ape to Apollo*, 221.
33. "Mr. Waterhouse Hawkins on the Gorilla," *Ipswich Journal*, October 26, 1861, 6; "The Gorilla," *Morning Chronicle*, August 12, 1861, 2.
34. "Man's Place in Nature," *Reflector* 1 (1863): 46. The phrase "the paragon of animals" derives from *Hamlet* 2.2.309.
35. See Gowan Dawson, *Darwin, Literature and Victorian Respectability* (Cambridge: Cambridge University Press, 2007), 65.
36. "What There Is in the Roof of the College of Surgeons," *Household Words* 2 (1850): 465.

37. William H. Flower, "Reminiscences of Professor Huxley," *North American Review* 161 (1895): 284.

38. William Henry Flower, *Catalogue of the Specimens Illustrating the Osteology and Dentition of Vertebrated Animals, Recent and Extinct, Contained in the Museum of the Royal College of Surgeons of England*, 2 vols. (London: Royal College of Surgeons, 1879–84), 1:v and 2:xiii.

39. Richard Owen, *Descriptive Catalogue of the Osteological Series Contained in the Museum of the Royal College of Surgeons of England*, 2 vols. (London: Taylor and Francis, 1853), 2:868.

40. Flower, *Catalogue*, 1:6.

41. Richard Owen, "Osteological Contributions to the Natural History of the Anthropoid Apes," *Transactions of the Zoological Society* 5 (1862): 24–25.

42. Flower, *Catalogue*, 1:7.

43. Owen, *Descriptive Catalogue*, 2:869.

44. See Ruth Richardson, *Death, Dissection and the Destitute* (London: Routledge and Kegan Paul, 1987), 53–54.

45. B. W. Hawkins to H. Lee, January 16, 1868, MS. 5383/2, Wellcome Trust Library, London.

46. Flower, *Catalogue*, 1:7.

47. Drewry Ottley, *The Life of John Hunter* (London: Longman, 1835), 10.

48. Ruth Richardson says that "it seems certain that the great majority of resurrected corpses were those of the poor." *Death, Dissection*, 63.

49. Quoted in Jessie Dobson, *John Hunter* (Edinburgh: E. & S. Livingstone, 1969), 178.

50. Elizabeth Allen et al., eds., *The Case Books of John Hunter FRS* (London: Royal Society of Medicine, 1993), 308.

51. See Dawson, *Show Me the Bone*, 272.

52. Duke of Argyll, "The Reign of Law," *Good Words* 6 (1865): 272–73.

53. See Colin Trodd, Paul Barlow, and David Amigoni, "Uncovering the Grotesque in Victorian Culture," in *Victorian Culture and the Idea of the Grotesque*, ed. Trodd, Barlow, and Amigoni (Aldershot, UK: Ashgate, 1999), 1–20.

54. See Enrico De Pascale, *Death and Resurrection in Art* (Los Angeles: J. Paul Getty Museum, 2009); and Deanna Petherbridge and Ludmilla Jordanova, *The Quick and the Dead: Artists and Anatomy* (Berkeley: University of California Press, 1997).

55. According to Sarah Webster Goodwin, the dance of death was "one of the most popular, sustained motifs in European arts and literature of the nineteenth century." *Kitsch and Culture: The Dance of Death in Nineteenth-Century Literature and Graphic Arts* (New York: Garland, 1988), 12.

56. William Harrison Ainsworth, *Old Saint Paul's*, 3 vols. (London: Hugh Cunningham, 1841), 2:131, 128, 133, 130, and 135.

57. [Leifchild], "Man's Place," 287 and 288.

58. Arnold Brass, *Das Affen-Problem* (Leipzig: Biologischer Verlag, 1908), 8. On the

ghost train, see Maximilian J. Rudwin, *The Origin of the German Carnival Comedy* (New York: G. E. Stechert, 1920), 15–21.

59. See Patricia Anderson, *The Printed Image and the Transformation of Popular Culture, 1790–1860* (Oxford: Clarendon Press, 1991), 23–27 and passim.

60. Leonard Huxley, *Life and Letters of Sir Joseph Dalton Hooker*, 2 vols. (London: John Murray, 1918), 2:32; Frederick H. Burkhardt et al., eds., *The Correspondence of Charles Darwin*, 30 vols. (Cambridge: Cambridge University Press, 1985–2023), 11:228 and 179.

61. Burkhardt et al., *Correspondence of Charles Darwin*, 11:179.

62. Ainsworth, *Old Saint Paul's*, 2:132 and 129.

63. [Leifchild], "Man's Place," 288.

64. Huxley, "Zoological Relations," 68.

65. John Fiske, *Edward Livingston Youmans: Interpreter of Science for the People* (New York: D. Appleton, 1894), 150 and 152.

66. See Adrian Johns, *Piracy: The Intellectual Property Wars from Gutenberg to Gates* (Chicago: University of Chicago Press, 2009), 291–302.

67. *Report of the Superintendent of the Coast Survey* (Washington, DC: A. O. P. Nicholson, 1855), 210.

68. See April F. Masten, *Art Work: Women Artists and Democracy in Mid-Nineteenth-Century New York* (Philadelphia: University of Pennsylvania Press, 2008), 124–25.

69. See Foster Wild Rice, "The Jocelyn Engravers," *Essay Proof Journal* 5 (1948): 213–18.

70. "Description of the Frontispiece," in *Liberty Almanac for 1852* (New York: American and Foreign Anti-Slavery Society, 1852), 18 and 19. "SC" (*Sculpsit*) signifies who made it and "NY" where it was made.

71. See the wood-engraved plates "Inspection and Sale of a Negro" and "Branding a Negress" in Brantz Mayer, *Captain Canot* (New York: D. Appleton, 1854), facing 94 and 102.

72. "[Book Reviews]," *New-York Daily Tribune*, July 6, 1863, 10.

73. Francis Lieber, *No Party Now; But All for Our Country* (New York: C. S. Westcott, 1863), 9.

74. See Iver Bernstein, *The New York City Draft Riots* (New York: Oxford University Press, 1990). The riots began on July 13, 1863, and continued for three days.

75. J. H. Van Evrie, *Negroes and Negro "Slavery"* (New York: Van Evrie, Horton, 1861), 96.

76. "[Book Reviews]," 10.

77. See Bernstein, *New York*, 19–21.

78. "Prof. Huxley on the Negro," *New-York Daily Tribune*, March 19, 1864, 3.

79. Huxley, *Man's Place*, 78 and 143.

80. See Nicolaas Rupke, "The Origins of Scientific Racism and Huxley's Rule," in *Johann Friedrich Blumenbach: Race and Natural History, 1750–1850*, ed. Rupke and Gerhard Lauer (London: Routledge, 2019), 233–47.

81. [T. H. Huxley], "Emancipation — Black and White," *Reader* 5 (1865): 561.
82. "Professor Huxley's Lectures on 'The Structure and Classification of the Mammalia' at the Royal College of Surgeons," *Reader* 3 (1864): 267.
83. "Learned Societies and Institutions," *London Review* 4 (1862): 162; "Huxley on Fossil Man," *Medical Times and Gazette*, no. 607 (1862): 159.
84. On Huxley's dismissive attitudes toward gender equality, see Evelleen Richards, "Huxley and Woman's Place in Science: The 'Woman Question' and the Control of Victorian Anthropology," in *History, Humanity and Evolution*, ed. James R. Moore (Cambridge: Cambridge University Press, 1989), 253–84.
85. T. H. Huxley, "On the Methods and Results of Ethnology," *Fortnightly Review* 1 (1865): 268.
86. T. H. Huxley, *On Our Knowledge of the Causes of the Phenomena of Organic Nature* (London: Robert Hardwicke, 1862), 22.
87. Stephen Jay Gould, "A Sea Horse for All Races," *Natural History* 104, no. 11 (1995): 74.
88. See Luisa Calé, "Frontispieces," in *Book Parts*, ed. Dennis Duncan and Adam Smyth (Oxford: Oxford University Press, 2019), 27–37.
89. Thomas Hughes, "Anthropology: An Historical Sketch," *American Catholic Quarterly Review* 18 (1893): 618.
90. Burkhardt et al., *Correspondence of Charles Darwin*, 18:107.

4 Frauds and Forgeries

1. Georg Uschmann and Ilse Jahn, eds., "Der Briefwechsel zwischen Thomas Henry Huxley und Ernst Haeckel," *Wissen-schaftliche Zeitschrift der Friedrich-Schiller-Universität Jena* 9 (1959–60): 23 and 13. Published translations are used when available and my own translations when they are not.
2. P. H. Pye-Smith, "Haeckel's Development of Man," *Nature* 11 (1874): 4.
3. Uschmann and Jahn, "Briefwechsel," 23.
4. T. H. Huxley, "Science," *Academy* 7 (1875): 17 and 18.
5. Ernst Haeckel, *Anthropogenie* (Leipzig: W. Engelmann, 1874), 486, 487, 296, and 8.
6. Haeckel, *Anthropogenie*, 491 and 487.
7. See Frank B. Tipton, *A History of Modern Germany Since 1815* (Berkeley: University of California Press, 2003), 59.
8. See Nina Amstutz, *Caspar David Friedrich: Nature and the Self* (New Haven: Yale University Press, 2020), 91–94 and 118.
9. Ernst Haeckel, *Natürliche Schöpfungsgeschichte* (Berlin: Georg Reimer, 1868), 520.
10. Nick Hopwood, *Haeckel's Embryos: Images, Evolution, and Fraud* (Chicago: University of Chicago Press, 2015), 112 and 113.
11. T. H. Huxley, "Prefatory Note," in *Freedom in Science and Teaching*, by Ernst Haeckel (London: C. Kegan Paul, 1879), xviii.

12. Ernst Haeckel, "Thomas Huxley and Karl Vogt," *Fortnightly Review* 58 (1895): 466–67.

13. On Huxley's reservations about Haeckel, see James R. Moore, "Deconstructing Darwinism: The Politics of Evolution in the 1860s," *Journal of the History of Biology* 24 (1991): 383–89.

14. Uschmann and Jahn, "Briefwechsel," 13; Haeckel, "Huxley and Vogt," 464. On Haeckel's "questionable" sense of humor, see Mario Di Gregorio, *From Here to Eternity: Ernst Haeckel and Scientific Faith* (Göttingen: Vandenhoeck & Ruprecht, 2005), 234; on Huxley's use of humor, see Donald Watt, "Soul Facts: Humour and Figure in T. H. Huxley," *Prose Studies* 1 (1978): 30–40; and James G. Paradis, "Satire and Science in Victorian Culture," in *Victorian Science in Context*, ed. Bernard Lightman (Chicago: University of Chicago Press, 1997), 164–69.

15. Haeckel, *Natürliche Schöpfungsgeschichte*, 240.

16. Haeckel, *Anthropogenie*, 456; Thomas Henry Huxley, *Evidence as to Man's Place in Nature* (London: Williams and Norgate, 1863), 105.

17. See Hopwood, *Haeckel's Embryos*, 203.

18. Haeckel, *Anthropogenie*, 488.

19. Haeckel, *Anthropogenie*, vi.

20. Ernst Haeckel, "Adolf Giltsch: Ein Nachruf," *Jenaische Zeitung*, June 28, 1911, 2.

21. The abbreviation "del." conventionally stood for *Delin*, Latin for "he drew it."

22. "Lith. Anst. v." was a standard abbreviation of the German for "Lithographed at the Institution of . . . "

23. J. C. Hasse to E. Haeckel, October 19, 1874, A 30255, Archiv des Ernst-Haeckel-Haus, Friedrich-Schiller-Universität, Jena, Germany.

24. C. L. Brace, "Darwinism in Germany," *North American Review* 110 (1870): 293.

25. E. Haeckel to C. Lyell, November 27, 1868, Correspondence of Sir Charles Lyell, Coll-203/1/1798, University of Edinburgh Library.

26. Haeckel, *Natürliche Schöpfungsgeschichte*, 555.

27. Uschmann and Jahn, "Briefwechsel," 19.

28. "Taf." is an abbreviation of *tafel*, German for "plate."

29. Haeckel, *Anthropogenie*, 488–89 and 490–91.

30. William Henry Flower, *Catalogue of the Specimens Illustrating the Osteology and Dentition of Vertebrated Animals, Recent and Extinct, Contained in the Museum of the Royal College of Surgeons of England*, 2 vols. (London: Royal College of Surgeons, 1879–84), 1:6. The index, also known as the cephalic index, is calculated by multiplying the skull's breadth by 100 and dividing by the length.

31. Ernst Haeckel, *Natürliche Schöpfungsgeschichte*, 2nd edn. (Berlin: Georg Reimer, 1870), 619, 621, and 618. Although species and genus names are italicized in the main text (as here with *Pithecanthropus*), when they appear in quotations they retain the format used in the original source (as with Haeckel's "Homo primigenius").

32. Ernst Haeckel, "Vorwart," in *Über den Ursprung der Sprache*, by W. H. J. Bleek (Weimar: Hermann Boehlau, 1868), iv.

33. Haeckel, *Natürliche Schöpfungsgeschichte*, 2nd edn., 619. On Haeckel's attitudes toward race, see Robert J. Richards, *The Tragic Sense of Life: Ernst Haeckel and the Struggle over Evolutionary Thought* (Chicago: University of Chicago Press, 2008), 269–76.

34. Haeckel, *Natürliche Schöpfungsgeschichte*, 2nd edn., 620.

35. Haeckel, *Anthropogenie*, 491.

36. Uschmann and Jahn, "Briefwechsel," 25.

37. E. Haeckel to A. Haeckel, October 11, 1874, A 37607, Archiv des Ernst-Haeckel-Haus.

38. Frederick H. Burkhardt et al., eds., *The Correspondence of Charles Darwin*, 30 vols. (Cambridge: Cambridge University Press, 1985–2023), 22:588.

39. C. Kegan Paul to E. Haeckel, April 8, 1876, A 23040, Archiv des Ernst-Haeckel-Haus; Uschmann and Jahn, "Briefwechsel," 25.

40. Kegan Paul to Haeckel, April 8, 1876, A 23040, Archiv des Ernst-Haeckel-Haus.

41. See Hopwood, *Haeckel's Embryos*, 165–66.

42. See Hopwood, *Haeckel's Embryos*, 166.

43. Quoted in Hopwood, *Haeckel's Embryos*, 167.

44. Joseph McCabe, "Preface," in *The Evolution of Man*, by Ernst Haeckel, 2 vols., trans. McCabe (London: Watts, 1906), 1:xiii.

45. Richards, *Tragic Sense*, 384.

46. *Proceedings of the Fourth International Congress of Zoology* (London: C. J. Clay, 1899), 76 and 77.

47. "The Cambridge Scientific Congresses," *Nation* 67 (1898): 200.

48. Henry Fairfield Osborn, "The Influence of Habit in the Evolution of Man and the Great Apes," *Bulletin of the New York Academy of Medicine* 4 n.s. (1928): 219; Henry Fairfield Osborn, "Recent Discoveries Relating to the Origin and Antiquity of Man," *Palaeobiologica* 1 (1928): 191.

49. "Cambridge Scientific Congresses," 200.

50. Ernst Haeckel, *The Last Link* (London: Adam and Charles Black, 1898), 75 and 77.

51. See Gary Beegan, *The Mass Image: A Social History of Photomechanical Reproduction in Victorian London* (Basingstoke, UK: Palgrave Macmillan, 2008), 186–209.

52. Ernst Haeckel, *Sandalion* (Frankfurt: Neuer Frankfurter Verlag, 1910), 26–27.

53. E. Haeckel to Duke of Saxe-Meiningen, March 31, 1905, f. 1335, Freifrau von Heldburg Hausarchiv, Thüringisches Staatsarchiv, Meiningen, Germany.

54. Haeckel, *Sandalion*, 27.

55. Haeckel, "Adolf Giltsch," 2.

56. Haeckel, "Adolf Giltsch," 2.

57. A. Giltsch to E. Haeckel, March 2, 1904, A 475, Archiv des Ernst-Haeckel-Haus.

58. E. Haeckel to Duke of Saxe-Meiningen, May 30, 1904, f. 1334, Freifrau von Held-
burg Hausarchiv. Photogram was an alternative term for photograph in the nine-
teenth and early twentieth centuries.

59. Ernst Haeckel, *Der Kampf um den Entwickelungs-Gedanken* (Berlin: Georg
Reimer, 1905), 40.

60. Haeckel, *Kampf*, 59.

61. Haeckel, *Kampf*, 40, 59, and 62.

62. E. R. L., "Vertebrata," in *Encyclopædia Britannica*, 9th edn., 25 vols. (Edinburgh:
Adam and Charles Black, 1875–89), 24:180.

63. Haeckel, *Kampf*, 57 and 40.

64. Joseph McCabe, "Introduction," in *Last Words on Evolution*, by Ernst Haeckel,
trans. McCabe (London: A. Owen, 1906), 8.

65. Haeckel, *Anthropogenie*, 488 and 493.

66. Haeckel, *Last Words*, 50.

67. Joseph McCabe, "Haeckel's Embryo-Drawings," *Literary Guide*, no. 177 (1911): 34.

68. Hopwood, *Haeckel's Embryos*, 232.

69. Arnold Brass, *Das Affen-Problem* (Leipzig: Biologischer Verlag, 1908), 8.

70. J. Assmuth and Ernest R. Hull, *Haeckel's Frauds and Forgeries* (Bombay: Examiner
Press, 1915), 84 and 99.

71. Arnold Brass, *Das Affen-Problem*, 2nd edn. (Leipzig: Heinrich Wallmann, 1909),
8 and 9.

72. See Hopwood, *Haeckel's Embryos*, 134–37 and 236–37.

73. Haeckel, *Sandalion*, 27.

74. Haeckel, "Adolf Giltsch," 2.

75. McCabe, "Embryo-Drawings," 34.

76. Brass, *Affen-Problem*, 8.

77. Brass, *Affen-Problem*, 2nd edn., 8 and 9.

78. Assmuth and Hull, *Haeckel's Frauds*, 84–85.

79. Assmuth and Hull, *Haeckel's Frauds*, 86 and 87.

80. Assmuth and Hull, *Haeckel's Frauds*, 85, 86, and 87.

81. Assmuth and Hull, *Haeckel's Frauds*, 87.

82. William K. Gregory, "The New Anthropogeny," *Science* 77 (1933): 29 and 39.

83. Osborn, "Influence of Habit," 219, 220, and 221.

84. Henry Fairfield Osborn, "The Influence of Bodily Locomotion in Separating Man
from the Monkeys and Apes," *Scientific Monthly* 26 (1928): 385.

85. Quoted in Roger Lewin, *Bones of Contention: Controversies in the Search for
Human Origins*, 2nd edn. (Chicago: University of Chicago Press, 1997), 57; T. H.
Huxley, "On the Zoological Relations of Man with the Lower Animals," *Natural
History Review* 1 n.s. (1861): 67.

86. Osborn, "Bodily Locomotion," 385.

87. Osborn, "Recent Discoveries," 191.

88. Henry Fairfield Osborn, *Impressions of Great Naturalists* (New York: Charles Scribner's Sons, 1924), 71, 89, and 93.
89. Henry Fairfield Osborn, *The Earth Speaks to Bryan* (New York: Charles Scribner's Sons, 1925), 62 and 61–62.
90. Osborn, *Earth Speaks*, 60.
91. Osborn, "Bodily Locomotion," 387.
92. Osborn, "Influence of Habit," 219.
93. Ape Man Vs Dawn Man: Illustrations, VPA 1 Box 72 folder J, General Correspondence, Vertebrate Paleontology Archives, American Museum of Natural History.
94. Osborn, "Influence of Habit," 220.
95. Osborn, "Recent Discoveries," 191.
96. "Osborn States the Case for Evolution," *New York Times,* July 12, 1925, XX:1.
97. "'Dawn-Man' Appears as Our First Ancestor," *New York Times,* January 9, 1927, XX:3.
98. *Murders in the Rue Morgue,* directed by Robert Florey (Universal Pictures, 1932), 00:06:12–42.
99. "Dr. Henry F. Osborn 75 Years Old Today," *New York Times,* August 8, 1932, 17.
100. On Hall, see Michael L. Stephens, *Art Directors in Cinema: A Worldwide Biographical Dictionary* (Jefferson, NC: McFarland, 1998), 147–52.
101. Quoted in David A. Kirby, "Darwin on the Cutting-Room Floor: Evolution, Religion, and Film Censorship," *Osiris* 34 (2019): 64.
102. *Murders in the Rue Morgue,* 00:06:03–07.
103. Quoted in Kirby, "Darwin," 64.

5 A Museum of Ideas

1. "The Progress of Science," *Scientific Monthly* 22 (1926): 173.
2. "A Museum of Evolution," *Literary Digest* 88, no. 3 (1926): 24.
3. Clara M. LeVene, ed., *General Guide to the Exhibition Halls of the Peabody Museum of Natural History* (New Haven: Peabody Museum of Natural History, 1927), 6–7, 9, and 36.
4. Henry Fairfield Osborn, "The Origin of Species, 1859–1925," in *Addresses Delivered on the Occasion of the Dedication of the New Museum Building, 29 December 1925* (New Haven: Peabody Museum of Natural History, 1926), 38.
5. "Evolution Museum Dedicated at Yale," *New York Times,* December 30, 1925, 9.
6. "Osborn Ranks Evolution Law of Nature," *New Haven Register,* December 30, 1925, 2.
7. "Osborn States the Case for Evolution," *New York Times,* July 12, 1925, XX:1.
8. "Progress of Science," 175.
9. "Faced Death to Capture Million-Year-Old Animals," *Boston Sunday Post,* January 3, 1926, B:4.

10. Richard Swann Lull, *The Ways of Life* (New York: Harper, 1925), 252.

11. Richard Swann Lull, *Ancient Man* (New York: Doubleday, 1928), 21.

12. Richard Swann Lull, "Connecting and Missing Links in the Ascent to Man," in *Creation by Evolution*, ed. Frances Mason (New York: Macmillan, 1928), 261; quoted in "Yale's New Museum of Evolution," *Outlook* 142 (1926): 60. On new approaches to natural history museums in the 1920s and 1930s, see Karen A. Rader and Victoria E. M. Cain, *Life on Display: Revolutionizing U.S. Museums of Science and Natural History in the Twentieth Century* (Chicago: University of Chicago Press, 2014), 91–135.

13. F. A. Lucas to R. S. Lull, April 6, 1925, YPM VPAR.000280, Richard Swann Lull Papers, Vertebrate Paleontology Division Archives, Yale Peabody Museum of Natural History.

14. F. A. Lucas to R. S. Lull, March 5, 1925, YPM VPAR.000280, Lull Papers.

15. H. F. Osborn to R. S. Lull, May 17, 1928, YPM VPAR.000280, Lull Papers.

16. Mildred C. B. Porter, *Behavior of the Average Visitor to the Peabody Museum of Natural History* (Washington, DC: American Association of Museums, 1938), 15.

17. William K. Gregory, "The Museum of Things Versus the Museum of Ideas," *Science* 83 (1936): 588.

18. Henry Fairfield Osborn, "The Influence of Bodily Locomotion in Separating Man from the Monkeys and Apes," *Scientific Monthly* 26 (1928): 385.

19. "32,500 See Peabody Museum in a Month," *Hartford Daily Courant*, February 8, 1926, 5.

20. "Sir John Struthers," *Lancet* 153 (1899): 612.

21. "The Welsh Museum," *Public Library Journal* 4 (1903): 75 and 76.

22. Arthur Keith, *Concerning Man's Origin* (London: Watts, 1927), 8 and 9.

23. Keith, *Man's Origin*, 12.

24. Quoted in Roger Lewin, *Bones of Contention: Controversies in the Search for Human Origins*, 2nd edn. (Chicago: University of Chicago Press, 1997), 56.

25. "Evolution and Religion," *New York Times*, March 5, 1922, XX:2.

26. See Ronald Rainger, *An Agenda for Antiquity: Henry Fairfield Osborn and Vertebrate Paleontology at the American Museum of Natural History, 1890–1935* (Tuscaloosa: University of Alabama Press, 1991), 163–69.

27. Henry Fairfield Osborn, *The Hall of the Age of Man* (New York: American Museum of Natural History, 1921), 4–8. On the hall's arrangement, see Marianne Sommer, *History Within: The Science, Culture, and Politics of Bones, Organisms, and Molecules* (Chicago: University of Chicago Press, 2016), 67–92.

28. "'Dawn-Man' Appears as Our First Ancestor," *New York Times*, January 9, 1927, XX:3.

29. D. Goldstein to H. F. Osborn, January 6, 1930, VPA 1 Box 71 folder B, General Correspondence, Vertebrate Paleontology Archives, American Museum of Natural History.

30. "'Dawn-Man' Appears," XX:3.

31. See, for instance, H. F. Osborn to W. K. Gregory, April 5, 1932, William King Gregory Papers G7441, American Museum of Natural History Library.

32. Quoted in Sheila Ann Dean, "What Animal We Came From: William King Gregory's Paleontology and the 1920's Debate on Human Origins" (PhD diss., Johns Hopkins University, 1994), 219.

33. William K. Gregory, "Comparative Anatomy," in *Fifty-Sixth Annual Report of the Trustees for the Year 1924* (New York: American Museum of Natural History, 1925), 98.

34. Henry Fairfield Osborn, *The Hall of the Age of Man*, 2nd edn. (New York: American Museum of Natural History, 1923), 29.

35. Henry Fairfield Osborn, *The Hall of the Age of Man*, 5th edn. (New York: American Museum of Natural History, 1929), 5.

36. Osborn, *Hall*, 5th edn., 32 and 33.

37. Barnum Brown, William K. Gregory, and Milo Hellman, "On Three Incomplete Anthropoid Jaws from the Siwaliks, India," *American Museum Novitates*, no. 130 (1924): 1.

38. Henry Fairfield Osborn, *The Hall of the Age of Man*, 3rd edn. (New York: American Museum of Natural History, 1925), 41.

39. See Osborn, *Hall*, 3rd edn., 40; Henry Fairfield Osborn, *The Hall of the Age of Man*, 4th edn. (New York: American Museum of Natural History, 1927), 44.

40. Osborn, *Hall*, 2nd edn., 28.

41. Osborn, *Hall*, 5th edn., 32.

42. William K. Gregory, "Is the Pro-Dawn Man a Myth?" *Human Biology* 1 (1929): 153.

43. Osborn, *Hall*, 5th edn., 32.

44. Osborn, *Hall*, 3rd edn., 41 and 45.

45. Henry F. Osborn, "Facts of the Evolutionists," *Forum* 75 (1926): 851.

46. W. K. Gregory to H. F. Osborn, November 30, 1920, VPA 1 Box 72 folder F, General Correspondence, Vertebrate Paleontology Archives.

47. William K. Gregory, "Two Views of the Origin of Man," *Science* 65 (1927): 602.

48. William K. Gregory, "The New Anthropogeny," *Science* 77 (1933): 29.

49. William King Gregory, *Evolution Emerging*, 2 vols. (New York: Macmillan, 1951), 1:543.

50. William King Gregory, "The Origin, Rise and Decline of *Homo Sapiens*," *Scientific Monthly* 39 (1934): 488.

51. Gregory, "New Anthropogeny," 30.

52. W. K. Gregory to H. F. Osborn, February 10, 1921, VPA 1 Box 72 folder F, General Correspondence, Vertebrate Paleontology Archives.

53. Gregory, "New Anthropogeny," 30 and 39.

54. W. K. Gregory to G. P. Putnam, September 1, 1928, Gregory Papers G7441.

55. William K. Gregory, "The Upright Posture of Man," *Proceedings of the American Philosophical Society* 67 (1928): 374.

56. William King Gregory, "The Lineage of Man," in *Creation by Evolution*, ed. Mason, 291.
57. William K. Gregory, "Dawn-Man or Ape?" *Scientific American* 137 (1927): 232.
58. Gregory, "New Anthropogeny," 36.
59. Gregory, "Upright Posture," 340.
60. Gregory, "Origin, Rise and Decline," 484.
61. Gregory, "Upright Posture," 371.
62. Edwin H. Colbert, *William Diller Matthew, Paleontologist: The Splendid Drama Observed* (New York: Columbia University Press, 1992), 122.
63. See, for instance, H. Ziska to W. K. Gregory, August 23, 1927, Administrative Records Related to the Papers of William King Gregory 1921–1948, American Museum of Natural History Library.
64. Edwin H. Colbert, *Digging into the Past: An Autobiography* (New York: Dembner, 1989), 141.
65. Quoted in Edwin H. Colbert, "William King Gregory 1876–1970," *National Academy of Sciences Biographical Memoirs* 46 (1975): 95; H. Ziska to W. K. Gregory, August 23, [1930], Administrative Records Related to the Papers of Gregory.
66. William K. Gregory, *Our Face from Fish to Man* (New York: G. P. Putnam's Sons, 1929), 86.
67. William K. Gregory, "Building a Super-Giant Rhinoceros," *Natural History* 35 (1935): 343.
68. C. Meadowcroft to G. H. Sherwood, November 4, 1929, Central Administration Archives 1192, American Museum of Natural History Library.
69. Colbert, "Gregory," 104. On Gregory's comic verse, see Dean, "What Animal," 316–17.
70. "Full Faces," *Grapevine* 2, no. 1 (1938): 2.
71. William Beebe, "Foreword," in Gregory, *Our Face*, iv.
72. Gregory, "Upright Posture," 376 and 339.
73. Gregory, "Origin, Rise and Decline," 484.
74. "Science and the Criminal," *Popular Science Monthly* 88 (1916): 556.
75. Gregory, "New Anthropogeny," 39.
76. Gregory, "Origin, Rise and Decline," 484 and 495.
77. See Dean, "What Animal," 167–73.
78. Gregory, "Origin, Rise and Decline," 496.
79. "Evolution and Religion," XX:2.
80. Henry Fairfield Osborn, *Man Rises to Parnassus* (Princeton: Princeton University Press, 1928), 219.
81. "'Dawn-Man' Appears," XX:3.
82. Gregory, "Upright Posture," 339.
83. Gregory, "Two Views," 601.
84. W. K. Gregory to D. M. S. Watson, January 3, 1927, Gregory Papers G7441.

85. Gregory, "Origin, Rise and Decline," 484; Gregory, "Two Views," 601.

86. William K. Gregory, "The Animal Ancestry of Man," in *Human Biology and Racial Welfare*, ed. Edmund V. Cowdry (New York: Paul B. Hoeber, 1930), 53.

87. William K. Gregory, "The Origin of Man from the Anthropoid Stem—When and Where?" *Proceedings of the American Philosophical Society* 66 (1927): 440.

88. Thomas Henry Huxley, *Evidence as to Man's Place in Nature* (London: Williams and Norgate, 1863), 105.

89. Gregory to Watson, January 3, 1927, Gregory Papers G7441.

90. Gregory to Watson, January 3, 1927, Gregory Papers G7441.

91. W. K. Gregory to W. D. Matthew, February 20, 1922, Gregory Papers G7441.

92. William K. Gregory, "Comparative and Human Anatomy," in *Sixty-First Annual Report of the Trustees for the Year 1929* (New York: American Museum of Natural History, 1930), 76.

93. W. K. Gregory to G. H. Sherwood, January 24, 1930, Central Administration Archives 1192. On the financial crash's implications for natural history museums, see Rader and Cain, *Life on Display*, 110–11.

94. See H. Ziska to W. K. Gregory, January 22, 1937, Administrative Records Related to the Papers of Gregory.

95. See Valérie Chansigaud, "Scientific Illustrators," in *A Companion to the History of Science*, ed. Bernard Lightman (Oxford: Wiley-Blackwell, 2016), 121–22.

96. Mai Reitmeyer, Rebecca Morgan, and Tom Balone, "Beyond Charles Knight: Women Paleoartists at the American Museum of Natural History in the Early Twentieth Century," in *The Evolution of Paleontological Art*, ed. Renee M. Clary, Gary D. Rosenberg, and Dallas C. Evans (Boulder, CO: Geological Society of America, 2022), 173.

97. Gregory, "New Anthropogeny," 39.

98. W. K. Gregory, [untitled memorandum], n.d., Gregory Papers G7441.

99. William K. Gregory and Marcelle Roigneau, *Introduction to Human Anatomy* (New York: American Museum of Natural History, 1934), 28 and 31.

100. Gregory and Roigneau, *Introduction*, 29.

101. William King Gregory, *Man's Place Among the Anthropoids* (Oxford: Clarendon Press, 1934), 5.

102. Osborn to Gregory, April 5, 1932, Gregory Papers G7441.

103. Quoted in Brian Regal, *Henry Fairfield Osborn: Race and the Search for the Origins of Man* (Aldershot, UK: Ashgate, 2002), 186.

104. Quoted in Jonathan Peter Spiro, *Defending the Master Race: Conservation, Eugenics, and the Legacy of Madison Grant* (Lebanon, NH: University of Vermont Press, 2009), 214–15.

105. Quoted in Spiro, *Defending*, 233.

106. Henry Fairfield Osborn, "The Evolution of Human Races," *Natural History* 26 (1926): 4.

107. Osborn, *Man Rises*, 219.

108. Osborn, "Human Races," 6.

109. See Regal, *Osborn*, 167.

110. Osborn, "Human Races," 5.

111. E. Stewart to H. F. Osborn, December 28, 1929, VPA 1 Box 71 folder B, General Correspondence, Vertebrate Paleontology Archives. On Stewart's involvement with the Immigration Act, see Ethelbert Stewart, "The New Immigration Quotas, Former Quotas, and Immigration Intakes," *Monthly Labor Review* 19 (1924): 1–11.

112. See Rainger, *Agenda*, 178.

113. Peter J. Bowler, *Life's Splendid Drama: Evolutionary Biology and the Reconstruction of Life's Ancestry, 1860–1940* (Chicago: University of Chicago Press, 1996), 429.

114. Quoted in Rainger, *Agenda*, 231.

115. William K. Gregory, "Theories of Evolution," *Yale Review* 14 (1925): 600.

116. Gregory, "Origin, Rise and Decline," 496.

117. Gregory, *Our Face*, vii.

118. W. E. B. Du Bois, *Dusk of Dawn* (New York: Harcourt, Brace, 1940), 98.

119. See Spiro, *Defending*, 340.

120. *A Decade of Progress in Eugenics* (Baltimore: Williams & Wilkins, 1934), 507.

121. See Devon Stillwell, "Eugenics Visualized: The Exhibit of the Third International Congress of Eugenics, 1932," *Bulletin of the History of Medicine* 86 (2012): 206–36.

122. H. F. Osborn to W. K. Gregory, May 25, 1935, Gregory Papers G7441.

123. Quoted in Dean, "What Animal," 257.

124. D. R. Barton, "The Indoor Explorer," *Natural History* 42 (1938): 379.

125. H. F. Osborn to W. K. Gregory, March 23, 1935, Gregory Papers G7441.

126. "Down the Saw-Dust Trail," *New Masses* 17, no. 8 (1935): 5.

127. See *Sixty-Fourth Annual Report of the Trustees for the Year 1932* (New York: American Museum of Natural History, 1933), 73.

6 Raisins in the Pudding

1. See Marcel Chotkowski LaFollette, *Science on the Air: Popularizers and Personalities on Radio and Early Television* (Chicago: University of Chicago Press, 2008), 75–76.

2. William Beebe, *The Arcturus Adventure* (New York: G. P. Putnam's Sons, 1926), vi.

3. "Off Hoping to Find the Sargasso Sea," *New York Times*, February 9, 1925, 17; William K. Gregory, "Palaeontology of the Human Dentition," *American Journal of Physical Anthropology* 9 (1926): 402.

4. Gregory, "Palaeontology," 402.

5. On American scientists' growing recognition of the necessity of popularization in the 1920s, see LaFollette, *Science on the Air*, 48–51 and 127–29.

6. Quoted in Sheila Ann Dean, "What Animal We Came From: William King Gregory's Paleontology and the 1920's Debate on Human Origins" (PhD diss., Johns Hopkins University, 1994), 303.

7. W. K. Gregory to D. M. S. Watson, January 3, 1927, William King Gregory Papers G7441, American Museum of Natural History Library.

8. Quoted in Dean, "What Animal," 303.

9. Quoted in Ronald Rainger, *An Agenda for Antiquity: Henry Fairfield Osborn and Vertebrate Paleontology at the American Museum of Natural History, 1890–1935* (Tuscaloosa: University of Alabama Press, 1991), 77.

10. William King Gregory, *Evolution Emerging*, 2 vols. (New York: Macmillan, 1951), 1:542 and 543. On religious fundamentalists' use of radio, see Douglas Carl Abrams, *Selling the Old-Time Religion: American Fundamentalists and Mass Culture, 1920–1940* (Athens: University of Georgia Press, 2001), 35–39.

11. William King Gregory, "The Origin, Rise and Decline of *Homo Sapiens*," *Scientific Monthly* 39 (1934): 484.

12. William K. Gregory, "The Upright Posture of Man," *Proceedings of the American Philosophical Society* 67 (1928): 339.

13. On early images of prehistoric humans, see Stephanie Moser, *Ancestral Images: The Iconography of Human Origins* (Ithaca, NY: Cornell University Press, 1998).

14. Edwin H. Colbert, *William Diller Matthew, Paleontologist: The Splendid Drama Observed* (New York: Columbia University Press, 1992), 103.

15. W. K. Gregory to M. Keller, March 4, 1929, Gregory Papers G7441.

16. William K. Gregory, *The Origin and Evolution of the Human Dentition* (Baltimore: Williams & Wilkins, 1922), 396.

17. Quoted in Dean, "What Animal," 282. On the design and marketing of popular science books in this period, see Marcel Chotkowski LaFollette, "Crafting a Communications Infrastructure: Scientific and Technical Publishing in the United States," in *A History of the Book in America*, vol. 4: *Print in Motion: The Expansion of Publishing and Reading in the United States, 1880–1940*, ed. Carl F. Kaestle and Janice A. Radway (Chapel Hill: University of North Carolina Press, 2009), 246–55.

18. Byron C. Nelson, *"After Its Kind": The First and Last Word on Evolution* (Minneapolis: Augsburg, 1927), 40.

19. Quoted in Thomas Grant, "Judge," in *American Humor Magazines and Comic Periodicals*, ed. David E. E. Sloane (New York: Greenwood, 1987), 116.

20. Quoted in Constance Areson Clark, *God—or Gorilla: Images of Evolution in the Jazz Age* (Baltimore: Johns Hopkins University Press, 2008), 193.

21. "Osborn States the Case for Evolution," *New York Times*, July 12, 1925, XX:1.

22. Paul Reilly, "We Ain't Even Holding Our Own," *Judge* 89, no. 2 (1925): 2.

23. See Rosemarie Ostler, *Dewdroppers, Waldos, and Slackers: A Decade-by-Decade Guide to the Vanishing Vocabulary of the Twentieth Century* (Oxford: Oxford University Press, 2003), 29.

24. Reilly, "We Ain't," 2.

25. See Ronald L. Numbers, *The Creationists: From Scientific Creationism to Intelligent Design*, 2nd edn. (Cambridge, MA: Harvard University Press, 2006), 89 and 105.

26. W. K. Gregory to L. P. Osborn, December 17, 1927, Gregory Papers G7441.

27. Gregory to Watson, January 3, 1927, Gregory Papers G7441.

28. W. K. Gregory to G. P. Putnam, October 25, 1927, Gregory Papers G7441.

29. W. K. Gregory to G. P. Putnam, September 1, 1928, Gregory Papers G7441.

30. W. K. Gregory to F. Green, August 26, 1927, Gregory Papers G7441.

31. Gregory to Green, August 26, 1927, Gregory Papers G7441.

32. Gregory, "Upright Posture," 374.

33. Gregory to Putnam, September 1, 1928, Gregory Papers G7441.

34. Invoice for H. Ziska, December 1, 1927, Gregory Papers G7441.

35. William K. Gregory, *Our Face from Fish to Man* (New York: G. P. Putnam's Sons, 1929), xiii.

36. W. K. Gregory to M. Keller, December 17, 1928, Gregory Papers G7441.

37. "Scientists at Work—Wm. K. Gregory," *Evolution* 1, no. 10 (1928): 7.

38. Gregory, *Our Face*, xiii.

39. See Clark, *God—or Gorilla*, 150–51.

40. Gregory, "Origin, Rise and Decline," 484.

41. Henry Fairfield Osborn, *The Hall of the Age of Man*, 3rd edn. (New York: American Museum of Natural History, 1925), 45.

42. See Patrick Brantlinger, *Dark Vanishings: Discourses on the Extinction of Primitive Races, 1800–1930* (Ithaca, NY: Cornell University Press, 2003), 124–40; and Tom Lawson, *The Last Man: A British Genocide in Tasmania* (London: I. B. Tauris, 2014).

43. "Australian Natural History," *Hobart Mercury*, August 12, 1921, 5.

44. "Australian Natural History," 5.

45. See Vivienne Rae-Ellis, "The Representation of Trucanini," in *Anthropology and Photography, 1860–1920*, ed. Elizabeth Edwards (New Haven: Yale University Press, 1992), 230–33.

46. W. K. Gregory to G. H. Sherwood, May 4, 1922, Central Administration Archives 120, American Museum of Natural History Library.

47. See Rae-Ellis, "Trucanini," 232.

48. Gregory, *Our Face*, 76–77.

49. Gregory, *Human Dentition*, 403 and 402.

50. See Joan R. Mertens, *The Metropolitan Museum of Art: Greece and Rome* (New York: Metropolitan Museum of Art, 1987), 65.

51. Gregory, *Our Face*, 77 and 84.

52. Quoted in Dean, "What Animal," 237; William K. Gregory, "Theories of Evolution," *Yale Review* 14 (1925): 600.

53. On this myth, see Lyndall Ryan, *The Aboriginal Tasmanians*, 2nd edn. (Sydney: Allen & Unwin, 1996), 1–3.

54. Gregory, *Evolution Emerging*, 1:533.

55. Gregory, *Our Face*, vii and ix.

56. Gregory, *Our Face*, 77, 74, and 243.

57. Gregory to Keller, December 17, 1928, Gregory Papers G7441.

58. W. S. Thompson to W. K. Gregory, December 18, 1928, Gregory Papers G7441.

59. William K. Gregory, "The Museum of Things Versus the Museum of Ideas," *Science* 83 (1936): 587–88.

60. William K. Gregory and Marcelle Roigneau, *Introduction to Human Anatomy* (New York: American Museum of Natural History, 1934), 46 and 43.

61. Gregory, "Origin, Rise and Decline," 496.

62. This is certainly how the exhibit has been interpreted by historians; see, for instance, Devon Stillwell, "Eugenics Visualized: The Exhibit of the Third International Congress of Eugenics, 1932," *Bulletin of the History of Medicine* 86 (2012): 226.

63. "Check List of New Books," *American Mercury* 18, no. 2 (1929): x.

64. William K. Gregory, "How Man Was Created," *Popular Science Monthly* 118, no. 6 (1931): 17.

65. "Scientists at Work," 7.

66. On the relation between objectivity and styles of visual representation, see Lorraine Daston and Peter Galison, *Objectivity* (New York: Zone, 2007), 125–37 and passim.

67. Gregory, "How Man," 17.

68. On representations of the great chain of being, see J. David Archibald, *Aristotle's Ladder, Darwin's Tree: The Evolution of Visual Metaphors for Biological Order* (New York: Columbia University Press, 2014), 1–13.

69. William K. Gregory, "The New Anthropogeny," *Science* 77 (1933): 30.

70. William K. Gregory, "We Got Our Face from a Fish," *Popular Science Monthly* 119, no. 1 (1931): 23.

71. P. Cooper to W. K. Gregory, January 2, 1931, Gregory Papers G7441.

72. W. K. Gregory, "New Publications: *The Science of Life*," *Natural History* 31 (1931): 225

73. H. G. Wells, Julian Huxley, and G. P. Wells, *The Science of Life*, 3 vols. (London: Amalgamated Press, 1929–30), 1:2 and 1.

74. Wells, Huxley, and Wells, *Science of Life*, 1:2; Julian Huxley, *Memories* (London: George Allen, 1970), 165.

75. Wells, Huxley, and Wells, *Science of Life*, 1:2; H. G. Wells, *The Outline of History* (London: George Newnes, 1920), 41. On the close relation between the two books, see Peter J. Bowler, *Science for All: The Popularization of Science in Early Twentieth-Century Britain* (Chicago: University of Chicago Press, 2009), 103–7.

76. Gregory, "New Publications: *Science of Life*," 225.

77. H. G. Wells, *The Salvaging of Civilization* (London: Cassell, 1921), 111.

78. Memorandum of Agreement between H. G. Wells and the Amalgamated Press

Ltd., June 1927, 70B6667, H. G. Wells Papers, The Henry W. and Albert A. Berg Collection of English and American Literature, The New York Public Library, Astor, Lenox, and Tilden Foundations.

79. H. G. Wells to A. S. Watt, November 29, 1928, 70B6632 folder 2, Wells Papers.

80. Max Judge, "William Spencer Bagdatopolous," *Artwork* 4 (1928): 258.

81. L. M. Gander, "W. S. Bagdatopolous," *Studio* 93 (1927): 94 and 99.

82. Wrapper of *The Science of Life*, part 1 [March 1929], i; Wells, Huxley, and Wells, *Science of Life*, 1:ii.

83. Wells, Huxley, and Wells, *Science of Life*, 1:ii.

84. Alison Bashford, *An Intimate History of Evolution: The Story of the Huxley Family* (London: Allen Lane, 2022), 152.

85. Wrapper of *Science of Life*, part 1, ii.

86. Wells, Huxley, and Wells, *Science of Life*, 1:2.

87. Huxley, *Memories*, 155.

88. Juliette Huxley, *Leaves of the Tulip Tree* (London: John Murray, 1986), 113.

89. H. G. Wells, "The Threatened University," *Saturday Review* 80 (1895): 804.

90. David C. Smith, ed., *The Correspondence of H. G. Wells*, 4 vols. (London: Pickering and Chatto, 1998), 1:268.

91. Memorandum of Agreement, June 1927, 70B6667, Wells Papers.

92. Huxley, *Memories*, 170.

93. Smith, *Correspondence of H. G. Wells*, 3:271.

94. Huxley, *Memories*, 161, 156, and 170.

95. Huxley, *Memories*, 155.

96. Wells, Huxley, and Wells, *Science of Life*, 2:531.

97. Wells, Huxley, and Wells, *Science of Life*, 2:531, 1:317, and 2:532.

98. Wells, Huxley, and Wells, *Science of Life*, 2:531.

99. See W. K. Gregory to M. J. Akeley, October 27, 1930, Gregory Papers G7441.

100. Wells, *Outline*, 39–40.

101. William K. Gregory, "The Gorilla's Foot," *Nature* 112 (1923): 933.

102. H. G. Wells, *The World of William Clissold*, 3 vols. (London: Ernest Benn, 1926), 1:38 and 42.

103. William K. Gregory, "A Critique of Professor Osborn's Theory of Human Origin," *American Journal of Physical Anthropology* 14 (1930): 133; "Scientists at Work," 7.

104. Cooper to Gregory, January 2, 1931, Gregory Papers G7441.

105. Gregory, "New Publications: *Science of Life*," 225.

106. [Advertisement], *Popular Science Monthly* 119, no. 4 (1931): 15.

107. Huxley, *Memories*, 157 and 160.

108. Huxley, *Memories*, 160; Grover Smith, ed., *Letters of Aldous Huxley* (London: Chatto & Windus, 1969), 295.

109. Smith, *Letters of Aldous Huxley*, 288.

110. Huxley, *Memories*, 160.

111. Huxley, *Memories*, 160.

112. Aldous Huxley, ed., *The Letters of D. H. Lawrence* (London: William Heinemann, 1932), xv.

113. Aldous Huxley, "Progress," *Vanity Fair* 29, no. 5 (1928): 105.

114. D. H. Lawrence, "Notes and Reviews: *The World of William Clissold*," *Calendar of Modern Letters* 3 (1926): 256.

115. James T. Boulton, ed., *The Letters of D. H. Lawrence*, 8 vols. (Cambridge: Cambridge University Press, 1979–2001), 5:513.

116. Boulton, *Letters of D. H. Lawrence*, 6:279–80.

117. Wells, *William Clissold*, 3:850.

118. Huxley, *Leaves*, 115.

119. Smith, *Letters of Aldous Huxley*, 298.

120. Smith, *Letters of Aldous Huxley*, 340; Huxley, *Memories*, 160.

121. Aldous Huxley, *Point Counter Point* (London: Chatto & Windus, 1928), 293 and 290–91.

122. Huxley, *Point Counter Point*, 291.

123. Boulton, *Letters of D. H. Lawrence*, 6:601 and 617.

124. Jerome Meckier, "Quarles Among the Monkeys: Huxley's Zoological Novels," *Modern Language Review* 68 (1973): 277.

7 Battle of the Bones

1. See D. R. Barton, "The Indoor Explorer," *Natural History* 42 (1938): 379.

2. "Full Faces," *Grapevine* 2, no. 1 (1938): 2.

3. H. Ziska to C. Meadowcroft, May 8, [ca. early 1930s], Administrative Records Related to the Papers of William King Gregory 1921–1948, American Museum of Natural History Library.

4. C. Meadowcroft to W. K. Gregory, December 12, 1947, Administrative Records Related to the Papers of Gregory.

5. Elwyn L. Simons, "Francis Clark Howell," *Proceedings of the American Philosophical Society* 155 (2011): 208.

6. John G. Fleagle, "Elwyn LaVerne Simons: 1930–2016," *Evolutionary Anthropology* 26 (2017): 100.

7. Elwyn L. Simons, "A View on the Science: Physical Anthropology at the Millennium," *American Journal of Physical Anthropology* 112 (2000): 442.

8. Simons, "Howell," 208.

9. Simons, "View," 442.

10. Simons, "Howell," 208; Simons, "View," 442.

11. E. L. Simons to Time-Life Books Division, October 15, 1964, YPM VPAR.002664, Elwyn LaVerne Simons Archives, Yale Peabody Museum of Natural History.

12. Simons, "Howell," 208; F. Clark Howell and the Editors of Time-Life Books, *Early Man* (New York: Time-Life Books, 1965), 41.

13. See, for instance, J. David Archibald, *Aristotle's Ladder, Darwin's Tree: The Evolution of Visual Metaphors for Biological Order* (New York: Columbia University Press, 2014), 19.

14. Elwyn L. Simons, "Some Fallacies in the Study of Hominoid Phylogeny," *Science* 141 (1963): 880.

15. W. K. Gregory to H. F. Osborn, February 10, 1921, VPA 1 Box 72 folder F, General Correspondence, Vertebrate Paleontology Archives, American Museum of Natural History.

16. Simons, "Some Fallacies," 880.

17. L. S. B. Leakey, "The Evolution of Man," *Discovery* 25, no. 8 (1964): 49.

18. Ernst Mayr, "Taxonomic Categories in Fossil Hominids," *Cold Spring Harbor Symposia on Quantitative Biology* 15 (1950): 109.

19. Ian Tattersall, *The Strange Case of the Rickety Cossack* (New York: Palgrave Macmillan, 2015), 70.

20. See Vassiliki Betty Smocovitis, *Unifying Biology: The Evolutionary Synthesis and Evolutionary Biology* (Princeton: Princeton University Press, 1996), 24–30 and passim.

21. Mayr, "Taxonomic Categories," 109, 114, 110, and 118.

22. Elwyn L. Simons, "New Fossil Primates: A Review of the Past Decade," *American Scientist* 48 (1960): 179.

23. Simons, "Some Fallacies," 880, 881, 886, and 882.

24. Annotated list of "Hominoidea," YPM VPAR.003547, Simons Archives. These were the approximate dates for the three periods that were current in the mid-1960s. Each has subsequently been revised and brought forward.

25. Annotated list of "Hominoidea," YPM VPAR.003547, Simons Archives.

26. E. L. Simons, "Old World Higher Primates: Classification and Taxonomy," *Science* 144 (1964): 710.

27. Elwyn L. Simons, "On the Mandible of *Ramapithecus*," *Proceedings of the National Academy of Sciences* 51 (1964): 530.

28. Annotated list of "Hominoidea," YPM VPAR.003547, Simons Archives.

29. Elwyn L. Simons, "Classification as Synthesis," in *The Origin of Man*, ed. Paul L. DeVore (New York: The Wenner-Gren Foundation, 1965), 49.

30. Robert Claiborne, *Climate, Man, and History* (New York: W. W. Norton, 1970), 175; Sonia Cole, *Leakey's Luck: The Life of Louis Seymour Bazett Leakey, 1903–1972* (London: Collins, 1975), 294.

31. E. L. Simons, "The Significance of Primate Paleontology for Anthropological Studies," *American Journal of Physical Anthropology* 27 (1967): 308, 310, and 311.

32. Quoted in Roger Lewin, *Bones of Contention: Controversies in the Search for Human Origins*, 2nd edn. (Chicago: University of Chicago Press, 1997), 132.

33. E. L. Simons, "A Source for the Dental Comparison of *Ramapithecus* with *Australopithecus* and *Homo,*" *South African Journal of Science* 64 (1968): 103.

34. Leakey, "Evolution of Man," 49.

35. Ian Tattersall, "Elwyn LaVerne Simons (1930–2016)," *American Anthropologist* 118 (2016): 991.

36. Cole, *Leakey's Luck*, 293.

37. L. S. B. Leakey, "East African Fossil Hominoidea and the Classification Within This Super-Family," in *Classification and Human Evolution*, ed. Sherwood L. Washburn (London: Methuen, 1963), 48.

38. Quoted in Virginia Morell, *Ancestral Passions: The Leakey Family and the Quest for Humankind's Beginnings* (New York: Simon & Schuster, 1995), 291.

39. Quoted in Lewin, *Bones of Contention*, 92.

40. Simons, "Some Fallacies," 881.

41. This was *Limnopithecus macinnesi*, which Leakey named with Wilfrid Le Gros Clark.

42. E. L. Simons and D. R. Pilbeam, "Preliminary Revision of the Dryopithecinae," *Folia Primatologica* 3 (1965): 94.

43. Elwyn L. Simons, "The Early Relatives of Man," *Scientific American* 211 (1964): 60.

44. L. S. B. Leakey, "An Early Miocene Member of the Hominidae," *Nature* 213 (1967): 161.

45. Leakey, "Fossil Hominoidea," 48.

46. Howell and Time-Life, *Early Man*, 42.

47. Simons, "Significance," 316; Leakey, "Early Miocene Member," 155.

48. Annotated list of "Hominoidea," YPM VPAR.003547, Simons Archives.

49. L. S. B. Leakey, "A New Lower Pliocene Fossil Primate from Kenya," *Annals and Magazine of Natural History* 4 (series 13) (1961): 689, 695, and 692.

50. Elwyn L. Simons, "The Phyletic Position of *Ramapithecus,*" *Postilla*, no. 57 (1961): 1 and 5.

51. Simons, "Early Relatives," 62; Simons, "Phyletic Position," 5. G. Edward Lewis, who discovered the first *Ramapithecus* fossils in India and named the taxon, had identified certain hominid-like characteristics in the jaw, but his claims, published in 1934, were quickly rejected. See Lewin, *Bones of Contention*, 87–90.

52. Simons, "Dental Comparison," 98.

53. Simons, "Some Fallacies," 886.

54. Simons, "Classification as Synthesis," 45.

55. Simons, "Significance," 317.

56. Leakey, "Evolution of Man," 49.

57. Howell and Time-Life, *Early Man*, 42.

58. Howell and Time-Life, *Early Man*, 42.

59. Simons, "Phyletic Position," 4.

60. Annotated list of "Hominoidea," YPM VPAR.003547, Simons Archives.

61. Alfred Sherwood Romer, "Human Biology: *Early Man*," *Quarterly Review of Biology* 41 (1966): 347.

62. Creighton Gabel, "Book Reviews: *Early Man*," *American Anthropologist* 68 (1968): 1581.

63. L. S. B. Leakey, P. V. Tobias, and J. R. Napier, "A New Species of the Genus *Homo* from Olduvai Gorge," *Nature* 202 (1964): 9.

64. L. S. B. Leakey, "The Evolution of Man," *Discovery* 25, no. 10 (1964): 68.

65. Annotated list of "Hominoidea," YPM VPAR.003547, Simons Archives.

66. Annotated list of "Hominoidea," YPM VPAR.003547, Simons Archives.

67. Leakey, "Evolution of Man," 68.

68. J. T. Robinson, "*Homo 'habilis'* and the Australopithecines," *Nature* 205 (1965): 122 and 123.

69. D. R. Pilbeam and E. L. Simons, "Some Problems of Hominid Classification," *American Scientist* 53 (1965): 250–51.

70. Robinson, "*Homo 'habilis*,'" 123.

71. Annotated list of "Hominoidea," YPM VPAR.003547, Simons Archives.

72. J. T. Robinson, "The Affinities of the New Olduvai Australopithecine," *Nature* 186 (1960): 456 and 458.

73. Simons, "Significance," 308.

74. Mayr, "Taxonomic Categories," 112 and 113.

75. Ian Tattersall, "Book Reviews: *Early Man*," *American Journal of Physical Anthropology* 39 (1973): 481.

76. F. Clark Howell and the Editors of Time-Life Books, *Early Man*, 2nd edn. (New York: Time-Life Books, 1970), 43.

77. Simons, "Significance," 314.

78. See F. Clark Howell and the Editors of Time-Life Books, *Early Man*, Young Readers edn. (New York: Time-Life Books, 1968), 31.

79. "Battle of the Bones," *Newsweek*, April 19, 1965, 39.

80. Mayr, "Taxonomic Categories," 116; Simons, "Classification as Synthesis," 44.

81. L. S. B. Leakey, "New Finds at Olduvai Gorge," *Nature* 189 (1961): 650.

82. Annotated list of "Hominoidea," YPM VPAR.003547, Simons Archives.

83. Mayr, "Taxonomic Categories," 114 and 113.

84. Simons, "Some Fallacies," 880.

85. Mayr, "Taxonomic Categories," 110; Simons, "Some Fallacies," 880.

86. Simons, "Some Fallacies," 888.

87. Simons and Pilbeam, "Preliminary Revision," 98–99.

88. Mayr, "Taxonomic Categories," 111.

89. Simons, "Some Fallacies," 883.

90. Lewin, *Bones of Contention*, 136.

91. John Napier, "Five Steps to Man," *Discovery* 25, no. 6 (1964): 34.

92. Napier, "Five Steps," 35

93. Simons, "Early Relatives," 50 and 51.

94. Howell and Time-Life, *Early Man* (1965), 196 and 6.

95. F. Clark Howell, "European and Northwest African Middle Pleistocene Hominids," *Current Anthropology* 1 (1960): 224.

96. F. Clark Howell, "Comment: New Discoveries in Tanganyika," *Current Anthropology* 6 (1965): 400 and 401.

97. F. Clark Howell, "Recent Advances in Human Evolutionary Studies," *Quarterly Review of Biology* 42 (1967): 484.

98. Susan C. Antón, "Of Burnt Coffee and Pecan Pie: Recollections of F. Clark Howell," *PaleoAnthropology* 5 (2007): 51 and 47.

99. Time-Life Internal Report, May 24, 1965, Reference Files 1907–2015, MS 3009-RG1, Time Inc. Records, New-York Historical Society.

100. William Howells, "Introduction," in Howell and Time-Life, *Early Man* (1965), 7.

101. Gabel, "Book Reviews: *Early Man*," 1581.

102. "Battle of the Bones," 38; Elwyn L. Simons, "Film Reviews: *Doctor Leakey and the Dawn of Man*," *American Anthropologist* 71 (1969): 578.

103. Richard G. Klein, "F. Clark Howell, 1925–2007," *National Academy of Sciences Biographical Memoirs* (2013): 11.

104. "Searching for the Common Link," *Time*, February 3, 1967, 65.

105. See Cole, *Leakey's Luck*, 410–16.

106. Simons recalled that the image was used "with Clark's blessing." Simons, "Howell," 208.

107. See, for instance, https://leakeyfoundation.org/ and https://twitter.com/The LeakeyFndtn.

108. W. M. Krogman, "Book Reviews: *Early Man*," *American Journal of Physical Anthropology* 23 (1965): 445.

109. Quoted in David Barringer, "Raining on Evolution's Parade," *I.D.* 53, no. 2 (2008): 60.

110. Quoted in Barringer, "Raining," 60.

111. Quoted in Richard Conniff, *House of Lost Worlds: Dinosaurs, Dynasties, and the Story of Life on Earth* (New Haven: Yale University Press, 2016), 217.

112. Simons, "Howell," 208.

113. Jennifer Tucker, "Evolution of a Lightning Rod," *Boston Globe*, October 28, 2012, K:2.

114. Simons, "View," 442.

115. Simons, "New Fossil Primates," 188 and 185.

116. Elwyn L. Simons, "In Pursuit of Man's Pedigree," *Yale Alumni Magazine* 32, no. 2 (1969): 25.

117. Simons, "New Fossil Primates," 188.

118. E. L. Simons, "Unraveling the Age of Earth and Man," *Natural History* 76, no. 2 (1967): 57; Elwyn L. Simons, "Evolution of the Primates to Man," *Proceedings of*

the XVI International Congress of Zoology, 6 vols. (Washington, DC: XVI International Congress of Zoology, 1963), 4:77.

119. Tattersall, *Strange Case*, 72.

120. Mayr, "Taxonomic Categories," 118.

121. Simons, "Evolution of the Primates," 76.

122. Simons's rather arch sense of humor is mentioned in several of the biographical reminiscences in John G. Fleagle and Christopher C. Gilbert, eds., *Elwyn Simons: A Search for Origins* (New York: Springer, 2008).

123. Pilbeam and Simons, "Some Problems," 255.

124. Bernhard Rensch, "Histological Changes Correlated with Evolutionary Changes of Body Size," *Evolution* 2 (1948): 218.

125. On problems with the rule, see Stephen Jay Gould, "Cope's Rule as Psychological Artefact," *Nature* 385 (1997): 199–200.

126. Simons, "New Fossil Primates," 189.

127. Simons, "Man's Pedigree," 26.

128. Howell and Time-Life, *Early Man* (1965), 42.

129. Elwyn L. Simons and Peter C. Ettel, "Gigantopithecus," *Scientific American* 222 (1970): 78.

130. See Simons, "Man's Pedigree," 24–27.

131. Illustration Mock-Up for the Evolution of Man, YPM VPAR.002792, Simons Archives.

132. Simons, "Early Relatives," 61.

133. Pilbeam and Simons, "Some Problems," 256.

134. Simons, "Man's Pedigree," 26.

135. Howell and Time-Life, *Early Man*, Young Readers edn., 30.

136. E. L. Simons, "Book Reviews: *Mankind in the Making*," *American Scientist* 48 (1960): 405A.

137. E. L. Simons to Time-Life Books Division, January 11, 1965, YPM VPAR.002664, Simons Archives.

8 A Completely New Step

1. Adrienne L. Zihlman and Jerold M. Lowenstein, "False Start of the Human Parade," *Natural History* 88, no. 7 (1979): 89.

2. Zihlman and Lowenstein, "False Start," 86.

3. "The Age of Man: A Matter of No Little Dispute," *Philadelphia Inquirer*, June 5, 1980, A:8.

4. D. R. Pilbeam and E. L. Simons, "Some Problems of Hominid Classification," *American Scientist* 53 (1965): 238.

5. E. L. Simons and D. R. Pilbeam, "Preliminary Revision of the Dryopithecinae," *Folia Primatologica* 3 (1965): 138.

6. Elwyn L. Simons, "Classification as Synthesis," in *The Origin of Man*, ed. Paul L. DeVore (New York: The Wenner-Gren Foundation, 1965), 48.

7. Elwyn Simons, "Ways of Seeing," in *Passionate Minds: The Inner World of Scientists*, ed. Lewis Wolpert and Alison Richards (Oxford: Oxford University Press, 1997), 150 and 155.

8. Elwyn L. Simons and Peter C. Ettel, "Gigantopithecus," *Scientific American* 222 (1970): 78.

9. Annotated list of "Hominoidea," YPM VPAR.003547, Elwyn LaVerne Simons Archives, Yale Peabody Museum of Natural History.

10. F. Clark Howell, "Recent Advances in Human Evolutionary Studies," *Quarterly Review of Biology* 42 (1967): 484.

11. The respective payments to Simons and Howell are discussed in more detail in chapter 7.

12. Rudolph F. Zallinger, "Creating the Mural," in *The Age of Reptiles: The Great Dinosaur Mural at Yale* (New York: Harry N. Abrams, 1990), 19.

13. Carl O. Dunbar, "Recollections of the Renaissance of Peabody Museum Exhibits, 1939–1959," *Discovery* 12, no. 1 (1976): 19.

14. Lee Grimes, "An Interview with Rudolph F. Zallinger," *Discovery* 11, no. 1 (1975): 34.

15. Grimes, "Interview with Zallinger," 34.

16. Quoted in Robert T. Elson, *The World of Time Inc.: The Intimate History of a Publishing Enterprise, 1941–1960* (New York: Athenaeum, 1973), 425 and 427–28.

17. Maitland Edey, *Great Photographic Essays from "Life"* (Boston: New York Graphic Society, 1978), 16. On *Life*'s circulation, see Loudon Wainwright, *The Great American Magazine: An Inside History of "Life"* (New York: Alfred A. Knopf, 1986), 179.

18. Dunbar, "Recollections," 22.

19. Quoted in Wainwright, *American Magazine*, 175.

20. Edey, *Photographic Essays*, 16.

21. Quoted in Wainwright, *American Magazine*, 162.

22. Lincoln Barnett, "The Dawn of Religion," *Life* 39, no. 24 (1955): 78 and 87.

23. On *Life*'s photojournalistic style, see Claude Cookman, *American Photojournalism: Motivations and Meanings* (Evanston, IL: Northwestern University Press, 2009), 145–77.

24. Edward K. Thompson, *A Love Affair with "Life" & "Smithsonian"* (Columbia: University of Missouri Press, 1995), 160.

25. Quoted in Wally Swist, "A Salute to the Varied Career of Rudolph Zallinger," *Connecticut Artists* 2, no. 3 (1979): 43.

26. Quoted in Curtis Prendergast, *The World of Time Inc.: The Intimate History of a Publishing Enterprise, 1960–1980* (New York: Athenaeum, 1986), 66.

27. Maitland Edey, "Some Notes on the Early Days of Time-Life Books," Subject Files, MS 3009-RG2, Time Inc. Records, New-York Historical Society.

28. Quoted in Prendergast, *Time Inc.*, 394 and 71.

29. "The Story of Time Life Books" (1969), Reference Files 1907–2015, MS 3009-RG3, Time Inc. Records, New-York Historical Society.

30. Edey, "Some Notes," Time Inc. Records.

31. Edey, "Some Notes," Time Inc. Records.

32. See Swist, "Varied Career," 43.

33. Quoted in Swist, "Varied Career," 43.

34. Edey, "Some Notes," Time Inc. Records.

35. F. Clark Howell and the Editors of Time-Life Books, *Early Man* (New York: Time-Life Books, 1965), 63. On Matternes's approach to depicting prehistoric humans, see Stephanie Moser, *Ancestral Images: The Iconography of Human Origins* (Ithaca, NY: Cornell University Press, 1998), 164–67. Oddly, Moser's book does not mention Zallinger.

36. "Muralist at Yale Is Amused by Questions of 'Audience,'" *Washington Post,* May 19, 1968, F:2.

37. W. Suschitzky, *Photographing Animals* (London: The Studio, 1941), 36.

38. Julian Huxley and W. Suschitzky, *Kingdom of the Beasts* (London: Thames and Hudson, 1956), 45; Suschitzky, *Photographing Animals,* 18.

39. Howell and Time-Life, *Early Man,* 41.

40. Quoted in Swist, "Varied Career," 44.

41. Quoted in Swist, "Varied Career," 44.

42. Simons, "Ways of Seeing," 150.

43. W. J. T. Mitchell, *The Last Dinosaur Book* (Chicago: University of Chicago Press, 1998), 191–92.

44. On photo-realist art, see Louis K. Meisel, *Photo-Realism* (New York: Harry N. Abrams, 1980).

45. Howell and Time-Life, *Early Man,* 41.

46. The reasons for this change of name are discussed in chapter 7.

47. "A. afarensis [*sic*]," C16, Rudolph F. Zallinger's Preliminary Drawings for "The Road to Homo Sapiens," Smithsonian National Museum of Natural History.

48. "A. afarensis [*sic*]," C16, Zallinger's Preliminary Drawings.

49. F. Clark Howell, "Early Phases in the Emergence of Man," in *Proceedings of the XVI International Congress of Zoology,* 6 vols. (Washington, DC: XVI International Congress of Zoology, 1963), 4:82.

50. "A. afarensis [*sic*]," C16, Zallinger's Preliminary Drawings.

51. Howell, "Early Phases," 84 and 85.

52. "A. afarensis [*sic*]," C16, Zallinger's Preliminary Drawings.

53. See "Drama of the Evolution of Man," *New York Times,* March 19, 1961, SM:30–31; "What Man Will Be Like in 101,969 A.D.," *New York Times,* August 13, 1961, SM:47. It is unclear which of the articles contained the photograph to which Howell referred.

54. "Drama of the Evolution of Man," SM:31.

55. Harry L. Shapiro, "Department of Anthropology," in *Ninety-Second Annual Report of the American Museum of Natural History* (New York: American Museum of Natural History, 1961), 26.

56. Quoted in Tracy Teslow, *Constructing Race: The Science of Bodies and Cultures in American Anthropology* (Cambridge: Cambridge University Press, 2014), 322.

57. Quoted in Teslow, *Constructing Race*, 323.

58. See "Australopithecus," C6, Zallinger's Preliminary Drawings.

59. Melanie G. Wiber, *Erect Men / Undulating Women: The Visual Imagery of Gender, "Race" and Progress in Reconstructive Illustrations of Human Evolution* (Waterloo, Ontario: Wilfrid Laurier University Press, 1998), 168.

60. Ryan M. Campbell, Gabriel Vinas, Maciej Henneberg, and Rui Diogo, "Visual Depictions of Our Evolutionary Past," *Frontiers in Ecology and Evolution* 9, no. 639048 (2021): 13.

61. Ernst Mayr, "Taxonomic Categories in Fossil Hominids," *Cold Spring Harbor Symposia on Quantitative Biology* 15 (1950): 112.

62. See Christa Kuljian, *Darwin's Hunch: Science, Race and the Search for Human Origins* (Johannesburg: Jacana, 2016).

63. Erika Lorraine Milam, *Creatures of Cain: The Hunt for Human Nature in Cold War America* (Princeton: Princeton University Press, 2019), 38.

64. Theodosius Dobzhansky, Ernst Mayr, and Elwyn Simons, *Evolution and the Descent of Man*, Speaking of Science audiotape series: 2 (Washington, DC: American Association for the Advancement of Science, 1972), RZA 3560, Recorded Sound Research Center, Library of Congress.

65. Elwyn L. Simons, "Some Fallacies in the Study of Hominoid Phylogeny," *Science* 141 (1963): 879.

66. See Anthony Q. Hazard, *Postwar Anti-Racism: The United States, UNESCO, and "Race," 1945–68* (New York: Palgrave Macmillan, 2012).

67. William Howells, "Homo Sapiens: 20 Million Years in the Making," *UNESCO Courier* 25, no. 8/9 (1972): 6 and 9.

68. See Hazard, *Postwar Anti-Racism*, 146–49.

69. Howells, "Homo Sapiens," 12.

70. Wiber, *Erect Men*, 167.

71. Quoted in Prendergast, *Time Inc.*, 71.

72. Quoted in Cookman, *American Photojournalism*, 177. On *Life's* inherent conservatism, see the essays in Erika Doss, ed., *Looking at "Life" Magazine* (Washington, DC: Smithsonian Institution, 2001).

73. Howell and Time-Life, *Early Man*, 49 and 174.

74. Howell and Time-Life, *Early Man*, 146–47.

75. Howell and Time-Life, *Early Man*, 147.

76. Wiber, *Erect Men*, 113.

77. Edey, "Some Notes," Time Inc. Records.

78. "Story of Time Life Books," Time Inc. Records.

79. Edey, "Some Notes," Time Inc. Records.

80. "A. afarensis [sic]," C16, Zallinger's Preliminary Drawings.

81. See "Death Notice: Arnold C. Holeywell," *Washington Post*, October 10, 2010, C:10.

82. "Story of Time Life Books," Time Inc. Records.

83. Howell and Time-Life, *Early Man*, 6.

84. Quoted in Prendergast, *Time Inc.*, 72 and 66.

85. George V. Kelvin, *Illustrating for Science* (New York: Watson-Guptill, 1992), 54 and 20.

86. See Test Pages from *Early Man*, YPM VPAR.000299, Simons Archives.

87. Howell, "Early Phases," 82.

88. F. Clark Howell, "The Hominization Process," in *Horizons of Anthropology*, ed. Sol Tax (Chicago: Aldine, 1964), 51.

89. The ambiguity in the number of simians reflected the still uncertain status of *Ramapithecus*.

90. Howell and Time-Life, *Early Man*, 41 and 45.

91. Thomas Henry Huxley, *Evidence as to Man's Place in Nature* (London: Williams and Norgate, 1863), 95.

92. [John Roby Leifchild], "*Evidence as to Man's Place in Nature*," *Athenæum*, no. 1844 (1863): 287.

93. Zallinger's concerns, as related by his daughter Lisa David, are discussed in chapter 7.

94. Frank H. T. Rhodes et al., *Evolution* (New York: Golden Press, 1974), 144.

95. "Story of Time Life Books," Time Inc. Records.

96. See "Time Incorporated Invites You . . . ," *Los Angeles Times*, October 26, 1971, advertising supplement.

97. "The Unearthing of Early Man," *Philadelphia Inquirer*, January 17, 1971, advertising supplement.

98. See Milam, *Creatures of Cain*, 194–95; and Robert Poole, "*2001: A Space Odyssey* and 'The Dawn of Man,'" in *Stanley Kubrick: New Perspectives*, ed. Tatjana Ljujić, Peter Krämer, and Richard Daniels (London: Black Dog, 2015), 174–97.

99. Norman Mailer, "A Fire on the Moon," *Life* 67, no. 9 (1969): 34.

100. "Ad Astra," *New York Times*, July 21, 1969, 16.

101. "Evolution into Space," *New York Times*, July 20, 1969, E:12.

102. "Evolution into Space," E:12.

103. "Unearthing of Early Man," advertising supplement.

104. Quoted in Matthew D. Tribbe, *No Requiem for the Space Age: The Apollo Moon Landings and American Culture* (Oxford: Oxford University Press, 2014), 39.

105. "The Moon and Middle America," *Time*, August 1, 1969, 10–11.

106. On the moon landings and ideas of progress, see Tribbe, *No Requiem*, 59–60 and 72–74.

107. "Story of Time Life Books," Time Inc. Records.
108. Edey, "Some Notes," Time Inc. Records.
109. Quoted in David Barringer, "Raining on Evolution's Parade," *I.D.* 53, no. 2 (2008): 60.
110. "Unearthing of Early Man," advertising supplement.
111. Marvin L. Lubenow, *Bones of Contention: A Creationist Assessment of Human Fossils*, 2nd edn. (Grand Rapids, MI: Baker, 2004), 39 and 40.
112. Edey, "Some Notes," Time Inc. Records.
113. Mike Pence, "Theory of the Origin of Man," *Congressional Record* 148.93 (July 11, 2002): H4527.

Epilogue

1. "Elwyn L. Simons, Scientist Who Found Early Human Forebears, Dies at 85," *New York Times*, March 17, 2016, A:19.
2. On Mankoff's career, see Bob Mankoff, *How About Never—Is Never Good for You? My Life in Cartoons* (New York: Henry Holt, 2014).
3. Constance Areson Clark, "'You Are Here': Missing Links, Chains of Being, and the Language of Cartoons," *Isis* 100 (2009): 572.
4. See "The Monkey Suit," episode twenty-one of *The Simpsons*'s seventeenth season, which was first broadcast in 2006. The "Homersapien" sequence was produced for the Fox Broadcasting Company to promote the episode.
5. On the history of such cartoons, see Clark, "'You Are Here.'"
6. Stephen Jay Gould, *Wonderful Life: The Burgess Shale and the Nature of History* (New York: W. W. Norton, 1989), 31.
7. For an overview of such intersections, see Caroline A. Jones and Peter Galison, "Picturing Science, Producing Art," in *Picturing Science, Producing Art*, ed. Jones and Galison (New York: Routledge, 1998), 1–23.
8. Quoted in Reena Jana, "Natural Selections: Zadok Ben-David's 'Evolution and Theory,'" in *Evolution and Theory*, ed. Binghui Huangfu (Singapore: Earl Lu Gallery, 1999), 16.
9. Quoted in Richard Cork, Yael Guilat, Felicity Fenner, John McDonald, and Fumio Nanjo, *Zadok Ben-David: Human Nature* (London: Circa, 2017), 20.
10. Quoted in Cork et al., *Zadok Ben-David*, 36; Felicity Fenner, "Zadok Ben-David," in *Evolution and Theory*, ed. Huangfu, 10.
11. Meir Agassi, "Scenes from Apocalypse and Comedy, Evolution and Theory," in *David Mach: Zadok Ben-David* (Tel Aviv: Chelouche Gallery, 1997), 11.
12. C. Owen Lovejoy, Gen Suwa, Scott W. Simpson, Jay H. Matternes, and Tim D. White, "The Great Divides: *Ardipithecus ramidus* Reveals the Postcrania of Our Last Common Ancestors with African Apes," *Science* 326, no. 5949 (2009): 73 and 100.

13. Lovejoy et al., "Great Divides," 100 and 103.

14. Jay H. Matternes, "4,000,000 Years of Bipedalism," *National Geographic* 168 (1985): 574–77.

15. Lovejoy et al., "Great Divides," 73 and 104.

16. Lovejoy et al., "Great Divides," 101; Jay Matternes and Richard Milner, "Jay Matternes, Self-Portrait," *Natural History* 120, no. 12 (2012): 19.

17. Lovejoy et al., "Great Divides," 100.

INDEX

Page numbers in italics refer to figures.

359

Haeckel, Ernst (*continued*)
 repurposes *Man's Place in Nature's*
 frontispiece, 122, 138, 139, 140, 140–41,
 147–49, 148, 151, 152, 156; *Sandalion*, 146;
 sense of humor, 121, 150, 175; use of con-
 jecture, 117, 118, 120, 133, 171. See also
 Anthropogenie (Haeckel)
Hall, Charles D., 155
Hamilton, Edward A., 293, 294
Hardwicke, Robert, 44
Hasse, Johann Carl, 127
Hawkins, Benjamin Waterhouse: in
 America, 55–56, 72–79, 81; antagonism
 toward Huxley, 45, 47–51, 55, 56, 57–58,
 59, 62, 72–73, 74, 80–81, 83, 84, 87–88,
 149, 160, 256; artistic limitations, 24–25,
 51, 56–57; bigamous marriage, 26, 55,
 72, 81; on bipedal dinosaurs, 73–74, 80;
 *Comparative Anatomy Applied to the
 Purposes of the Artist*, 84–87; *A Compar-
 ative View of the Human and Animal
 Frame*, 37, 38, 67, 79; and Crystal Palace,
 26, 30, 31, 32, 46, 50, 55, 73; disdain for
 experts, 37, 39–40, 45, 54; early drawings
 of apes, 27–29, 28, 84, plate 1; *An Ele-
 mentary Atlas of Comparative Osteology*,
 24, 39, 43, 52–53, 53, 54, 56, 57, 60; finan-
 cial problems of, 26, 55; and *Glyptodon*,
 23–24, 26, 52, 56; and gorilla, 31–34,
 36–39, 40–42, 47–50, 51, 54, 74, 76, 83,
 87–88, 94, 97, 113, 149, 298, 316; hatred
 for apes, 84, 87; and Hunterian Museum,
 26, 30–31, 37, 39, 48–49, 98–100, 131, 316;
 imprecision of, 45, 75, 76; involved with
 Man's Place in Nature's frontispiece, 3,
 23, 25, 26–27, 29, 39, 42–43, 45–46, 57–58,
 62, 63, 67, 72–73, 74, 81, 83, 84, 91, 97,
 99–100, 123, 132, 149, 153–54, 187, 315–16;
 as lecturer, 32–33, 34, 40, 42, 43, 47,
 50–51, 72, 79, 83, 97; as lithographer, 24,
 37–38, 43, 56, 57; opposed to evolution,
 26, 45–46, 50, 54, 62, 69, 72, 73, 81, 83,
 84, 87, 149, 316; and Owen, 30–32, 46,
 69; and photomechanical methods,
 36, 57, 61, 64–65; and race, 37, 77–79,
 85–86, 92, 97, 110, 187; religious beliefs
 of, 72; subverts *Man's Place in Nature's*

frontispiece, 47–51, 48, 75, 76–77, 77, 79,
 84–88, 85, 86, 92, 122, 149, 316; as taxi-
 dermist, 30, 31, 38, 79; and unity of plan,
 46–47, 52, 53; works for Huxley, 23–24,
 39, 40, 42–43, 46–47, 50, 51–53, 54, 55,
 57, 60, 62, 63, 112, 131
Hawkins, Louisa, 55, 81, 325n105
Hawkins, Mary, 325n105
Holeywell, Arnold Clark, 292–94, 296, 297,
 301, 303
Home, Everard, 100
hominids, 16, 235–36, 249–50, 257, 286–87,
 288. *See also individual species*
Homo erectus, 236, 249, 259, 298
Homo habilis, 244–45, 246, 247, 250, 251,
 252, 253, 254, 255, 314
Homo primigenius, 133, 134
Homo sapiens, 175, 177, 180, 225, 245, 249,
 261, 287, 288, 298
Hooker, Joseph Dalton, 103
Howell, Francis Clark: advises Zallinger,
 233, 253, 268, 279–84, 281, 283, 285, 292,
 293, 294; on bipedalism, 268, 294, 297; as
 circumspect, 267–68, 279; as impartial,
 253–54, 255, 263; and Leakey, 253, 254,
 255; on "The Road to Homo Sapiens,"
 256, 306. *See also Early Man* (Howell),
 BOOK; *Early Man* (Howell), "THE ROAD
 TO HOMO SAPIENS"
Howells, William, 253–54, 287–88, 290
Hull, Ernest Reginald, 145, 147, 149, 152;
 Haeckel's Frauds and Forgeries, 147
Hunter, John, 31, 98, 99, 100, 101
Hunterian Museum, 24, 25, 37, 39, 43,
 48–49, 59, 60, 92, 98–101, 131, 132, 161, 316
Huxley, Aldous, 19, 224, 225–27; *Point
 Counter Point*, 19, 224, 225–27
Huxley, Julian, 194, 216, 219, 220, 221, 224,
 225, 226. *See also Science of Life, The*
 (Wells, Huxley, and Wells)
Huxley, Juliette, 219, 225
Huxley, Thomas Henry: attitude toward
 artists, 26, 57, 59–60; attitude toward
 Hawkins, 23–24, 25, 47, 51–52, 56–58,
 59, 73, 74, 80, 160, 256; commissions
 Hawkins, 23–24, 39, 40, 42–43, 46–47,
 50, 51–53, 54, 55, 57, 60, 62, 63, 112, 131;